Iraq War Cultures

PETER LANG
New York • Washington, D.C./Baltimore • Bern
Frankfurt • Berlin • Brussels • Vienna • Oxford

Iraq War Cultures

EDITED BY Cynthia Fuchs and Joe Lockard

PETER LANG
New York • Washington, D.C./Baltimore • Bern
Frankfurt • Berlin • Brussels • Vienna • Oxford

Library of Congress Cataloging-in-Publication Data
Iraq War cultures / edited by Cynthia Fuchs, Joe Lockard.
p. cm.
Includes bibliographical references.
1. Iraq War, 2003– —Social aspects—United States.
2. Popular culture—United States. 3. Visual communication—United States.
4. War and society—United States. 5. Violence—Social aspects—United States.
I. Lockard, Joe, 1953– II. Fuchs, Cynthia.
DS79.764.U6I73 956.7044'31—dc22 2009043237
ISBN 978-1-4331-0289-9 (hardcover)
ISBN 978-1-4331-0288-2 (paperback)

Bibliographic information published by **Die Deutsche Nationalbibliothek**.
Die Deutsche Nationalbibliothek lists this publication in the "Deutsche
Nationalbibliografie"; detailed bibliographic data is available
on the Internet at http://dnb.d-nb.de/.

Cover art by Robbie Conal

The paper in this book meets the guidelines for permanence and durability
of the Committee on Production Guidelines for Book Longevity
of the Council of Library Resources.

© 2011 Peter Lang Publishing, Inc., New York
29 Broadway, 18th floor, New York, NY 10006
www.peterlang.com

Printed in the United States of America

For Bernie

—Cynthia Fuchs

To Adam, Noah, and Hannah

—Joe Lockard

Contents

Section III: Truth Games

Section IV: Word Wars

Section V: Teach the Children

"Shrapnel throughout the Body"

U.S. War Culture and Iraq

CYNTHIA FUCHS & JOE LOCKARD

> There are photos as well—one shows a father rushing through the street,
> his face torn with a last frantic hope,
> His son in his arms, rag-limp, chest and abdomen speckled with deep,
> dark gashes and smears of blood.
> Propaganda's function, of course, is exaggeration: the facts are there,
> though, the child is there . . . or not there.
> —C. K. WILLIAMS, "SHRAPNEL"

"Our combat mission is ending, but our commitment to Iraq's future is not" (White House 2010). Precious little fanfare accompanied President Barack Obama's announcement on 31 August 2010 that the last U.S combat troops were leaving Iraq. Unlike the countdown that George W. Bush's 18 March 2003 declaration that Saddam Hussein and his sons had to leave Iraq in 48 hours ("Their refusal to do so will result in military conflict, commenced at a time of our choosing") or his notorious assertion on 2 May 2003 that the mission was accomplished, the withdrawal of U.S. troops took place quietly and over long days and nights. Supply trucks and Stryker vehicles rolled across the border into Jordan, as soldiers in helmets and sunglasses kept watch, and occasionally spoke with U.S. reporters. On 19 August, Staff Sgt. Steven Bearor of Merrimac, N.H., summed up, "The best part of getting back to Kuwait? One, I know no one else is going to get hurt, and, two, I'm going home" (PBS 2010).

As noble and hopeful—and narrowly focused on U.S. casualties—as the sergeant's sentiment may have been, the truth is, as Obama underscored that night, the hostility continues. "Even as Iraq continues to suffer terrorist attacks," he said, "Security incidents have been near the lowest on record since the war began. And Iraqi forces have taken the fight to al Qaeda, removing much of its leadership in Iraqi-led operations." Between such "incidents" and "fighting," it is plain that more people will be hurt.

The Iraq War, in other words, persists, as do the cultures that both structure and emerge from it. Iraq is now a profoundly fractured post-war state, the result of self-admitted American errors in the past and continuing confusion since. In his speech on 31 August 2010, President Obama went on to say, "Of course, violence will not end with our combat mission. Extremists will continue to set off bombs, attack Iraqi civilians and try to spark sectarian strife. But ultimately, these terrorists will fail to achieve their goals." To keep back this amorphous threat, U.S. entanglements with Iraq are only beginning, in material and figurative senses. As the *New York Times* observed on 16 October 2010, the line between "terrorists" and others is ever more difficult to draw, as former members of the Awakening Councils have been turning to Al Qaeda for answers, or at least questions formulated in response to their recent wartime and occupation experiences. (Williams and Adnan 2010). The unremitting war in Afghanistan—now termed "Obama's War" as the Administration has accelerated drone attacks and sanctioned assassinations even as it has "accepted and approved the path of peace" the Karzai government has taken via negotiations with "moderate" elements of the Taliban—demonstrates the long-term American investment in the "war on terror."

Stateside, and in multiple ways, Bush's war remains a problem for Obama's America, burdened with a legacy of debt, political skepticism, and civic restlessness, both in the States and abroad. At the same time, Iraq War cultures endure in U.S. and international popular texts, shaping cynicism as much as conviction, manifest in frustrations ranging from the left to the right, the Net Roots to the Tea Parties. Even as the United States distances itself from "combat operations" in Iraq, effects of the war continue to be felt, shifting, painful, and pervasive.

The C.K. Williams poem above describes the visible effects of war injuries, the damage done to an Iraqi child's body by American-made and -fired shrapnel, and his father's grief. But we might ask: can any representation of that death—poetic or photographic—portray its gruesomeness and injustice? Efforts to represent, whether in film, drama, video games or literature, are at once expository and allusive, limited and provocative. Like the shrapnel that penetrated the child's body, in Iraq and again in Williams' mind's eye, U.S. society is penetrated by cultural representations of violence, representations that cannot dematerialize the real anguish of Iraq and its people.

* * * * *

How do U.S. consumers absorb violent imagery? In this collection Patrick Brantlinger argues that the mystification of terror conceals the ordinariness of violence in the United States. The imputation of foreign threat obscures the real source of fear and terror in daily life in the United States. Although the Obama administration early on distanced itself from the phrase "war on terror" (*Washington Post*, 25 March, 2009), post-9/11 fears of the Middle East continue to dominate U.S. popular culture. Can we imagine an un-terrified world, Brantlinger asks, one that rejects the imposition of terror as the paradigm for global relations? For Leanne McRae, another sort of paradigm is constructed in popular memory. Her chapter in this book analyzes the Bush Administration's use of 9/11 iconography—photos, footage—as a new centerpiece of American nationalism, drawing on imagery from World War II to legitimate the invasion of Iraq. Calculated official discourses, according to both Brantlinger and McRae, built a rhetorical culture that facilitated the Iraq War.

David Clearwater looks at the influence of video games on public support for the Iraq War in "Zap the Iraqoids! War and Video Games," and maps a representational history of war video games from the Gulf War forward. Video games have become a preferred means through which the U.S. military shapes public expectations of war, recruits volunteers for service, and trains those recruits. Beyond fetishizing generic combat violence, the new games feature virtual simulations of advanced land weaponry that is currently in development, thus shaping perceptions of today's wars as thrillingly futuristic.

Taking up another sort of fetishistic imagery, Murray Pomerance looks at the history of American movie representations of Arabs, beginning nearly a century ago in silent films, through 2005's *Syriana*, linking them to 19th century imperialist ideologies. Pomerance's tour of these filmic engagements with the Middle East underlines the extent to which broad stereotypes govern Hollywood productions and so allow military action in Iraq to look like self-defense rather than invasion. Cynthia Fuchs' "'You Just Want Stories': Iraqi Subjects, American Documentaries" looks at anther sort of representation, as U.S. documentary makers focus on Iraqi interview and observational subjects, revealing and investigating cultural biases even in the most well intentioned of relationships. Anna Froula's chapter turns towards the parodic critique of U.S. empire in 2004's *Team America: World Police*. She points to its dissection of neoliberal consumerism, especially as it is confused with "freedom," concluding that the movie demonstrates how "Americans are inherently complicit in the national imperialist enterprise, even if motivated by good intentions."

Given these parameters, how can cultural production confront military violence more explicitly and link it to socio-economic regimes? Tony Perucci revisits the photographs of Abu Ghraib as a violent spectacle produced by neoliberalism's demands

for the pacification of economic markets. Here the photos are not deviant, but symptomatic, a performance directed against who refuse to integrate into the global marketplace. Though President Bush declared, "That's not how we do things in America," Perucci submits that the CIA torture memos released in April 2009 reveal that this is very much how things have been done in and by America (*New York Times*, Mayer).

It is hardly surprising that the invasion of Iraq occurred against a specifically American historical backdrop, including the U.S. defeat in Vietnam. This specter has had recent effects, as when the military refused to let Joan Baez to sing at Walter Reed Hospital (*Washington Post*, May 2, 2007). Some months later, President Bush attempted to expel these ghosts in a lengthy speech in Kansas City before the Veterans of Foreign Wars. He denounced the Iraq-Vietnam analogy at length (American Presidency Project). But, as Zoe Trodd and Nathaniel Nadaff-Hafrey argue, the Vietnam war cannot be exorcized from U.S. cultural memory. Their chapter examines the "feedback loop" that continually repeats Vietnam-era fears and themes, tracing it across political rhetoric, music, video games, documentary films, poetry, and journalism.

Stephanie Athey looks to memoir for such connections, specifically, Tony Lagournis' *Fear Up Harsh: An Army Interrogator's Dark Journey Through Iraq* (2007). He reveals how torture, hardly secret but nonetheless shameful behavior during the Vietnam War, emerged as a marketable self-redemption narrative during the Iraq War. As Athey observes, violence systems mask and mitigate criminal culpability by alleging the existence of "bad apples," that subordinates betrayed their military superiors.

Even as more information emerges concerning who ordained what tactics, apologists for the Iraq War contend that the abuses of prisoners dishonor the warrior code and the intrinsic nobility of state violence. The two final essays of this volume argue otherwise, that U.S. educational culture produces violence—even excessive violence—so it is normative, not exceptional. Kenneth Saltman traces the recent history of a private non-profit corporation's "democracy promotion" in Iraq and other countries. The "new imperialism" of the Iraq War and authoritarian privatization, Saltman argues, share the same ideological origins. Such education and promotion can be understood in multiple ways. For Henry Giroux, Abu Ghraib reveals inherent racism, dehumanization, and social hierarchies. It also provides a point from which we can begin to rethink education's role in creating a political culture that values dialogue and dissent, one that rejects "the irresponsible violence-as-first-resort ethos of the Bush administration." Tragic and outrageous as it is, the Iraq War also provides an opportunity for education and recreation.

* * * * *

A book that interrogates the representations of an ongoing war is premised on many complications, not least being the war's irresolution. This one has evolved over time, and so we owe special thanks to our contributors, who must have wondered when and in what form their essays would see daylight.

Iraq War Cultures has several origins. It began as an editorial concept behind a series of essays published in *Bad Subjects*, the journal of a political and cultural studies collective in which Joe Lockard participated for many years. Cynthia Fuchs' continuing work on U.S. popular culture and media criticism has also led to a separate book project on post-9/11 war documentaries. Plans for this volume arose after we organized a packed-house "Iraq War Culture" panel at the Modern Language Association's 2005 convention, an occasion later castigated by Accuracy in Academia on grounds that "Getting current events insights from English professors is a risky proposition." (Kline & Seymour, 2007, 37). We have been aided in this work by the encouragement and forbearance of our editor Mary Savigar, production manager Bernadette Shade, and the staff of Peter Lang Publishing, who have brought the book to press. We also thank our friends, students, and colleagues at George Mason University and Arizona State University, who have supported our work.

<div align="right">—CF & JL</div>

WORKS CITED

Castronovo, Russ (2001). *Necro Citizenship: Death, Eroticism, and the Public Sphere in the Nineteenth-Century United States* Durham, NC: Duke University Press.

"Karzai Welcomes Obama's Suggestion of Talks with Taliban." (2009). Radio Free Europe. 8 March.

Kline, Malcom & Julia Seymour (2007). *The Real MLA Stylebook* Washington, DC: Accuracy in Academia.

Mayer, Jane (2008). *The Dark Side: The Inside Story of How the War on Terror Turned into a War on American Ideals* New York: Doubleday.

New York Times (2009). "A Guide to the Torture Memos."

Obama, Barack (2010). "Remarks by the President in Address to the Nation on the End of Combat Operations in Iraq." 31 August 2010.

PBS Transcript. 19 August 2010.

White House (2009). "Remarks of President Barack Obama—Responsibly Ending the War in Iraq," February 27, 2009.

Williams, CK. (2010) *Wait.* New York: Farrar Straus Giroux.

Williams, Timothy, and Duraid Adnan (2010). "Sunnis in Iraq Allied with U.S. Quitting to Rejoin Rebels." *The New York Times.* 16 October 2010.

Wilson, Scott, and Al Kamen. (2009). "'Global War on Terror' Is Given New Name." *Washington Post* (March 25). p. A4.

Wiltz, Teresa. (2007). "Joan Baez Unwelcome at Concert for Troops," p. C1. *Washington Post* (May 2).

SECTION I

Imperial War at Home

Shopping on Red Alert

The Rhetorical Normalization of Terror

PATRICK BRANTLINGER

Terror has long been terrible: but to the actors themselves it has now become manifest that their appointed course is one of Terror; and they say, Be it so. "Que la Terreur soit à l'ordre du jour."

—THOMAS CARLYLE, *THE FRENCH REVOLUTION*

Waiting for my flight, I hear the announcement: "The Department of Homeland Security has just raised the terror threat level to orange. Be on the look-out for any suspicious activity." The girl drinking pop has purple streaks in her hair. A suit-and-tie man reads the *Wall Street Journal*. A woman in fringed leather jacket yacks at her cell phone. The only suspicious character may be the pale young man with the backpack pacing nervously near the counter. Why so nervous? Suddenly he returns my stare. Am I suspicious? When I went through the security check, they seized my toothpaste. My miniscule tube weighed 2.5 ounces (or less). "This needs to be in a plastic bag," said the guard; "If you want it back—" "Never mind; I'll buy some when I get there." I didn't ask why my toothpaste would be safer in a plastic bag.

In the hotel gift shop I paid six dollars for a giant tube of Crest—the only size they had. Because I couldn't take it on the flight home, I left it for the maid. Are toothpaste sales skyrocketing? I tried to think about the relationship between toothpaste and terrorism; I couldn't think of any. However, during a press conference on October 11, 2001, President Bush (W) advised:

The American people have got to go about their business. We cannot let the terrorists achieve the objective of frightening our nation to the point where we don't—where we don't conduct business, where people don't shop. (qtd. in Miller, 297)

This was hardly FDR's "the only thing we have to fear is fear itself." It was instead one of many occasions when W's rhetoric , wittingly or otherwise, worked to normalize terror. The standard message is this: despite the U.S. military's "shock and awe" response to 9/11, we may never be able to let down our guard against our shadowy new enemies—"the terrorists," whoever they are. But we can still shop (unless we drop).

FIRE SALES

No one doubts that, since 9/11, "terror" has become "the order of the day." Massive, terrifying military power has been deployed—far beyond anything "the terrorists" can muster—to ensure that it has. "Orwellian 'Bushspeak,'" of course, attributes terrorism entirely to the other side (Kellner, 19). Meanwhile, not just W-speak but the rhetoric of the mass media and of many other politicians and governments renders terror routine, the "new normalcy." According to terrorism expert Charles Kegley, "Crisis, the Chinese proverb maintains, comprises both danger and opportunity. The opportunity before us is to understand the character of the new threats and to deal with them in ways that allow the world to adjust to the 'new normalcy' of life in the midst of fear" (2). Perhaps Kegley does not really mean that the purpose of understanding "the new threats" is not to eliminate terrorism, but merely to help people adjust to "fear" as part of the "new normalcy" (a phrase he puts in scare quotes, without citing a source). Nevertheless, he adds: "This fear now *is* normal. Terror and the chronic threat it arouses have become constants" (3). Here, too, Kegley's wording is oddly topsy-turvy: isn't it the "chronic threat" of terrorist attacks that arouses "terror," rather than the other way around? But in current parlance, "chronic threat" and "terror" are apparently synonymous, as are "terrorism" and "terror." Kegley's language is characteristic of the tautological discourse of terror that has become normal since 9/11. We are repeatedly said to be terrified by "terror" itself, with or without help from "the terrorists."

The elision of "terrorism" and "terror" is symptomatic of how the Bushites seized on 9/11 as, in W's words, an "opportunity to strengthen America" (qtd. in Parenti, 2). "Terrorism" isn't routine, but "terror" can be. If the aim of the Bush regime has been to frighten us so that we change our political if not our business habits, how is that different from the aim of the terrorists? To instill fear in the minds of the populations they target is one terrorist objective, and they have succeeded—so the rhetoric of terror implies. A whole new "fear industry" has emerged, including

such outfits as ChoicePoint, which is "the largest personal database company in America," ready to snoop where the FBI, CIA, and NSA legally cannot (Palast, 38–45). And there are the private security firms like Blackwater—now renamed Xe—whose mercenaries in Iraq make up the second largest force after the U.S. military (Scahill, xxvi).

Apart from the rise of Islamic "jihadism," 9/11, and the invasions of Afghanistan and Iraq, is anything new about the supposedly new normalization of terror? Perhaps its mass mediation since the introduction of television in the 1950s is its most novel feature.

Certainly terrorism is not new. Nor are "weapons of mass destruction" and their use, even by nonstate terrorists. During the Nazi nightmare, Walter Benjamin declared that, for "the oppressed," history is always "a state of emergency." That is the case today for Afghans, Iraqis, Darfurians, and millions of others in the impoverished and embattled "failed states" of the world.[1]

But is the U.S. a shining "city on the hill"? Citing Benjamin, Michael Taussig writes: "In talking terror's talk are we ourselves not tempted to absorb and conceal the violence in our own immediate life-worlds, in our universities, workplaces, streets, shopping malls, and even families, where, like business, it's terror as usual?" (4). Taussig stresses the violence and terror that permeate everyday life, though these are not unique to our era. What is unique is "terror's talk," the rhetorical overkill that, in the guise of warning the public about the supposedly new "chronic threat," treats terror as foreign, assailing us from abroad, and therefore ironically as extraordinary, something entirely novel in our lives. As ideological mystification, nothing works better to conceal the ordinary terror of everyday life than the notion of the supposedly alien terror that attacks us out of the blue—while we're shopping, or just going about our business.

Besides telling us to keep on shopping, W also advised Americans to be suspicious of our neighbors—everywhere around us, terrorists may be "lurking." If we're suspicious of our neighbors, moreover, they will be suspicious of us (see, e.g., Kellner, 19). And why not? After all, it's now normal to have your toothpaste seized at airports, your shoes x-rayed, and your travels through the aisles of your local Wal-Mart videotaped, because, no matter how unafraid you are, you may be somebody other people should fear. Though you know you're not a terrorist, how can we tell you're not? Prove it. What books have *you* checked out from your library lately? We're all plenty scared (or told we are)—look out especially for people with dark complexions and foreign accents, even in your local Wal-Mart (they may be temps, however, rather than terrorists).

Instead of treating terrorism as exceptional and, even after 9/11, not nearly so lethal to ordinary Americans as traffic accidents, smoking, or bee stings, the rhetoric of the Bush regime and the press rendered "terror," despite its supposed foreignness,

pervasive and downright homey. The title of the "Department of Homeland Security" sounds like a unit in Sears or JCPenney, while also suggesting that what it aims to defend us against—terrorism? terror? or just insecurity?—has come home to roost. Further, one obvious indication that terror is now like shopping or the weather is Homeland Security's color-coded terror alerts. They are of course terrorism alerts; but they are usually called terror alerts. The terrorists don't have to strike again to keep the country in a state of red or orange alert: Homeland Security will do that for us, thank you. Like hailstorms or hurricanes, moreover, supposedly the terrorists may go on attacking forever, but with ups and downs, just like barometer readings. Whether the terror alerts are as accurate as weather forecasts is beside the point; they don't need to be accurate to demonstrate that terror (we're told) now permeates every facet of daily life. And that's just the point: a terrorized public is a docile one, willing to accept whatever the government says will protect us from even bigger doses of terror—so let's take our umbrella[2] and go shopping before the mall explodes.

The "war on terror" has also helped to normalize terror as the new national emotion (if there was a national emotion before 9/11, perhaps it was happiness, as in "life, liberty, and the pursuit of happiness"). Both the Bushites and the media seized on the notion that 9/11 was a "new Pearl Harbor" and that it might be the start of World War III. In contrast to the American and "coalition of the willing" forces that invaded Afghanistan and Iraq, however, the enemy military was difficult to identify and, in the case of 9/11, self-destroying. W himself acknowledged, "These people don't have tanks. They don't have ships. They hide in caves. They send suiciders out" ("Truth," 5).[3] Except for the U.S. invasions, "war" seems hyperbolic, as does "jihad."

Moreover, as with "terror alert," what should properly be called the "war on terrorism" was typically shortened to the "war on terror." Thus, prematurely announcing "mission accomplished" on the deck of the USS Abraham Lincoln (1 May 2003), W declared: "The battle of Iraq is one victory in a war on terror that began on September the 11th, 2001 and still goes on" (qtd. in Everest, 3). It's not just terrorism we're fighting, it's terror itself, the greatest bogeyman of all. Besides, since all wars are terrifying, any "war on terror" is over before it begins—this second tautology suggests that such a conflict produces the very thing it seeks to combat. How do you allay or defeat terror, an emotion all normal humans are equipped to feel on terrifying occasions, while the mass media are constantly blaring, like air-raid sirens, that your country is waging war against that phantasmic but universal (normal) emotion? It's possible to catch or kill a terrorist, but not terror.

The semantic difference between "terrorism" and "terror" may seem insignificant, but in statement after statement by the Bushites and the media, "terror" was treated as routine. For many reasons, terrorism can't be routine. One is that it aims

to disrupt routines, and another is that the Bushites needed to claim they are effectively waging war against it. Yet terror (we're told) pervades the very air we breathe. The rhetoric of terror shoves aside all other issues—the economy, the environment, education, corporate, and political scandals. However, both the international and the domestic measures to combat terrorism have often been more about public relations than about actually protecting the public. Thus, in *The Terrorism Trap*, Michael Parenti writes:

> Many of the measures taken to "fight terrorism" have little to do with actual security and are public relations ploys designed to (a) heighten the nation's siege psychology and (b) demonstrate that the government has things under control. Hours after the September 11 attacks, the US Navy deployed aircraft carriers off the coast of New York to "guard the city," as if a mass invasion were in the offing. National guardsmen...armed with automatic weapons patrolled the airports. Flights were canceled until further notice. Sidewalk baggage check-ins and electronic tickets were prohibited for a time, all supposedly to create greater security. (5; see also Falk, 119)

One can add to Parenti's list numerous items such as seizing unbagged toothpaste and warrantless wiretapping. The Bushites were upset when the wire-tapping was leaked to the media, but the leak didn't hurt the general cause of persuading the public that a massive, shadowy struggle is going on, right here in the "homeland," between the terror cops and terror. Yet adequate measures to improve port security, to protect nuclear power plants, and to stop the Chinese from importing toxic toys and pet food have not been taken. Meanwhile, Hurricane Katrina demonstrated how unprepared government at any level is to handle a new emergency—to those who were injured, killed, or rendered homeless by it, a disaster every bit as terrifying as 9/11.

Can't Shop? Try Looting

In Katrina's wake, there wasn't much shopping going on in New Orleans. But according to the media, looting was, and it seemed to be just as big a deal as the flooding. For a while, looting outclassed the bungling of relief by W, FEMA, and on down the governmental ladder to the cops, including several who shot unarmed black people (maybe looters, maybe not). After 9/11, we—or rather, Afghanistan and Iraq—got "shock and awe," which we got to watch on television. After Katrina, the mostly black victims of that perfect storm got nothing (if they didn't get shot); we also got to watch them on television as they struggled with the flood and with the nonrelief. "Brownie, you're doing a heck of a job," W told the bungler in charge of FEMA ("Truth," 1). Why were the responses by W and his minions to 9/11 (shock and awe) and Katrina (bungling) so dramatically different? The hurricane

killed 1,800 people, about half the number of people who died in the World Trade Center. But Katrina destroyed most of New Orleans and disrupted tens of thousands of lives. At the start of 2007, over half of the former residents remained "in exile," and many of these have now been "evicted from emergency housing" in Baton Rouge, Houston, and elsewhere (Davis, 254). New York City survived 9/11—shopping goes on there as usual; it is still not clear, five years after the hurricane, that New Orleans has survived.

There are two main reasons why the Bush regime reacted swiftly and with full military force to 9/11 and then reacted so ineptly to the devastation of New Orleans. One is "the military-industrial complex," our own enormous terror machinery. America is the country with by far the most WMDs, and besides using them in Afghanistan, Iraq, and elsewhere, it does a regular business peddling them to the "failed states" who shop for them.[4] If you want to buy missiles, bombers, or tanks, the United States has the edge on the market. In his 1961 farewell address, President Eisenhower warned America about the growing power of the U.S. military and the defense industries. Ike knew that "the military-industrial complex," as he dubbed it, was already influencing far too many aspects of American politics and economics. Rather than heeding Ike's warning, W and his neoconservative henchmen viewed 9/11 as their chance to call the American military and gut-level patriotism into action. As part of his lame duck effort to bring peace and democracy to the Middle East, W signed a deal on January 14, 2008 to sell "state of the art" weapons to Saudi Arabia for $20 billion.

The second reason for the different responses to 9/11 and Katrina is racism.

Even before the Iranian hostage crisis of 1979, the American media regularly stereotyped Islam and people of Middle Eastern descent in negative terms. The Oklahoma City bombing in 1995 was immediately blamed on Islamic terrorists, even though the bomber was a disgruntled American veteran, Timothy McVeigh. A 1995 review by Fairness and Accuracy in Reporting noted that the mass media frequently speak of "Islamic violence," but never of "Christian violence" as in attacks on abortion clinics (Hagopian, 103). Films and TV programs often feature sinister Arabs or Muslims scheming criminal plots; mainstream movies that offer sympathetic portrayals of Islamic characters are almost nonexistent. Needless to say, 9/11 has only increased the stereotypical association of Middle Easterners (minus Israelis) with terrorism.

One upshot of all the stereotyping has been an explosion of that old version of domestic terrorism—hate crimes. According to the FBI's annual reports, hate crimes aimed at mosques, Muslims, and people perceived as Middle Eastern "spiked" after 9/11, and continue at much higher levels than before that tragic date. On 9 July 2005, a Molotov cocktail was thrown into the mosque in my usually peaceful hometown (Bloomington, Indiana), and six months later two bombs dam-

aged a Cincinnati mosque, to cite just two of many incidents. The Council on American-Islamic Relations points out that hate crimes often go unreported because "victims do not dare go to the authorities." The crimes are compounded by official harassment: hostile cops and immigration agents, snoops in search of terrorists. Thousands have left the United States, seeking refuge in Canada or returning to Pakistan, Egypt, and elsewhere (Hagopian, 45).

Furthermore, most of the victims of Hurricane Katrina were African Americans. Many did not own cars and could not leave before the storm hit. Many also lived in the neighborhoods where the worst flooding occurred. As already noted, immediately after the storm, the media broadcast rumors about black gangs looting and shooting other people. But the only verified shooting was done by the cops, some of whom also engaged in looting.[5] And Blackwater arrived before most federal agencies and charity organizations, supposedly to help with relief efforts but actually to beef up security and prevent more looting. Its mercenaries were already patrolling the streets of "Baghdad on the Bayou" when Homeland Security hired them (Scahill, 327). TV images of "looting, lawlessness, and chaos" were "racist and inflammatory," writes Jeremy Scahill in his study of Blackwater; "What was desperately needed was food, water, and housing. Instead what poured in fastest were guns. Lots of guns" (323).

Entire sections of New Orleans—poor, mainly black neighborhoods—may never be rebuilt, and public housing is being demolished. In the black neighborhood known as the Ninth Ward, instead of new houses, at one point white developers were planning to bulldoze the ruins and install two championship golf courses. What is being rebuilt are the homes of the wealthy, the port facilities, and the businesses and industries that cater to tourists. Rebuilding homes for the poor—that is, mainly for black people—is not a priority. On the contrary, the mainly white powers-that-be have seen the aftermath of Katrina as an opportunity to rebuild New Orleans without an African-American underclass. As rapper Kanye West said, "George Bush does not care about black people." At least, W did not care about poor black people unless he and his cronies could find ways to keep them from voting. As the storm approached New Orleans, in New York City Condoleezza Rice went shoe shopping.[6]

While the mainstream media attended to looting in flooded New Orleans, the looting of Iraq received very little attention. Oh, yes, there was something about the looting—presumably by Iraqis—of that country's "national treasures" from museums and libraries in Baghdad. Perhaps (it was suggested) U.S. troops could have done more to prevent that from happening, but after all, they had their hands full guarding Iraq's other national treasures—its oil wells. Archaeologist Paul Zimansky called the looting of the museums and libraries "the greatest cultural disaster of the last 500 years" (qtd. in Johnson, 47). The Bushites did not think it was all that seri-

ous, however. According to Chalmers Johnson, Rumsfeld "compared the looting to the aftermath of a soccer game" and declared: "Freedom's untidy....Free people are free to make mistakes and commit crimes" (47).

As to other aspects of "rebuilding" Sadam Hussein's "failed state," L. Paul Bremer made sure its government-run agencies and industries were privatized, with major U.S. corporations making off with the loot—or with a lot of it, anyway (Juhasz, 185–260; Klein, 325–340). There has been some grumbling in the press about the billions of dollars that have gone unaccounted for—somebody's loot, of course, but when it's in such enormous quantities, it seems qualitatively different from a few poor black folks taking food from 7-Elevens just to survive in their flooded city. In the American mass media, the looting of Iraq's—and world history's—cultural treasures has been almost invisible, in contrast to the so-called looting in New Orleans. When referred to at all, the missing billions looted from Iraq is discussed under the rubric of "corruption," which media stereotyping long ago identified as something Iraqis and other Middle Easterners engage in—unlike Americans or American corporations such as Halliburton or Enron. Today the long-anticipated looting—you can't call it shopping—of Iraqi oil is just beginning.

TELEVANGELICAL TERRORS

9/11 was a spectacular video event—Al-Qaeda could not have wished for a better, more terrifying result in terms of media coverage. Neither could the Bushites.

Rumsfeld's "shock and awe" and Bush's "mission accomplished" posturings were just two of now countless instances of American politicians' reacting to television as much as to terrorism—or exploiting them simultaneously. Al-Qaeda's videotapes have also been smash hits. Years before 9/11, ABC's Ted Koppel opined:

> Without television, terrorism becomes rather like the philosopher's hypothetical tree falling in the forest: no one hears it fall and therefore it has no reason for being. And television, without terrorism, while not deprived of all interesting things in the world, is nonetheless deprived of one of the most interesting.

Quoting this remark, Zulaika and Douglass note that Koppel "himself [is] a product of terrorism news" (7). The same is true for other television newscasters who operate as terrormongers rather than as critical analysts of such mongering. If you're shopping around for terror, TV news is as good a place to start as zombie movies (see also Kellner, 49–70).

For the policymakers and the Pentagon, "the order of the day" since 9/11 has been fighting "terror" by "counterterror"—that is, by using the methods of the terrorists themselves. The "shock and awe" bombardments, the arrest and often tor-

ture of thousands without due process, the deliberate rejections and violations of international treaties and laws, the flouting of the UN (John Bolton: knock off the top ten floors of the UN building and they won't be missed), the wiretapping and other forms of surveillance under the Patriot Act, were sold with apocalyptic (supposedly Christian) invocations of good versus evil, and of God and Armageddon. The religious rhetoric also served both to sanctify counterterror as official policy and to normalize terror. These are all now aspects of business as usual. Meanwhile Al-Qaeda turned the religious equation around with its invocations of good versus evil, Allah and Armageddon, and W or Dick Cheney as Beelzebub (Phillips, 206).

No doubt Al-Qaeda wishes that it could bring American business crashing down like the Twin Towers, symbols of that business. No doubt, too, members of both the Clinton and Bush regimes wish they had captured or killed bin Laden, although they had plenty of opportunities to do so that they failed to pursue (St. Clair, 22–26). But just as Al-Qaeda can't stop Americans from shopping, neither could the Bushites win the war on terror that it so furiously and futilely waged in Iraq and elsewhere. Indeed, winning that unwinnable war would have put the Bushites out of business. Of what value is peace to a self-proclaimed "war president"? 9/11 gave the Bushites their raison d'être as well as their cover for going after the oil. The war on terror has unfolded in its myriad bloody ways—in Afghanistan, in Iraq, in the Philippines, in Colombia—but also in the Gaps and Guccis, the Targets and Wal-Marts of the world. Wherever there are terrorists who hate America and want to destroy us, supposedly the antiterrorist forces of the U.S. government would be ready for them, W in the lead:

> We're tracking down terrorists who hate America one by one. We're on the hunt. We got
> 'em on the run, and it's a matter of time before they learn the meaning of American justice.
> (qtd. in Miller, 291).

That sort of cowboy talk hardly squared, however, with the very different claim that, in the words of Dick Cheney, the war on terror may go on for a "long, long time, perhaps indefinitely" (qtd. in Kellner, 20), much to the benefit of oil and defense industries like Halliburton.

The war on terror may go on forever or until the end of the world, because (we were told) it is the ultimate war of good against evil. Although Bush tried to avoid the word "crusade" in talking about his war on terror, paradoxically the apocalyptic language that he and the Christian right applied to the fray once again helped to normalize terror. Shopping may be normal, but the Bible is the revealed truth— hence, ultra-normal from a fundamentalist perspective. Shopping and Armageddon aren't poles apart; they go hand in hand—they happen every day. Now is the hour of Wal-Mart and also of the Beast (Domke, 26). To defeat the terrorists, we need

to shun the devil and to keep a grip on our purses and purchases. None of this is abnormal, because throughout history (i.e., after the fall) Satan has been trying to slay business-as-usual—the American, Christian way of life, a.k.a. shopping. W and Co. understood that there are other religions than born-again Christianity even in the United States. Yet according to right-wing evangelists like Pat Robertson, America is a "Christian country." As Stephen Colbert put it in his remarks to the White House correspondents on 3 May 2006, "And though I am a committed Christian, I believe that everyone has the right to their own religion....I believe there are infinite paths to accepting Jesus Christ as your personal savior."

Colbert did not go on to say that God speaks directly to W, but he didn't need to. The White House correspondents understood that the great "Decider" is in close personal touch with Our Heavenly Father. Or so W claimed: "I trust God speaks through me. Without that, I couldn't do my job" (qtd. in Phillips, 208). Again, "God told me to strike at al-Qaeda and I struck them, and then He instructed me to strike at Sadam, which I did, and now I am determined to solve the problem of the Middle East" (qtd. in Burbach & Tarbell, 16). When Pat Robertson resigned as head of the Christian Coalition late in 2001, evangelicals came to view W as "the de facto leader of the Christian Right" (Domke, 162). On the Christian Broadcasting Network, Robertson assured his viewers that if W fails at anything "God picks him up because he's a man of prayer and God's blessing him" (qtd. in Domke, 16). For evangelicals, many now chagrined by the loss of their born-again Republican as president and commander-in-chief, one nice feature of the continuing war on terror remains that the terrorists will fry eternally in the fiery pit, where torture is the norm.

Speaking to Congress on September 20, 2001, W declared: "The course of this conflict is not known, yet its outcome is certain. Freedom and fear, justice and cruelty, have always been at war. And we know that God is not neutral between them." If these two sides "have always been at war," when will it ever end? There can be no timetable for withdrawal from Armageddon. Even if he had to stop calling his war on terror a "crusade," W knew what it was both normal and ultimate. And he knew as well that "Every nation in every region now has a decision to make. Either you are with us or you are with the terrorists." So, too, that redoubtable Christian Tom DeLay, echoing W:

> The war on terror is not a misunderstanding. It is not an opportunity for negotiation or dialogue. It's a battle between good and evil, between the Truth of liberty and the Lie of terror. Freedom and terrorism will struggle—good and evil—until the battle is resolved. These are the terms Providence has put before the United States, Israel, and the rest of the civilized world. They are stark, and they are final. (qtd. in Miller, 270)

In this formulation, "terror" stands for three different "final" notions, all muddled together: it is at once the fear the terrorists are seeking to instill in us; it is terror-

ism as such; and it is the ideology of the terrorists—"the Lie of terror." And besides just plain evil, we know—or Tom DeLay knows—what that ideology is: it's radical Islam, subbing for communism.

So long as the war on terror is cast as a "crusade" or a "clash" between incompatible "fundamentalisms" or even "civilizations," rhetorically there is no room for compromise: such a war can only end in the total destruction or ultimate damnation of one side or the other. But what or who exactly is this enemy, this other side? Surely not an entire civilization or religion? Even though it sounds brave and decisive to declare that the world is split down the middle—the good and free Christians (most Americans) on one side and the bad and unfree Muslims on the other— thoughtful Christians and Muslims understand that evil inhabits every human breast and that Satan is a character in both the Bible and the Koran. So is Jesus.

Nevertheless, Democrats and Republicans alike bought into the Bushites' war on terror and the apocalyptic, gunslinger rhetoric that has been selling it like snake oil since 9/11. During his 2003 campaign for the presidency, John Kerry tried to outterrorize the Republican terrormongers with the refrain "I will capture or kill all the terrorists." Okay, big guy—go round 'em up. Thankfully Kerry did not give a religious spin to his rhetoric, though that may be one reason why he lost the election. And yet both parties and the mainstream media routinely reproduce "the apocalyptic worldview that now dominates our government—and that is also thriving elsewhere in the world, frequently *against* this government," as Mark Crispin Miller notes: "It is a Manichaean worldview, purist, fierce, explosive, and uncompromising, yet terror-stricken too and livid with self-hatred" (106).

"From his bunker," Greg Palast noted, "Mr. Cheney has created a government that is little more than a Wal-Mart of fear ..." (37). Just how terror-stricken most Americans have been is hard to tell, however. According to a Gallup poll taken in January 2005, 38 percent of Americans claimed they were "very concerned" or "concerned" that they themselves might be victims of a terrorist attack. But that means 62 percent were not all that concerned. Most people I know were more afraid of global warming or of what W would do next than of new terrorist attacks.

THE AGE OF TERROR? HAVE A NICE DAY

Since 9/11, close to one hundred books have appeared using "The Age of Terror" or of "Terrorism" as title or subtitle.[7] "Age" is a historical designation, of course, so is this claim good history or only hysteria? Statistics seem to bear it out, and yet much depends on definitions and also on how reliable the numbers are now and have been in the past. One familiar statistic is that, in 2006, terrorist acts topped 10,000 for the first time in history. But when did such acts begin to be counted, and what

exactly counts as a terrorist act? If the experts can't agree on a definition (and they can't), then it's difficult to see what such a number means. Suicide bombings in Iraq may be terrorist acts, but they could just as well be counted as acts of war. Killing civilians instead of combatants is one measure of terrorism, but then U.S., Israeli, British, and NATO forces do that routinely. Innumerable acts of war have killed millions of noncombatants throughout history. If acts of war are counted as versions of terrorism, the number goes through the roof. By such a reckoning, during World War II or the Vietnam War there were far more terrorist acts destroying million more lives than 9/11 or even its aftermaths in Afghanistan and Iraq.

Though the phrase "Age of Terror(ism)" cropped up occasionally before 9/11, the destruction of the World Trade Center catapulted it into a cliché. Clichés are often true, but there are several problems with this one. For one thing, besides the issues of definition and statistics, those who assert that ours is the Age of Terror are operating as prophets rather than historians. Their alleged Age of Terror begins with 9/11 or very recently so that this "age" lies mainly ahead of us. Many of the prophets seem to believe that terrorism, supposedly more or less confined to the Middle East until now, has been globalized by 9/11; perhaps this justifies interpreting that date as the start of a new era. But terrorism is not the recent invention of Islamic madmen; it is perhaps as old as mankind. That's a terrifying idea, though peace and law and order have equally long histories—and history continues.

Unlike many of the politicians and pundits, the academic experts at least recognize that terrorism has a past as well as a future. Albert Parry, Walter Laqueur, and other historians point out that the terms "terrorist" and "terrorism" were coined in the 1790s, during the French revolutionary "Reign of Terror." Unlike today's terrorists, however, the Jacobin terrorists were in power; they were, moreover, like their American revolutionary counterparts, democratic advocates of "the rights of man." In 1793, faced with the threats of invasion from abroad and subversion at home, the Committee of Public Safety, headed by Robespierre, made "terror the order of the day." That's a quotation from Robespierre himself, who believed "the republic of virtue" could only be secured by making it "the terror" of "the oppressors." "Bliss was it in that dawn to be alive," wrote William Wordsworth; however, the dawn of modern democracy also opened the era of industrial execution via the guillotine. Its use during the Reign of Terror is a clear example of state terrorism, but so were the repressive measures of the monarchy that the French Revolution overthrew.

That terror could be deliberately adopted as state policy was evident to Machiavelli, who advised his Prince "it is better to be feared than loved." Many "princes" have understood this: history is rife with examples of state terrorism. Today's Age of Terror proclaimers, however, often ignore state terrorism. Thus, in *No End to War: Terrorism in the Twenty-First Century*, Laqueur includes only a cou-

ple of pages on "state-sponsored terrorism" (223–225), and his examples are the usual suspects: Libya, Iran, Syria, and so forth—but not Israel and not the United States. This is a standard ploy on the part of those terrorologists who practice what Edward Herman calls the "pseudo-science" of terrorology (53). Many of the experts who proclaim that 9/11 is the dawn of the Age of Terror are quite selective about what they identify as terrorism.

In contrast, Herman distinguishes between what he calls "retail" or nonstate and "wholesale" or state terrorism (12). Can the retail terrorism of Al-Qaeda or even the Aryan Nation be understood minus the context of wholesale state terrorism? Though a distinguished historian, Laqueur dismisses those like Herman who stress that context. He thinks Noam Chomsky's "neoanarchist" insistence that it is "wrong to study substate political violence (i.e., terrorism) in isolation" renders "the study of terrorism impossible" and that Chomsky's is "a manifestly absurd approach" (140). So Laqueur chimes in with the pundits and politicians who, as Philip Herbst notes in *Talking Terrorism*, prefer "a definition of terrorism that excludes violent acts of the powerful and their clients." Terrorism is thus "the violence perpetrated by groups" or individuals "against a government or its citizens," but not the other way around (Herbst, 167).

If waging a "preemptive war" of "shock and awe" with thousands of civilian casualties counts as terrorism, then Laqueur's is the incoherent, "absurd approach." When has the torture of prisoners held by a state not constituted terrorism? If planting roadside bombs is terrorism, what about dropping cluster bombs and using depleted uranium shells? Laqueur claims that it is a waste of time to try to define terrorism. Even limiting it as he first did in *Terrorism* (1977) to "an insurrectional strategy that can be used by people of very different political convictions" does not help: "No definition of terrorism can possibly cover all the varieties…that have appeared throughout history."

For the first edition of *Political Terrorism: A Research Guide* (1977), Alex Schmid listed over one hundred definitions. The experts agree, of course, that terrorism exists, and many of them also insist that states practice it, even when the official label is counterterrorism. Modern examples of state terrorism include those analyzed by Patricia Marchak in *Reigns of Terror*: the Ottoman Empire during the Armenian genocide, the USSR during the "Great Terror" under Stalin, the Nazi Holocaust, and so on through Cambodia's "killing fields" and Yugoslavia's "ethnic cleansings." Herman's *The Real Terror Network* adds numerous examples from U.S. counterterrorist activities in Central and South America (see also Gareau). As both Marchak and Herman note, counterterrorism is typically just as terroristic (if not more so) as what it claims to be combatting. Now and in the past, Marchak comments, "The vast majority of crimes against humanity, and by far the largest number of deaths

and disappearances, have been caused not by small groups of revolutionaries, but by organized states against their own citizens and the citizens of other countries" (vii; Herman, 83; Falk, 76). Genocides are frequently, although not always, versions of state terrorism. Perhaps because of this, Laqueur does not deal with them. But downplaying both genocides and state terrorism while stressing only the violent deeds of nonstate actors produces myopic results.

Before dubbing our era the Age of Terror, the politicians, pundits, and terrorologists should also ask if it makes sense to name any complex historical period for a single emotion. After all, when was the age of regret or of joy? "The Age of Anxiety" became something of a cliché for the 1930s, but it's difficult to think of other examples. Rather than identifying terror as the main characteristic of our era, it may be more reasonable to think of it as a universal political emotion. In *Fear: The History of a Political Idea*, Corey Robin notes that terror may even be the most basic political emotion, the one that binds humans together in search of security. In the 1600s, Thomas Hobbes made "terror the order of the day" in political theory. Because the "state of nature" is one of "continual fear, and danger of violent death," humans formed communities to escape it (Hobbes, 100). But Hobbes also argued that people would not obey such moral "laws" as "justice, equity, modesty, mercy...without the terror of some power, to cause them to be observed" (129). The terror of nature is what forces people to band together; the terror of the king or the law is what keeps them together.

Hobbes was an authoritarian upholder of monarchy. Opposed to his dismal view of both nature and society were such early liberal theorists as John Locke; Enlightenment philosophers from Montesquieu to Kant opined that the fundamental emotional tie binding societies together was not fear but sympathy. People joined together in society because of "the law" and economic "self-interest," yes, but also because of "fellow-feeling," a mingling of emotional identification and mutual respect for each other. This was the optimistic view of both the French and the American revolutionaries—terrorists to their opponents—who gave us our Bills of Rights and our present-day conceptions of human worth, freedom, and possibility.

SHOPPING AROUND FOR A BETTER WORLD

Suppose bin Laden were captured or killed, Al-Qaeda crushed, the U.S. occupation of Iraq ended, and the conflict between Israel and Palestine settled. Terrorism might not vanish, but it would greatly diminish. An unterrified world, at peace and on its way to solving such seemingly ageless problems as global poverty, would put

"war presidents" out of business. The Department of Homeland Security could be disbanded and FEMA strengthened. The military could be radically downsized, and billions reinvested in social programs that benefit ordinary Americans. The prophetic pundits who come up with such headlines as "The Age of Terror" would have to come up with very different ones: "The Age of Peace" or of "International Harmony," perhaps. Such a prospect won't sound entirely far-fetched after recalling Bush, Sr.'s 1991 declaration of "a new world order" (although he criticized himself for not being good at "the vision thing," what was on his shopping list?). Following the collapse of the Soviet Union but before 9/11, many neoconservatives shared with liberals a highly optimistic "vision thing."

Insofar as Age of Terror claims are predictions rather than historical accounts, they ignore the hazards of political forecasting, close relative of the "vision thing." After all, who foresaw the downfall of communism in eastern Europe and the Soviet Union? But back then, a mere two decades ago, some of the politicians and pundits who now trumpet the Age of Terror were playing a very different tune. With capitalism and liberal democracy seemingly victorious, 1989–1991 was the dawn of an age of universal peace and prosperity. What's become of all those rosy "new world order" and "end of history" prophecies?

Paradoxically, the history of terrorism may offer some support for those older, hopeful forecasts. Terrorism is certainly as old as states and empires, but a case can be that the modern "Age of Terror(ism)" is winding down rather than just beginning. The two World Wars, the Korean and Vietnam Wars, the Gulf War, and now the invasions and occupations of Afghanistan and Iraq offer little or no cause for hope. The ratcheting-up of violence since World War II, including major genocides in Cambodia, Rwanda, Bosnia, the Congo, and the Sudan, signals the opposite of a winding down of terrorism. Like the war on terror, the Israeli-Palestinian conflict appears interminable and sure to fuel more terrorism, not less.

The good news, however, is that both repression and terror are in retreat and, just as the Bushites claimed they hoped, democracy is in the rise. Since World War II, the United Nations and other international institutions and laws have been major gains for global peace and order (despite John Bolton). So has the emergence of the European Union. Also after the 1940s, most former colonies have gained their official, political independence from the Western empires (though in many cases, economic dependency continues). Just as astonishing as the downfall of the Soviet Empire, the *apartheid* regime in South Africa has been swept away. And the recent elections in Latin America that have empowered democratic socialist leaders who are putting the welfare of the masses back on the agendas of their countries are also hopeful. Though Hugo Chávez of Venezuela is both hated and feared by many in the United States, his advocacy of a "Bolivarian" federation may lead to a unity in

South America that could help to overcome centuries of imperial exploitation and repression. Moreover, human rights organizations such as Amnesty International are making headway; their reports are part of the reason why the Bush regime came to be hated by millions around the world—and not just by "the terrorists." Perhaps nothing caused support for the invasion and occupation of Iraq to wane so quickly as the revelations of abuses and torture at Abu-Ghraib, Guantanamo, and elsewhere.

The end of the Cold War, writes Richard Falk, opened "incredible historical opportunities to create a safer and fairer world order." All the tools are at hand. The only thing wanting is leadership, from the United States among other countries, with enough of "the vision thing" for pursuing disarmament, strengthening the UN, and insisting on a "fair…solution of the Israel/Palestine encounter." Further, science and technology are developing new ways to manage environmental problems, to cure or eliminate many diseases, and to overcome global poverty. Besides the deaths and destruction wrought by 9/11, its main cost may well prove to be delaying the realization of these hopeful possibilities for decades—or however long the "Age of Terror" takes to get over itself. Let's hope "age" turns into something much shorter. Perhaps what is new about terrorism today, apart from the rhetorical hype that sustains it, is its exhaustion—its angry impotence in light of the desire of the vast majority for peace, stability, prosperity, and freedom. After all, as the motto of the World Social Forum has it, "Another world is possible."

NOTES

1. "Failed state" discourse is partly a recent attempt by neoconservatives in the United States to justify "preemptive war" against states deemed "failed" largely because opposed to U.S. policies and because alleged to be harboring terrorists. Compare Fukuyama and Chomsky.
2. In calling on Congress to help create the Department of Homeland Security, W averred: "I want all agencies involved with protecting America under one umbrella" (qtd. in Domke, 129).
3. W also referred to "the terrorists" as "these hateful few…who kill at the whim of a hat" (17 September 2004). In that formulation, the "hateful few" don't sound much like an army necessitating either a defensive or a "preemptive" war ("Truth," 3).
4. Apparently in denial about what the United States has been using in Afghanistan and Iraq, W said on 3 October 2003, "Free nations do not develop weapons of mass destruction" ("Truth," 9).
5. On 4 September 2005, seven officers, responding to rumors of sniping from Danziger Bridge, shot six people, killing two and wounding four others. These people do not seem to have been armed. As people tried to cross another bridge into Jefferson Parish, police from there fired over their heads to force them to turn back. Five New Orleans officers were also fired for looting.
6. Congressman Barney Frank calls what is happening to Black New Orleans "a policy of ethnic cleansing by inaction" (qtd. in Davis, 228).

7. Based on the World Libraries Catalogue Web site. About half of the titles or subtitles use "age of terrorism"; the other half use "age of terror." Before 9/11, according to WorldCat, only nine titles or subtitles included these phrases, and a couple of these do not refer to the present "age."

WORKS CITED

Burbach, R., & Tarbell, J. (2004). *Imperial Overstretch: George W. Bush and the Hubris of Empire*. London: Zed Books.

Chomsky, N. (2006). *Failed States: The Abuse of Power and the Assault on Democracy*. New York: Henry Holt.

Davis, M. (2007). *In Praise of Barbarians: Essays against Empire*. Chicago: Haymarket Books.

Domke, D. (2004). *God Willing? Political Fundamentalism in the White House, the "War on Terror," and the Echoing Press*. London: Pluto Press.

Everest, L. (2004). *Oil, Power and Empire: Iraq and the US Global Agenda*. Monroe, ME: Common Courage Press.

Falk, R. (2003). *The Great Terror War*. New York: Olive Branch Press.

Fukuyama, F. (2004). *State-Building: Governance and World Order in the 21st Century*. Ithaca: Cornell University Press.

Gareau, F. (2003). *State Terrorism and the United States*. Atlanta: Clarity Press.

Hagopian, E. C. (2004). *Civil Rights in Peril: The Targeting of Arabs and Muslims*. Chicago: Haymarket Books.

Herbst, P. (2003). *Talking Terrorism: A Dictionary of the Loaded Language of Political Violence*. Westport, CT: Greenwood Press.

Herman, E. S. (1982). *The Real Terror Network: Terrorism in Fact and Propaganda*. Boston: South End Press.

Hobbes, T. (1962). *Leviathan*. London: Collier Macmillan.

Johnson, C. (2006). *Nemesis: The Last Days of the American Republic*. New York: Henry Holt.

Juhasz, A. (2006). *The Bush Agenda: Invading the World, One Economy at a Time*. New York: HarperCollins.

Kegley, C. W., Jr., ed. (2003). *The New Global Terrorism: Characteristics, Causes, Controls*. Upper Saddle River, NJ: Prentice Hall.

Kellner, D. (2003). *From 9/11 to Terror War: The Dangers of the Bush Legacy*. Lanham, MD: Rowman and Littlefield.

Klein, N. (2007). *The Shock Doctrine: The Rise of Disaster Capitalism*. New York: Henry Holt.

Laqueur, W. (1977). *Terrorism*. Boston: Little, Brown.

Laqueur, W. (2004). *No End to War: Terrorism in the Twenty-First Century*. New York: Continuum.

Marchak, P. (2003). *Reigns of Terror*. Montreal: McGill-Queen's University Press.

Palast, G. (2006). *Armed Madhouse*. New York: Dutton.

Parenti, M. (2002). *The Terrorism Trap: September 11 and Beyond*. San Francisco: City Lights Books.

Parry, A. (1976). *Terrorism: From Robespierre to Arafat*. New York: Vanguard.

Phillips, K. (2006). *American Theocracy: The Peril and Politics of Radical Religion, Oil, and Borrowed Money in the 21st Century*. New York: Penguin.

Scahill, J. (2007). *Blackwater: The Rise of the World's Most Powerful Mercenary Army*. New York: Nation Books.

Schmid, A. (1984). *Political Terrorism: A Research Guide*. New Brunswick, NJ: Transaction Books.

St. Clair, J. (2005). *Grand Theft Pentagon: Tales of Corruption and Profiteering in the War on Terror.* Monroe, ME: Common Courage Press.

Taussig, M. (1989). "Terror as Usual: Walter Benjamin's Theory of History as a State of Siege," *Social Text 23*(Fall/Winter), 3–20.

"Truth." "The Truth about George." [http://www.thetruthaboutgeorge.com/bushisms] Accessed October 20, 2009.

Zulaika, J., & Douglass, W. A. (1976). *Terror and Taboo: The Follies, Fables, and Faces of Terrorism.* New York: Routledge.

Memory, Meaning, and Mass Destruction

LEANNE MCRAE

In an age of propaganda, political simplicities and violence, our stories are crucial. Apart from the fact that the political has to be constantly interrogated, it is in such stories—which are conversations with ourselves—that we can speak of, include and generate more complex and difficult selves. (Kureishi, 10)

After the initial shock of the trade towers collision and collapse on September 11, 2001, the media spotlight focussed on the intensely emotional and personal stories of individuals—New Yorkers, family members, husbands, and wives in the towers and the victims of hijacking in the planes. Communication and connection were heavily emphasized with the ringing resonance of mobile phones and phantom messages left on answering machines by fearful passengers. This public performance—broadcast on news networks—revealing personal pain in a public forum demonstrated a gap in the popular memory. These events were so far outside the comprehension of Americans that there was no anchorage to a dominant national discourse outside of the family to focus the meanings and memories of this tragedy. The highly emotional rhetoric was the only modality immediately comprehensible to U.S. citizens and others observing their television screens across the world. Focusing on the horror and the impact on individual lives created a common reference point—a point of collectivity whereby highly ideological memories

of community and belonging could be activated and defended. National identity was reduced to and reinscribed through the intensely localized emotional connection to family.

Following this event, a series of collapsing narratives focussing on national cohesion and community conspired to create war. From September 11, 2001 to March 21, 2003, multiple memories were mobilized to gather support for a second war in Iraq. The memories that were constructed around and through September 11 segued into the ideologies of conflict far too easily. The trajectory of these 18 months (and beyond) demonstrates the importance of popular, collective, and official memories in our consciousness of community and collectivity.

How do we struggle over memory? Recollections of events in the past are remembered in the present through carefully crafted forgetting strategies that mask complexities and coherence in collectively witnessed events. The argument presented will track the narrative put in place after September 11, 2001. These imaginings framed our sense-making of this attack—and provided the impetus for "Operation Iraqi Freedom." A process of forgetting was activated by the Bush regime to fill the gaps and absences in collective and popular memories. The official ideologies were encoded with popular histories of war connected to a burgeoning Christian religious fundamentalism.

Through four sections in this chapter, I will trace how memories were cohered. In the first section a mapping of memory, its connections to history, and the formation of identity is produced. In the second, I show how immediately after September 11, 2001 George W. Bush constructed clear divisions between "us and them" by enfolding these distinctions within a conservative Christian framework. Then, I demonstrate how this religious rhetoric combined with a rewriting of the narratives of World War II to activate an imagining of the United States as a divine defender of freedom. In the fourth and final front, popular culture is conjured to visualize the imagery of World War II, Hitler, *Saving Private Ryan*, and *Black Hawk Down* that were specifically activated to facilitate mythologies of war and the forgetting of Korean and Vietnamese conflicts.

The struggle for popular memory is a process that is constantly becoming and never completely closed. It is precisely in these spaces where the Bush regime did its most potent reimagining work. The argument here will demonstrate how popular memories, intertwined with, and were overwritten by Bush and Blair. By investigating the language and imagery used in the post–September 11 period, leading up to and throughout the second war in Iraq, I will demonstrate how popular memory is critical in the cohesion of the national popular.

PONDERING THE PAST

"Who controls the past," ran the Party slogan, "controls the future: who controls the present controls the past." (Orwell, 37)

Historical narratives cannot be formed and framed among the incoherent hodge-podge of human experience without strategies of selection. History and "memory [are]…active structuring process[ess]" (Popular Memory Group, 234). Both these formations strive to construct stories—a linear tale—in which to create coherent subjectivity and public record. In order to mask inconsistencies and irreconcilable events, entire sections of the past are ignored and "swept" away. Forgetting is not just an official strategy to present a socially acceptable narrative of heritage and home, but is absolutely crucial to the construction of a coherent personal identity. David Lowenthal affirms that "to generalize and act effectively requires not an ency-clopaedic but a highly selective memory and the ability to forget what no longer matters" (194). The consequences of remembering *everything* would be crisis and confusion. Attaching personal memory to official historical structuring tools enables subjective anchorage through time and space. It is necessary that "as an organized construct…the individual past parallels the collective past" (Le Goff, 3). The shared imaginings add credence and coherence to personal reminiscence. In an Orwellian world, a padded past is the modality through which information, remembering, and knowledge are controlled. Past, present, and future can be curtailed through the reimagining of events, images, and narratives.

History is filled with these disappearances. They are not spurious or random. They are connected to the power structures a society perpetuates. What is remembered of the past is shaped by "the context of the present, and never disassociated from considerations of power" (Osborne, 45). The narratives that we tell ourselves of the past are tales for the present. The great men we hail as the makers of our history are part of the strategies engaged to colonize popular memory.

Popular culture is recruited in this strategy and the media are the space where the imaginings are given life. Remembering past events is often helped and hindered in popular culture texts activating, questioning, and validating histories.

The field is crossed by competing constructions of the past, often at war with each other. Dominant memory is produced in the course of these struggles and is always open to contestation. (Popular Memory Group, 207)

It is the contested spaces between personal, collective, and dominant memories so that a cohesive and consensual popular memory is produced. It is popular memory that translates personal experiences into and through dominant memories.

Powerful interests seeking maintenance of the status quo strive to colonize the spaces in which popular memory is formed—influencing the outcome of the struggle between dominant and personalized pasts. By challenging the efficacy and efficiency of personal memories, dominant interests seek to reshape retrospection. It is "the range of meanings commonly attached to memory…[that] transcends and sometimes obscures these relations with the past" (Lowenthal, 193). The intimacy between the previous and the present in popular memory begins to generate a sense that "the past is understood…not as a given 'thing,' but as a force constantly resonating in the present, producing new layers of sound and meaning" (Popular Memory Group, 243). It is through these new spaces of meaning that "disappeared" identities can be recalled. It is also in this struggle where colonization of popular memory occurs.

Popular memory is a crucial site in contemporary displays of power. Henry Giroux demonstrates how significant the popular media are in mobilizing these unofficial spaces of meaning. He affirms the importance of "the enormous ways in which popular and media culture construct…meanings, desires, and investments" (Giroux, 38). The intersections between popular culture and popular memory generate an intensely cohesive nature that can be accessed as a space for imagining and activating the national popular. During and after September 11, 2001, George W. Bush battled for popular memory through constructions of the nation-state. His strategy was to limit and control the resonance of alternative rememberings and imaginings circulating through official and unofficial discourses in the media, education infrastructures, and government rhetoric—not just of September 11, but whole sections of U.S. and world history. The ease with which this social regulation was embraced and believed by citizens was not only embedded in the familiar othering strategies that cause us to imagine and fear difference as deviance. Rather, a complicated common sense, not simply inscribed by a binarized fear of others/terrorists, but also configured by economic and social strategies of success, national histories, and mediated memories functioned to frame action taken post–September 11, 2001.

INGSOC 101

> We're overcoming the evil done to us, as well, through military action…I want to assure you we don't seek revenge, we seek justice. And I believe that if we're patient and resolved and united, that out of this evil will come lasting peace. (Bush, April 11, 2002)

> War is peace
> Freedom is slavery
> Ignorance is strength
> (Orwell, 6)

A reification of a nostalgic past as an attachment to social conservatism serves nationalizing interests well. Memory assists in the fabrication of past events through popular consciousness. Popular memory can be relied upon to create the appropriate memory even if one never existed. In terms of the national popular, once "the border-posts have been dug in…the myths of antiquity are spun and the recent cultural/political origins of identity are covered up by the 'genesis stories'" (Bauman, 17). These are stories that validate a collective and coherent past allocating ownership of time and space to a particular identity or ethnicity. National imaginings are rarely so volatile when they are connected to "ethnic identities" (Henkes & Johnson, 136). The perceived incursion of "ethnic others" corrupting the coherence of the nation-state offers an evocative imagining. The borders must be protected with force in order to secure national coherence. As a result, "violence, which otherwise would call the bluff of communal unity, is thereby recycled into the weapon of communal defence" (Bauman, 19). Defense of the nation-state is permitted to reify the persistence of a cohesive national community. Violence directed outward is verifiable and necessary in this context. For the purposes of popular memory it is fundamental, as a sense of the past must be produced in "a public 'theatre' of history, a public stage and a public audience for the enacting of dramas concerning 'our' history" (Popular Memory Group, 207). September 11, 2001 provided this stage. It allowed American patriotism to focus through the overt and violent incursion of others into the nation-state. It enabled George W. Bush and his administration to harness a collective and mythic imagining of the U.S. community. It provided the unstable conditions to contract back to national defense against dangerous global forces. These "historical ideologies" (Popular Memory Group, 248) of national cohesion are particularly resonant during this time of wavering "social improvement or decline." In an age where individuals are working under immense economic hardship and social disaffiliation (Ehrenreich; Newman; Aronowitz & Cutler), the comfort of focussing energy and attention on external threats distracts from the social responsibilities of governments. In order to activate popular memories, public spectacle must prevail. The notion of "genesis stories" provided the groundwork for sustained public spectacle of instability that was justified by the language of the Bush administration through the very early alliance of the United States with God, and the rendering of Osama bin Laden and then Saddam Hussein as the Devil.

ALLIES AND THE ALMIGHTY

Soon after the dust settled at Ground Zero, it became clear that the U.S. government would not be promoting peace. In his initial statements on the day of attack,

George W. Bush hinted at the trajectory about to be embraced when he ordered "a full-scale investigation to hunt down and to find those folks who committed this act" (11 September 2001). On September 12, 2001 the tone became more deliberate. His language revealed a new consciousness.

> As a mark of respect for those killed by the heinous acts of violence perpetrated by faceless cowards upon the people and freedom of the United States on Tuesday, September 11, 2001, I hereby order…that the flag of the United States shall be flown at half-staff at the White House and upon all public buildings and grounds,…until sunset, Sunday, September 16, 2001. (12 September 2001)

In these initial reactions, the seeds were sowed for an intensely emotional connection to the nation-state through border protection and parochialism. This statement was made the same day another speech circulated, striking up the first of a series of binarized but intimately intertwined imaginings of invasion, enemies, nationhood, and freedom for the American people. Within these initial speeches, a very specific rendering of U.S. history, democracy, and liberty functioned to redefine the recent and distant past—a past of inexplicable and unwarranted attack on U.S. sovereignty. George W. Bush worked in spaces of official, collective, and popular memory to mobilize support for his position. By reremembering the past, a particular present gained currency—a present of evil foes and invasion of U.S. power and sovereignty.

> This enemy hides in shadows, and has no regard for human life. This is an enemy who preys on innocent and unsuspecting people, then runs for cover…This enemy attacked not just our people, but all freedom-loving people everywhere in the world. The United States of America will use all our resources to conquer this enemy. We will rally the world. We will be patient, we will be focused, and we will be steadfast in our determination. (12 September 2001)

A faceless enemy enabled the Bush administration to amplify a fear of otherness and rev up the border protection pulpit. The insidious threat constructed a halo of hollow caricatures—embodied in the ambiguity and ellusiveness of Osama bin Laden—to instil panic and cultivate a culture of suspicion. Balancing this anxiety with strength, sovereignty, resilience, togetherness, and community created a syncopated tempo designed to control and cauterize public opinion. A collective and cohesive national identity formed in direct opposition to an external threat was characterized most strongly in a declaration on September 20, 2001 when George W. Bush effectively binarized world opinion by stating "every nation, in every region, now has a decision to make. Either you are with us, or you are with the terrorists" (20 September 2001). On February 5, 2002, in a speech hailing new funding for research into bioterrorism, the dictation was unmistakable.

I view this as a struggle of tyranny versus freedom, of evil versus good. And there's no in between, as far as I'm concerned. Either you're with us, or you're against us. (20 September 2001)

Bush succeeded in monopolizing the discourse by turning September 11 and the conflicts following this event into a struggle of good against evil—a concept constantly reaffirmed by his repeated use of the phrase "evil doers." He redrew U.S. borders, made national concerns global concerns, and kick-started a curtailment of public debate and civil rights—not least embodied in the antiterrorism bill "The Patriot Act." A singular and purposeful positioning of U.S. nationhood and nobility placed September 11, 2001 and its following events outside of conventional politics. George W. Bush's decision making was placed above everyday life—justified by the intensive reification of the imagined nation-state and cohesion of the national popular. By appealing to a collective sense of U.S. destiny and divine right, Bush brokered a blank cheque.

After September 11, 2001 the intense Christian fundamentalism that peppered his rhetoric reaffirmed and reified a religious imagining for the U.S. people as divine servants of God maintaining a duty to bring forth righteousness and justice to the world. Religious passages infiltrated George W. Bush's speeches and policy platforms as he instigated "Faith-Based Initiatives." Its function was to create a sense of divine destiny—a "genesis story"—upon which to anchor national identity. This tempo continued to gather momentum through the next few months and neither George W. Bush nor his speechwriters had any problems in an April 2002 speech that demonstrated profoundly problematic religious rhetoric.

I mean, government can write checks, but it can't put hope in people's hearts, or a sense of purpose in people's lives. That is done by people who have heard the call and who act on faith and are willing to share that faith. And I'm not talking about a particular religion—I'm talking about all religions under the Almighty God. (11 April 2002)

In a disturbing tone George W. Bush simultaneously allocates space for difference, and then denies its currency. He collectivized the American community around a Judeo-Christian faith limiting the spaces for alternative worship. Bush managed to remove his decision making from the realms of citizenry and politics and place them as universally divine doctrine. He thereby reduced the scope for conversation and questioning by reifying his position as common sense. By shutting out alternative imaginings and ideas, he routed public opinion. Bush co-opted collective memory and attached it to dominant narratives to capture and contain the personal imaginings of individuals.

MOBILE MEMORIES

Higher ideals of liberty, freedom, justice, and human rights were delicately thread-ed through deadly and draconian conservative ideologies of the nation-state and imperial power in the post–September 11 period. Bush hailed a memory of global policing and the United States as guardians of justice and defenders of liberty. Popular memories of the United States resisting invasion and winning war reaffirmed these ideologies.

> We will remember a generation that liberated Europe and Asia, and put an end to concentration camps. We will remember generations that fought in the cold mountains of Korea, and manned the outposts of the Cold War. We will remember those who served in the jungles of Vietnam, and on the sands of the Persian Gulf. In each of these conflicts, Americans answered danger with incredible courage. We are equal to every challenge. And now, a great mission has been given a new generation—our generation—and we vow not to let America down. (30 October 2001)

One month earlier Prime Minister Tony Blair animated an imagining of World War II that was to prove extremely valuable to George W. Bush. What was perhaps most devastating about this turn of events was the extent of the forgetting. Within one speech, Blair was able to write out of history the deeply significant role of the British in World War II. For almost two years Britain stood alone against the Nazis while millions died, because the United States refused to enter the war. They only took up arms after the tragedy at Pearl Harbour in December 1941—when it was in their interests to do so. This knowledge was ignored—rewritten—in the 18 months between September 11, 2001 and March 21, 2003.

> I would like to repeat that my father's generation went through the experience of the second world war, when Britain was under attack, during the days of the Blitz. And there was one nation and one people that, above all, stood side by side with us at that time. And that nation was America, and those people were the American people. And I say to you, we stand side by side with you now, without hesitation. (Blair, September 20, 2001)

No mention was ever made of the absence of U.S. forces in the first two years of World War II. This memory was lost. It was conveniently forgotten so the spin-doctors could conjure popular memories—of the United States's role in the heroics of this war. In following speeches George W. Bush consistently hailed World War II figures and strategies. In one speech he called up the images of President Truman, Winston Churchill, and Army Chief of Staff, General George Marshall—all within a single paragraph.

> As Army Chief of Staff, General Marshall became the architect of America's victory in the second world war. He fought tenaciously against our enemies, and then worked just as hard

to secure peace. President Truman considered George C. Marshall the greatest man he knew. Above all said Winston Churchill, Marshall "always fought victoriously against defeatism, discouragement and disillusionment." (17 April 2002)

Sanitized versions of warfare and victory were funnelled through the popular remembrances of World War II. Through these means, Bush crafted the national popular. In colonizing popular memory he confirmed an imagining of U.S. identity that supported, and even demanded the pursuit of conflict. A sense of collectivity and cohesion brought the nation together and enabled a forgetting—a collective amnesia—of U.S. history meddling in the affairs of other nations and interference in world politics—ignoring wider socioeconomic strategies and interests being played out in globalization that benefit (among others) U.S. corporations and industries (Chomsky; Vidal)

George W. Bush used the popular memory of World War II, Hitler, Auschwitz, and the Holocaust to verify the "Holy-ness" of invading Iraq. The strategy was to inscribe U.S. invaders as "liberators" in line with the D-Day landing at Normandy. During Operation Enduring Freedom and leading up to Operation Iraqi Freedom George W. Bush was careful in his framing of the U.S. military as freedom fighters (17 April 2002). He connected this imagining to World War II knowledges, memories, and images to create the Iraqi threat. A visualization of war narratives gained in currency and frequency as time passed. Memories were monitored and manipulated with this imagery.

> Since September the 11th, we have been the kind of nation our founders had in mind, a nation of strong and confident and self-governing people. And we've been the kind of nation our fathers and mothers defended in World War II; a great and diverse country, united by common dangers and by common resolve. (30 April 2002)

The selective amnesia around its representation forgot the memories involving the Catholic sanction of genocide, the atrocities at Hiroshima and Nagasaki, the firebombing of Tokyo, and alliances with Stalin. Instead, imagery of heroism was employed to reify America's postwar economic recovery and status on the world stage as guardians of freedom. As the enemy turned from Afghanistan to Iraq, a direct correlation between the homicidal activities of Hitler and Saddam Hussein peppered the popular media.

The imagery being employed was specifically directed at attaching itself to the popular memory that has circulated about World War II and Hitler. Representing Saddam Hussein in the same manner as the Nazi leader created a highly codified imagery for people to anchor their sense-making to. This highly selective remembering of World War II was employed by the United States and involved activat-

ing narratives of social justice specifically designed to mask the less successful wars in Korea and Vietnam. This turn to the past was fundamental for the invaders to shape public opinion by creating a completed narrative even before the story had begun. For "historical consequences are at least partly worked out and understood, whereas results of present acts are not yet to be seen" (Lowenthal, 234). The narrative of Hitler's monstrousness and downfall was resolutely mobilized in the popular consciousness. It enabled a supreme confidence in the United States's divine duty to destroy oppression.

The mobilization of popular memory was crucial for the invaders to mask the interests of globalization and the nation-state. No better example of Bauman's "law of the stronger" (12) can be found than the second Iraq war. It bears all the hallmarks of global interests "mak[ing] themselves inaccessible [to the] people whom they dominate and off whose labour they live" (5) and "do[ing] everything they can to gain and retain the right to define the contents and the limits of sovereignty from one case to another" (10). Saddam Hussein had been in power for over 25 years and conducted atrocities throughout his reign. Post–September 11, 2001 it became convenient for the United States to "liberate" Iraqi citizens. The conflict embodied Bauman's criteria for global war-making in the interests of market economies. He argues these are wars from a distance, not over territory necessarily, but over markets. Most crucially "the wars promoting the globalising cause are meant to 'bomb the reluctant into submission'" (7). The United States's aptly named "shock and awe" offensive fit snugly into this analogy. However, in order to maintain the illusion and "escape the charge of aggression" popular memory must be enlisted to assist in the imagining of the nation-state through a mythologized history. These conditions require an intense international cohesion for the perpetuation of U.S. interests.

The ambiguity of memory enables the "nurturing of ideas and myths as the emotional and sentimental glue than binds people together" (Osborne, 41). In the spaces left unfilled, "a common heritage or identity [is built] for new generations on the foundations of a 'should have been' past" (42). All the great narratives of communal spirit and heroism stand instead of pasts invested in difficulty and deviance. The conjuring of mythical memories for the nation-state is important for a vision of the future. Creating a coherent trajectory from the past into the future validates the righteous invasion of Iraq. Demonstrating the coherence of national identity through a "collective awareness and identity that is promoted through a sense of historical experience" (41) helps to orchestrate a "collective remembering—and if necessary, collective amnesia" that emphasizes a "restructuring and preserving [of] the past to encourage the present to build and secure the future" (42). This even extends to pasts that never existed.

MOVIES AND MEMORIES

On March 23, 2003 Private Jessica Lynch was captured by Iraqi soldiers. On April 1, she was rescued in a covert operation. This story was unremarkable as war stories go. What *is* significant is how this narrative was constructed and covered in the media. Following her rescue her image was splashed across newspapers. On the *West Australian*, her image was accompanied with the headline "The Iraqi who saved Private Lynch." In *Time* magazine, it was simply "Saving Private Jessica."

The popular memory mobilized in the film *Saving Private Ryan* was written over Private Jessica Lynch's experience. The myths of World War II were also rewritten in the film. This fiction is given currency as a potent emotional vision of heroism is created. Images of communal belonging, sacrifice, and honor are conjured through this headline. This may seem to be sensationalism by the popular media. Yet, it is deeply significant "because 'the past' has [a] living active existence in the presence that it matters so much" (Popular Memory Group, 211). The memories that are chosen are important for our sense of history, continuity, and identity and "a false recollection can be as durable and potent as a true one, especially if it sustains as self-image" (Lowenthal, 200). Jessica Lynch's story is forever tethered to competing historical sources seeking to confine her within popular memory and a narrative that attaches easily to the national popular. In the text accompanying the above image, the role of the popular media in reifying and activating memory is explicit. Among the description of her daring rescue, U.S. Colonel Harry Warren states, without irony, that "It worked perfectly. It was like *Black Hawk Down*, except nothing went wrong" (qtd. in Morse, 57). This popular film is being used as a collective reference to validate U.S. resilience. One must assume he is attempting to conjure the imagery of U.S. heroism constructed in that film, rather than the gross incompetence. While *Black Hawk Down* is an uncomfortable fit, *Saving Private Ryan* and other World War II memories are not. The war has provided popular culture with a bank of heroic and stable images that can be easily conjured to placate an unstable, war-mongering nation-state.

> World War II has provided an inexhaustible supply of historical fact and fiction, much of it in the heavily militaristic guise and reinforced by the close convergence of war, fighting and a boy culture in men, young and old. (Popular Memory Group, 209)

The popular memories and representations of Vietnam work against these interests. Films like *Apocalypse Now, Platoon,* and *Full Metal Jacket*, and melodramatic television like *Tour of Duty, China Beach,* and even *M*A*S*H* (set in Korea, but widely viewed as a commentary on Vietnam) provide harsh criticism of war and the mil-

itary. Where popular memories of Vietnam *were useful* was in limiting the level of criticism that could be directed at the war effort—especially once it got underway.

A popular memory of the "victim veteran" (Lembeke, 66) that emerged out of the Vietnam conflict gained currency primarily through the visual media. This is the figure of the damaged and disempowered war veteran discarded by society and suffering from posttraumatic stress, disability, or nervous breakdown. *Coming Home* epitomizes and empathizes with this character. This film was part of a reimagining of war veterans. From the mid-1970s onward, there was an active process of reremembering the Vietnam War. Unable to reconcile its loss, U.S. national consciousness had to assign blame. In this line of thinking "the war was not lost in Southeast Asia, it was lost at home" (84) as a result of war protesters and their "attack" on serving soldiers. Consequently "the notion that Vietnam veterans were treated abusively by the anti-war movement, even spat upon, is now widely accepted" (83) even though these cases were extremely rare. This popular memory is significant as it was hailed actively during the lead up to the Gulf War part two, where protests that took place on a startling scale across the world were criticized for being antisoldier rather than antiwar. The popular memory of protesters "damaging" soldier's esteem and morale was activated very strongly and it very effectively limited any criticism of invasion. These memories gave George W. Bush the platform he needed to collectivize the national popular and provide the impetus for armed conflict. Via a series of imaginings, public debate was curtailed and the righteousness of U.S. sovereignty affirmed. The incredible power of memory as the colonizing space of Bush's administration can be seen in the events broadcast onto our screens during Operation Iraqi Freedom. The popular media swallowed the war rhetoric readily. It made great television. Images of tanks streaming across the desert accompanied by a recent memory of the United States as divine liberator defending American sovereignty (and markets) made a formidable entertainment package. Sexy stories rather than serious consequences and consciousness peppered the popular media.

The capacity for past events to move through time and claim resonance in the present is the space of and for popular memory. What we remember and how we remember it are powerful social shaping tools. Memory is ambiguous, and it is this simultaneous ambivalence and potency in the past that makes memories powerful. Our sense of history is embedded in these imaginings, yet our own experiences are denied currency until they can be placed into a narrative (history and popular culture) that frames and limits what can be known of that experience. The second war against Iraq demonstrates the struggle over popular memory whereby official discourses sought to claim currency on the back of a national popular supported by a collective memory of the past. The fluidity and flexibility of memory make it aptly suited to the mythologizing of the past in the present. George W. Bush and his

administration relied on the anxiety and ambiguity of memory to prize open the popular in order to activate imaginings of war, threat, and the nation-state. Through these means a new narrative was constructed to fit into easy ideas about terrorists, the Middle East, and conflict. Popular memories were conjured to curtail critique. Through intersection of personal, collective, and official memories, popular memory was rewritten to advance the interests of invasion.

WORKS CITED

Agamben, G. (1993). *Infancy and History*. London: Verso.

Aronowitz, S., & Cutler, J. (eds.). (1998). *Post-work: The Wages of Cybernation*. New York: Routledge.

Balmer, R. (2003). "Bush and God," *Nation*, 267(14).

Bauman, Z.(2001). "Space in the Globalizing World," *Theoria*, June, 1–22.

Bélanger, A. (2002). "Urban Space and Collective Memory: Analysing the Various Dimensions of the Production of Memory," *Canadian Journal of Urban Research*, 11(1), 69–92.

Brand, S. (1999). *The Clock of the Long Now*. New York: Basic Books.

Chomsky, N. (2002). *September 11*. Crow's Nest: Allen and Unwin.

"Cover Page." (2003). *Time Magazine*, April 21.

Draaisma, D. (2000). *Metaphors of Memory*. Cambridge: Cambridge University Press.

Ehrenreich, B. (2001). *Nickel and Dimed*. New York: Henry Holt.

Giroux, H. (2003). *The Abandoned Generation: Democracy Beyond the Culture of Fear*. New York: Macmillan Palgrave.

Henkes, B., & Johnson, R. (2003). "Silence across Disciplines: Folklore Studies, Cultural Studies and History," *Journal of Folklore Research*, 39(2/3), 125–146.

Kelly, J. (2003). "How We Cover War and Uncover History," *Time Magazine*, March 31, 10.

Kureishi, H. (2005). *The Word and the Bomb*. London: Faber and Faber.

Lal, V. (2002). "Unhitching the Disciplines: History and the Social Sciences in the New Millennium," *Futures*, 34, 1–14.

Le Goff, J. (1962). *History and Memory*. New York: Columbia University Press.

Lembeke, J. (1999). "From Oral History to Movie Script: The Vietnam Veteran Interviews for *Coming Home*," *Oral History Review*, 26(2), 65–86.

Lowenthal, D. (1985). *The Past Is a Foreign Country*. Cambridge: Cambridge University Press.

Marcus, G. (1995). *The Dustbin of History*. Cambridge, MA: Harvard University Press.

Morse, J. (2003). "Saving Private Jessica," *Time Magazine*, April 14, 56–57.

Newman, K. (1999). *No Shame in My Game: The Working Poor in the Inner City*. New York: Vintage.

Orwell, G. (1949). *1984*. London: Martin Secker and Warburg.

Osborne, B. (2001). "Landscapes, Memory, Monuments, and Commemoration: Putting Identity in Its Place," *Canadian Ethnic Studies*, 3, 39–77.

Popular Memory Group (1982). "Popular Memory: Theory, Politics and Method," in R. Johnson, G. McLennan, B. Schwarz, & D. Sutton (eds.), *Making Histories*. Minneapolis: University of Minnesota Press, 205–252.

Roberts, L. (1997). *From Knowledge to Narrative* Washington: Smithsonian Institution Press.

Studdert, D. (1999). "Bondi, Baywatch and the Battle for Community," *Arena Magazine*, 42(August–September), 28–33.

Vidal, G. (2002). *Dreaming War: Blood for Oil and the Cheney-Bush Junta.* New York: Thunder Mouth's Press.

White, H. (1997). "Historical Emplotment and the Problem of Truth," in K. Jenkins (ed.), *The Postmodern History Reader.* London: Routledge, 392–396.

Wright, P. (1992). *A Journey Through Ruins.* London: Flamingo.

Zandy, J. (ed.). (1994). *Liberating Memory.* New Brunswick: Rutgers University Press.

SPEECHES

Blair, T. "UK's Blair pledges solidarity," September 20, 2001. Press Release by the White House.

Bush, G. W. "Remarks by the President after two planes crash into the world trade center," September, 11, 2001. Press Release by the White House.

Bush, G. W. "Statement by the President in his address to the nation," September 11, 2001. Press Release by the White House.

Bush, G. W. "Honoring the victims of the incidents on Tuesday, September 11, 2001," September 12, 2001. Press Release by the White House.

Bush, G. W. "Remarks by the President in photo opportunity with the National Security Team," September 12, 2001. Press Release by the White House.

Bush, G. W. "President's remarks at a national day of prayer and remembrance," September 14, 2001. Press Release by the White House.

Bush, G. W. "Remarks by the President upon arrival," September 16, 2001. Press Release by the White House.

Bush, G. W. "'Islam is peace' says President" September 17, 2001. Press Release by the White House.

Bush, G. W. "President signs authorization for use of military force bill," September 18, 2001. Press Release by the White House.

Bush, G. W. "Address to a joint session of Congress and the American people," September 20, 2001. Press Release by the White House.

Bush, G. W. "Presidential address to the nation," October 7, 2001. Press Release from the White House.

Bush, G. W. "President increases immigration safeguards," October 29, 2001. Press Release by the White House.

Bush, G. W. "President launches 'Lessons of Liberty,'" October 30, 2001. Press Release by the White House.

Bush, G. W. "President increases funding for bioterrorism by 319 percent," February 5, 2002. Press Release by the White House.

Bush, G. W. "Presidential address to the nation," April 11, 2002. Press Release from the White House.

Bush, G. W. "President promotes faith-based initiative," April 11, 2002. Press Release by the White House.

Bush, G. W. "President outlines war effort," April 17, 2002. Press Release by the White House.

Bush, G. W. "President promotes compassionate conservatism," April 30, 2002. Press Release by the White House.

Bush, G. W. "President urges Congress to support nation's priorities," July 8, 2002. Press Release by the White House.

Bush, G. W. "President discusses Iraq, the economy and homeland security," August 16, 2002. Press Release by the White House.

Bush, G. W. "President discusses security and defence issues," August 21, 2002. Press Release from the

White House.

Bush, G. W. "Saddam Hussein's deception and defiance," September 17, 2002. Press Release by the White House.

Bush, G. W. "President Bush calls on Congress to act on nation's priorities," September 23, 2002. Press Release by the White House.

Bush, G. W. "President delivers 'state of the union,'" January 28, 2003. Press Release by the White House.

Bush, G. W. "President discusses the future of Iraq," February 26, 2003. Press Release by the White House.

Bush, G. W. "President Bush: Monday 'moment of truth' for world on Iraq," March 16, 2003. Press Release from the White House.

Cheney, D. "Vice President speaks at VFW 103rd national convention," August 26, 2002. Press Release by the White House.

SECTION II

Acting Out

Bagdad Bad

MURRAY POMERANCE

> I took a special delight in picturing, in my imagination, the splendor and
> majesty of the wrathful brute.
> —H. D. NORTHROP, *WONDERS OF THE TROPICS, OR, EXPLORATIONS AND ADVENTURES OF*
> *HENRY M. STANLEY* (310)

> You must be careful in Bagdad.
> —THE THIEF OF BAGDAD (1940)

On Wednesday July 19, 2006, at a little past 10:00 P.M. Eastern Time, CNN broadcast a short interview between one of its Middle Eastern correspondents in Syria and a Lebanese mother who had escaped the Israeli-Hezbollah conflict in Beirut with her tiny children. Gaunt, wearied, but still fiercely bright-eyed, the woman expressed her support for Hezbollah and reiterated that one day her children would grow up and return to fight against Israel. It was a stark and brutal reminder of the depth and extremity of the ferocity, single-mindedness, and bitterness of the Arab temperament when Israel and the West are concerned, a portrayal in unmistakably clear lines of Arabian difference from "us," Arabian alignment, in the long term, against what Israel and the United States stand for. The mother was predicting the state of a world she knew she might not live to see, a world in which a gigantic battle would be pursued, if necessary, forever after. Other voices in other clips bemoaned the fact that the Arab world in general was abandoning Lebanon, and even in the echoes of these was a picture of Arabian inten-

tion as divided, conflicted, resentful, hopelessly impure. Nor was it easy to neglect the obvious presence of CNN as the "voice" that was telling us all this, a Western narrator telling a story, and populating it with characters, which would appeal to the Western mind.

That, since Gamel Abdel Nasser's threat to push Israel into the sea in the 1950s and the acrimony of the Six-Day War in 1967 and of all the wars and stalemates and Intifadas and proto-Jihads that have followed it, the Arab has been an icon of Western journalism is not to say that we have attended to Arab culture only in the postmodern world. The *New York Times* of Friday May 20, 1904 reported the abduction in Tangier of Mr. Ion Perdicaris and his stepson "by Raisuli, the brigand, and his band of 150 armed men." Raisuli is described as "notorious" and his men as "fanatical" ("American Abducted," 2–3). But although the content of the story is an illegal assault performed by an Arab and his band against two Westerners, the tone of the article is not only sober and tranquil but genteel and respectful of Raisuli's status among his own people. "He has written the Sultan's representative here, stating the terms on which he is prepared to release the prisoners. These include the withdrawal of the Sultan's army at present engaged in fighting refractory tribes." The elevation of the language civilizes Raisuli, exactly as the direct face-on presentation of the Lebanese woman on CNN, as she warns that her infants will grow into men and return to kill Israelis in the future, renders her, and the people she is photographed to represent, barbaric and bellicose, or at the very least confrontatory: warlike in a way that far exceeds consciousness or even bloodlines but spreads through history, beyond the individual, beyond the situation, onto a kind of eternal battlefield.

Indeed, if the journalistic account of the Arab has morphed in a hundred years from respectful distance to blunt face-to-face confrontation, if the Arab painted in our consciousness by a manipulative journalism, once a power unto himself and a stranger, has become instantly recognizable as mad for unbounded vengeance, it is not *only* through news reporting that we have come to know Arab culture and life. Stephen Gaghan's *Syriana* (2005) is an example of Hollywood's formation of the Arab as a mythic figure, one that admittedly seems almost journalistic in its mode of recounting events and drawing characters. Although the central happening in the film is not a direct presaging of the conflict between Israel and politically motivated (and supported) Arab terrorists, it is modeled upon a historically real event, the bomb attack, October 12, 2000, on the *USS Cole* in port at Aden by Ibrahim al-Thawr and Abdullah al-Misawa, two very young men, portrayed in the film as adolescents, surely the children of some unseen mothers who stood, if not in front of CNN cameras then at least on some real ground in the early 1980s and pledged that their sons would grow up and return to fight the West. But if *Syriana* in some way represents our mode of imagining the Arab at the beginning of the twenty-first cen-

tury, a very different—romantic and playful—set of figurations played onscreen at the beginning of the twentieth, including, but by no means exhaustively represented by the characterizations of Ramon Novarro, Rudolph Valentino, and Douglas Fairbanks. These were Arabs we unabashedly adored: their children, if they returned at all, would return only to capture our children's hearts. To take some steps following the curious line of descent in our filmgoing imagination, from these adorable Arabs of the screen to the threatening army modeled on Saddam Hussein, Abu Musab al-Zarkawi, and Sheik Hassan Nasrallah, is my intent here. How has the Arab been drawn, and then systematically redrawn, in our collective dream? We have been dreaming him, to be sure, since as non-Arabs we have no opportunity to close the distance and really known him.

THE ARAB ECSTATIC

Early in his second novel, *The Longest Journey* (1907), E. M. Forster (himself something of a fan of the Arab—the Egyptian tram conductor Mohammed el-Adl was his lover) presents us with a startling description of a room at Cambridge:

> Over the door there hung a long photograph of a city with waterways, which Agnes, who had never been to Venice, took to be Venice, but which people who had been to Stockholm knew to be Stockholm....On the table were dirty teacups, a flat chocolate cake, and Omar Khayyam, with an Oswego biscuit between his pages. (11)

One may wonder, not who is right, perhaps, but who is closer to the truth—Agnes, who has never been to Venice but thinks she is looking at Venice, or the people who have been to Stockholm and know they are looking at Stockholm? To press a point, what is more pressing, thought or knowledge? Or what business does Agnes have, never having visited Venice, forming opinions of it?

There is a frame of reference, to be sure, in which the Agneses of this world can easily and unequivocally be shown to be always and endlessly in error: a frame in which distances and perspectives can be thought mechanical and real, geographic formalities to be appreciated with precision and recognized in sobriety. In such a logic, strangers can see a culture only from the outside, and only in their own terms, that is to say, blindly. The Westerner, for example, cannot know what it is that lies under the mask he calls the Orient; is stymied and incapacitated by his very conception of it, paralyzed by his very wish to imagine an Oriental world. But this is not the only frame of reference available to those who would come to terms with their experience, and its very aura of certainty—that within its confines one is able to produce and sustain the value we call *knowledge*—saps it, sometimes, of the power to produce motion. Perhaps it is Agnes to whom we should be paying attention, that

stranger who can "take" a city rendered in a picture, to which she has never paid a visit, to be Venice; even though the contemporary world has certainly turned its eyes toward those knowledgeable insiders, who have "been to Stockholm," who, indeed, have presumably made themselves one with the territories in which they render judgment and who have pronounced inaccessible the imaginations of others far away.

Henry Northrop's 1889 account of Stanley's voyages in search of Livingstone is filled with descriptions of "singular habits," "exploits," "remarkably handsome natives," "cannibals and poisoned arrows," and coming "face to face with the monsters." If toward the dark unknown the nineteenth-century's imperialist imagination turned a cupidinous, defining, appropriating eye—here is Northrop quoting a description of the Shillook people, up-river from Cairo, in 1889:

> With the pride of a father he said, "These are my fighting sons, who many a time have stuck to me against the Dinka, whose cattle have enabled them to wed."
>
> Notwithstanding a slight knowledge of Negro families, I was still not a little surprised to find his valiant progeny amount to forty grown-up men and hearty lads. "Yes," he said, "I did not like to bring the girls and little boys, as it would look as if I wished to impose upon your generosity."
>
> "What! More little boys and girls! What may be their number, and how many wives have you?"
>
> "Well, I have divorced a good many wives; they get old, you know; and now I have only ten and five." But when he began to count his children, he was obliged to have recourse to a reed, breaking it up into small pieces.
>
> Like all Negroes, not being able to count beyond ten, he called over as many names, which he marked by placing a piece of reed on the deck before him…The sum total, with the exception, as he had explained, of babies and children unable to protect themselves, was fifty-three boys and twenty girls—seventy-three! (*Wonders*, 514)

There is also in its orientation a richly self-conscious capacity to dream. Hunting for lion, Northrop apotheosizes the excitement of confrontation with a profound otherness: "I took a special delight in picturing, in my imagination, the splendor and majesty of the wrathful brute, as he might stand before me. I peered closely into every dark opening, hoping to see the deadly glitter of the great angry eyes" (310). This is hardly the even-minded and illuminating tone of the zoologist, nor is it the culturally informed turn of the autobiographer, and so, in its way, it is presumptuous. And it is this presumptuousness that I think merits our careful attention.

Like the lion in Northrop's wild imagination, the Arab has long existed not only for and in himself but also outside of himself, in a kind of ecstasy, as a central figure in the Western imagination. For contemporary Western dreamers, a particular inspiration in configuring this fabulous creature has been the Iranian poet, mathematician, and astronomer Omar Khayyam (1048–1131), the translation of whose *Rubáiyyát* by Edward FitzGerald (1809–1883) is surely that "fellow" (fellah) with

the "Oswego biscuit between his pages" in Forster's passage, above. To be sure, it was hardly as much Khayyam's Khayyam as FitzGerald's Khayyam who struck the Western imagination. Christopher Decker argues:

> Until the popularity of Fitzgerald's translation awakened a universal interest in the quatrains of Khayyam, the reputation of the medieval Persian skeptic was supported on the historical importance of his scientific achievements. Scholars of Near Eastern culture still insist that, although they consider Khayyam's quatrains negligible beside his treatise on algebra, they have the greatest admiration for Fitzgerald's poem. The cavilling about Fitzgerald's "free translation" has died down, and most agree that a remarkable transfusion occurred when Khayyam's quatrains were newly enfleshed in the *Rubaiyat of Omar Khayyam*. Readers of several generations have likewise seen Fitzgerald and Omar Khayyam as twin souls, or as one soul shared between their verses. This neat biographical twist repeats (too hyperbolically) Fitzgerald's own appraisal of his relationship with Khayyam. (*Rubáiyyát*, xviii)

This Arab of the West, if you will, this FitzGeraldian Khayyam or whatever burnoosed, tanned, moonlit figure we invent upon the sands—in one of his early roles, the Ramon Novarro who would later embody a fabulous popular Arab sheik onscreen performed as Khayyam's nephew, in fact, in *The Rubaiyat* for Ferdinand Earle (1922)—is anything but an authentic representative of a culture or political-economic system, and authenticity cannot be used as a standard for measuring or estimating him. As Edward Said (54–55) writes, "Imaginative geography and history help the mind to intensify its own sense of itself by dramatizing the distance and difference between what is close to it and what is far away." And it is certainly a view from far away, an outsider's view, that is being concretized and made hegemonic, as we "see new things, things seen for the first time, as versions of a previously known thing" (58–59); as we occupy ourselves "by making statements about it, authorizing views of it, describing it, teaching it, settling it, ruling over it: in short, Orientalism as a Western style for dominating, restructuring, and having authority over the Orient" (3). FitzGerald's Khayyam, like so much else of Araby that has come into our usage in the West, is "fundamentally a political doctrine willed over the Orient because the Orient was weaker than the West, which elided the Orient's difference with its weakness" (204).

Unsurprisingly, the anti-Orientalist rhetoric apotheosized in Said is a groundstone for much contemporary thought about the representation of ethnicity in general, and Arabs in particular, in Hollywood film. While the Arab filmmaker, such as Youssef Chahine with his Alexandria series (1978, 1990, 2004) or, perhaps, Ismaël Ferroukhi with *Le Grand Voyage* (2004), may be taken more or less at face value as delivering an unadulterated view of a particular culture, the Hollywood filmmaker is considered to be shooting always from an unelidable, incontestable, uncontractable distance even when, like Rex Ingram in 1923 for *The Arab* or Alfred

Hitchcock in 1955 for *The Man Who Knew Too Much*, he journeys to Tunis or Morocco with his crew. Indeed, the Western filmmaker is at a distance from his subject when he films Araby, Stephen Gaghan no less with the politically astute and documentary-styled *Syriana* than Ron Clements and John Musker with the unveiledly meager *Aladdin* (1992) or Michael Powell and Emeric Pressburger with the fabulous *Thief of Bagdad* (1940). In the contemporary critical mind, the Western observer is accorded neither the grace to comprehend the otherness with which the Orient provides him, nor the liberty to collapse that defining, that alienating, distance from which he sees.

THE ARAB AS CAMEO

However, it is his very falseness as a representation that has endeared the imaginary Arab to us, since it has permitted us to configure him as a receptacle for our most deeply charged projections of the secret self we cannot bring ourselves to see in the mirror (see: Fiedler). Is it not wholly unsatisfying to proclaim about the Hollywood Arab that he is incorrectly drawn, that he does not indicate (is no index for) a real social world, that he is preposterous if not insidious, alienating, cheap, and malformed, an open lie, while all of this is self-evident? Given that we use, as Said would have it, "a Western style for dominating, restructuring, and having authority over the Orient" (3), are we obliged as Westerners, then, merely and wholly to abandon that style? Surely the anthropologist, like the cultural and political theorist, would recognize the Westerner's "Arab" as a figment and construction, having first come to know, if not the culture of the Orient per se then at least by approximations the limits to such knowledge and the extreme exaggerations and extrapolations that constitute our everyday way of thinking. But Hollywood tolerates no such modesties, and offers up in full flesh a character to feed the starving imagination, since even—especially!—in the face of knowledge the imagination must be fed. Should we never imagine anything we have not experienced? Should Agnes, confronted by the word "Venice," call up only a blank slate? (I mean by "imagine" not simply configure spontaneously, but also labor to represent and dramatize.) And even if we have some experience, what is the profit in declining to form an imagination, in contributing to that great cultural repository of myths that I might call, adapting Charles Taylor, the "social 'imagin'-ary"?

Taking cinema as a stimulus rather than a reflection, as a myth rather than a report, and operating on the assumption that movies do not only reflect reality but also offer a phantasmagoria for our contemplation and wonder, let us look at the Arabs of the Western screen to see what they suggest and imply quite apart from the (ultimately tedious) fact that they are not really Arabs but only "things of dark-

ness" we must acknowledge ours. For certainly it is easy enough to point to any screen image as in some respects hollow and cravenly false. Take Anthony Quinn's performance as the Bedouin Auda in David Lean's *Lawrence of Arabia* (1962); much in the way that today's politically correct orientations to ethnicity might denigrate, as denigrating, the German actor Henry Brandon's performance as the Commanche Scar in John Ford's *The Searchers* (1956), the Mexican Quinn's work can effortlessly be labeled outrageous, false, manipulative, misleading, revisionist, or plainly propagandistic. (And Novarro was also Mexican, Valentino Italian.) Yet this does not eradicate our actual experience of that performance in itself (since a performance or characterization is not *only* a reference to a real social world), or blunt the sharpness of a configuration of the Arab that is engendered and encouraged by it. This figure he embodies—black-garbed, taciturn, brutal, swarthy, hungry for value, stalwart, direct—is something we need to admire, and at the same time admire from a distance, since it is as someone *else* that we persist in appreciating Auda, not as one of our own. This othering is part of our project; this other is a being we desperately need to find on our horizon. If our configuration of Auda is inutile in a politically complex world—if it does not help us sit and negotiate for oil with real Saudis—yet it nevertheless anchors our dreams. Our image of the world, our world-thought, is inflected not only by facts but also by extensions and contractions of facts, by potentialities, projections, extrapolations, hieroglyphs. Art is not science.

A second, similarly facile approach is to frame the mythical construction as springing from, and therefore mainly evidencing, political and social patterns in the culture of those who imagine it. As Brandon's racist Scar is a product of the white-dominated, racist Republican 1950s, Quinn's Auda reflects the jaunty cultural imperialism of Kennedy's Camelot. The flamboyant myth, then, if it must be tolerated in its perniciousness, is seen to be valuable at least as a symbol of the culture that spells it out. Orientalism can be fine if it teaches us about ourselves as Orientalists, shows us bluntly that, to quote Said again, we are bent upon our desire "to manage—and even produce—the Orient politically, sociologically, militarily, ideologically, scientifically, and imaginatively during the post-Enlightenment period" (3).

So, this painful ambivalence about the Arab—an imaginary personage in flowing robes, perhaps seated upon his camel on what seem like boundless sands: in *The Passenger* (1975), Antonioni has him rhythmically jiggling his legs to urge his camel forward through a long, gracile pan—has led us both to dismiss powerful representations as trivial and to aggrandize them obsessively as grossly explanatory. Everything of our alienation can be learned from our will to power, even and at the same time as that precise will to power is an ugly aberration that pushes the world away, maims strangers, decapitates economies and teaches us nothing. If we are culpable for imagining, how fascinating and how intoxicating we are in that culpabil-

ity and, apparently, how worth castigating. In an exhaustive disciplinary treatise list-
ing hundreds upon hundreds of such ugly misrepresentations, *Reel Bad Arabs: How
Hollywood Vilifies a People,* Jack Shaheen quotes William Zinsser's riposte that
"The Arabian Nights never end…:

> It is a place where young slave girls lie about on soft couches, stretching their slender legs,
> ready to do a good turn for any handsome stranger who stumbles into the room. Amid all
> this décolletage sits the jolly old Caliph, miraculously cool to the wondrous sights around
> him, puffing his water pipe…This is history at its best. (22)

In this zone, nothing if not an equivocal topos, we find, writes Shaheen, embed-
ded in plots that tend to seem utterly senseless beyond their functioning to pack-
age such delectables for the Western eye, "humiliated, demonized, and eroticized"
Arab women (22); gratuitous cameos of Arabs in films that have nothing to do with
the Middle East, "appearing like unexpected jumbo potholes on paved streets"
(27); caricatures of the Egyptian from "souk swindlers" to "begging children scratch-
ing for baksheesh" (24); a plethora of villains, typically "rabidly anti-American" (15)
and often "trying to rape, kill, or abduct fair-complexioned Western heroines" (16);
and, paramount among all grotesqueries, the sheikhs, "slovenly, hook-nosed poten-
tates intent on capturing pale-faced blondes for their harems" (19). And often, so
that the moral entrepreneurs of America would not be disturbed by the interracial
thrust of their passions, the sheikhs who appear to lust after white women are them-
selves, in their secret selves, white. So it is that in George Melford's *The Sheik* (1921),
Ahmed Ben Hassan (Rudolph Valentino), after seducing the white adventuress Lady
Diana Mayo (Agnes Ayres) and keeping her in his desert tent, is ultimately revealed
to be nothing but the child of Europeans, raised by an Arab and awarded the lega-
cy of the old man's sheikdom because of the purity of his devotions to the Arab way
of life. "His hand is so large for an Arab," murmurs Diana, and Shaheen archly won-
ders, "How small or large should an Arab's hand be?" (424)

While still we believe in Ahmed as Arabian, however—that is, while still,
before the film's climax, we possess the capacity to find his sexuality with the
woman outrageous and even offensive—*The Sheik* is rife with scenes of lascivious
coyness, as though brazenly to suggest the queer, potent, idiosyncratic pleasures of
miscegenation and play them out fully before retracting, then repressing, them at
the conclusion. "*The Sheik*'s record-breaking popularity enabled Paramount to make
$3 million-plus on the film," writes Shaheen. "Studio ads spurred viewers to 'see the
auction of beautiful girls to the lords of Algerian harems'" (424). Then the castiga-
tion: "Police sought hundreds of runaway girls whose destination was reputed to be
the Sahara," he quotes Valentino's biographer (424), thus clinching the socializing
effect of the cinematic image, suggesting it is hardly only a fiction in which we revel.
"We must wake from the dream," the film itself seems to say ultimately, bringing

us down to earth with the Sheik's real biography and thus affirming not only that his Arabia was a dreamland but also that dreams are barren and insufficient. The *New York Times* was almost instantly ready to wake: "By the time half a dozen of these glaring white desert scenes have followed each other on the screen your eyes are ready to give up" ("Screen," November 7, 1921).

Yet, what if we attempt to transcend this blinding guilt—or at least this blindingly guilty view—and accept ourselves, as viewers, for the strangers that, quite simply, we are? As North Americans viewing pictures of the Arab world, we are constrained by archetypes and expectations bred in a long history of cultural fabrications, to the degree that a film as contemporary and (apparently) scathingly observant as *Syriana* is developed out of the modes of seeing and thinking that were engendered much earlier, when the Arab held an entirely different value for us, who inhabit the diaspora as a natural habitat, than he does today when with our cell phones and our CNN, our laptops and our iPods, the diaspora has become everywhere.

THE ARAB WE LOVED

The Hollywood "Arab" onscreen is now, broadly speaking, a venomous threat if not simply a lowly reprobate: we can recall, among thousands of characterizations, situations, and stereotypical misrepresentations—all of which contribute to our deepest dream, our most profoundly "secret self," as Leslie Fiedler once put it: the viperous Baka (Vincent Price) in *The Ten Commandments* (1956), the piggish Abou ibn Kader (Topol) in *Cast a Giant Shadow* (1966), the unkempt Mr. Habib (Eugene Levy) in *Father of the Bride Part II* (1995), the Palestinian, Syrian, and Libyan terrorists of *Patriot Games* (1992), the murderous Arab assassin (Stanley Tucci) in *The Pelican Brief* (1993), the Muslim terrorists planning a hijack in *Women on the Edge of a Nervous Breakdown* (1988).

But it was first in wide-eyed astonishment, and later in admiration, perhaps even love, and certainly a degree of lust that we adopted him in the early days of cinema, notwithstanding the presence as well in early films of Arab villains who darkened the horizon. He enchanted us far more than he threatened, like the Sufi in the traditional tale who, traveling alone, is faced suddenly with a giant ghoul who promises to destroy him:

> "If you want a trial of strength," said the Sufi, "take this stone and squeeze liquid out of it." He picked up a small piece of rock and handed it to the apparition. Try as he might, the ghoul could not. "It is impossible; there is no water in this stone. You show me if there is." In the half-darkness, the master took the stone, took an egg out of his pocket, and squeezed the two together, holding his hand over that of the ghoul. The ghoul was impressed; for people are often impressed by things that they do not understand. (Shah, *Tales*, 43)

George Méliès made *Le Palais des Mille et Une Nuits* in 1905, a phantasmagoria of gaily berobed mystics and wild creatures in an elaborate jungle that transforms into a secret palace where turbaned and pantalooned dervishes dance with skeletons under a panoply of stalactites. Méliès uses feux d'artifice, optical dissolves, elaborate changes of scenery—including sets flying from above and rising from beneath, and smoke effects to suggest a world of relentless and oneiric magical transformation. This meticulously staged and filmed "Arabic" world, populated, to be sure, by the most European-looking of personae in their robes or tutus, aligns a significant Western vision of the Orient with the principle of spectacle, embodying what Tom Gunning has called the "cinema of attractions," a "conception that sees cinema less as a way of telling stories than as a way of presenting a series of views to an audience, fascinating because of their illusory power (whether the realistic illusion of motion offered to the first audiences by Lumière, or the magical illusion concocted by Méliès), and exoticism" (57). The Araby of Méliès, indeed, beautifully conflates two kinds of wonder: first, the imagined originary realm of sheiks and princesses, demons, magicians, impassable territories, and confoundingly elaborate designs (in an opening sequence layers of trees pull back repeatedly to reveal a domain hidden far beneath their coverage); and second, the actual realm of the moving picture with its inherent optical magic. From the earliest days, then, Araby on film was, in a very important way, film itself.

To fixate upon Western film audiences principally as appropriators of the Arab character or culture, then, to unrelentingly question fascination as a will to power, is to cover over both hunger and love, not to say all of the great philosophical inspiration that might make us crave to know how the world might link itself to what we can see, an inspiration that is at the root of cinema and that is also profoundly expressed in screen tales of Araby. To pretend that power has always been what our relation to the screen Arab is about is finally to neglect our own most riddling desire. One of the early explicit kindlings of that desire was Cecil B. DeMille's *The Arab* (1915). Edgar Selwyn's play *The Arab* was filmed in 17 days, at a cost of a little more than a million dollars a day; released two months later, it netted four times as much money. No prints of the film currently exist, but it is described by Liam O'Leary as centering on "a missionary's daughter in love with an Arab chief's son" (134), and thus as a precursor to the Famous Players-Lasky/Paramount production of *The Sheik*. When *The Sheik* became a major hit in 1921, the rights were sold by Paramount to Metro, "for director Rex Ingram and his new discovery, Ramon Novarro" (Birchard, 50). Ingram flew off to film in Tunis.

Ingram, according to Erich von Stroheim "the world's greatest director" (Soares, 27), was renowned for his artfulness with the screen image and "had longed for the day when he could get away from Hollywood" (O'Leary, 128). Shooting with them, and even "[taking] part in one of the spectacular scenes of the film" with the

Arab riders (129), he "felt a strange affinity with the Arab people, approving of their rather passive attitude to life, contrasting it with the rush and bustle of hard-working life he had been leading in Hollywood" (129). At the Oasis of Gabès outside Tunis, he "used authentic Arab costumes, weapons, dancers, and extras and made friends with many of the local leaders. The Bey of Tunis presented him with the Order of Niftkan Itchkar" (Ellenberger, 36). Ingram and his lover Alice Terry adopted an Arab youth, "who played in several of their films" (Shaheen, 73). Although he shot his interiors for *The Arab* in Paris, and would later spend considerable time filming other pictures at the Victorine studio complex in Nice, the world of Arab life had intoxicated him, and Ingram finally adopted Mohammedanism (O'Leary, 173, 197ff.) around the time he shot the original *Garden of Allah* (1927). The story of *The Arab* was designed to compete with *The Sheik*, its European heroine besotted by an Arabian prince now a staple of the Hollywood construction of Arab life. Both *The Arab* and *The Sheik* focus on this ménage in the desert between a man whose skin is swarthy and whose heritage is unclear, and a woman who is alabastrine and civilized but who forsakes the tedium of her civilization for an "adventure" that brings her under his control. As Shaheen (422–425) describes *The Sheik*, so it can be said of *The Arab* that it contains a typical "inquisitive English heroine," as well as the vast alluring desert beautifully photographed, and a city environment in which the new (Western) world can "rub shoulders with the old." Ingram was passionate about getting social and cultural details as correct as possible when he filmed in the East. Shooting *Baroud* in 1932, for example, "he was so conscientious that he made the journey from Tangiers to Rabat in cars used by lower-class Moroccans. At Rabat he donned an Arab costume so that he could more intimately mingle with the street crowds without being identified as a European" (L. H. Burel to O'Leary, quoted in O'Leary, 194).

The Arab as transformer of self is a repetitive theme. In 1933, Sam Wood used a script by Elmer Harris and Anita Loos to make an opulent, and rather extraordinary, adaptation of the same story (shot by Harold Rosson) titled, equivocally enough, *The Barbarian*. Again, an Arab prince (Novarro) woos a European woman (Myrna Loy) and in the conclusion, she leaves a European lover (Reginald Denny) at the altar, running away with the Arab. Interesting in this film are several fillips of narrative, all of which help to make possible the portrayal of the Arab as a focus of Western cupidity: Jamil the prince is being educated, according to tribal custom, by subjecting himself to the rigors of the marketplace, yet rather than try his hand at openly buying and selling there, he prefers to meet people (and play with their purses) by disguising himself in the role of *dragoman*—"The best *dragoman* in all Egypt!" Thus we find ourselves neatly situated to see him pilfering costly jewels from credulous European women in the opening sequence, and supported in any prejudice we might have brought to the film of Arabs as unscrupulous thieves. Jamil, it

turns out, is anything but unscrupulous and anything but as lowly in sentiment or dignity as a *dragoman*. Unable to accept the obvious fact that his charms, musical and other, have captured her heart, Diana Standing (Loy) haughtily rides off to the desert, soon finding herself in the domain of the nefarious and lustful Achmed Pasha (Edward Arnold), whence Jamil rescues her at peril of his life. Alone with him at an oasis, she must submit to his advances, but she receives his apology. Coy and aloof, she pretends to coldness while he kisses her garment in gratitude and plies her with poetry. "Where do you learn these phrases?" she asks glibly. "We are in the Garden of Allah, Mademoiselle," says he softly, "the soft perfumed air is filled with the magic knowledge of all the millions who have lived and loved and sung under these crystal stars." Again he tries to kiss her and she takes a whip to him, making possible a demonstration, in a beautiful piece of staging, of not only her felt superiority but also his quietly wounded dignity. Later, he proposes marriage and after musing at length she accepts, giving herself over to a lengthy and transcendent native marriage ceremony in which holy waters are brought for them to drink; but when the cup is in her hand, she throws the sacred liquid into his face and arrogantly walks out on him. It is not until the European ceremony, where she is to wed the quirky and smug Gerald, that she sees her emotions clearly, realizes it is Jamil she needs, and decides to join him. The apparent liberality of the film's ending is disparaged by Shaheen:

> A 1933 scenario that permits an Egyptian to marry an English socialite?! Not exactly. Final frames show Diana and Jamil cruising down the Nile. Diana alludes to "a call of the blood," telling Jamil, "Did you know my mother was an Egyptian?" Sighs Jamil: "I wouldn't care if she was Chinese." (87)

Yet another contrivance is the characterization of Di's elderly companion Powers (Louise Closser Hale), initially something of a harridan hostile to Jamil and eager to read his attentiveness to Diana through a lens of Orientalist suspicion, then slowly converted to a clownish admirer who comes to a distinct sensitivity to the prince, able to instantly recognize his personal song ("Love Songs of the Nile," by Nacio Herb Brown and Arthur Freed) when she hears it wafting on the evening air. Powers complains of the lurching of her camel by imitating its movements for Di several hours later and in a manner that is a walking parody of the sexual thrust. Through Powers's attentions to, and less constrained attraction to, Jamil we are able to see through Di's composed, even haughty, self-restraint to an albeit mawkish model of the curiosity and sexual eagerness that lie beneath.

In all of these films, the central hero character is a sheik swathed in romance. George Melford's *The Sheik* (1921) in fact establishes its central hero as the romantic ideal of an Englishwoman, Diana, who is so smitten with his style of life that she makes a vow to leave her coterie and head off into the desert for an extended meditation. Here she is picked up by Ahmed ben Hassan and brought to his

encampment, an "oasis" of civility in the vast stormy desert. She gives all appearance of wanting to escape from him, until late in the film when he appears to be injured; her sudden intensity of concern makes plain what viewers enticed by the romance of Araby expected all along, namely that her heart had much earlier been given over to this prince of the desert. She makes a proclamation of love. And now it turns out that he is no Arab after all, but a British nobleman raised in the desert by an old sheik. The Western infatuation for Arab culture is spelled out in this film, then, as an attraction to itself, or to its own imagination of the faraway. Yet, for all the narcissism of this investment, the affection is genuine. To discount Diana's emotion for Ahmed at the end of the film, on the basis that he is in truth only as English as she, is to forget the delight that her interest in him offered earlier in the narrative, when with her we were convinced of his authenticity. As, from 1921 onward, we sang—

> I'm the sheik of Ar-a-by;
> Your love be-longs to me.
> At night when you're a-sleep,
> In-to your tent I'll creep. (Words and music by Harry Smith, Francis Wheeler, & Ted Snider)

To some extent we believed ourselves.

THE ARAB GARDENER

That early films about the Arab featured an infatuation, successful or not, between Arabs and Europeans—specifically between the European female and the at least presumably Arab male—mirrored European political influence in North Africa and played it as a natural attraction rather than a strategy for controlling land, cultures, and resources. And yet there was an attraction, perhaps for the quality of boundlessness that seemed to emanate from every desert setting, or for the freedom to ride the sands without pathways; the European imagination, after all, was confined intensively, always had been, in relatively tiny dispensations of property overflowing with population. In Araby there was space and wind, thus, apparently, a primordial setting as yet undivided by lusts for power. *The Garden of Allah*, filmed from the Robert Hichens novel first by Colin Campbell for Selig in 1916, then by Ingram for MGM in 1927, and finally, in spectacular Technicolor, by Richard Boleslawski for David O. Selznick in 1936 with Marlene Dietrich and Charles Boyer, tells the tale of a Trappist monk who reneges on his vows, flees his monastery, and goes into the world, where he falls in love with a woman who seeks purity and resolution for her life; when finally it is revealed to her who he truly is, their marriage crumbles and he must return to his monastery in order to save his soul. A story like this could

have been set virtually anywhere, since all that was required was a cloister to run away from and an interesting space in which to meet, woo, marry, and live with a woman of one's dreams. But North Africa provides precisely the vast desert with its constantly shifting, magnificent sands—a metaphor for the sanctified life, for Godly purity, for continuous change, for religiosity, and for the inevitable simulacrum of Paradise, the oasis in which the man and woman can sit by the tranquil pool under the splendid palms, meditating, staring into one another, finding what crowded civilization cannot hope to provide. The same passion for distances and tranquility that occupied Ingram may be thought to have obsessed Selznick, as frenetic and troubled a human being as ever produced films in Hollywood. The desert itself need only be a place to which the troubled spirit can flee, the anticivilization without shape, without pressure, without form.

What marks the Selznick film as especially interesting is that its Arabs (here, as typically, played by actors who are anything but Arab themselves) constitute deflections from the romantic vector, two of them preposterous comic figures (Batouch [Joseph Schildkraut] and his brother Hadj [Henry Brandon]) and one a genuinely chilling, distant, sand diviner (John Carradine, prefiguring, as he tells the future by scraping through sand with his stick, the "teller of tales" in the marketplace in Hitchcock's *The Man Who Knew Too Much*). Batouch's obsequiousness in courting the favor of the European Domini Enfilden (Dietrich) is played for comedy, as is his brother's utter ineptness at learning English. The diviner seems half in another world, blind to this one, a creature who endures through time with no sense of its passing and for whom present and past are eternally present—in short, a living poem or dream and yet, for all this, strange and troubling in the relatively mundane context that frames the rest of the story. Because these characters are so quirky, they cannot figure to hold and focus our romantic predispositions, and so the film, riddled through with the dominating qualities of its setting, nevertheless informs us that the honeymoon with the beautiful Arab is, by 1936, over. We have become so accustomed to him that he need function only to marginally decorate the European tale set in his territory; and if the future foretold by the diviner in fact takes place as the development of the diegesis, we need not return to him for a reaction, or fixate upon him in any way, since his function is to seem a little threatening and very foreign, not attract and hold us by the power of our desire.

THIEVES OF BAGDAD

In both Raoul Walsh's 1924 *The Thief of Bagdad* and Michael Powell's 1940 Technicolor version of the same story, the hero (Douglas Fairbanks; John Justin) is no less Middle Eastern than Ramon Novarro or Rudolph Valentino could appear

to be in their sheik films, and he is posited in the narrative as authentically Arab. The earlier film tells the story of Ahmed, thief of Bagdad (Fairbanks, bare-chested, in a bathing suit with pantaloons), eager for the love of the Princess (Julanne Johnston), whose hand he must work to secure by enduring flames, beasts, and the manifold secrets—objects, territories, incantations—that appear to construct the space of Araby here onscreen. The film itself works like a magnificent winding design, with Ahmed racing in and out of the gates of the city (gates that open simultaneously in four directions and close with sharp teeth coming together), climbing up and down a magical rope, and darting from side to side of the gauze curtain the Princess uses to coyly hide herself as he kindles her desire. Throughout, the screen is filled with the (literally) amazing designs of William Cameron Menzies, whose high walls, towering gates, and profuse ornamentation are seen by Walsh with an exquisite eye for the angle that maximizes the intensity of visual stimulation and cultural density onscreen. In this film, the Arab figure remains an object of adoration, as he was in *The Sheik*, chiefly because of his charming insouciance as he steals, his dynamic posturing (Fairbanks seems to dance his way through the film), and his ultimate humility. When it appears that foreign suitors will win his love before he can, he prostrates himself in the Mosque and follows the guidance of the Imam, trusting in Allah and in the power of his faith. But more than a figure of attraction, Ahmed persists through his graphic movement as a central organizing element in the visual spectacle of this film. Just as our sensibilities might be stunned by his coming into possession of a talisman key, or by the magical rope he manages to scale and descend, or by the figure of the rose that appears magically in the sand from Mecca that inspires the princess's maid (Etta Lee) to divination, by the magical apple that revives the dead, by the three suitors gazing at an all-seeing crystal that shows them, as in a tiny cinema, what is happening elsewhere or flying to Bagdad on a magical carpet, or by Ahmed flying through the air on a winged horse; so are we caught in an aesthetic trance by Menzies's designs, no matter how quotidian is their function for the plot: the array of giant earthenware pots in the marketplace, for example, in which Ahmed hides (and out of which, as though they are wombs, he is born to freedom); the harbor of the Island of Wak, with its arches and balconies and multiple boats; the vision of the phallic turrets of Bagdad juxtaposed against the vulvar vases in the princess's bedroom. Because of the design, and Fairbanks's twisting, swaying, shifting, and returning movements through it, the screen is an epitome of the *arabesque*, an "intricate, nonrepresentational, infinitely graceful decorative style" (Davenport, 6).

The Bagdad of the 1940 remake is in splendid Technicolor, vanishing off in shades of periwinkle and lavender as it mounts into a range of hills; just as its companion city of Basra is a barrage of pinks. Its port is all vermilion sails and green waters, its flying horse ascends into an azure sky like a speeding cloud, its ginni

emerges as a tower of dark green smoke from a dark green bottle, its hero has coppery skin and is accompanied by a young friend with skin of bronze. The configurations of Menzies's 1924 designs, then, have been rounded and saturated with the color designs of Vincent Korda; yet the world depicted is essentially the same arabesque zone, a stunning and incessantly surprising vista of magical incantations, powerful visions, and endless hungers. The central character has been split in two: Ahmed (Justin) is the King of Bagdad, tricked by his evil vizier Jaffar (Conrad Veidt) into relinquishing his identity and visiting his people, then arrested and threatened with execution. He meets a young thief, Abu (Sabu), who helps him to escape, find, and win the love of the Princess of Basra (June Duprez), and finally triumph over Jaffar and return to his kingship. In writing of Paul Leni's *Waxworks* (1924), a film that in part describes the Baghdad of the Arabian Nights, J. P. Telotte notes "the sort of *interior* world that the film describes" ("Expressionism," 21). The interiority extends beyond German Expressionism to all early films of Araby—indeed, Expressionism may have been ideal as a form in which to evoke the worlds of these films exactly because it's cloistered and repressive, its cloying sense of always anticipated desire exactly suited the way in which our culture, holding us in and back, has forced us to imaginations of spiraling, imprisoning, yet magically transforming worlds. The "unbridled appetites" of Leni's Caliph's court (Telotte, 22) are reflected in the insatiable (and childish) hungers of the Sultan of Basra (Miles Malleson), who must always have another magical toy. The twisting Bagdad of *The Thief of Bagdad*, then, was never intended to signify anything but the innermost coils of our own secrets, our most private, horribly enticing world. By 1940, however, the fabular delights of Araby are not enough on their own terms: evil must also inhabit this universe generically. In the 1924 film, malice was personified by a Prince of the Mongols (Sojin) who schemed artfully, yet without hunger, to win the Princess, but now a transcendent negative force appears in the visage and action of a dark Arab (played, of course, by a German), a man whose magical vision presents him with an alternative future universe in which all power belongs to him. His head always covered by a dark turban, his face partially masked by a tidy Oriental moustache, his eyes bulbous and penetrating, his postures cramped and despotic, Jaffar is the prototype of all future bad Arabs onscreen. But if Jaffar is a moral danger, he is not, perhaps, the principal agent that makes Bagdad a place in which we "must be careful." For again with this film, in part with the stunning effect of Technicolor very richly used and in part because of the story's focus on opticality, the power of the optical experience is stressed: doubly. It is a breathtaking vision to watch: as Jaffar's ship sweeps into port at Bagdad; or as Ahmed sits begging against a background of the purple vistas; as Abu flies through the air with the Djinn; as the Sultan of Basra plays with his elaborate toys. But the open invocation of opticality in the diegesis is unmistakable: Jaffar's ship has a cloven eyeball painted on its prow, and it passes us in a

very lengthy shot as slowly we zoom in on it. And Jaffar uses his optical powers to mesmerize the princess, to blind Ahmed, and to turn Abu into a dog. "Veidt knew how to use the muscles of his face and eyes, and I knew how to photograph them," wrote Powell (319). Spelled out onscreen, then, is the peculiar power of the same gaze we employ to see the film. The film thus suggests the magical formula by which cinematic manipulation becomes attractive for the viewer.

Yet, stunned by the optical treasures of *The Thief of Bagdad*, Lesley Stern writes not only that the film "used colour in all its glory to render a fabulous fantasy world" and "messes about with time and space in a marvelous fashion" but also, oddly, that, "Richly endowed with special effects, it is spectacular and sensational, *more concerned with affecting the senses than corralling belief*" ("The Other Side of Time," 39, emphasis mine). In a central way, affecting the senses is all about corralling belief. As I suggested about *Vertigo*, another film fashioned in the arabesque mode, "Dramatic engrossment is itself vertiginous. William James wrote of our perception of reality that it invokes a vertiginous pleasure. All attraction is a form of love, and all love is a falling" (*Eye*, 225). James also writes, in his essay on the perception of reality, that what is overwhelming to the senses we have a tendency to deem real (real, at least, while we are attending to it). From this point of view, what is most stunning about *The Thief of Bagdad* is exactly that it is stunning—the fact that it presents us with so many surfaces that radiate with sensuality and appeal, so many events that seem to defy natural laws as we have learned them, so much by way of transformation, quite as though the material substance of the world were in a constant fluidity; in short, so much magic. If before the 1930s films about Araby lured us by offering a world of freedoms and naturalism, of mystery and incomprehensibility, what Telotte calls an interiority, *The Thief of Bagdad* makes the source of attraction explicitly presentational, even confrontational (the shots of Jaffar using his eyes to spell Ahmed and Abu have him stare into the camera). It is not moral danger the screened Bagdad offers—a sense of good and evil utterly at odds with our own, embodied by every non-Western character—but the danger of allure; that we can find it impossible to take our eyes off the pink parapets, the silvery six-armed statue with a dagger secreted in its blue hair, even the colorful ship rolling on the blue, blue sea. Rather than a belief in the causal connections between events, it is a belief in the presence of manifestation that this film corrals, a belief in happening *sui generis*. Transformed into a dog, Abu is on board Jaffar's ship and is discovered there. He is thrown overboard, and swims to shore. Leaping onto the dock and shaking himself out, he is suddenly rehumanized, before our very eyes. To know that we are watching a cinematic special effect does not diminish the thrill of this sensation, it only increases it. If Bagdad is dangerous, then, Bagdad is cinema. And the danger is the source of our pleasure there.

MODERNIZING THE FORMULA

Both versions of *The Thief of Bagdad* in their distinct ways, the first in tinted black and white and the second in color, captivated their audience (and a third, animated version, Disney's *Aladdin* [1992], functioned to do the same for contemporary audiences, albeit less enchantingly, with Alan Menken's slick music and Robin Williams's goofy vocalization of the Genie filling in for Arthur Edeson's black-and-white images set in Menzies's oversized, phantasmagorical sets, and George Périnal's stunning Technicolor cinematography, respectively). Kevin Brownlow (9) writes that seeing an original release print of the Fairbanks film is an "extraordinary experience"; while Stern describes the Powell as depicting a "fabulous fantasy world" ("Other Side," 39). Each film thus provided its audience with a visually stunning enterprise, calculated to deceive and surprise the imagination. But the two films shared another quality, and in this joined many of the early representations of Arabs onscreen from *The Arab* to *The Sheik* to *The Barbarian* and even, obliquely, to *The Garden of Allah*, namely the centrality of a European female whose romantic obsession with the Arab overwhelms, then finally redeems, her. In the early films, this female is a European character played unaffectedly by a European actress. In both versions of *The Thief*, she is narratively Arab but is embodied through a performance by a European or American actress that accentuates the strange melding of Arab and non-Arab elements as participatory to the romance. *The Barbarian* opens with a playful sequence in which the Arab protagonist (Novarro) bilks two women of jewelry by pretending to gift them with an ancestral ring: the first is American, and must return "to Iowa!," the second a German speaker who is responded to by Navarro fluently in her own language. In all of these films, then, and notwithstanding the introduction of the Arab villain in *The Thief of Bagdad* (1940), Araby is most centrally pictorialized as a setting for romantic fascination, sensory delusion, thrilling intoxication, loss of control, subjection to the natural elements, and metamorphosis, and these experiences are centralized in a vulnerable female who is a stand-in for the viewer.

By contrast, the non-Arab (American) female lead in Hitchcock's *The Man Who Knew Too Much* (1956), Jo Conway McKenna (Doris Day), is on her toes when she travels in Araby. She is suspicious of the Arabs she meets—an aggressive husband on a bus, angry that her son has accidentally torn off his wife's veil, and a man who dies in the Place Djemaa el Fna, only accidentally revealing himself to be a European made up to look like an Arab. She is victimized by Arab men, especially an unseen one whose voice it is that informs the McKennas, and us, that their child has been kidnapped. Beginning as an exotic locale, Araby becomes for the Americans, rather quickly, a nightmare prison from which their emotions drive them to escape but in which, they know, it is possible their missing son may be hidden. For Jo, indeed,

Marrakech is a place where strangers turn out to be even stranger than she had thought; where events are not what they seem to be; where people all around are masked—not merely by long-obscuring robes. This is not a film in which an American woman is lured by an Arabian spell; all to the contrary. The romantic and ancient Arabic world of sheiks and sultans, caliphates and viziers, magic flying carpets and massive earthenware pots, flying horses, and mysteriously drugged potions have been utterly transcended by a contemporary political sphere in which economic, tactical, mundane realities prevail. But the effect on Jo is much the same. Distraught over the loss of her son, subject to her own doctor/husband's drugging, Jo is caught in the arabesque no matter how hard she tries to resist it and no matter how contemporary her situation. The film was shot on the eve of the revolt against the French, and everything of the Americans' relation to Arab characters is mediated by bureaucratic authorities pronouncing the rules of multiculturalism.

For David Lean in *Lawrence of Arabia* (1962), the desert is the setting for an immense political transformation as Arabia meets modernity. Prince Faisal (Alec Guiness), influenced by T. E. Lawrence (Peter O'Toole), is trying to establish sovereignty for his people in the face of a European hegemony. An uneasy ally is Auda abu Tayi (Anthony Quinn), ferocious and animalistic leader of the Bedu, and conflicted between the modernist and traditional positions staked out by these two is Sherif Ali (Omar Sharif)—a dashing prince sufficiently enamored of Lawrence to see that his rational ways and access to military technology are powerful tools for bringing a primitive people into the twentieth century, yet sufficiently enmired in his own inherited passions and territorial sentiments to distrust Lawrence even as, emotionally, he bonds with him in brotherhood. Faisal is played as a grand intelligence, infinitely patient in its sagacity, tranquil as the rolling sand; Guiness keeps his eyelids half-closed when he speaks. His character indeed seems to *be* the desert. Further, the connection between the desert, as *topos*, and the Arab as eternal presence is struck again and again through Freddie Young's overwhelming 65 mm color photography of dunes in Jordan and elsewhere. Bosley Crowther, indeed, was struck unhappily: "It is such a laboriously large conveyance of eye-filling outdoor spectacle—such as brilliant display of endless desert and camels and Arabs and sheiks and skirmishes with Turks and explosions and arguments with British military men—that the possibly human, moving T. E. Lawrence is lost in it" ("Screen"). If earlier sheiks onscreen *knew* the dunes, controlled the desert as a geographical and intentional space, Faisal has actually become a landscape. Ali is too young, too hot-blooded for this sort of philosophical resignation; Auda is too emotional, too physical and precipitate. The shockingly blond, blue-eyed Lawrence is the feminized, passive European who falls in love—if not precisely with the sheik himself then with his culture, his manners, his language, his hopes, his people: in love, if, exhaustively, from a kind of erotic distance ("He is so obviously an outsider,"

wrote Roger Ebert, "that he cannot even understand, let alone take sides with, the various ancient rivalries" ["Lawrence"]). To have Lawrence played with so delicate an ambiguity, sexually—in a scene where he is flogged by the Turkish Bey (Jose Ferrer) we are given to see the odd masochistic pleasure he takes at each lash—is to link him with the long line of female Arab-lovers that stretched before. In 1990, Ralph Fiennes debuted in the role of Lawrence in *A Dangerous Man* for British television, with Siddig el Fadil (now Alexander Siddig) playing Prince Faisal; here the relation between the two was a bond of staid and loyal brotherhood, Lawrence, as pale behind Fiennes's face as behind O'Toole's, colder and more detached while still yearning for all the formalities of relationship. O'Toole's Celtic heat inflames his presentation of Lawrence so that the European seems erotically stimulated by everything about Faisal's world, the rugs in the desert tent upon which he perches, the hooded eyes peering from under the *kaffiyah*, the way Sherif Ali rides toward him in the midday sun, emerging out of the blistering heat waves like a dream. "It is spectacle and experience," writes Ebert, "and its ideas are about things you can see or feel, not things you can say."

John Milius's *The Wind and the Lion* (1975) is something of a return to the mythical Araby of the earliest films, while still retaining the political thrust highlighted by Hitchcock and Lean. *Wind* and *Lawrence* are indeed interesting to examine in light of one another, since they depict events in the Middle East at around the same time in history, the earliest years of the twentieth century. Whereas in *Lawrence* the confrontation between Europeans and Arabs is worked through as a political, diplomatic, and historical problem, Milius's film treats it as a pretext for blustering, dramatic military intervention on one hand and a romantic flight of the imagination on the other. Eschewing historical fact, *The Wind and the Lion* erases Ion Perdicaris and picks up the traditional thread of the European woman caught up with an Arab man who first threatens, then mystifies, and finally attracts her by substituting Eden Pedecaris (Candice Bergen), a single mother whose wealthy husband is nowhere to be seen. In *The Sheik*, it will be remembered, Lady Diana Mayo decided to decamp from the European colony to find herself in the glorious desert, where she was more or less abducted and held at length by Sheik Ahmed ben Hassan. This man first repelled and horrified her, then became a source of mysterious pleasure, then became the object of her adoration and trust. In *Lion*, Mrs. Pedecaris, who with her two children (Simon Harrison; Polly Gottesmann) is abducted by Mulay Achmed Mohammed el-Raisuli the Magnificent (Sean Connery) and carried away to the desert, is a vision of Americanized European refinement, hardly when she is seized and carried off a pretext for a claim, such as the one made in 1904 in the *Times*, that "The attitude of the Moors toward Europeans has grown more and more antagonistic"; Raisuli acts forthrightly enough, and Eden's retainers are slaughtered, to be sure, but she is clearly what Lady Diana

Mayo was at first, a sexual prize. Raisuli's political intention, to the extent that he can be said to have time for one outside of his lengthy moments of chiding, taunting, and otherwise wooing Mrs. Pedecaris's attentions, is to embarrass the Sultan of Morocco, who has, in his opinion, been too warmly courting the favor of European powers, but in the process of taking this American woman hostage he infuriates Teddy Roosevelt (Brian Keith) into mobilizing a military intervention (that is ultimately unsuccessful). The invocation of American, French, German, British, and Moroccan governments, as well as the will of Raisuli and his Berbers, constitutes at least a political backdrop against which the story of estrangement and cultural accommodation can be told. But the center of the film is the development of a relationship of trust and friendship between Eden and Raisuli, in short the flowering of her ability to find him appealing when his first presentation of self was as a thunderous, murderous invader bent on destroying her sophisticated European world. Less covertly than other films, then, *Wind* seems to suggest the discomfiture of the cultivated woman in Western civilization, her ultimately vacuous position in a world lorded over by the kind of males Teddy Roosevelt symbolizes. As monstrous as he may at first seem, the Arab—in all these films but here with unmistakable directness—promises a richer, if less modernized, life.

The theme of escape from modernity is furthered gloriously in Bernardo Bertolucci's *The Sheltering Sky* (1990), where the Arab, although embodied in a tribal leader at a key moment in the narrative, is in general more a landscape than a person, more a vastness than a point of focus, more a seductive incomprehensibility than a stereotype. In the 1930s, Kit and Port Moresby (Debra Winger, John Malkovich), joined by their friend Tunner (Campbell Scott), have left New York to voyage into the Sahara. Kit is tense, bored; Port, a composer, needs to hear a different sound in his head, see a fresh vista, experience the unknown; Tunner is following, eager for Kit, eager, in a way, for Port. From village to village they travel, always unrested and vague. Abandoning Tunner, Port and Kit try to resuscitate their marriage in the vast wilderness. Port becomes infected with typhus, slides into a fever, lingers at length under Kit's tearful, tender nursing, and then quietly dies. Lost in space and without grounding, Kit begs a ride with a caravan, is taken upon his camel by the leader and treated as his wife, and finally escapes to the questionable haven of Western civilization again. Here is restruck the theme of the sheik enamored of a Western woman, capturing her, disrobing her, washing her in wonder, possessing her passionately, even though all this comes as the climax of a lengthy essay on marital trust, cultural ignorance, the limits of the self—all Western themes, to be sure. In a summary voice-over, Paul Bowles explains how little time we have, how finite experience is.

More than just Kit's lover, in this film the Arab is a spirit of the desert—certainly a spirit more than a figure, even though he does in truth figure within it, fig-

ure everywhere: there are thousands of gesticulating, murmuring, dancing, singing, gazing people wrapped head to foot in robes (rather like the milling crowds in the Place Djemaa el Fna in *The Man Who Knew Too Much*). The desert itself, its occasional fly-ridden villages all soft-stoned and labyrinthine (in one, magnificently, a camel train meanders through bleached narrow streets); its yawning oases; its sunburnt dunes; its dry rocks (photographed, all, with exceptional beauty by Vittorio Storaro) embody a shifting, delirious, ancient, and fluid arcaneness, a great Breath. Is the beautification of the camera, however, a Western conceit? *Sheltering Sky*, a depiction of the desert even more stunning than what we find in the canonical *Lawrence of Arabia*, really raises the question framed implicitly by Ramon Novarro when he went to Tunisia to make *The Arab*: "The desert—also the South Sea islands—are very lovely to look at in pictures, but [when] you go there, you lose all that romantic feeling" (quoted in Soares, 60). Always the native people the Moresbys meet are watching, playing their flutes, tapping their drums, ululating, watching, endlessly and unfathomably. When Kit leaves her Bedouin husband's compound and finds a marketplace, she dives after some food and tries to pay for it with francs. No one will touch her money, no one regards it as a thing at all; the real medium of exchange here is something else, something of the body, of time, of servitude.

The Arab in New Critical Light: *Aladdin*

In all of these screen treatments, we can find some splitting of the Arab into two manifestations, the seductive and beautiful embodiment of some spirit of the desert and an evil, manipulative, greedy, and magically empowered force of darkness. Disney's *Aladdin* (1992) recapitulates these characterizations, exchanging the European female for an Arab princess in the spirit of *The Thief of Bagdad*, who, just as in both versions of *The Thief*, is daughter to a quirky, somewhat absent-minded, and doting father who holds her to an overarching and preexistent "rule" that she must marry a princely suitor. This film has Shakespearean undertones. The evil vizier Jafar, who seeks the magic lamp of the genie, is accompanied by a jabbering parrot named, of all things, Iago; this casting him as an Othello figure and bringing to the fore the relation between Othello's moral and physical darkness. The princess is accompanied by a huge pet tiger, reminiscent of the companion of Altaira (Anne Francis), the science-fiction adaptation of Miranda in *Forbidden Planet* (1956), this arrangement rendering her goofy father as a kind of failed Prospero; Aladdin, the "diamond in the rough" who will capture her love and save her from an awful fate, as an innocent Ferdinand; and the towered city of Agrabah in which all this occurs as a kind of dream island of the East. In *The Golden Voyage of Sinbad* (1974), the eponymous prince (John Phillip Law) is in battle with the evil magician Koura

(Tom Baker), who wishes to obtain a piece of ornamental jewelwork that he can match with a fragment already in his possession to make a magical key: in *Aladdin*, Jafar uses two golden ornamental fragments to assemble a key to the secret underground cave, a monstrous sand lion that emerges from the purple twilight desert sands. And the princess escapes from the palace by disguising herself as a commoner, in which guise she meets Aladdin much as in *The Thief of Bagdad* (1940) King Ahmed meets his adventure because he has disguised himself to walk among his people, or in *The Barbarian* the princely Jamil disguises himself as a servant in order to learn about life.

If the animated musical form of *Aladdin* makes possible a distancing from the story, a kind of winking parody in which no magic, no enchantment, no love is to be taken as real—for instance, having stolen a loaf of bread, the thief Aladdin escapes the royal guards, singing jazzily, "One jump…ahead of the lawman / That's all…and that's no joke / These guys don't appreciate I'm broke …"—it also allows, at the same time, for the romantic vision of Arabia to be intensified in hue and saturation (Aladdin and Jasmine meet against the background of a vivid raspberry and persimmon sky; the desert by moonlight is the color of amethysts), for the character stereotypy to be exaggerated for dramatic effect (with sleazy merchants' popping eyeballs winking in every direction; with Jafar's hollow cheeks twitching and blue), and for the "magic" of the Arabian nights to be effected directly onscreen through what had by 1992 become quite standard Disney animation styles of pixilation, camera movement, and extension of graphic line. *Aladdin*, then, is at once the most magical (and orchestrated) Arabian screen tale, purely as image, even as its imagery is utterly hollow, its music trashy, its plot predictable.

That it could in no way be seen as a realistic portrait of the Arab—realistic like Jamil when he glowers at Di Standing for whipping him in *The Barbarian*; realistic like Fairbanks's Ahmed the thief straining to leap into and out of the giant urns in the marketplace, realistic like the mastermind of the kidnapping in *The Man Who Knew Too Much* when from behind we see him speaking on the telephone—was perhaps politically ideal at the time, since coordinated hostilities in the January 1991 Gulf War had terminated only about a year before, to be replaced by efforts to sustain southern and northern "no-fly zones" for the protection of Shiites and Kurds, respectively. By November 1992, when *Aladdin* was released, the monomaniacal Saddam Hussein had come more or less thoroughly to symbolize the Arab in the Western imagination. A tense stalemate existed between Hussein's beleaguered Iraq, still subject to UN sanctions, and a West determined to prove—yet so far unsuccessful in proving—that weapons of mass destruction were being mounted there. The animated quality of *Aladdin*, then, offered soft and plastic imagery that made possible a wide range of spectatorial reference, while at the same time making it possible for viewers to step back from the story and recognize it overtly as a

narrative construct. While earlier films about Arabs, however preposterous their narratives, had been readable as unauthored versions of a real world, *Aladdin* could be nothing but a concoction, its desperate civilians and pompous royalty, its dark-cheeked vizier nothing but figments of the Western narrative imagination. *Saddam* was real.

Prior to this narratological watershed, we had imagined the Arab as eternally proximate, indeed had configured him onscreen using Italians, Mexicans, Jewish Americans, Englishmen—actors who seemed to be extensions of the Western Self. And if this standardized form of depiction represented a way for the non-Arab West to assimilate the Arab and his culture, it also signaled an embrace and an attempt at union, a dissolution of cultural difference that, as much as it made the Arab European or American, made the European or American Arab. The frequently used strategy of having the European or American *female* fall in love with the sheik or prince, therefore, not only appropriates Arab masculinity (to the extent that this character can be taken seriously as Arab) but, more importantly, stands in as an explicit marker for the underlying approximation that is being engineered by the films in general. Ramon Novarro's embodying Jamil (a contractual bond) is signed overtly by Di Standing's final passion for the prince (a diegetic bond); in both cases, the non-Arab figure and the man of the desert are brought into a fateful clinch. But with *Aladdin*, the situation is modified in important ways. The Arabs of the film all take second place to Robin Williams's manic turn as the ginni of the lamp, Roger Ebert describing his scenes as "so captivating we almost forget about the rest" ("Aladdin," online). Then, the prince and princess, labeled as Arabian, are constructed as Semitic only in the thinnest possible way; their behavior, their vocalization, their attitudes all directly connote not only the West, but the Western teenage mentality. The *New York Times* described "the sloe-eyed Princess Jasmine" as "a nymph in harem pants" (Maslin, "Disney"); the *Chicago Sun-Times* calls the youths "pale and routine" and says bluntly that they "look like white American teenagers" (Ebert, "Aladdin"). Roger Ebert seems perturbed writing this, commenting on the film's "odd use of ethnic stereotypes" in order to complain not that "the Arab characters have exaggerated facial characteristics—hooked noses, glowering brows, thick lips" but that Aladdin and Jasmine don't share those features quite enough. "Wouldn't it be reasonable that if all the characters in this movie come from the same genetic stock, they should resemble one another?" Given that the "genetic stock" these characters come from is animator's ink, this is a bewildering question, indeed. But it does handily reveal that by the time of *Aladdin*'s release, in a climate where tension between the West and Arab nations was daily news—two days after Bill Clinton's election and less than a week before *Aladdin* premiered, Syria was worried he would adopt a "more pro-Israeli stance" and Hussein "fired a gun in the air to celebrate Mr. Bush's defeat. 'Bush fell a long time ago when he decided to bomb

Baghdad,' Mr. Hussein said" ("Foreigners Hope")—the explicit, exaggerated "eth-
nicity" of the screen Arab could finally and avowedly become the basis of critical
reception.

It is in this new critical light that Dave Kehr of the *New York Times* can write
in July 2006 of Valentino's 1921 performance as the Sheik as "crude, wildly melo-
dramatic and hopelessly naïve," full of "excesses" that were "hardly typical of
Valentino or of silent film at the height of its sophistication" ("Choice"), this even
though, as popular reviewers now make certain to aver, "*The Sheik* made [Valentino's]
name a household word…As a direct result of the picture's enormous success,
Valentino's salary more than doubled, flappers began calling attractive men 'sheiks'"
(*TV Guide*); or, "From this film Rudolph Valentino became one of the biggest
international stars Hollywood has ever known" (Schwartz, online); or, "he gazed at
his heroines with a seductive blend of passion and melancholy, guaranteeing to
moisten the sensibilities of enthusiastic female audiences. When the Valentino
craze reached its pinnacle with a kitschy desert romance melodrama, *The Sheik*,
women fainted in the aisles and Arab motifs influenced fashions and interior
designs" (Bourne, online). Valentino, *today*, is a hollow mask, not focus of real
desires. And as to Ramon Novarro, cultivated by Metro as his competition, Antonio
Rios-Bustamante claims, "You cannot understand the 1920s without understand-
ing the 'Latin Lover' craze…You cannot understand MGM without understand-
ing Ramon Novarro" (quoted in Rodriguez). This "understanding" is a far cry from
"fainting in the aisles" and redecorating one's home; it is a distanced and judgmen-
tal application of critical intelligence that has become popular now, even automat-
ic in most circles, but that has replaced a kind of frenzied adoration and stunned
gaze of earlier years.

A CYNICAL VIEW: *THREE KINGS* AND *SYRIANA*

By the time David O. Russell released *Three Kings* in 1999, enough time had
passed that the Gulf War could be seen only cynically. Not only was the construct
of the Arab as a beautiful, romantic creature lingering in a paradise free from the
debilitating constraints of Western society a hollow and utilitarian projection; the
eager and romantically open Westerner was equally preposterous, a cover, at least,
for the vengeful, cupidinous, and territorial creature who could operate on military-
economic, not mythic, interests without a whiff of interest in personality, embod-
iment, culture, history, or experience per se. In Nicholas Ray's 1957 *Bitter Victory*,
the passionate and involved approach of the poet-Westerner to Arabia and the cold-
hearted and brutal tactical and utilitarian approach of the military bureaucrat were
contrasted dramatically in the conflict between Brand (Curt Jurgens) and Leith

(Richard Burton) (see Pomerance, 191–195). By the late 1990s, however, as cultural studies, and specifically the critical approach of such thinkers as Said, reached a zenith in the critical universe, neither the poet-dreamer nor the military strategist could be taken at face value by artists or audiences. The American Army in Iraq is shown to be populated by uninformed and misdirected zealots, equipped with automatic weapons and Beach Boys audiocassettes, desperately hungry to ransack a territory for which they have no feeling and in which they have no historical investment—in this case searching for one of Saddam Hussein's hidden bunkers filled with Kuwaiti bullion. Todd McCarthy notes that "No Hollywood film in memory has addressed" this issue of "the amorality and lack of consistent principles in American foreign policy" ("Three Kings"). Again, then, we have protagonists searching for fabulous treasure hidden under the sand, as in "Ali Baba and the Forty Thieves," *Aladdin*, and a thousand variants. But romantic involvement goes completely by the wayside. It is March 1991, and the war is just over. An American platoon has captured a group of Iraqis, who are labeled "ragheads" or "towelheads," "dune coons," "sand niggers," "camel jockeys." One officer says to another, "I don't even know what we did here.…Tell me what we did here." A longhorn steer blocking a road has been booby-trapped with a cluster bomb. The desert is a vast, flat, unpicturesque wasteland, stretching as far as the eye can see, dotted with burning oil wells throwing black smoke against the relentless blue sky. (In *Jarhead* [2005], these same fires are shown at night, the oil falling like a black rain upon a desert already coated black.) If the American soldiers are brutal and trigger-happy, their Arab victims are money-hungry and craven: Mark Wahlberg, George Clooney, and company invade one underground bunker and find a bunch of men lazily guarding a trove of computers, automatic coffee machines, CD players stolen from Kuwait: "Newest and best!" one of them says, offering a sound system to Wahlberg. "Newest and best has better noise reduction," the American says, slapping the man down.

Here, the cruel vizier/Sultan is the absent Saddam, his leering face on wall-size posters and his army racing around in loud-mouthed panic. The Iraqis, indeed, are uniformly out of control, screaming hysterically, urgently anxious, undisciplined, eager to make moves, rather than obsessed with the hypnotic rhythms and tranquil resignation that is evident in *Sheltering Sky* or in certain scenes in *The Passenger*, such as one in which a witch doctor, hypnotic and wise, interviews an American television journalist ("Your questions tell me more about you than my answers could possibly tell you about me"). It is as though in enduring the Gulf War and its villain protagonist, Saddam, at a distance through media reports, the audience for whom this film was made had experienced a profound awakening from the dream of Araby: a shocking movement that could be understood as a "reentry" into a "real" world of political alignments, religious passions, and geographical lusts. The romantic figure of the sheik could never inhabit this world, nor could the innocent

European attracted to him, male (as in the case of Lawrence) or female. In this "New Araby," the cattle are liable to explode in one's face, the underground treasure is high-powered domestic appliances exchangeable in an international market.

The world of high romance has been lowered into the boue, and what is at stake in the desert is not yearning and pleasure and strangeness but survival against an antagonist far too comprehensible, far too capable of understanding. In one village, as women and children are being rounded up by the Americans in a panicky stand-off against Iraqi troops, "The United States military is in charge here," a soldier arrogantly says, and one of the Iraqis, behind sunglasses, coldly stares at him in mute and sagacious denial. In *Le Grand Voyage* this "new Araby" is a Muslim scepter extended from one urban neighborhood in the south of France, along the north shore of the Mediterranean through Bosnia and Turkey all the way to the Hadj at Mecca. The "sheik" is a young Arab medical student, Reda (Nicolas Cazalé), beset by his father's command to quit school and drive the old man to his once-in-a-life-time pilgrimage. The European, feminized culture that yearns for proximity to him, represented most pointedly by his cell phone on which he keeps trying to reach his girlfriend and which, one day while he is sleeping, his traditionalist father throws into a roadside garbage can. Reda is torn between the strict and demanding Muslim culture of his father and the liberated—and also undirected—modern world that his girlfriend represents. The father seems to dominate the boy: Reda becomes angry when the cell phone is lost, then sullen, then acquiescent, then resentful and nihilistic as they approach Mecca, but finally meditative and compliant; yet when the father dies, the youth heads back to his former life, perhaps with a new ray of concentration in his eye for the principles of a religion of the past, perhaps with the lightheadedness that comes from finally being able to breathe.

Syriana moves even further into a rational discourse of the relation between the West and Araby, a politically informed anthropology that attempts to jettison romantic dreams and comprehend the Arab in his own historical and cultural terms. The "sheik" figure here is Emir Hamed Al-Subaai (Nadim Sawalha), complicit in a profound tragedy but less out of self-reliance and aloofness (Sherif Ali shooting a man for drinking from his well in *Lawrence*) than because he has invested too much, perhaps too trustingly, in the global economy that reduces all men to ciphers transacting beneath their cultures; and because technology is eclipsing him. At his vast estate in Marbella, Spain, he is throwing a huge party, to which has been invited Bryan Woodman (Matt Damon), an American economic analyst and television personality, along with his family (Amanda Peet; Steven Hinkle; Nicholas Art). Woodman wants a moment of the Emir's time. His older boy, meanwhile, is at poolside. In his office, the infirm old Emir is entertaining some Japanese businessmen, flanked by his rival sons, the Princes Nasir (Alexander Siddig)—who seeks to modernize and democratize his country—and Meshal (Akbar Kurtha), who

wonders whether he will continue his father's autocratic rule. In the background a closed-circuit television system displays various angles on the estate—the Emir is showing off his high technology to Japanese guests. What we see—but no one else does—is that when the old man gives the command to turn on lights in various areas, including around the swimming pool, the lights inside the pool fail to go on. A jump to a close shot underwater shows that there has been a short circuit in these, and a buzzing on the sound track cues us that the swimming pool has silently become electrified. Suddenly we see Woodman's son preparing to dive in—he has been much chided for being a sissy and now needs to prove himself. He jumps. When pandemonium breaks loose, the open circuit is disabled and Woodman races to the pool and jumps in, but it is too late. Later, in a private meeting between Nasir and Woodman, we learn that the Emir was so upset he had the entire estate razed to the ground. Nasir has been authorized to offer Woodman access to a huge oil deal, a deal that Woodman archly interprets as blood money.

Here is a transformation of the sheik formula that makes the besotted European a sleek bourgeois myrmidon of the effete (read: feminized, and passive) global media, dependent upon the Emir for privileged access to information and thus lured into his opulent precincts. If Woodman is first paralyzed with grief, then astonished and offended that the Arabs would seek to buy him off, he nevertheless permits himself to come closer to their oil business than his wife would like to countenance and, with their other child, she sourly moves back to London. Woodman becomes Nasir's trusted adviser. On a much vaster canvas, the film puts American military, political, and intelligence interests at the feet of both Nasir and Meshal, courting each but finally, after the Emir's death, prevailing over Nasir's attempt to take over the country by arranging for his brutal high-tech assassination. While the sleekness of the action in this film, its terse expressivity, its decisive angularity and forceful thrust, all reflect again and again the kind of arrogance that *Three Kings* made popular as a reflection of Western thought about the Arab after the Gulf War, there remains a strong and rhythmically repeated hint of seduction in the film, borrowed from the long line of treatments I have discussed and embodied in the fey and puissant Dean Whiting (Christopher Plummer), head of a major Washington law firm and a man with considerable access to secrets and influence in the international arena. It is not merely Whiting's orchestration, by way of the CIA bureaucracy and covert military facilities, of the assassination of Nasir and his family that this film highlights; it is Whiting's sinuous, unctuous, and sadomasochistic snappiness with Meshal as he lays the ground for his plot, his simpering passivity when challenged by Bob Barnes (George Clooney), a former CIA agent doggedly on the trail of a stolen missile, and Whiting's obsessiveness. This is a man who has been, as it were, in many beds, probably at the same time. Through Whiting's magnifi-

cent classiness—which rivals Myrna Loy's in *The Barbarian*, to be sure—and gracile bisexuality, *Syriana* gives us a contemporary sheik film, posing this lawyer who works in whispers from across the ocean in secret rooms as the true modern supplicant for the Arab's keen attentions. Whiting is at a perfectly gracious remove from the murder he commands: Nasir's motorcade struck by a remote-controlled SCUD, the prince's Range Rover is reduced to a small puddle of molten metal half sunk into a crater in the highway. Black smoke rises as from a burning oil well. Woodman, stunned, climbs out of the motorcade and stumbles toward the hazy towers of Riyadh across flat, unmarked sands.

Also introduced in *Syriana* is a teenage boy, Wasim Khan (Mazhar Munir), whose father has been fired from his job at an oil rig as a result of the Emir's dealings. He comes under the influence of Mohammed Sheik Agiza (Amr Waked), a mullah who takes him under his wing at a rural study retreat, patiently and gently courts his loyalties, and teaches him the Koran. Later, we discover that with his friend Farooq (Sonnell Dadral) he has been initiated into Agiza's al Qaeda cell— "We are a small group...the ones who carry convictions and ambitions. And within this group...there is another, smaller group...who flee from the worldly life...in order to spread the true faith"—and these are the two youths who at film's end motor out into the harbor at Aden with the stolen missile in the prow of their dhow and fatally contact with a tanker (standing in for that "guided-missile destroyer weighing eighty-three hundred tons," the *USS Cole*, which on October 12, 2000 was made to look, finally, "like a gutted animal" [Wright "Agent," 62–63]). The sheik's moral instruction to Wasim is of a kind incommensurate with Western morality in the extreme, the very negation of the positions undertaken by all the principal Arab characters in films before this, who, while they may act either for or against Western protagonists nevertheless always behave the way Westerners would, albeit within their flowing robes and within a romanticized light. Even the Emir and his two princes in this film, Arab by costume and décor and manner, are Western by logic. But in Sheik Agiza, virtually silent, hypnotic, quiet in his demands yet firmly obsessed by a way of seeing the world that is utterly different, we have an ultimate screen embodiment of the Otherness that romanticism failed to imagine.

The collision of the dhow with the tanker—perverted religious commitment and antimodernist pastoral sentiment directed against the capitalist giant that subsumed the Arab world with its hegemony—occurs with quiet, almost sepulchral, music in the background, and at the precise moment of contact the screen goes silent and white. This is the whiteness of a great explosion experienced personally, of course, but also a blank canvas, an invitation to look over our long history of pictorialization and imagination and conceive the Arab, his world, and our relation to them, over again.

WORKS CITED

"American Abducted; Warship to Tangier" (1904). *New York Times*, May 20, 2–3.

Birchard, R. S. (2004). *Cecil B. DeMille's Hollywood*. Lexington: University Press of Kentucky.

Bourne, M. "The Sheik/The Son of the Sheik: Special Edition"; http://www.dvdjournal.com/reviews/s/sheik21.shtml. Accessed May 6, 2009.

Brownlow, K., & Kobal, J. (1979). *Hollywood: The Pioneers*. New York: Alfred A. Knopf.

Crowther, B. (1962). "Screen: A Desert Warfare Spectacle: 'Lawrence of Arabia' Opens in New York"; *New York Times*, December 17.

Davenport, G. (1981). *The Geography of the Imagination*. San Francisco: North Point Press.

Ebert, R. (1992). "Aladdin," *Chicago Sun-Times*, November 25; http://rogerebert.suntimes.com/apps/pbcs.dll/article?AID=/19921125/REVIEWS/211250301/1023. Accessed May 6, 2009.

Ebert, R. (1999). "Three Kings," *Chicago Sun-Times*, October 4; http://rogerebert.suntimes.com/apps/pbcs.dll/article?AID=/19991004/REVIEWS/910040306/1023. Accessed May 6, 2009.

Ebert, R. (2001). "Lawrence of Arabia (1962)," *Chicago Sun-Times*, September 2; http://rogerebert.suntimes.com/apps/pbcs.dll/article?AID=/20010902/REVIEWS08/109020301/1023. Accessed May 6, 2009.

Ellenberger, A. R. (1999). *Ramon Novarro: A Biography of the Silent Film Idol, 1899–1968*. Jefferson, NC: McFarland.

Fiedler, L. A. (1978). *Freaks: Myths and Images of the Secret Self*. New York: Simon & Schuster.

Fitzgerald, E. (1997). *Rubáiyát of Omar Khayyám: A Critical Edition*. Christopher Decker (ed.). Charlottesville and London: University Press of Virginia.

"Foreigners Hope Clinton Keeps Policy" (1992). *New York Times*, November 5, B10.

Gunning, T. (1990). "The Cinema of Attractions: Early Film, Its Spectator and the Avant-Garde," in T. Elsaesser (ed.), *Early Film: Space Frame Narrative*. London: BFI, 56–62.

Kehr, D. (2006). "Critic's Choice: New DVD's," *New York Times*, July 11, B3.

Maslin, J. (1992). "Disney Puts Its Magic Touch on 'Aladdin,'" *New York Times*, November 11; http://movies2.nytimes.com/mem/movies/review.html?_r=1&title1=&title2=ALADDIN+(MOVIE)&reviewer=Janet+Maslin&v_id=1338&pdate=19921111&oref=slogin. Accessed July 26, 2006.

McCarthy, T. (1999). "Three Kings," *Variety*, September 22; http://www.variety.com/review/VE1117752173?categoryid=31&cs=1. Accessed May 6, 2009.

Northrop, H. D. (1889). *Wonders of the Tropics, or, Explorations and Adventures of Henry M. Stanley*. London: Earl.

O'Leary, L. (1980). *Rex Ingram: Master of the Silent Cinema*. Dublin: Academy Press.

Pomerance, M. (2005). "1957: Movies and the Search for Proportion," in M. Pomerance (ed.), *American Cinema of the 1950s: Themes and Variations*. New Brunswick: Rutgers University Press, 177–200.

Powell, M. (1986). *A Life in Movies*. New York: Alfred A. Knopf.

Rodriguez, R. (1996). "The Early Years—The Portrayal of Minorities in Hollywood Film Industry," *Black Issues in Higher Education*, January 11: 12, 23; http://www.findarticles.com/p/articles/mi_m0DXK/is_n23_v12/ai_18184074. Accessed May 6, 2009.

Said, E. (1978). *Orientalism*. New York: Random House.

Schwartz, D. "*The Sheik*"; http://www.sover.net/~ozus/sheik.htm. Accessed May 7, 2009.

Scott, A. O. (2005). "Clooney and a Maze of Collusion" *New York Times*, November 23; http://movies.nytimes.com/2005/11/23/movies/23syri.html?partner=rssnyt&emc=rss. Accessed May 6, 2009.

Shah, I. (1984). *Tales of the Dervishes*. London: Octagon Press.

Shaheen, J. G. (2001). *Reel Bad Arabs: How Hollywood Vilifies a People*. Brooklyn: Olive Branch Press.

"The Sheik," *TV Guide*; http://online.tvguide.com/movies/database/showmovie.asp?MI=38932. Accessed May 7, 2009.

"The Sheik (1921)," "The Screen," *New York Times*, November 7.

Soares, A. (2002). *Beyond Paradise: The Life of Ramon Novarro*. New York: St. Martin's Press.

Stern, L. (2005). "From the Other Side of Time," in I. Christie & A. Moor (eds.), *The Cinema of Michael Powell: International Perspectives on an English Film-Maker*. London: BFI, 36–55.

Telotte, J. P. (2006). "German Expressionism: A Cinematic/Cultural Problem," in L. Bradley, R. B. Palmer, & S. J. Schneider (eds.), *Traditions in World Cinema*. New Brunswick: Rutgers University Press, 15–28.

Wright, L. (2006). "The Agent," *New Yorker*, July 10 and 17: 62–73.

"America , Fuck Yeah!"

Patriotic Puppetry in
Team America: World Police

ANNA FROULA

In October and November 2001, Hollywood industry heads met with Bush administrators to discuss how, as master puppeteer Karl Rove put it, "to produce a number of substantive measures that will materially strengthen our war efforts" (Rowe). Sylvester Stallone reportedly began scripting a film in which Rambo parachutes into Afghanistan to fight the Mujahadeen—his former allies in the anti-Soviet *Rambo III* (1988). A 2005 treatment called *Rambo IV: Holy War* pitted Rambo, now an environmentalist and convert to Sufi Islam, against "sadistic Islamic terrorists" that hijack the UN Assembly and "hold the world...ransom." The actual film, *Rambo* (2008), however, dropped any engagement with the Bush administration's "war on terror," and instead placed Rambo in Myanmar to protect Karen villagers and American missionaries from the country's military regime. Prior to Hollywood's reimagining of post-9/11 global warfare in such productions as the television series *Over There* (2005) and feature films like *American Soldiers* (2005), *The Kingdom* (2007), *Redacted* (2007), and *Lions for Lambs* (2007), American movie audiences only found puppets taking up arms against post-9/11 terrorists.

Released closer to the 2004 presidential election than Michael Moore's *Fahrenheit 9/11* (2004) and inspired by Jerry Bruckheimer's formulaic action films, Trey Parker and Matt Stone's titular paramilitary *Team America: World Police* operate from a base inside the presidential mouths of Mount Rushmore. Consisting of an enormous eagle carrying if not consuming the world in its beak, the team's logo emblematizes the aim of the notorious Project for a New American Century to

maintain America's global dominance and the catch-22 inherent to that project.[1] The code name of President Jimmy Carter's botched attempted rescue of Americans held hostage in Iran on April 24, 1980, which "collapse[d] virtually before it had begun," was "Eagle Claw" (Bacevich, 104). *Team America* received mixed reviews from critics attempting to polarize the politics of the avowedly libertarian *South Park* creators.[2] For example, Brian C. Anderson, the author of *South Park Conservatives*, gleefully equates "the movie's true villains: the Islamic fanatics and North Korean madman Kim Jong-Il" with "Hollywood's antiwar liberals" (83). Appearing to accept the film's playful—and Anderson's literal—equation of celebrity-espoused ideological dissent with actual acts of terrorism, *Salon.com*'s Charles Taylor exasperatedly charged the film with being "so determined not to have a point of view that it cancels itself out in the manner of those CNN 'debates' where two talking heads from opposing sides gainsay each other for five minutes." Yet it is precisely this comprehensive satire of both the warmongering Bush administration neoconservatives and the futile peacenik grandstanding of Hollywood liberals that functions not only as an emblematic representation of a sharply divided American response to the "global war on terrorism" but also as a larger critique of America's cultural imperialism.

The movie begins with a group of mysteriously funded paramilitary puppets fighting terrorists in Paris, France, where the untimely death of Team member Carson necessitates the recruitment of Broadway actor Gary Johnston. With the application of brown makeup, facial hair, and a towel turban, Gary's ability to "valmorphorize" into Middle Eastern terrorist, "Hakmed," enables him to "act" his way into the terrorist network in Cairo, Egypt. Meanwhile, UN Weapons Inspector Hans Blix tries to search Kim Jong-Il's palace for Weapons of Mass Destruction, only to be duped into a violent, Bond-esque death in the dictator's shark tank. Masterminding a terrorist plot to transform all nations into third world countries, a lonely Kim Jong-Il manipulates the Hollywood elite and assorted world leaders into attending a peace conference to distract them so his terrorist network can detonate weapons of mass destruction worldwide.

Disrupting the dictator's master plan, rogue terrorists plant bombs at the Panama Canal in retaliation for Team America's collateral destruction of Cairo. Distraught that his acting has caused harm, Gary quits the team and returns to New York City to drown his sorrows in a cesspool of his own vomit—literally. A joint counterattack by the terrorists and the North Korean air force thwarts the Team's attempts to stop Kim Jong-Il and results in the rendition of the Team to the dictator's palace prison. Simultaneously, an anti-Team America protest depicts a ham-filled, grand-standing Michael Moore puppet transforming into a suicide bomber who destroys Team headquarters.[3] Gary returns to the smoldering remains to make amends and fellates Team leader Spotswoode to prove his loyalty to the

team. After a hilarious training montage, Gary reunites with the Team to help them escape and successfully defeat the dictator's plans despite the violent resistance of the Hollywood actors.

In all of its raunchy irreverence, *Team America* indicts not only Hollywood actors posing as political spokespeople and the U.S. Defense Department's tendency to "destroy the village to save it" but, crucially, the film's own overindulgent audience for its indiscriminate consumption of American imperialism. Most prominently, the theme song of the film, "America, Fuck Yeah!" and its four reprises lampoon not only the United States's overreliance on military responses to international conflict but also its nationalist celebration of hypercapitalism. Mockingly appearing to affirm many of our national exports, the longer soundtrack version of "America, Fuck Yeah!" follows a list of popular American corporations and products with an enthusiastic chorus of "fuck yeahs!": "McDonald's!" "Wal-Mart!" "The Gap!" "Baseball!" "NFL!" "Rock and roll!" "The internet!" "Slavery! Fuck Yeah!" By crudely ratifying a multitude of such successful industries, the song encapsulates American history into a single aggressive tableau of overconsumption. "America, Fuck Yeah!" epitomizes, in staccato, our culture's inordinately high obesity rate; outsourced sweatshop industries; enduring myths of the classless, upwardly mobile American dream; MTV-edited attention spans; national pastimes of costly distraction and our gadget-driven mastery of globalization, as well as our continued exploitation of dark-skinned peoples. Later verses similarly reify this theme in different but equally superficial detail: "Starbucks!" "Disney World!" "Bed, Bath and Beyond!" "Sushi!" "Fake tits!" and "Las Vegas!" but with notably fewer "Fuck Yeahs!" for such unpatriotic commodities as "Sportsmanship," and "Books."

Evoking President George W. Bush's exhortation to find closure for the trauma of September 11's terror attacks through the power of travel and purchase, "America, Fuck Yeah!" regales its audience with what Dana Heller refers to as "the uninhibited pursuit of pleasure that makes us American citizens" (Heller, 23).[4] This laundry list of pleasurable offenses attacks the "obscene underside" of the much-touted American way of life, since redefined as patriotic acts of citizenship after 9/11. For as Žižek argues, "our 'Freedoms' themselves serve to mask and sustain our deeper 'unfreedom'"; that is, the numbing pleasures of overconsumption distract us from dirty business of government (2). "America, Fuck Yeah," blatantly exposes how, far from being a partisan concern, global military supremacy is deeply embedded within American national identity. Policing the world, decried in by Ohio Senator Robert A. Taft (1941) as "wholly foreign to our ideals of democracy and freedom," has become, as he feared, "our manifest destiny...our national identity," a destiny embraced by liberals and conservatives alike in the form of peacekeeping missions and, now, preemptive war (Taft & Wunderlin, 245–246).

Fearful that Americans would stop spending in the wake of 9/11, Scanlon notes,

"advertisers and merchandisers won the battle against a sluggish spending trend by linking patriotism, American prosperity, and consumerism…in what could be called, in the post-9/11 penchant for mercenary metaphors, a bloodless coup" (179). In fact, a *Harper's* (2002) list of trademark applications registered in the first few months after 9/11 includes the phrases "Americans Are Winners," "America's Rage," and, of course, "Fight Terrorism: Go Shopping."[5] "When people thought of purchasing symbols of American identity and perseverance," continues Scanlon, "they turned to Wal-Mart" (177). Said one shopper in an interview, "We've grieved, prayed, memorialized and now are retaliating. We can all do our part by spending money as usual for the common everyday things" (Shade, Wf4). In this formulation, consuming every day, or overconsuming as usual, becomes a paradoxically a priori act of manufacturing national security.

Far from a "liberal" denouncement of Bush policy, however, the film opens in a pretentious, marionette Paris, France—exactly, as a subtitle notes, 3,635 miles from America—where the streets are literally paved with croissants. After a young French boy bumps into a terrorist, recognizable by his stereotypically Middle Eastern music and turban, Team America unleashes its firepower from a squadron of red, white, and blue air assault vehicles and an enormous militarized Hummer worthy of the Governator. As Bacevich observes,

> The global military supremacy that the United States presently enjoys—and is bent on perpetuating—has become central to our national identity. More than America's matchless material abundance or even the effusions of its pop culture, the nation's arsenal of high-tech weaponry and the soldiers who employ that arsenal have come to signify who we are and what we stand for. (1)

Synecdochal for all American citizens, Team America embodies the conjoining of popular culture with America's military industrial complex via techno-savvy warriors. In the ensuing battle, the team deploys the best clichés of Hollywood action movies. "Why can't they ever do this the easy way?" shouts Chris to Joe, as they repel from the helicopter under fire from heavy automatic weapons. On the ground, Chris and a terrorist throw aside their arms and engage in elaborately choreographed hand-to-hand combat. Beneath the layer of amusing spectacle, *Team America*'s marionette puppets fighting Islamic terrorists suggest more intricate relationships between action figures, puppet strings, and political maneuverings—relationships that literalize the Reagan-esque propensity to blend movies with foreign policy, one that culminates in a performance as orchestrated and symbolic as the U.S.-designed toppling of Saddam Hussein's statue on April 9, 2003.[6]

The Parisian battle razes several famous landmarks, a destructive fantasy of preemptive revenge that received rave reviews on the prowar, anti-France Web site www.fuckfrance.com. At one crucial moment, Joe misses the terrorist and, instead,

lands a rocket-propelled grenade on the Eiffel Tower, which crushes the Arc d'Triumph. "Damn, I missed him," he says, oblivious to or unperturbed by the collateral damage, not to mention the ironic symbolism. Joe's lack of recognition amid the city's smoking remains the fundamental disconnect between the highly trained killers of the U.S. Armed Forces and the gory consequences of their training, as well as the televisually literate American consumers who watch war at a safe two-dimensional distance. As one sergeant commented after a skirmish in Iraq in March 2003, "We had a great day....We killed a lot of people....We dropped a few civilians, but what do you do?" (Filkins, B1).[7] As Michael Ignatieff concluded at the end of the twentieth century, for Americans at least, war had lost its slaughterhouse connotations from World War I and become "a spectacle...a spectator sport" (191). In this equation, as Virilio (1989) and other scholars have noted, shaping perspective is as, if not more, important than reality, because the former can determine the latter. Indeed, this scene surreptitiously provides metonymic substitutes for the absent images of actual devastation of the archives of human history in Baghdad's National Museum and National Library and Archives in April 2003 while Coalition troops guarded Iraqi oil fields.[8]

While—indeed because—Paris is burning, *Team America* literalizes the gore and destruction alluded to in the abstract euphemism of Secretary of Defense Donald Rumsfeld's "messy democracy" to describe the postinvasion chaos in Iraq.[9] The puppet warriors unwittingly create a spectacle of vengeance in the land of our right-wing's surrogate enemy that finds an eerie analogue in the jumbo jets that slammed into the skyscraping phallic signifiers of U.S. capitalist superiority on 9/11. From her red, white, and blue jet, Sarah blasts her missiles into the womb-like entrance of the Louvre that is full of treasures from France's own global conquests. Satirically imagining how an imperial power "fucks up" its enemies anywhere they happen to be, this recurring sexual trope depicts the explicitly material destruction of another culture on accident, or, rather a natural by-product of war.

If the larger story of the "war on terror" is a righteous, rape-revenge narrative, then it follows the convention that the United States will punish countries that would stand between the nation and the enemy that screwed it. By so crudely sexualizing this conflict, the film fantasizes a simplified, effective response to America's metaphysical rape that satirizes the most facile interpretation of the 9/11 attacks—that is, "they" hate "our" freedoms. Conversely, this scene portrays how we look to much of the world where, as Thomas Friedman argues, "people can no longer distinguish between American power, American exports, American cultural assaults, American cultural exports, and plain old globalization." Hence, while Team America celebrates its victory, the Parisians stare in shock and awe at their smoldering city, bringing to mind Johnson's prescient observation in *Blowback*: "Terrorism by definition strikes at the innocent in order to draw attention to the sins of the invul-

nerable" (33). Gleefully, Team America perpetuates these sins in the puppets' failure to bear the responsibility—and the reconstruction—of their police actions. Similar to how politicians and corporate advertisers alike interpreted the meaning of 9/11 for the families of the victims, the team interprets the scene for the Parisians—incorrectly. "Bonjour everyone; everything is bon," Joe announces in Frenglish, "we stopped the terrorists." Overlooking the citizens' trauma and the aftermath of this friendly fire in which Team America does more damage than the actual Islamic terrorists have yet done, the World Police puppets congratulate each other on their mission accomplished.

The audience, however, finds brief Bruckheimer-inspired respite from the carnage in Carson's proposal of marriage to teammate Lisa. Unfortunately, the mock romantic closure has deadly consequences as a terrorist, assumed dead, emerges monstrously from the fountain to gun down the bridegroom, a victim of the Team's prematurely declared victory. Much as the media spectacle of Pvt. Jessica Lynch's "rescue" distracted the American home front from the destruction of Iraq and its citizens in the U.S.-led 2003 invasion, Lisa's tortured screams effectively and affectively subsume the tragedy of the destruction of Paris into the personal pain of one American woman. The crane shot's perspective on Lisa's personal grief effaces the city's charbroiled remains and shifts the audience's attention to this blond embodiment of American victimhood, thereby implicating viewers in the single-minded focus on American loss and the failure to reconstruct communities that crumble under U.S. military wrath.[10] As Žižek argues, "on September 11, the United States of America was given the opportunity to realize what kind of world it was part of. It might have taken this opportunity—but it did not; instead it opted to reassert its traditional ideological commitments: out with feelings of responsibility and guilt towards the impoverished Third World, we are the victims now!" (47). The sympathetic perspective of an attractive, blond warrior instead revises a story of American invasion into a narrative of solipsistic persecution.

Hence, Lisa's hijacking of the Parisians' grief embodies how, as Ramazani observes, "We remember our wounds to heal our wounds; we keep our wounds open not to better remember the similar wounds we inflict on the world but the better to forget, belittle, or ignore them" (121). Accordingly, the film exposes how the American "culture of revenge" exports the U.S. death penalty to other nations and demonstrates that "America is prepared to change the world to keep from changing its lifestyle" (Burch, 133). Cross-cutting from Lisa's grief to New York City, Team America's subsequent recruitment of Gary Johnston begins with a tracking shot through Times Square's neon explosion of that lifestyle: Cadillac, Coca-Cola, Morgan-Stanley, Marlboro, BMW, Jell-O, Levi's, and, finally, two nearly naked blonds writhing on a poster with no visible brand name. This garish exhibition of the decentralized material power of American cultural imperialism significantly

associates these consumer spending and attention habits with both the center of cultural arts and 9/11's ground zero, further suggesting that the nation has "gotten over" the event previously thought to usher in "the end of irony" by shopping away its nightmares.[11]

But, behind closed doors in the midst of this orgiastic corporate glow, we enter the theater playing *LEASE*, a parody of the Broadway musical *RENT* that explores the lives of artists grappling with AIDS. This send-up of the wildly successful play—and now Hollywood movie—also emphasizes an even greater threat to humankind than terrorism with its finale, "Everyone has AIDS." In an indictment of the West's inadequate response to this deadly epidemic, the song even implicates "the pope" for his ban on condom use and his hatred of homosexuality, both positions that AIDS campaigners describe as "bleak failures" in the global fight against the disease ("No Praise"). The lyrics' racial slur—"spades"—invokes the racism inherent in Global Gag Rule, a Reagan-era policy reinstated by the Bush administration but rescinded by the Obama administration, on the U.S. Agency for International Development in places like Africa. This rule "restricts foreign non-governmental organizations (NGOs) that receive USAID family planning funds from using their own non-US funds to provide legal abortion services, even where a women's physical or mental health is endangered" (Fasy). My point here is that, while "Everyone has AIDS" uncouthly mocks the plot of *RENT*, the song also indicts U.S. national priorities that spend billions of dollars occupying other countries in the name of the "Global War on Terrorism" rather than demonstrating fiscal responsibility toward improving health care and authentically moral charity.

These numbers, nonetheless, speak to what Michael Rogin and other American scholars have termed our "imperial amnesia," which typically motivates our collective sense of revenge (106). Rogin argues, "the history of imperialism and slavery has encoded a nightmare of racial massacre....That nightmare of red and black murdering white inverts actual history in which massacres...were usually the other way around" (109). This imperial fantasy of "savage violence" creates and dehumanizes an enemy that unites citizens far more effectively than the abstract threat of a disease perceived to strike only marginalized groups and forgotten parts of the globe. Yet to keep its satire of the Right and Left fair and balanced, the song's liberal, feel-good response, "come on everybody we've got quilting to do" emphasizes how performing symbolic rituals, such as the Hollywood elite acts out on the world's stage, cannot solve this health care disaster, which has killed considerably more people than Islamic jihad. Lead actor Gary's description of his convincing method acting further emphasizes the disconnect between America and the global AIDS crisis: we only *act* like we care.

The movie's narrative return from *LEASE* to Team America's recruitment of Gary relies, in part, on the cultural context of the 1980s' military resurgence embod-

ied by such films as the original *Rambo* trilogy and *Top Gun* (1986), movies that exemplified actor-president Ronald Reagan's taste in movies and foreign policy (Jeffords). Spotswoode calls Gary a "Top Gun" actor, a "renegade Maverick"— explicit references to the film in which Tom Cruise helped revitalize the public image of and recruitment for the U.S. Armed Forces by transforming the prodigal son into heroic fighter pilot. For Spotswoode, the actor is his "perfect weapon," a revised John Wayne locking and loading, or a singing actor who literally enters the kind of combat that Hollywood films turn into corporate franchises by reinterpreting the American experience of war into marketable, heroic versions of American history and ideology. "Like it or not," Lisa tells Gary, who is initially reluctant to join the team, "you're the one with the power to do something," that is, the power to act. Rather than escape Mount Rushmore for the stage, though, he spends some time pondering his civic duty in a scene that revisits military history through the power of memorial. As Gary visits the monuments and memorials that surround Washington DC's National Mall, the movie's nondiegetic country ballad, "Freedom Isn't Free," asks, "If you don't throw in your buck o' five, who will?"

"Freedom Isn't Free," the legacy of the Korean War, parodies post-9/11 nationalist country songs—and the celebrities who capitalized on the tragedy—as well as American ignorance of Islam and the Middle East—typified in Alan Jackson's "Where Were You (When the World Stopped Turning)," in which he sings:

> I'm just a singer of simple songs
> I'm not a real political man
> I watch CNN but I'm not sure I can tell you
> The difference in Iraq and Iran
> But I know Jesus and I talk to God.[12]

Parker and Stone's musical reenacting of an American "infantile citizen" motivates Gary to join the team by envisioning the "war on terrorism" in terms of past wars.[13] Filtering an American perspective of this conflict through the ideological lens of the Cold War, for example, familiarizes the unknown enemy into a recognizable cast of evil characters. Parker and Stone frame one shot in such a way to justify this interpretation as it makes Gary appear to be staring into the barrel of an anonymous weapon while his hands are bound in chains. To escape bondage to an "ideology of hatred," Gary will "throw in" his "buck o' five." In a similar stab at jingoist rock ballads, "America, Fuck Yeah!" also burlesques Toby Keith's five-time platinum "Courtesy of the Red, White, and Blue (The Angry American)," a song that calls 9/11 "a mighty sucker punch from somewhere in the back" and promises "We'll put a boot in your ass. It's the American way." "America, Fuck Yeah!"'s crude lyrics, "Lick my butt and suck on my balls," find a parallel demand of sexual submission in Keith's forced sodomy by shitkicker footwear, a threat that effectually emasculates the ter-

rorists even as it portrays us as masterfully sadistic rather than freedom-loving.

Still, the film manages to critique America's warrior response to 9/11 in a way that can both please and anger liberals and conservatives, while simultaneously denouncing the polarity of contemporary American political discourse. *Team America, World Police* functions on a level of interpretive difficulty that allows the casual viewer to pick and choose points that would support his or her partisan beliefs since it often infuses potentially fixed or determinate interpretations with ironic resistance (Battigelli).[14] On one hand, we have what my students termed "Bush-bashing." A seemingly blind faith in lieu of a dependable, clearly designed strategy or depth of understanding evokes an America in which President Bush regularly and famously made decisions on the basis of his own faith. When Team America goes to Cairo so Gary can infiltrate the terrorist network, he asks Lisa why she believes in him. "Sometimes, believing is all we have," she responds.

On the other hand, after Team America's widespread destruction of Cairo results in the terrorists' retaliatory bombing of the Panama Canal, the Film Actors Guild, or FAG, publicly denounces them for creating new enemies. Satirizing the cultural pathologizing of homosexuality, the acronym further evinces the Bush administration's portrayal of its enemies as effeminate.[15] After all, in *South Park: Bigger, Longer, and Uncut* (1999), Parker and Stone's cartoon of Saddam Hussein's homosexual affair with Satan ends with his anal impalement in Hell, a leering wink to the "Bend Over, Saddam" invitations on ordinance dropped by U.S. bombers in George H. W. Bush's Desert Storm (Gardiner). But much like the homoerotic burlesque of Joe and the terrorist's dance of war in Paris, the mockery of FAG also associates Hollywood actors with the "enemy combatants" in Iraq—specifically, that is, the men forced to simulate fellatio on each other for Military Police cameras in Abu Ghraib. As surrogates for the dead 9/11 terrorists and the secret networks of al-Qaeda, FAG stand-ins personify a fantasy enemy who boasts but ultimately is not "man enough" to defeat the Cowboy Nation.

In a naïve antiwar speech mocking the actor's 2002 $56,000 open letter to President Bush in the *Washington Post*, a Sean Penn puppet serves as the dreamer of an overly optimistic Left: "Last year I went to Iraq. Before Team America showed up, it was a happy place. They had flowery meadows and rainbow skies and rivers made of chocolate, where the children danced and laughed and played with gumdrop smiles." Though the film does not censor the expansive collateral damage Team America inflicts wherever it lands, it is equally cynical about what we might term the utopist spin of the antiwar movement.

Another scene mockingly criticizes the United Nations when Hans Blix threatens to punish Kim Jong-Il with merely epistolary sanctions for developing WMDs, that is, he can expect an "angry letter." Even though the movie at least places the weapons inspector in the country that undisputedly possesses the very sort of

WMDs that the Bush administration invoked to justify its invasion and subsequent occupation of Iraq, Blix's inability to act depicts the agency as an impotent figure-head. But again, this criticism is hardly one-sided, as right-leaning critics have alleged. After all, Spotswoode chastises Team America's talking INTELLIGENCE system for an error that resulted in the successful terrorist attack on the Panama Canal. The computer apologizes and continues to work without any indication its intel has improved. Meanwhile puppet bodies float like bath toys amidst the wreck-age, some "2,193 miles south of the real America," eerily anticipating the images of bloated casualties from the Indonesian tsunami disaster of December 2004 and the aftermath of the U.S. Army Corps of Engineers' New Orleans Levee breakdown in 2005. Also entertaining the fantasy that those who speak publicly against the Bush administration are anti-American terrorists, Parker and Stone send Michael Moore to suicide-bomb the team's headquarters in the protest scene, rather than to help the victims of the Panama Canal explosion. Thus Moore embodies the media-starved activist and bloated capitalist pig who has grown fat on America's cultural imperialism, now a home-grown dissident turned terrorist.

Most significantly, the film offers a critique of the primitive concept of Islamic "terrorists" that many Americans have via the easy convention of ethnic stereotypes and action films.[16] They even turn their heads when Lisa says, "Hey terrorist, ter-rorize this." "They" are, in Lisa's words, "malignant narcissists," yet the Team, as our heroic citizenry, patriotically rallies behind the power of pride. Gary's "valmoriph-ication" into Middle Eastern Hakmed exposes our attempts to remake the world and our enemy from a largely ignorant, Americentric perspective. Like Alan Jackson, Americans do not always know where or whom we fight, so the film notes via sub-titles each foreign location's physical distance and direction from America. Thus Parker and Stone provide us with a slapstick reimagining of a "global war on ter-rorism": bumbling, incomprehensible terrorists whose physical characteristics and musical leitmotif make them instantly recognizable in a crowd of civilians and Hollywood actors countering the plans developed in the late-2001 meetings between the Bush White House and Hollywood. The simplified Us/Them, Good/Evil, Self/Other, Christian/Muslim assumptions that fuel both American support for mil-itary spending and the restrictions of the Patriot Act flatten the complexities of twentieth-century history that began the "war on terror," even before 9/11 "changed everything," a point not lost on the yet at-large embodiment of anti-American ter-rorism himself. In 1998, Osama bin Laden proclaimed, "The Americans started it and retaliation and punishment should be carried out following the principle of rec-iprocity, especially when women and children are involved" ("Interview"). Yet cul-tural amnesia allows us to forget that America itself has often failed "to differentiate between the military and the civilians or between men and women or adults and children" ("Interview"). Thus we may righteously utter such jingoist responses as

"America, Fuck Yeah!" or "We'll put a boot in your ass," but terrorists speak only a primitive, comic lexicon of "Derka derka, sherpa, Mohammed, jihad."

While the film provides us with an imaginary visual knowledge of the invisible, shapeless terror cells that the Patriot Act is ostensibly designed to penetrate, there are no marionette politicians for terrorism's sworn enemies—no dangling George Bush, Dick Cheney, Karl Rove, Dick Rumsfeld, Richard Perle, Tony Blair, Jacques Chirac, or Paul Wolfowitz puppets match wits or tiny weapons with FAG— a point sourly noted by the Left and celebrated by the Right. Nevertheless, Parker and Stone's comic rendering of the president's *policies*, rather than the politicians themselves, forces a reevaluation of how Americans conceive of participatory democracy. Rather than simply pitting partisan puppets against each other, the film targets its audience for fueling the celebrity obsession industry and its lack of civic participation.

Charting the dangerous intersection of celebrity and politics, Dana Nelson writes, "Politics is thus relocated to the realm where the celebrity 'haves' engage in what organizational behavioralist Rakesh Khurana has described as the 'irrational quest for' a 'corporate savior' that may not mirror so much as eventually succeed our nation's search for a presidential savior" (11). Explicitly parodying George Bush would be complicit in Presidentialism, or what Nelson criticizes as symptomatic of cultural amnesia. The President of the United States, she argues, is

> a *functionary*. Our country has never been able to remember that, and the antidemocratic affect generated by our desire to place our man in "the nation's number one democratic office," to see him as the "most powerful man on earth," is as disabling as the factual expansion of executive branch power. Looking for the (right) president to save (us from) democracy is antidemocratic and self-infantilizing. (12)[17]

Known for their disdain for people who vote without knowledge of candidates or issues, Parker and Stone create a fantasy that targets Bush administration policies rather than parodies the idiosyncrasies of the politicians themselves. Certainly, as the efficiently stage-managed "Town Hall" meetings and press conferences with recent U.S. presidents indicate, political leadership is akin to Team America's tactics of infiltrating terrorist networks: one must act convincingly and recite the memorable soundbytes.

Undoubtedly though, the greatest point of bipartisan and binaristic resistance resides in the conflict between Team America and FAG, which ironically deploys hawkish Rumsfeldian rhetoric against the team. As if ironically channeling Toby Keith, Actor-President Alec Baldwin warns, "If violence is all these bastards understand, violence is what they'll get," a threat that casts the Left as appropriating the problem-solving methodology of the Right.[18] In addition, FAG's uniting with the terrorists makes literal the symbolic rhetoric deployed by the Right against the Left.

More important, however, is that so-called liberal Hollywood is complicit in the Right's nationalism as "American's greatest export: its vision of itself reflected upon and redefined in celluloid" (Sardar & Davies, 3). Via the exportation of Hollywood culture, all the actors burlesqued in the film, excluding Janeane Garofalo, have played roles in war films. Not surprisingly, the most conflicted actor is Alec Baldwin whose resumé varies from CIA agent Jack Ryan to his most nationalist role, Lt. Col. James Doolittle in *Pearl Harbor* (2001), a film *Team America World Police* denounces in a song.

A number of the war films that *Team America*'s FAG actors appear in may certainly be read more complexly than simply prowar. But although conventional wisdom asserts that films such as *Apocalypse Now* (1979) or *The Thin Red Line* (1998) are antiwar, *Jarhead* (2003) author Tony Swofford contends that, for young soldiers, there is no such thing as an antiwar film. He explains, "Vietnam films are all prowar, no matter what the supposed message, what Kubrick or Coppola or Stone intended.…[marines] watch the same films and are excited by them, because the magic brutality of the films celebrates the terrible and despicable beauty of their fighting skills. Fight, rape, war, pillage, burn.…The supposed antiwar films have failed" (Weschler, 76). By this logic, *Team America: World Police* could fall into the prowar category regardless of the complexities of its politics. Currently, along with Starbucks Frappuccino, Coca-Cola, and Spam, U.S. Marines deployed in Iraq's Camp Taqaddum can purchase copies of the *Team America* DVD, in their PX (Bissell, 45).[19]

Thus, as U.S. soldiers swelter in the Middle Eastern desert without adequate armor, obviously differentiated enemies or clearly designed victory and exit strategies, they may watch their marionette counterparts fighting caricatured terrorists with superior equipment. Hence, the ironic realities of empire in the era of decentralized warfare beg the question not *if* war but *how* and *when*, or as Weschler phrases it, "who gets *to* fuck and who *gets* fucked in war" (76). At the film's end, the actor-cum-terror-warrior Gary Johnston regurgitates the wisdom bestowed earlier by a New York City drunk—who looks suspiciously like a white-washed version of the terrorist puppets—empires are "dicks" by definition. As Gary reenacts the same speech before FAG, Team America, and assorted world leaders in their Disney attire, he argues that Team America will continue to be unpopular with "pussies" who deplore the hypermasculine posturing and tactics of "dicks." However, he continues, there are "assholes" out there that "dicks" must continue to fight, even though we will certainly fuck up and, thus, fuck over others in the process. But in resigning ourselves to the speechifying of the former alcoholic and grandstanding of this "top gun" actor—that America is a well-intentioned "dick"—the film nevertheless insists that Americans are inherently complicit in the national imperialist enterprise, even if motivated by good intentions. For the freedom of democracy

and hyperconsumption always seems to cost both us and others considerably more than a "buck o' five."

NOTES

I would like to thank Sean Morris and Michael Palmer for their numerous insights and comments on earlier drafts of this chapter.

1. The neoconservative think tank, which disbanded in 2006, expressed its goals of world domination in a 2000 document entitled "Rebuilding America's Defenses," in which it warned, "At present the United States faces no global rival. American's grand strategy should aim to preserve and extend this advantageous position as far into the future as possible" (i). See Donnelly, Kagan, and Schmitt. Bacevich further notes that the Pentagon's "announced long-range plans" plan for an "absence of anything remotely resembling a so-called peer competitor" (17).

2. We can separate *Team America: World Police*'s politically oriented reviews into three general categories: (1) right-leaning celebrations that ignore the critique of the Bush administration foreign policies and gloat at the critique of the liberal Hollywood actors; (2) confusion over what Parker and Stone intended in their fair and balanced attack on the polarization of political discourse; and (3) Left-leaning affirmations of the critique of George W. Bush's foreign policy that express bafflement at the film's attacks on the Left and question why it offered no corresponding politician to criticize on the Right. I would argue that all of these categorical responses misread one or more aspect of the film. However, one astute reviewer compared it to *Dr. Strangelove*, noting, "In today's political era where every supposed news outlet proudly wears its affiliations on its sleeve (FOX is conservative/Republican, CNN is liberal/Democrat, etc.), it's nice to experience balanced political commentary, which is exactly what *Team America* is, if you have an open mind." See Turner and Himes. A sampling of the basic categories follows: Regarding category (1), The film "makes our aggressive pursuit of the bad guys in the world uncompromisingly cool" (Hirsen). See also Holtreman; Hawkins; and Travers. Regarding category (2), Roger Ebert comments, "If I were asked to extract a political position from the movie, I'd be baffled. It is neither for nor against the war on terrorism, just dedicated to ridiculing those who wage it and those who oppose it. The White House gets a free pass, since the movie seems to think *Team America* makes its own policies without political direction." Regarding category (3), Kane asks, "Sure, Parker and Stone love skewering arrogant celebrities and their self-importance, but why don't we see a Bush, Rove, Rumsfeld or Cheney marionette?" Another frustrated reviewer, Kisonak, laments, "How, for example, do you spend two and a half years on a political satire and not get around to mentioning the president? A Bush doll with its strings pulled from above by a Cheney marionette would have said more about the comedy of errors that passes for White House policy these days than anything in this picture."

3. According to Trey Parker and Matt Stone, their representation of Michael Moore is inspired by the director's implication that they created a cartoon in *Bowling For Columbine* ("*Team America* takes on moviegoers").

4. President George W. Bush connected shopping and fighting terrorism in an October 2001 press conference: "The American people have got to go about their business. We cannot let the terrorists achieve the objective of frightening our nation to the point where we don't—where we don't conduct business, where people don't shop. That's their intention." ("President Holds")

5. Heller argues that 9/11 has taken on the "cultural function of a trademark, one that symbolizes

a new kind of national identification…alongside the almost sublime spectacle of national trauma that forced the brand name beyond the limits of what can fully be absorbed by the mind, seen by the eye, or portrayed by the artist and filmmaker" (3). Al-Qaeda's successful 9/11 attacks animated the specter of fear on which capitalism thrives. As Joe Lockard succinctly summarizes in his analysis of the *Terrorism Survival Guide*, "Without fear and insecurity capitalism would not have the economic sanctions that make it profitable" (222). See also Glassner.

6. See Jeffords for an analysis of President Ronald Reagan's merging of Hollywood fantasies and presidential leadership. See McAlister, especially Chapter 5, for an account of the U.S. military's orchestration of the toppling of Saddam Hussein's statue in Baghdad on April 9, 2003.

7. Filkins cites 28-year-old Sergeant Eric Shrumpf. Recalling an incident in which Shrumpf's unit killed a woman when it opened fire on one soldier standing near a small group of civilians, "I'm sorry," the sergeant said. "But the chick was in the way" (B1).

8. As Johnson writes in *Tomdispatch.com*, Iraq is the archaeological "'cradle of civilizations,' with a record of culture going back more than 7,000 years." Johnson further noted "the indifference—even the glee shown by Rumsfeld and his generals toward the looting on April 11 and 12, 2003, of the National Museum in Baghdad and the burning on April 14, 2003, of the National Library and Archives as well as the Library of Korans at the Ministry of Religious Endowments. These events were, according to Paul Zimansky, a Boston University archaeologist, 'the greatest cultural disaster of the last 500 years.'…Yet Secretary Rumsfeld compared the looting of Iraq to the aftermath of a soccer game and shrugged it off with the comment that "Freedom's untidy.…Free people are free to make mistakes and commit crimes."' See also Polk, Polk, and Schuster (5).

9. Secretary of Defense Donald Rumsfeld infamously remarked that the looting and pillaging of Iraq following the 2003 invasion was an aspect of "messy democracy" ("Remarks," 5).

10. Glanz details the "misuse" of reconstruction funding in Iraq. The auditor's report includes details such as stacks of shrink-wrapped U.S. currency tucked into foot lockers, tens of thousands of dollars lost to a serviceman gambling in the Philippines, and a desolate infrastructure. In the *Washington Post*, Ellen Knickmeyer confirms that millions of dollars have been directed from reconstruction projects to security, Saddam Hussein's trial, and the legal system. Furthermore, as of January 2006, the Bush administration announced it would not seek more funds than the $18 billion already allocated for reconstruction.

11. As Lockard argues, "Consumption itself becomes insurance against fears, rational and irrational" (223). See also de Zengotita.

12. In the *South Park* episode "Ladder to Heaven" Parker and Stone parody Alan Jackson in a plot where the country singer musically commemorates the boys building a ladder to heaven so they can retrieve a winning lottery ticket to a candy store shopping spree from their dead friend.

13. Berlant's "infantile citizen" fantasizes the United States as the "home for a child-citizen protected from the violence of capitalism, class, race, and sexuality" (21).

14. I thank Sean Morris for bringing Anna Battigelli's essay to my attention for this point.

15. Nelson heralds George Bush's Tom Cruise-like landing as an aspect of the overarching public relations campaign to portray the president who did not fight in Vietnam as "a hard warrior [who] guarantees our freedom" (6). See also Rich.

16. For an analysis of Hollywood's production and use of this stereotype, see Shaheen and McAlister.

17. Nelson further argues, "Looking to the president as the container, the chalice for our democratic hope, we collaborate with the very antidemocratic expansion of the presidency's powers, symbolic and actual, and with the antidemocratic contraction of our own" (11).

18. Žižek cites, among the failures in the Left's response to 9/11, the harping on the fact that the

CIA helped create the Taliban and Osama bin Laden. "Would it not be much more logical to claim that it is precisely America's duty to rid us of the monster it created? The moment we think in the terms of 'Yes, the WTC collapse was a tragedy, but we should not fully solidarize with the victims, since that would mean supporting US imperialism,' the ethical catastrophe is already here: the only appropriate stance is unconditional solidarity with all victims" (51). Finally, Žižek criticizes the protesters, such as the ones Parker and Stone parody at the foot of Mount Rushmore, for repeating peace mantras devoid of meaning (53).

19. Thanks to Jeff Birkenstein for bringing this to my attention.

WORKS CITED

Anderson, B. C. (2005). *South Park Conservatives: The Revolt Against Liberal Media Bias*. Washington, DC: Regnery.

AP. (2004). "*Team America* Takes on Moviegoers." October 15. http://today.msnbc.msn.com/id/6228221

Bacevich, A. (2005). *The New American Militarism: How Americans are Seduced by War*. New York: Oxford, 2005.

Battigelli, A. (2002). "John Dryden's Angry Readers," in J. Anderson & E. Sauer (eds.), *Books and Readers in Early Modern England*. Philadelphia: University of Pennsylvania Press, 261–281.

Berlant, L. (1997). *The Queen of America Goes to Washington City: Essays on Sex and Citizenship*. Durham: Duke University Press.

Bissell, T. (2006, January). "Improvised, Explosive, & Divisive: Searching in Vain for a Strategy in Iraq," *Harper's*, January, 41–54.

de Zengotita, T. (2002, April). "The Numbing of the American Mind: Culture as Anesthetic," *Harper's*, 33–40.

Donnelly, T., Kagan, D., & Schmitt, G. (2000). Rebuilding America's Defenses: Strategy, Forces and Resources for a New Century. *New American Century.org*; www.newamericancentury.org/RebuildingAmericasDefenses.pdf. Accessed December 10, 2005.

Ebert, R. (2004). "Review of the Film *Team America: World Police*," *Rogerebert.com*, October 15.

Fasy, T. (2005). "Attacks on Global Public Health and Reproductive Rights," *Revolution*, October 30; http://rwor.org/a/020/tribunal-indicts-bush-crimes.htm.

Filkins, D. (2003). "A Nation at War: In the Field Marines; Either Take a Shot or Take a Chance," *New York Times*, March 29, B1.

Friedman, T. L. (1999). "A Manifesto for the Fast World," *New York Times*, 6, 40.

Gardiner, J. K. (2004). "Why Saddam Is Gay: Masculinity Politics in *South Park: Bigger, Longer, and Uncut*," *Quarterly Review of Film and Video*, 22(1), 51–62.

Glanz, J. (2006, January 25). "Audit Describes Misuse of Funds in Iraq projects," *New York Times*, A,3.

Glassner, B. (1999). *The Culture of Fear: Why Americans Are Afraid of the Wrong Things*. New York: Basic Books.

Hawkins, J. (2004). "Review of the Film *Team America: World Police*," *Right wing news.com*, October 17; www.rightwingnews.com/archives/week_2004_10_17.PHP#003019.

Heller, D. (2005). "Introduction: Consuming 9/11," in D. Heller (ed.), *The Selling of 9/11: How a National Tragedy Became a Commodity*. New York: Palgrave, 1–26.

Himes, S. (2004). "Review of the Film *Team America: World Police*," *Flak Magazine*; http://flakmag.com/film/teamamerica.html.

Hirsen, J. (2004, October 11). "*Team America* Trounces the Left," *NewsMax*;

www.newsmax.com/archives/articles/2004/10/11/113754.shtml.

Holtreman, V. (2004, October 22). "Review of the Film *Team America: World Police*," *Screen Rant*; http://screenrant.com/archives/review-team-america-world-poli-545.html. Accessed October 21, 2005.

"I ♥ $ More Than Ever." (2002, February). *Harper's*, 25.

Ignatieff, M. (2000). *Virtual War: Kosovo and Beyond*. New York: Metropolitan.

Interview with Osama bin Laden. (1998, May). *PBS Online and WGBH/Frontline*. http://www.pbs.org/wgbh/pages/frontline/shows/binladen/who/interview.html. Accessed October 22, 2005.

Jackson, A. (2002). "Where Were You (When the World Stopped Turning)?" *Greatest Hits 2* [CD]. Los Angeles: Arista.

Jeffords, S. (1994). *Hard Bodies: Hollywood Masculinity in the Reagan Era*. New Brunswick: Rutgers University Press.

Johnson, C. (2000). *Blowback: The Costs and Consequences of American Empire*. Metropolitan: New York.

Johnson, C. (2005). "The Smash of Civilizations," *Tomdispatch.com*; from http://www.tomdispatch.com/index.mhtml?pid=4710. Accessed February 10, 2006.

Kane, P. J. (2004). "Review of the Film *Team America: World Police*," *Geoffrey!* http://www.geoffrey.com.au/review.htm?ID=92. Accessed October 21, 2005.

Keith, T. (2004). "Courtesy of the Red, White, and Blue (The Angry American)," *Greatest Hits, Volume 2* [CD]. Nashville: Dreamworks Nashville.

Kisonak, R. (2004). "Review of the Film *Team America: World Police*," *FilmThreat.com*, October 19; http://www.filmthreat.com/index.php?section=reviews&Id=6563. Accessed October 21, 2005.

Knickmeyer, E. (2006). "US Has End in Sight on Iraqi Rebuilding," *Washington Post*, January 2, A01.

Lockard, J. (2005). "Social Fear and the *Terrorism Survival Guide*," in D. Heller (ed.), *The Selling of 9/11: How a National Tragedy Became a Commodity*. New York: Palgrave, 221–232.

McAlister, M. (2005). *Epic Encounters: Culture, Media & US Interests in the Middle East since 1945*. Berkeley: University of California Press.

Nelson, D. (2006). "The President and Presidentialism." *South Atlantic Quarterly*, 105(1), 1–17.

"No Praise for Pope from AIDS Campaigners" (2005). *Terra Daily.com*, April 4; http://www.terradaily.com/2005/050404155456.wwrbq6kk.html. Accessed October 28, 2005.

Parker, T., & Stone, M. (Creators). (2002). "Ladder to Heaven." [Television Series Episode], in F. Agnone, II (Producer), *South Park*. Los Angeles: Comedy Central.

Polk, W. R., Polk, M., & Schuster, A. M. H. (eds.). (2005). *The Looting of the Iraq Museum: The Lost Legacy of Ancient Mesopotamia*. New York: Harry N. Abrams.

"President Holds Prime Time News Conference" (2001). *White House.gov*, October 11.

Ramazani, V. (2001). "September 11: Masculinity, Justice, and the Politics of Empathy," *Comparative Studies of South Asia, Africa and the Middle East*, 21(1–2), 118–124.

Rambo IV: Holy War. (2005). "London: Alpha1Media"; http://www.sepiamutiny.com/sepia/archives/Rambo_Holy_Warscript.pdf. Accessed October 20, 2005.

"Remarks by Secretary Rumsfeld to the 35th annual Washington Conference of the Council of Americas." (2005, May 3). *DoDNews*.

Rich, F. (2004). "How Kerry Became a Girly-Man," *New York Times*, September 5; http://www.nytimes.com/2004/09/05/arts/05RICH.html. Accessed May 8, 2009.

Rogin, M. (1990). "'Make My Day!': Spectacle as Amnesia in Imperial Politics," *Representations* 29, 99–123.

Rowe, V. (2001). "Hollywood Joins Fight Against Terror," *Filmstew.com*, November 14.

Sardar, Z., & Davies, M. W. (2004). *American Terminator: Myths, Movies, and Global Power*. New York: Disinformation.

Scanlon, J. (2005). "'Your Flag Decal Won't Get You into Heaven Anymore': US Consumers, Wal-Mart, and the Commodification of Patriotism," in D. Heller (ed.), *The Selling of 9/11: How a National Tragedy Became a Commodity*. New York: Palgrave, 174–199.

Shade, B. (2002, September 11). "Retailers Say Providing Comfort, Means to Express Patriotism Are Part of Their Role," *Pittsburgh Post-Gazette*, Wf4.

Shaheen, J. (2001). *Reel Bad Arabs: How Hollywood Vilifies a People*. New York: Interlink.

Taft, R. A., & Wunderlin, C. E. (2001). *The Papers of Robert A. Taft: 1939–1944*. Kent: Kent State University Press.

Taylor, C. (2004, October 15). "Review of the Film *Team America: World Police*," *Salon.com*; Expanded Academic ASAP database; Accessed December 20, 2004.

Team America Takes on Moviegoers (2004, October 15). *MSNBC.com*; http://www.msnbc.msn.com/id/6228221/. Accessed May 8, 2009.

Travers, P. (2004, October 14). "Review of the Film *Team America: World Police*," *RollingStone.com*.

Turner, S. (2004, October 17). "Review of the Film *Team America: World Police*," *CleverDonkey.com*; http://www.cleverdonkey.com/ViewArticle.asp?ID=152&Cat=Entertainment. Accessed October 21, 2005.

Virilio, P. (1989). *War and Cinema: The Logics of Perception*. London: Verso.

Weschler, L. (2005, November). "Valkyries over Iraq: The Trouble with War Movies," *Harper's*, 65–77.

Žižek, S. (2002). *Welcome to the Desert of the Real!: Five Essays on September 11 and Related Dates*. London: Verso.

Fight or Fuck

Performing Neoliberalism at Abu Ghraib

TONY PERUCCI

When I first saw the notorious photograph of a prisoner wearing a black hood, electric wires attached to his limbs as he stood on a box in a ridiculous theatrical pose, my reaction was that this must be a piece of performance art. The positions and costumes of the prisoners suggest a theatrical staging, a tableau vivant, which cannot but call to mind the "theatre of cruelty," Robert Mapplethorpe's photographs, scenes from David Lynch movies.

—SLAVOJ ŽIŽEK

You know, if you look at—if you, really, if you look at these pictures, I mean, I don't know if it's just me, but it looks just like anything you'd see Madonna, or Britney Spears do on stage. Maybe I'm—yeah. And get an NEA grant for something like this. I mean, this is something that you can see on stage at Lincoln Center from an NEA grant, maybe on *Sex in the City*—the movie. I mean, I don't—it's just me.

—RUSH LIMBAUGH

We're an empire now, and when we act, we create our own reality. And while you're studying that reality—judiciously, as you will—we'll act again, creating other new realities, which you can study too, and that's how things will sort out. We're history's actors…and you, all of you, will be left to just study what we do.

—SENIOR ADVISOR TO PRESIDENT BUSH

To consider the staging of torture at Abu Ghraib is to consider the performance of torture, torture as performance, and the photographic representation of torture. In this chapter, I am interested in how these dynamics serve those who adopt the

role of "history's actors" in an effort to construct the "new realities" that are both the spoils of war and the foundation of empire. These realities are constitutive of what I call the "performance complexes" of neoliberal empire, that is, the staging of an economic and ideological apparatus in which the "magic of markets" in service of profits takes precedence over any competing social interests. While neoliberalism calls for the dismantling of any state power that might regulate or limit corporate power in the interest of public good, and thus threaten profit and the free flow of capital, it also relies on the state subsidization of corporate partnerships in warfare and penality. The performance of the neoliberal economy thus depends upon the performance complexes that also produce it: the military industrial and the prison industrial complexes. In these institutional networks, the state contracts private corporations to take on formerly government practices of war manufacturing and prison building and maintenance. The profit motive of these corporations drives foreign and domestic policy to perpetual war and expanding incarceration as the neoliberal "idea that the market should be allowed to make major social decisions...[and] that corporations should be given total freedom" (George). These performance complexes are articulated with, and made visible in, the photographs from Abu Ghraib, where we see the violence of neoliberalism. This violence is unique not in its performance at Abu Ghraib, but rather in its revelation, that masked the ubiquity of violence as a constitutive element of the unequal global economic order.

HOW WE PERFORM THINGS IN AMERICA

"To live is to be photographed," suggests Susan Sontag in response to the Abu Ghraib photos, "...but to live is also to pose. To act is to share in the community of actions recorded as images" (28). Sontag's comments here mark not only the reality of the postmodern spectacle, in which an act is only worth doing if it is being photographed or videoed, but also the way in which the MPs and military intelligence officers in the Abu Ghraib photographs occupy the dual position of performer and spectator. We see in the photos the sadistic glee of the torturer and/as family photographer through the lens of the military camera. "The horror of what is shown in the photographs," Sontag argues, "cannot be separated from the horror that the photographs were taken—with the perpetrators posing, gloating, over their helpless captives" (26–27). The performed act of photography does not merely, or even primarily, document the violence enacted, but is constitutive of it. It evacuates the performed act of torture by aestheticizing it—transforming it from performance to the image of the spectacle.

There is nothing comparable to this act of photographic violence, she suggests, except the lynching photographs and postcards that circulated the American South

(and often sent to family in friends up North) in the late nineteenth and early twentieth centuries. These photos register the carnival atmosphere that accompanied the lynching of blacks in America as they reveal the jubilant families posing alongside mutilated corpses. The performed act of lynching photography, like torture photography, represents a "collective action whose participants felt perfectly justified in what they had done" (27). What Sontag suggests here is that the banality of the act of photography and the casualness of the pose bespeak a violence that the photographs themselves performatively enact, and do not merely represent.

> These photographs are, ontologically, not the performance. They are, as Susan Willis describes them, "Performance turned into artifact" (135). The photographs attempt to document the undocumentable, and yet serve as an index of the "horror that the photographs were taken." The multiplied horrors of the photographs—the corporeal reality of torture as well as the violence of the act of photographing and the enactment of the pose are only indexed but not represented by the photograph. The imminence of these acts—torture, photography, and the pose—are aestheticized and artifactualized in the photograph itself. As Angela Davis notes, following Adorno, part of the social violence of the Abu Ghraib photos is "that we project so much onto the ostensible power of the image that what it represents, what it depicts, loses its force" (*Abolition*, 50). The very spectacularity of the photographic image, thus, allows it to stand in for the performance and its affective potential.

Peggy Phelan's oft-cited and oft-maligned claim that performance's "life only is in the present" in that it erupts in a frenzy of the visible in a "manically charged present" of liveness is a propos here in that it is the disappearing "excess" that constitutes an act in performance (146, 148). Phelan's critical point in articulating an "ontology of performance" is to mark performance's imminence and ephemerality. For Phelan, performance is that element of the theatrical occasion that disappears, that exists only in its presence and its presentness. There is great radical potential in such an occasion, when the *presentation-of-presentness* makes visceral and haptic, the encounter with what Walter Benjamin calls the "presence of the now (*Jetztzeit*)" an enlivened encounter with the actuality of human pain, suffering, and pleasure that gives rise to the possibility of enacting social change *now* (261). This activating of the now that spurs the potential for activism is precisely what the "society of the spectacle" serves to tamp down. For such a society, Debord contends, is dependent upon a pacifying of the public sphere, as the image disconnects us from each other and from the politics of economic (re)production.

Thus, Phelan deems performance to be the element that operates in the theatrical occasion as an "excess," because it, by definition, cannot be reproduced, mass marketed, or sold. In her analysis of performance artist Festa's live enactments of enduring torturous pain, she notes that Festa's "Presentation-of-Presence" does not operate solely as spectacle, but also calls forth a second performance on the part of the spectator, which is characterized by "the recognition of the plentitude of one's

physical freedom in contrast to the confinement and pain of the performer's displayed body" (162–163). The artifactuality of the photographs masks the excess of performance that links the fate of the indignant (or jubilant) Western viewer and the tortured prisoner. Neoliberal empire depends upon the linkage between the spectator and spectacle of the photograph remain unmarked, as is demonstrated when George Bush dismissed the acts of the Abu Ghraib photos by saying "This treatment does not reflect the nature of the American people. That's not how we do things in America" (quoted in Rajiva, 12). The theatrical acts at Abu Ghraib are exactly how "we do things in America" in U.S. prisons, sweatshops, and immigration detention centers.

The unreproducibility of performative excess is part of how the photographs as artifact reproduce the violence of the performance of torture itself. That is to say, torture operates to reduce the torture victim to an object, as Elaine Scarry puts it, to a "body in pain." The excessive violence of torture, as with performance's excess, is incommunicable through the flattening artifact of the photograph. It is this process of "performance turning into artifact," the evacuation and erasure of the excess of violence (and of performance) that enables the deferral of that excess, which was manifested when the photographs were sent to MPs' families and friends as mementos, or even to the pleasure of indignation such representations evoke (or the pleasure evinced by Baudrillard in his claim that with these photographs, "America has electrocuted itself" [209]).

However, I want to mark here the performative excess without indulging in the violence of the lingering gaze over these photos, the imaginative recreation of these photos as a reenactment of the violence. Moreover, I want to do so without displacing the humanity of those tortured in the way that "spectacles of suffering" tend to reproduce the violence that incurs them, in no small part by making terror an amusement for the spectator. As Saidiya Hartman contends, even sympathetic white abolitionist recitations of slave coffles often served to "reinforce the spectacular character of black suffering" (3). The "shocking" photos at Abu Ghraib conceal as much as they reveal about the "shock and awe" theatricality of the War on Iraq. The spectacularity of these performances serves to mask the performance of economic interests that gave rise to the acts of torture at Abu Ghraib. A spectacular excess, the excess of profit, both causes the performances and is masked by them. The performance of torture at Abu Ghraib—masked by the artifacts of performance (and the artifactualization of performance)—is the performance of neoliberalism, "the terror of the mundane and the quotidian" masked by the shocking "spectacle" (4).

It was Oliver Cox, the radical black sociologist, who argued in the 1940s that it was critical to see lynchings of African Americans not only for the theatrical spectacles of violence that they were, but also as expressions of political economy. The

lynching, he contended, was not a production of a hysterical wildness or "strange madness," but rather a concomitant violence of the operation of capitalism, which required a cowed and exploitable laboring class (579). What Kirk Fuoss has called "lynching performances" were, Cox explains, central to the logic of early twentieth-century capitalism. The success of lynching performances hinged on the production of blacks (those lynched and those not-yet-lynched) as objects; the excess of violence and the excess of performance served to evacuate the subjecthood of African Americans in the interest of the excess of profit. This performance of objecthood served an ideological and economic interest in that it extended the conditions of slavery for African Americans that positioned them as simultaneously laborers and commodities.

Cox explains that the lynch mob is not primarily a spontaneous ensemble of irrational violence, but rather, "The mob is composed of people who have been carefully indoctrinated in the primary social institutions of the region to conceive of Negroes as extra-legal, extra-democratic objects, without rights which white men are bound to respect" (580). A similar corrective is needed in attending to Abu Ghraib, where the photographed soldiers were considered to be anomalous—disturbed individuals enacting "aberrant behavior" (qtd. in Rajiva, 79), rather than enacting a policy and cultural logic of neoliberalism, where "the US needs to pick up some country and throw it against the wall, just to show the world we mean business," as Michael Ledeen of the American Enterprise Institute suggests (RETORT, 103). The performance of violence at Abu Ghraib, like those enacted in lynching performances, functioned as such a form of "show business" in which the show served the capital interests of business.

> Lynching performances were, in Cox's view, not primarily performances of individual actors, but rather were the performance of an economic order, in which business showed that it meant business. Meanwhile, the spectacle of the lynching recast the racialized black body as the cause of the violence enacted upon it. What Saidiya Hartman calls the "racist optics" of such occasions is driven by such objectification, where the compelled performance of objecthood paradoxically enables the projection of "will" and "agency" onto black body, producing the "dissimulation of suffering through spectacle" (22). This compulsory performance of objecthood operates as a rationalizing force that both justifies and structures the racial economy. "By lynching," Cox argues, "Negroes are kept in their place, that is to say, kept as a great, easily-exploitable, common-labor reserve" (584). Lynching performances are, in Cox's view, "sub-legal contrivance[s]" that operate as an expression of, and in service to, a racialized political economy.

THE PERFORMANCE COMPLEXES OF NEOLIBERALISM

The performances of torture at Abu Ghraib serve a similar function in their operation as a staging of neoliberal globalization. Neoliberalism is the current reigning

economic philosophy; it mandates the absolute centrality of the market, the privatization of all social services, the end of the welfare state, and the commodification of all aspects of everyday life.[1] Neoliberalism represents the triumph of the corporation over the state, where the state no longer serves a Keynesian function to ameliorate the inequalities produced by capitalism, but rather serves solely to protect the rights and interests of capital. The Keynesian project, as Ruth Wilson Gilmore describes it,

> consisted of investments against the tide, designed to avoid the cumulative effects of downward business cycles by guaranteeing effective demand (via income programmes, public borrowing strategies and so forth) during bad times. The social project of Keynesianism…was to extend to workers…protections against calamity and opportunities for advancement. In sum, Keynesianism was a capitalist project that produced an array of social goods that had not existed under the preceding liberal (or laissez-faire) capitalist state form.

At first gloss, neoliberalism may seem to be simply an elimination of such a project, as government management of the economy is removed in service to the "invisible hand" of the market. Neoliberal empire is characterized in opposition to traditional American "liberalism" as characterized by Keynesian projects like the New Deal, which enact modest redistributive economic practices to counter capitalism's expected deleterious effects on the majority. However, while neoliberalism is "nominally democratic" (Duggan, xiii) it promotes a "culture of upward (re)distribution" (xvii) by *liberalizing* any state laws or regulations that might hinder corporate accumulation of profit. And yet, for successful economic performance, neoliberalism depends upon state-corporate partnerships. These state-corporate partnerships (including those with the military and prison industries detailed below) serve as a form of "protections against calamity and opportunities for advancement" for *corporations* rather than workers.

The emergence of the military industrial complex (MIC) in the mid-twentieth century can be seen as an early expression of the ascendancy of neoliberalism— as functions of the military were dispersed to a host of institutions outside of the state apparatus: namely, private corporations and universities. The government subsidization of private defense industries has been considered to be a form of "military Keynesianism" as the state underwrites the profitability of military production. However, the diffusion of governmental authority to a loose network of nongovernmental institutions is often where accounts of the MIC stop—where the primary danger of such an apparatus is the ability of private institutions to circumvent the scrutiny of the public.

We should not romanticize the military as a paragon of transparency operating in the public interest, but we must also consider the way in which the privatization of the military has created an economy dependent on the development and

support of war-making, the institution of what Seymour Melman calls the "permanent war economy." Moreover, the transnational corporation requires the military to secure its profitability through force. As neoliberal apologist Thomas Friedman puts it, "McDonald's cannot flourish without McDonnell Douglas....And the hidden fist that keeps the world safe for Silicon Valley's technologies to flourish is called the US Army, Navy, Air Force, and Marine Corps" (quoted in RETORT, 195). Thus, the condition of "perma-war" becomes an economic necessity to support the increasingly military-dependent corporations and an economy that depends on those corporations' profitability.

Such a transformation can also be seen in the emergence of a prison industrial complex (PIC), the more recent privatization of prisons, in which prison-building, prison operation, and prison-servicing have become entrenched in national and local economies and supported by a justice system structured by race. The dependence of small communities especially on a prison economy is enacted by neoliberal economic programs, polices, and practices. For example, one of the direct consequences of the shift of manufacturing overseas has been the devastation of many factory towns throughout the United States, resulting in many communities desperate for any large employer. Thus, the new privately owned prison becomes an employer of last resort. Municipalities are transformed, Michelle Brown suggests, into a

> "new American city"…whose self-sustaining abilities depend on the production of hard-line attitudes, more prisons, and, equally significant, more prison towns…culminating in a reconfiguration of social and economic life in distinctly penal terms. (984)

Thus, as cities become dependent upon the economic sustenance of the prison, the profit-seeking prison and the employment-seeking society have an economically linked interest in the ever expansion of prison populations.

The performances at Abu Ghraib represent an exporting of American penal culture—the normalization not merely of the disciplinary mechanisms of the penitentiary described by Michel Foucault, but also of the stubborn resilience of the staging of pain and terror onto the body of the condemned. As Dwight Conquergood writes in his cogent analysis of the "lethal theatre" of American executions, American penal culture remains dependent upon the brutalizing of the bodies of the condemned. Such performances, he explains, "are awesome rituals of human sacrifice through which the state dramatizes its absolute power and monopoly on violence" (342). These rituals are increasingly staged as sanitized acts, to mask the state's act of murder, as well as to elide the overwhelming racial basis that underwrites the logic of American executions.

While the publicity of the performance of executions requires the staged sterility of murder, it operates also to conceal the "messier" performances of violence that

operate as a daily ritual in many American prisons. A "political theatrics of terror" rules the lives of American prisons and poor neighborhoods where police maintain occupational presence, where *"ritualized displays of terror are built into American policing"* (Parenti, 136—emphasis in original). The experience of being inside a maximum security prison is one that is characteristic of what Michael Taussig calls "terror as usual," which he describes as a "state of doubleness of being in which one moves between somehow accepting the situation as normal, only to be thrown into a panic or shocked into disorientation" (18). Indeed, this performance consciousness is engendered by the American prison through the persistent staging of violence by guards, including mock executions. The theatrical enforcement of terror as usual functions as a part of the racially structured apparatus of the prison industrial complex in service of neoliberal market forces:

> many bodies—particularly those of young working class and lumpen men of color—are superfluous to capital's valorization. A growing stratum of "surplus people" is not being efficiently used by the economy. So instead they must be controlled and contained and, in a very limited way, rendered economically useful as raw material for a growing corrections complex. (Parenti, 137)

The theatrical violence and ritual terror of the prison industrial complex then are those that of neoliberalism.

What is perhaps most striking about the Abu Ghraib photos is that they *seem* to represent abnormality at all. The photos are, in a sense, the publicizing not only of the quotidian practices of American military detainment facilities, but also of accepted practices in U.S. prisons. The Abu Ghraib performances, then, can be seen as restagings of the "training" video produced by guards at the privately run Brazoria County Detention Center in Texas, where black inmates were chased and attacked by growling dogs. In fact, a number of the guards who performed in the Abu Ghraib photos were former prison guards, including Charles Graner, who had been "subject to numerous complaints of human rights violations and prisoner abuse" while working at a high-security prison in Waynesburg, Pennsylvania (Brown, 982). The performances at Abu Ghraib can be seen to go beyond Žižek's contention that they represent the "obscene underside of US popular culture," which is the normalization of fraternity initiation rites and hazings. Rather, they represent the global staging of America's new penal culture on the world stage, which celebrates a racialized brutal violence—a culture that is produced both by the economic structures and the cultural logic of neoliberalism. The spectacular revelation of the photographs reverses Taussig's formulation of the abnormal appearing normal. In these photographs, the quotidian theater of prison violence in the service of capital is seen as an accepted act of individual depravity, and the normal violence of neoliberalism appears aberrant.

America's prisons operate increasingly as forced labor farms; the shifting of manufacturing jobs to nonunion factories outside the United States has led the state to promise decimated small towns across the United States that the building and running of prisons will rehabilitate local economies by producing short-term construction jobs (though these contracts often go to large, out-of-state, nonunion contactors) and long-term prison guard jobs. It encourages corporations such as IBM, Boeing, and Microsoft to shift high-paying union jobs to prison (i.e., slave) labor—where corporations pay only pennies per hour, with no responsibility for worker safety or retirement and medical benefits. Third, as prisons are increasingly run by mega-corporations like Wackenhut and Lockheed-Martin, the maintenance of a surplus prison population produces profits by the securing of lucrative contracts in which compensation is based on a per prisoner basis.

It is perhaps the presence of Lockheed-Martin and Boeing, two of the largest weapons makers in the world (and two of greatest beneficiaries of the terror war increase in military spending), as beneficiaries of the prison economy that reveals that the relationship between the prison industrial complex and the military industrial complex is more than lexical. It is rather, as Davis points out, a relationship based on "mutual support" and "shared technologies" (*Are Prisons Obsolete?* 86). As the weapons makers who constitute the military backbone of globalization (i.e., the Military Industrial Complex) become increasingly dependent on prison slave labor and prison profiteering, the Military Industrial Complex, and the military imposition of U.S. hegemony as globalization necessitates the maintenance of the Prison Industrial Complex and its exploited labor force.

Thus, the American penitentiary can be seen not only as a condition for, and effect of (military) neoliberalism but also as a site conjoining the "new American militarism" (Bacevich) and the "new American city" (Brown) of penitentiary dependence. As such a conjuncture, the photos of torture at Abu Ghraib can be seen as ones that capture the staging of violence that secures the prison industrial complex and the military industrial complex together in a "symbiotic" (Davis, 86) relationship and as constitutive elements of neoliberalism.

The fact that the invasion and occupation of Iraq can be seen as a staging of neoliberalism as war extends this analysis. The invasion of Iraq, described by the *Wall Street Journal* as "one of the most audacious hostile takeovers ever" (RETORT, 50), was, according to the authorial collective RETORT, "privatization by occupation" (47), a contention supported by then Bush-Cheney campaign manager's comment that the war was about "getting Iraq ready for Wal-Mart" (49) and Cheney's own revealing admission that the war was a remarkable "growth opportunity" (41). Thus, in Abu Ghraib, we see not only the staging of what Shamir and Kumar call the "military backbone of globalization" but also the penitentiarial logic and practice that are instantiated in militarism and globalization.

FIGHT OR FUCK

What has been most "shocking" about the photos to many was the frequent presence of sexual humiliation—nude, hooded men stacked in pyramids, and forced to masturbate and simulate fellatio on each other. Most famously, these stagings often featured the cherubic PFC Lynndie England, enacting her celebratory pose of American mastery for the camera—showing a wide grin, and giving an approving thumbs up. In dialogue with shrouded men connected to electrodes, these photos represent, Susan Willis contends, "the pornographic sublime" (120). Indeed, pornography has been a central trope through which critics have reckoned with the photos. It is with the invocation of video pornography that they come to invoke performance: "Much like the producers of a low-budget porn flick, they set the stage for a sadistic theater" (Willis, 130). The coercive staging of sexual humiliation, not on a stage, but for a camera represents "war porn" for Baudrillard, in that "it all becomes a parody of violence, a parody of war itself, pornography becoming the ultimate form of the abjection of war which is unable to simply be war, to be simply about killing, and instead turns into a grotesque reality-show, in a desperate simulacrum of power" (206). The sadistic theater of power represents the collapse of the real; it implies the imminence of theatrical performance, and supplants it with the hyperreal reality show. But war has never been "simply about killing." In particular, America's history of war-making has long been based on a foreign policy driven by corporate profit. Moreover, the powerful depend upon their own performances of mastery "as a kind of self-hypnosis within the ruling groups to buck up their courage, improve their cohesion, display their power and convince themselves anew of their high moral purpose" (Scott, 67). In the context of Abu Ghraib, it was the staging of the soldiers as the subjects of the photographs, and the objectification of the prisoners, that performed this self-hypnosis. Even for the American civilian at home, the distance produced by the photograph allows the observer to *dis*identify with the actors, restoring the morality of the American crusade to spread neoliberal capitalism under the banner of "democracy" by disavowing the performances that secure it.

The spectacularity of the photographs' pornographic impulse mystifies the political economic function of Abu Ghraib (and on the War on Iraq in general) by casting these acts as primarily individual and sexual, rather than erotic expressions of "the larger cultural narrative…based upon class, prisons, and labor" (Brown, 983). The narrative, which is masked by the "frenzy of the visible" (Williams) of the pornographic impulse, is audible as a cultural logic of neoliberal violence. As with pornography, the torture photographs depend upon performance's imminence modified by the aestheticizing effect of its filming: "the events are real but staged" as Dora Apel points out, and yet "there is no 'fiction' of authenticity…because the

pleasure is not meant to be found in their pruriently deployed bodies but in the exultant mastery of those who would wield power over them, representing a different cultural and political order" (93). This mastery is denied at home for these soldiers and reservists who turn to jobs in the military or as prison guards as jobs of last resort where the "prison-industrial complex and military-industrial complex converge in a sociopolitical economy grounded in rural and lower-class life" (Brown, 983). The position of military prison guard enables a performance of mastery that the effects of neoliberalism, such as factory closings and the elimination of social services, have eliminated for them at home. Disciplined in minimum-wage service jobs through countless acts of humiliation and dispossession, they bring with them the cultural logic of neoliberalism as a normative mode of performance.

Moreover, their performances enact what Pierre Bourdieu calls the "ultimate foundation of this entire economic order placed under the sign of freedom…the *structural violence* of unemployment, of the insecurity of job tenure, and the menace of layoff that it implies." As violence is the structuring expression of freedom under neoliberalism, and is enacted by the American state of "freedom" as one of bombings and occupation, the performances at Abu Ghraib seem to hardly be surprising at all. Thus, Lila Rajiva's claim that "what makes the torture and terror of the warfare state ultimately pornographic […is that] our theater appears to be only a perverse enjoyment, a tasting of our freedom from all constraint, the self-pleasuring delight in its own performance" (100). If we consider such a theater of the warfare state to also be that of the economic order that animates it, then understanding Abu Ghraib as a performance of "freedom from all constraint" is an enactment of neoliberal culture.

The violence of neoliberalism staged at Abu Ghraib can be seen as a restoration of behavior rehearsed in American prisons, and as part of a legacy of military and CIA use of sexual humiliation as a torture technique. When Texas prisoner Roderick Johnson complained to prison officials that not only was he being regularly raped, but also that he was being tortured as a "sex slave," prison officials repeatedly responded that he should learn to either "fight or fuck" (aclu.org). This logic, where the only choices are fighting or fucking, is also that of neoliberalism. And perhaps, within the auspices of neoliberalism, this is the same option as competition of all against all is raised to a sacred position, neoliberalism demands all workers to be constantly fighting each other, and to be fucked by the state-backed corporate apparatus. Abu Ghraib is the staging of fighting or fucking as the realization of military neoliberalism.

Jon McKenzie calls this theatrical and organizational compulsion the command to "perform, or else," in which the demand to compete is impelled by threat. The "fight or fuck" performance in Abu Ghraib, in which fucking itself was a central part of the theatrics, was a coming together of the "perform, or else" performance of

neoliberalism in what José Muñoz calls "the burden of liveness," which is the historically constituted condition where people of color are demanded to enact their "difference" for the purpose of disgust, exoticism, or sublimity. But, perhaps more than anything, it is the compulsion to be "live" for the spectator, even a live object, that operates as this burden. I wish to close by considering how this racially constituted and compulsory liveness operates in these torture performances as a way to reckon with how Abu Ghraib connected these performance complexes: military industrial and prison industrial in service of neoliberalism.

This "burden of liveness" characterizes Coco Fusco's "Other History of Intercultural Performance," which recounts the legacy of staging racially constituted subjects as exotically figured objects—from slave auction blocks to the Hottentot Venus to Ringling Brothers circus exhibitions of pygmies as part of their animal parade. In the torture photos, exoticism is displaced by abjection, in which the staging of racial violence as banal and celebratory marks the banality of the racial violence of neoliberal globalization. If, as Baudrillard suggests, these photos are not representational because they are so embedded in the war itself, then what do they do? Baudrillard suggests that they are simply another expression of the "pornographic face of the war" (207–208). There is something audible in the frenzy of the visible that these photos cannot represent but instead make resonate (Moten, 196). For this staging of the banality of torture, the self-parody of power that does not know what do with itself, is part of a chain of performances that neoliberalism impels— one that links the MIC and the PIC in resuscitation of primitive accumulation (RETORT, 11). The photographs visually elide yet resonate with the echo of a chain that includes the demonstrations of military force against sweatshop workers in Central America as demanded by U.S. corporations who require wages kept low. The "new realities" that neoliberal empire enacts are theaters of violence—a militarily enforced private penitentiarism compelling performances of fighting and fucking—or else. The performances of torture at Abu Ghraib, in their banal and celebratory enactment of violence, are simply the spectacular realization of the ubiquitous violence that neoliberalism produces globally. Would that they would also be its undoing?

STEP OFF THAT BOX NOW

One of Barack Obama's first acts as president was to order the closing of Camp X-Ray in Guantánamo Bay, Cuba. In signing executive orders on his second day in office to prohibit torture, Obama was seen to have closed the book on U.S. practices of human rights violations. Bloomberg news columnist, Ann Wollner, writes that "Obama lifted the shame conjured by the words Abu Ghraib, Guantánamo Bay,

waterboarding, and extraordinary rendition" such that now so that the "Hooded Abu Ghraib inmate can step off that box now." Such a perspective mirrors the periodic declarations of the end of the legacy of slavery that began with the Emancipation Proclamation and have enjoyed a resurgence with the election of Barack Obama as president. As critical race theorists have continued to point out, the declaration of the "end of racism" in response to a decline in the more spectacular performances of lynching mask the persistence of institutional and strategically coded forms of racism. As Michael Eric Dyson recently argued, "One black man in public housing in DC [Obama] does not solve the problems of African-American culture across the board. He is an extraordinary man [...], but at the same time that Obama is here, Oscar Grant [a black man executed by BART police in Oakland] is being murdered. Black people are still being imprisoned at disproportionate rates" (*Real Time*).

Dyson has been one of the more vocal critics to remark on how the postelection proclamation of the death of racism is premature. And yet, in many of the numerous panels on which he has appeared liberal and conservative commentators alike bemoan desires to address racial inequality a refusal to accept "responsibility" for black criminality and to not temper every marking of racial inequality with gratitude for civil rights progress. While in conversation with Dyson on a recent edition of NPR's *All Things Considered*, for example, Joe Klein (who had only weeks before denounced the horrific crimes of Abu Ghraib as the true "Bush legacy") insisted that the "terror" imposed on African Americans was part of a "disgraceful history" and not of the "now" where we should be focusing on racial "progress" (*ATC*). Similarly, Pat Buchanan yelled at Dyson that "We [white folks] are not responsible for the fact that African Americans commit crimes at 7 percent the rate of white Americans [...] You're not owning up to anything, fella!" (*Hardball*).

Obama's reversal of Bush administration practices including CIA-run secret prisons, torture, and the closing of Guantánamo, while being significant changes, have masked the ubiquity of performance complexes of prisons and sweatshops. Moreover, this celebratory mode requires an eliding of the Bush measures that Obama has not reversed and, in some cases, affirmed its right to continue the practice of extraordinary rendition, indefinite detention, and warrantless wiretapping. As the *New York Times* has noted, the "break" from Bush torture policies "does not always seem complete enough" ("Mr. Obama and the Rule of Law").

Moreover, as long as Abu Ghraib and Guantánamo are considered to be anomalies rather than exemplary practices of neoliberalism, Obama's assertion that "America will not torture again" will not only prove to be false, it will enable the ongoing violence in American and transnational corporations' prisons and sweatshops. In her essay "Where is Guantánamo?" Amy Kaplan declares that due to the globality of the dehumanizing practices used there, that "Guantánamo is everywhere" (854). Thus, while the named places of Abu Ghraib and Guantánamo may

close, they will continue to exist in the spaces of neoliberalism as long as they prove profitable or as opportunities to extend the power of the market.

NOTES

1. Portions of this chapter have appeared in "Performance Complexes: Abu Ghraib and the Culture of Neoliberalism" in *Violence Performed: Local Roots and Global Routes of Conflict*. New York: Palgrave Macmillan, 2009, 357–371.
2. In the midst of the banking and housing market collapses in 2008, the reliability of neoliberalism is finally being tested. Vice President Joe Biden commented, for example, that he needed to "save the market from free marketers." While the consensus on neoliberalism has shown some signs of cracking, conservative politicians and pundits continue to deride all plans intended to ameliorate the effects of the crisis as "socialism you can believe in" (Sean Hannity) and "economic Marxism" (Bachmann). Even as the *New York Times* screams "Anglo-American Capitalism on Trial," others declare that reforms of neoliberalism are simply "the way to hell" (EU Chief and Czech Prime Minister Mirek Topolanek).

WORKS CITED

All Things Considered. (2009). "Holder's 'Cowards' Comments Examined." *National Public Radio*, February 20; http://www.npr.org/templates/story/story.php?storyId=100939348

Allen, J. (ed.). (2000). *Without Sanctuary: Lynching Photography in America*. Verlag: Twin Palms.

Apel, D. (2005). "Torture Culture: Lynching Photographs and the Images of Abu Ghraib," *Art Journal*, Summer, 88–100.

Bacevich, A. (2005). *The New American Militarism: How Americans Are Seduced by War*. New York: Oxford University Press.

Baudrillard, J. (2005). *The Conspiracy of Art: Manifestos, Interviews, Essays*. Ames Hodges. (trans.). New York: Semiotext(e).

Benjamin, W. (1968). "Theses on the Philosophy of History," in H. Arendt (ed.), H. Zohn (trans.), *Illuminations: Essays and Reflections*. New York: Schocken Books.

Bourdieu, P. (December 1998). "The Essence of Neoliberalism," *Le Monde Diplomatique*, English Edition.

Brown, M. (2005). "'Setting the Conditions' for Abu Ghraib: The Prison Nation Abroad," *American Quarterly*, 973–997.

Burns, J., & Thomas, L., Jr. (March 28, 2009). "Anglo-American Capitalism on Trial," *New York Times*.

Conquergood, D. (2002). "Lethal Theatre: Performance, Punishment and the Death Penalty," *Theatre Journal*, 54, 339–367.

Cox, O. C. (1945). "Lynching and the Status Quo," *Journal of Negro Education*, 14(4) (Autumn), 576–588.

Davis, A. (2003). *Are Prisons Obsolete?* New York: Seven Stories Press.

Davis, A. (2005). *Abolition Democracy: Beyond Empire, Prisons, and Torture*. New York: Seven Stories Press.

Debord, G. (1994). *Society of the Spectacle*. D. Nicholson-Smith (trans.). New York: Zone Books.

Duggan, L. (2003). *The Twilight of Equality: Neoliberalism, Cultural Politics, and the Attack on Democracy.* Boston: Beacon Press.

Fusco, C. (1995). "The Other History of Intercultural Performance," in *English Is Broken Here.* New York: Free Press, 37–63.

George, S. (1999). "A Short History of Neo-Liberalism: Twenty Years of Elite Economics and Emerging Opportunities for Structural Change." *Conference on Economic Sovereignty in a Globalizing World,* March 24–26.

Gilmore, R. W. (October 1998). "Globalization and US Prison Growth: From Military Keynesianism to Post-Keynesian Militarism," *Race and Class,* 40(2/3), 145–156.

Giroux, H. (2005). *The Terror of Neoliberalism: Authoritarianism and the Eclipse of Democracy.* Boulder: Paradigm.

Hardball with Chris Matthews. March 19, 2009. MSNBC.

Hartman, S. (1997). *Scenes of Subjection: Terror. Slavery, and Self-Making in Nineteenth Century America.* New York: Oxford University Press.

Johnson v. Johnson Case Profile. www.aclu.org

Kaplan, A. (2005). "Where Is Guantánamo?" *American Quarterly,* 57(3), 831–858.

Klein, J. (2009). "The Bush Administration's Most Despicable Act," *Time,* August 1; http://www.time.com/time/nation/article/0,8599,1870319,00.html.

Limbaugh, R. (2003). *The Rush Limbaugh Show,* March 5.

Matlin, D. (2005). *Prisons: Inside the New America.* 2nd ed. Berkeley: North Atlantic Books.

McCoy, A. (2006). *A Question of Torture: CIA Interrogation, from the Cold War to the War on Terror.* New York: Metropolitan Books.

McKenzie, J. (2001). *Perform or Else: From Discipline to Performance.* New York: Routledge.

Melman, S. (1985). *The Permanent War Economy: American Capitalism in Decline.* New York: Simon and Schuster.

Mirzoeff, N. (2005). *Watching Babylon: The War in Iraq and Global Visual Culture.* New York: Routledge.

Moten, F. (2003). *In the Break: The Aesthetics of the Black Radical Tradition.* Minneapolis: University of Minnesota Press.

"Mr. Obama and the Rule of Law" (2009). *New York Times,* March 21.

Muñoz, J. E. (1999). *Disidentifications: Queers of Color and the Performance of Politics.* Minneapolis: University of Minnesota Press.

Parenti, C. (1999). *Lockdown America: Police and Prisons in the Age of Crisis.* New York: Verso.

Perucci, T. (2009). "Performance Complexes: Abu Ghraib and the Culture of Neoliberalism," in P. Anderson & J. Menon (eds.), *Violence Performed: Local Roots and Global Routes of Conflict.* New York: Palgrave Macmillan, 357–371.

Phelan, P. (1993). *Unmarked: The Politics of Performance.* New York: Routledge.

Rajiva, L. (2005). *The Language of Empire: Abu Ghraib and the American Media.* New York: Monthly Review Press.

Real Time with Bill Maher. Episode #145. Originally aired March 13, 2009. HBO Films.

RETORT. (2005). *Afflicted Powers: Capital and Spectacle in the New Age of War.* New York: Verso.

Scarry, E. (1985). *The Body in Pain: The Making and Unmaking of the World.* New York: Oxford University Press.

Scott, J. (1990). *Domination and the Arts of Resistance: Hidden Transcripts.* New Haven: Yale University Press.

Sharma, S., & Kumar, S. (2003). "The Military Backbone of Globalization," *Race and Class,* 44(3)

(October), 23–39.

Sontag, S. (2004). "Regarding the Torture of Others," *New York Times Magazine*, 5(23), 24–42.

Taussig, M. (1992). *The Nervous System*. New York: Routledge.

Williams, L. (1999). *Hard Core: Power, Pleasure, and the "Frenzy of the Visible."* Berkeley: University of California Press.

Willis, S. (2005). *Portents of the Real: A Primer for Post-9/11 America*. New York: Verso.

Winant, H. (2001). *The World Is a Ghetto: Race and Democracy Since World War II*. New York: Basic Books.

Wollner, A. (2009). "Hooded Abu Ghraib Inmate Can Step Off That Box Now," *Bloomberg.com*, January 23.

Žižek, S. (2004). "Between Two Deaths: The Culture of Torture," *London Review of Books*, June 3; http://www.16beavergroup.org/mtarchive/archives/001084.php

SECTION III

Truth Games

"Zap the Iraqoids"

War, Video Games, and
Perception Management

DAVID CLEARWATER

...to what extent have images, derivative perspectives on the world, become the perceived sense of "reality" in contemporary culture? How much has this resulted from the cinematic representation of warfare in which people are separated from the real events and the mass horror of modern industrial warfare by layers of representational and interpretive distancing?...To what extent is war, at least the perception of it as represented by assembled moving images, a central part of modern consciousness?
—J. W. CHAMBERS AND CULBERT, D. *WORLD WAR II, FILM, AND HISTORY*

While Chambers and Culbert ponder the effects of filmic representations on the public's understanding of both a distant event such as World War II and war in general, such questions are equally relevant in the digital age. In fact, the layers of representational and interpretive distancing are especially important to consider in relation to the modern era of media saturation, convergence, and interactivity. In the past, mediated representations of warfare were mobilized in order to bring the war "home" for domestic audiences while simultaneously circumscribing what they can see. Today, we can see such perception management strategies employing interactive digital entertainment as yet another tool to influence public opinion. While the U.S. military has a long-standing relationship with entertainment media, in the past decade it has adopted a much more direct association with the commercial video game market. This chapter explores the ways that the commercial release of military-influenced video games frame recent international conflicts—the War

on Terror in Afghanistan (2001–) and the Iraq War (2003–)—and create points of identification for potential audiences that are remarkably consistent with other prowar discourses. More specifically, I am interested in how these games attempt to portray war as clean and without casualties while simultaneously mobilizing conventional war discourse and providing a subjective but virtual involvement with the "soldiering experience."

In order to understand the representational and discursive strategies employed by these games, it is necessary to consider them alongside the historical context of U.S. media-military relations. The U.S. experience of war—from World War II, through Vietnam, the Persian Gulf, to the present—has continuously affected the U.S. military's working relationship with media industries and institutions. For example, the Persian Gulf War in the early 1990s was the first to be televised live on TV for the benefit of home audiences (Kellner). As many commentators have argued, the dominant imagery of the conflict consisted of the video supplied by the Pentagon (usually of "smart" weapons impacting targets and shot either from the point of view of coalition aircraft or from cameras mounted on the weapons themselves) or imagery of coalition air strikes and returning Iraqi antiaircraft fire shot from the tops of Baghdad hotels. As Bruce Cumings would aptly describe it, the war unfolded on television screens through a "radically distanced, technically controlled, eminently 'cool' postmodern optic" (121).

The military-controlled press pools and other strict media management techniques ensured that killing and destruction were hidden from view, effectively removing the human element from warfare as it unfolded on television screens. In fact, the control of imagery coming out of the Gulf was so total that many critics of the war commented on the fact that the main characters of the war were not the soldiers or generals but the weapons themselves. As H. Bruce Franklin sarcastically asked, "After all, since one of the main goals was to create the impression of a 'clean' techno-war, almost devoid of human suffering and death, conducted with surgical precision by wondrous mechanisms, why not project the war from the point of view of the weapons?" (42) Qualitatively, the imagery of the Gulf War allowed viewers to act as witnesses but, as Cumings argues, in a radically distanced way. In that sense, many questioned the ability for the public to see the "real" war or the "reality" of war—most extreme was Jean Baudrillard's deliberately provocative argument in the French press that the war would not and, later, did not take place.

The screened version of the war provided spectators with a distanced, "clean" and spectacular view making modern conflict—as some feared—little more than a spectator sport; something that is readily apparent from the way the war was often described at the time. It was common to hear dissenting politicians, commentators, and journalists describe the conflict as a "joystick war," "Nintendo-like" (referencing the prominent Japanese game company), or simply "just like a video game"

(Swalwell). One Jordanian journalist (Khouri, 235), expressing his frustration over the international war coverage, offered a sarcastic battle cry: "Zap the Iraqoids!"

Interestingly, while such media management was successful in masking the reality of casualties and death, it did not provide the military—from the perspective of the U.S. Army at least—with the necessary representations of the heroic exploits of soldiers.[1] The specific nature of the Gulf War—the fact that it was largely an air conflict, the relatively short length of ground operations, and the extreme restrictions put on international journalists—precluded spectatorial identification with soldiers on the ground. In this sense, the media management accomplished one of the long-standing problems that the military faced since Vietnam: preventing journalists and, by extension, civilians watching in their living rooms, from getting too close to the realities of war. But in so doing, it also hid from view what is considered as the main character(istic) of any war: the U.S. soldiers and the combat experience.

In the various media strategies employed by the U.S. military during the War on Terror in Afghanistan and, especially, during the first years of the Iraq War, we can see how certain earlier elements were retained while others were employed to correct the deficiencies. The cool, spectacular postmodern optic was maintained as the public was given regular access to cruise missiles, bunker busters, air craft carriers, and dozens of other weaponry and machinery. This, however, was supplemented with a variety of new media strategies designed to give audiences access to the soldiers and the battlefield. One of the most significant was the new relationships with journalists and TV news media that often resulted in deployment of familiar tropes taken from reality TV. This can be readily seen in the embedding of journalists in Iraq and the earlier reality TV programs created during the War on Terror in Afghanistan.[2] Consequently, whether it is described as spectacle, technowar, virtual war, postmodern war, or—soon after the invasion of Iraq—"militainment" (Anderson), the ability of the U.S. military to direct and limit how the public sees war and military interventions can only be seen as increasing in its sophistication. Standing alongside these new developments is the U.S. military's direct and indirect involvement in the medium of video games and specifically in the genre of the military-themed shooter.

The most high-profile example would be *America's Army: Operations* (MOVES Institute/U.S. Army), first released in 2002. *America's Army* is a free, online, first-person shooter released for the PC platform and while the game's release was greeted with suspicion in some circles, it generated a great deal of excitement within the video game industry itself.

America's Army: Operations was developed at the Modeling, Simulation, and Virtual Environments Institute (MOVES) associated with the Naval Postgraduate School in Monterey, California and published by the U.S. Army via free download or CD-ROM available through recruiting centers. Specifically framed as a recruit-

ment tool, the idea originated with Colonel Casey Wardynski, who had originally developed a concept study "that envisioned using computer game technology to provide the public [with] a virtual Solider experience that was engaging, informative and entertaining" ("The Game Concept," n.d). While the game would see continuous updates through various rereleases and expansion packs, more recently the game has been turned into a franchise through a licensing agreement with the French publishing giant, Ubisoft. *America's Army: Rise of a Soldier* (Secret Level, U.S. Army/Ubisoft) was released in 2005 and *America's Army: True Soldiers* (Red Storm Entertainment/Ubisoft) was released in 2007. Other games that have been commercially released include *Full Spectrum Warrior* (Pandemic Studios, ICT/THQ, 2004) commissioned by the U.S. Army; its sequel, *Full Spectrum Warrior: Ten Hammers* (Pandemic Studios/THQ); and *Close Combat: First to Fight* (Destineer/2K Games), commissioned by the U.S. Marines.

Unlike *America's Army*, which was originally developed and distributed by the U.S. Army, *Full Spectrum Warrior* and *Close Combat: First to Fight* are derived from training simulations developed for the military by commercial studios. Much more numerous are games where the U.S. military has provided some sort of assistance or technical advice to the developers. Games in Ubisoft's *Ghost Recon* series (set in "the Tom Clancy universe") or Sony's *SOCOM: US Navy Seals* series are prominent and highly popular examples of this sort of indirect military involvement. While it might be surprising that the U.S. military is so directly involved in the commercial video game market, it can be in part explained by the symbiotic relationship between the military and the computer electronics industry that has existed since the 1960s and the broader role that the U.S. military plays in other popular entertainment industries.[3]

The genre of the military-themed shooter forms a part of the larger category of first- or third-person shooters that is popular in North America. The military-themed shooter genre is almost exclusively centered upon combat and its audience—generally composed of younger males—values realism, authenticity, fast action, and challenging and competitive play. Those titles in the genre that have a close proximity to the military will feature such relationships prominently in their advertising materials. For example, the marketing blurb on the back of *Close Combat: First to Fight* states: "Experience a first-person shooter so realistic, the Marines use it as a training tool." Such discursive framing is indicative of the primary goals of these games: to allow players to experience war from the point of view of an individual soldier. And the opportunity is no doubt a compelling one. As Henry Jenkins rightly points out, the success of action or combat games should be understood through the way they allow individuals to play or adopt culturally influenced (and, primarily masculine) behaviors that are privileged but largely unavailable in the real world.

Like Hollywood, the commercial video game industry places a great deal of emphasis on perceptual realism. The desire for ever-increasing levels of photorealistic representation—as well as accurate or "real-world" physics—is a central concern. Of course, "realism" is a notoriously difficult concept to pin down but when discussing realism in the military-themed shooter genre specifically, it becomes obvious that developers focus on a few specific aspects of the combat experience. In the sections that follow, I will examine the claims to realism and authenticity by looking at prominent titles, especially those with close ties to the U.S. military. By paying close attention to the representational, narrative, and discursive strategies employed in these games, we can see both how these games fit within the U.S. military's media and public relations as well as how the military leverages its role within the video game industry to frame modern warfare and influence public opinion.

FETISHIZATION OF MILITARY TECHNOLOGY

As previously mentioned, one of the dominant themes in the discussion of such games is the "realism" offered and both players and reviewers take a considerable amount of pleasure in the realistic modeling of weaponry, vehicles, and other military technology. In reviews of these games, providing a detailed list of weapons and their capabilities is common and is often the subject of discussion in online forums. As one player—contributing to the "User Review" section of IGN.com for *America's Army*—states,

> Realistic weapons are awesome in AA [*America's Army*]. Every gun is deatiled [*sic*] to the max, from the way your player squeezes the trigger or flips to change rate of fire or even reloads it. Americas [*sic*] Army is as real and intense as it can get. ("medmark")

The fascination with weapons and military technology offers an interesting point of identification for players and one that is often caught up within claims to realism and authenticity. Within the military-themed shooter genre, realism is primarily defined in visual terms; for example, through the appearance and performance-based aspects of weaponry (such as visual detail or rate of fire) and more generally through the modeling of character movements and the environment. Their claims to authenticity and the realistic portrayal of war are regarded as self-evident (in that objects "look" amazingly realistic) or are supplemented by the knowledge that the games have received military input or are designed by the military itself.

For games that are not designed or commissioned by the U.S. military, commercial studios will often send members of their development team to military facilities to observe and receive instruction in a variety of subjects including weapons

systems and operations, vehicle design, military tactics, protocol, and even termi-
nology.

An interesting example of the close relationship between the U.S. military
and the commercial video game industry is the inclusion of future weapon-soldier
systems in the video games themselves. Future weapon-soldier systems are in a con-
stant state of research and development and I would like to focus briefly on two that
have been featured in commercial titles: the Land Warrior system and the Future
Force Warrior system. *Delta Force: Land Warrior*, released by NovaLogic in 2000,
incorporated the Land Warrior system that was developed by the Army's Training
and Doctrine Command Analysis Center (TRAC) in Monterey, California. The
Land Warrior system consists of a lightweight, wearable computer system that incor-
porates various communications functions, a helmet-mounted LCD display, and a
modular weapons system. In order to incorporate a simplified version of the system
in the game, the producers worked with TRAC and sent design teams to observe
the testing of the system at Fort Benning, Georgia (Eckhart).

Similarly, *Ghost Recon 2* (Red Storm Entertainment/Ubisoft) and *Ghost Recon:
Advanced Warfighter* (Tiwak, Ubisoft Paris/Ubisoft) and its sequel would include
a related but much more futuristic weapons-soldier system that is currently under
development by the U.S. Army: the Future Force Warrior system.[4] As implement-
ed in the game, the inclusion of such equipment is not merely cosmetic but was
designed so that players could learn and use tactics that the system makes available.
These include the ability to use intelligence from Unmanned Aerial Vehicles
(UAVs), more specialized weapons (such as a camera mounted into the rifle) and
the ability to call-in air strikes. The way the system is incorporated in the game is,
of course, simplified but throughout the design process, the development team for
the game was invited to Fort Bragg, North Carolina to observe the use of weapons
and equipment (the game's designers also used Special Forces team members in the
motion capture process) and worked closely with the Natick Soldier Center where
the Future Force Warrior system is being developed (Chandler).

The Future Force Warrior program is overseen by the U.S. Army Soldier
Systems Center in Natick, Massachusetts.[5] The Army describes the system "as part
of the Army transformation to a Soldier-centric force that will complement future
combat systems" (Boujnida). It incorporates a variety of new technology including
advanced body armor, an "on-board" computer system, a drop-down and see-
through computer screen, and a microphone-based communications system. The
system has been in production over the past 10 years and is related to the earlier
Land Warrior system seen in Novalogic's *Delta Force: Land Warrior* (DeGay).

In addition to the public relations function, incorporating such systems in commer-
cially available games provides the military with training tools for its soldiers (and
future soldiers) in order for them to become familiar with the system itself. This is

essentially what happened with the aforementioned game *Delta Force: Land Warrior*. NovaLogic, the publisher and developer of the game, was originally contacted by the U.S. Army to modify its previously released *Delta Force 2* game as a training simulator (IGN). In an informal interview from 2004, Michael Macedonia, a former infantry officer and later chief science and technology officer at the U.S. Army's simulation and training office, recounts:

> … we were trying to figure out how to take commercial games and modify them to fit our training needs. So we go to NovaLogic and we said, hey, there's this new weapons system called Land Warrior that infantrymen wear. It looks like a Borg outfit. It's got the monocle, they see computer graphics on the monocle, and they've got a special radio, GPS, different types of weapons. What happened was, the soldiers were having a hard time learning how to use this thing. So we said, why don't we turn it into a game, so the soldiers could sort of practice it. And there's nothing classified about it at this point. So, NovaLogic said they'd incorporate it in the game….(Macedonia)

NovaLogic's subsidiary, NovaLogic Systems (NLS), produced the training software simulator, *Land Warrior* for the Army. Video game fans, however, could try out the Land Warrior system in NovaLogic's *Delta Force: Land Warrior* that saw commercial release in 2000.

REPRESENTATION OF DEATH AND CIVILIANS

While representation and performance of weapons and military equipment receive a great deal of attention from developers and players, the depiction of wounds or actual death are treated in a largely abstracted way. There is a considerable range in terms of these depictions and it is interesting that, generally, games outside of the military-themed shooter genre tend to focus more on gore or even bodily dismemberment. Titles that adopt science fiction or fantasy-based themes often tend toward very stylized or exaggerated representations of violence, something that is rarely seen in military-themed shooters as they often strive for a more serious tone. In addition, there is often a desire on the part of publishers to attract as wide an audience as possible. Consequently, achieving a Teen rating (in North America, provided by the Entertainment Software Ratings Board or ESRB) is crucial. *America's Army*, for instance, was designed for recruiting purposes and, therefore, targeted primarily a teen demographic. The game shows minimal blood and even provides "parental controls" to turn off the depiction of gore entirely or to only allow the child to play the "laser tag" missions.[6]

The manner in which the aftermath of the violence is depicted is an interesting point as well and is handled in a variety of ways. In many games, the dead bodies of opposing soldiers will be displayed after being killed by the player only to

disappear after a few seconds. All evidence of "the kill" might vanish or the body might be replaced with a small pool of blood and/or the opposing soldier's kit (weapons and ammunition). In similar fashion to the minimal representation of blood and gore, Eva Kingsepp points out that in games that strive for authenticity (military-themed shooters) the bodies simply disappear, while games that are more overtly fantastic and exaggerated (such as fantasy-based or science fiction titles) tend to more overtly display dead bodies, presumably as evidence of the player's in-game prowess.

The realism encountered in these military-themed games is spectacular but highly simplified. As such, a more significant abstraction is the fact that civilians are rarely represented in these games. This absence is interesting since, as Martin Bayer notes, civilians and civilian casualties have played an important role in affecting military operations in the past century. And it is especially significant in that many recent games, including those produced by or for the U.S. military, are meant to introduce players to the concept of MOUT (military operations in urban terrain) that increasingly forms an important aspect of contemporary military operations. In both *America's Army: Operations* and *Full Spectrum Warrior* civilians are rarely encountered but both games mention that killing civilians is strictly forbidden through the military's Rules of Engagement (ROE). Even though *Full Spectrum Warrior* is set in a large, fictional Middle Eastern city, the city is strangely devoid of human activity or any evidence that the city's inhabitants might be hiding inside the buildings. In *America's Army: Operations*, killing a civilian will result in points being deducted from the player's ranking score while killing too many teammates will result in the player being banned from online play. Still, civilians are a very minor component and there is relatively little emphasis placed on their presence (and meaning) when compared to the overly fetishistic ways that weaponry and military equipment are treated.

When we look at how realism is generally mobilized in the military-themed shooter genre it becomes clear that the tendency to emphasize weaponry and their largely spectacular but minimal consequences is remarkably consistent with the ways that war is often represented in other media. In a content analysis of news reports coming from embedded reporters during the invasion of Iraq in 2003—which is useful for comparative purposes since embeds provided a similarly "involved" view of combat and frontline activities as military-themed shooters—the Project for Excellence in Journalism found that while military action dominated the coverage (especially the depiction of weapons being fired), over half of the imagery did not include any depictions of the "results." Those that did show the results of the firing of weapons did so by showing nonhuman targets (buildings and vehicles). As might be expected and as the authors of the report say, "…none of the embedded stories studied showed footage of people, either US soldiers or Iraqis, being struck, injured or killed by weapons fired" (Rosenstiel & Mitchell et al., 5).

While we could not expect all commercial video games to be as graphic or realistic as actual combat, it is interesting to note what they intentionally include and leave out in terms of the fictionalized portrayal of combat. But if these games are "realistic," "authentic," or attempt to place the player in the role of the soldier, it would be reasonable to expect that the games should make an attempt to depict the difficulties that actual soldiers face, including how difficult it might be to distinguish between civilians and combatants or that killing a civilian might create psychological effects or have other real-world consequences. As Barbara Bedway says of the general lack of imagery of Gulf War's real-world effects, "the poverty of images has removed death from the war" (para. 17). Something similar could be said of the peculiar ways that death is approximated and abstracted within the military-themed shooter genre. And as I will explore in the following section, such a focus takes on different meanings when we consider how it is framed through narrative, the depiction of enemies, historical representation and other questions concerning the political and ideological aspects of these games.

FRAMING MODERN MILITARY CONFLICT: ENEMIES AND POLITICS

As we follow the evolution of the medium, we can see that story, character, and other narrative elements have become more prominent. Despite the fact that the military-themed shooter genre is not known for exceptional or complex story development, the characterizations, scenarios, and other narrative qualities are important to consider. Many titles take real, historical conflicts as their inspiration or present scenarios that are vaguely situated in the present (or very near future). Regardless of the specific approach used, realism and historical accuracy are often central for the genre. Consequently, it is important to consider how the "fictionalized" narratives generated by these games might inform or mediate the understanding of issues surrounding real-world conflict.

More so than other games in the genre, *Close Combat: First to Fight* pays particular attention to fleshing out the identity of opposing forces (or OPFOR, as they are commonly referred to by the military). While *Full Spectrum Warrior* is set in a fictitious Middle Eastern country, *Close Combat: First to Fight* is set in Beirut in 2006 and identifies a variety of enemy groups, including the Lebanese militia, militant radicals from the Atash movement (led by the "religious zealot" Tarik Quadan), Syrian troops, as well as Iranian Special Forces. In addition, the game's manual identifies various High Value Targets associated with these various groups that the player will encounter throughout the game. These fictional characters are provided with brief biographical data and are ranked using the playing card motif made famous during the Iraq War (Ace of Spades, Ace of Hearts, etc.).

While the various enemy factions vying for control of Beirut are completely fictional, the level of detail and close proximity to current events make the scenario all the more credible. This is especially true since the U.S. soldiers and the Marine unit the game portrays are based on their real-world counterparts.[7] The creators of the game are careful to not make specific reference to Islam (enemy characters are simply referred to as religious zealots or radicals) but the game includes characters from all major countries in the region. Even though the game is set in Lebanon and the other various factions or militaries involved come from Syria and Iran, some of the major enemy characters originally come from or have significant ties with other countries, including Yemen and Saudi Arabia and, not surprisingly, are characterized in typical ways. General Badr, the Ace of Spades, is driven by an overwhelming hatred of Western powers. Akhbar al'Saud, the Ace of Hearts, has ties with the Russians, is mainly motivated by "greed and a thirst for power" but is cowardly. Khalid Samar, the Ace of Diamonds, is sadistic and takes "delight in inflicting pain and fear in those who are weaker than him." The Ace of Clubs, Major Abdullah bin Katan, is Saudi by birth but now leads the Iranian Special Forces who are, we are told, aiding the radicals. He is described as a professional soldier but unimaginative (2K Games, 31). In contrast, the Marines are also described as professionals but are not guided by personal motives. Instead, their motivation is "forged by the fires of intense discipline to each other, the values of honor, courage, and commitment, and their country" (7), and their presence in Beirut is outlined as the initial component of a U.S. and NATO-led intervention called "Operation Preserve Peace."

Realism, authenticity, and historical accuracy are fluid terms that can be used to describe different representational aspects of a specific conflict and the question of how games are read—in terms of historical veracity—is certainly a complex question. In this sense, military-themed shooters enter into the debate over historical accuracy commonly encountered with regard to filmic portrayals of history. Similarly, but in relation to combat films, the editors of *Cineaste* argue that "since so many Americans rely on Hollywood films and television for their knowledge of history, and even current events, films such as *Black Hawk Down* and *We Were Soldiers* should not be regarded as merely innocuous genre entertainments" (Lucia & Porton, 1). The mediating effects of entertainment products upon historical understanding are, of course, never guaranteed as there will be a considerable range in audience reaction as well as historical knowledge that audience members bring to any film or game. However, we have to remember that the target audience of these games include teenagers and young adults whose abilities to judge historical veracity are still forming. Indeed, in a study examining the reaction of high school students to such entertainment, Peter Seixas argues that not only did students approach films as relatively accurate historical representations but sometimes judged their

validity through the work's aesthetics, primarily through the presence of recogniz-able filmmaking conventions and high production values.

Such questions concerning the mediating effects of entertainment pose simi-lar problems for the genre of the military-themed shooter. Many of these games combine various forms of, or claims relating to, both realism and authenticity while also providing a mixture of historical detail and fictionalized elements without clearly delineating either. *Conflict: Desert Storm II—Back to Baghdad* is interesting in this regard since one of the longest of the 10 missions in the game (Mission, 7) involves a scenario where the player enters an Iraqi chemical weapons facility where Sarin nerve gas is about to be loaded into SCUD missiles. Despite the fact that *Conflict: Desert Storm II* is a sequel to the first game and is set during the first Gulf War, the game was released in October 2003 (seven months after the U.S. and British-led invasion of Iraq) and, for the North American release, the subtitle *Back to Baghdad* was added.[8] At the time of the game's release, it was gradually becom-ing abundantly clear that coalition forces could not find any evidence that Iraq still possessed chemical or nuclear weapons. Of course, in the virtual Iraq of *Conflict Desert Storm II*, it was a very different story.

In other titles, the boundary separating reality from fiction can be even more difficult to judge. In *Full Spectrum Warrior* the instruction manual (as well as the in-game tutorials) provides the back-story for the game:

> A devastating wave of terrorist attacks spreads across Europe and Southeast Asia, targeting specifically US and U.K. interests, including embassies, regional corporate headquarters, and even western retail and restaurant chains. After months of intense hunting, US intelligence tracks the source of the attacks to the tiny eastern nation of Zekistan.
>
> After the US-led operations in Afghanistan and Iraq, thousands of ex-Taliban and Iraqi loyalists crossed the borders of Zekistan seeking asylum by invitation of the nation's dicta-tor, Al Afad. It wasn't long before the same terrorist training facilities and death-camps that the US fought to remove in Afghanistan were operating again under full sponsorship by Al Afad's government. After repeated warnings and failed diplomatic resolutions in the UN, NATO votes to invade Zekistan to depose Al Afad, eliminate the terrorist element, and stop the ethnic cleansing of the Zeki people. (THQ, 7–8)

The story's fictional status is rendered problematic through the similarity the sce-nario shares with the current geopolitical situation and the history of the region; especially for the ways it combines the historical situation of Iraq and Afghanistan into the fictional history of Zekistan. In the scenario, Zekistan is described as being "nestled between modern day Afghanistan, Pakistan, and China" and that its "history has always been punctuated by bloodshed and violence," including a 14-year resistance against Soviet invasion (THQ, 9). The game presents a very detailed history and, curiously, under the heading "Geopolitical Intelligence Report:

Zekistan," the game's manual provides a fictional bibliographic source: "Excerpt from *Under the Gun—A Brief History of the War on Terror*, by Liam A. Gomez, Harper Jones Press, London 2004" (9).[9]

The "historical" premise that *Full Spectrum Warrior* constructs is interesting for the ways that it supports some of the standard discourse and rhetorical framing often encountered in other, real-world justifications for military intervention. In fact, one of the few reviews that considered the politics of the game, the author mentions that it "reads like an American warmonger's wet dream":

> The scenario is made all the more ridiculous because the fictional situation is so dire that no one could possibly object to an invasion. Not only are there terrorist training camps and attacks against American "interests" there's even cultural genocide going on; still, the Americans wait until United Nations sanctions have run their course and the UN asks them to intervene, and here's the kicker: the country has absolutely no oil! (Weissenberger, para. 11)

Here it is interesting to note that the game does not try to reproduce history in any specific sense but instead reproduces the conditions and arguments commonly put forth in making the case for war—that is, in the real world—possible. As mentioned previously, *Close Combat: First to Fight* was released in 2005 and is set in Beirut amidst a terrorist insurgency and military coup taking place in 2006. And in many respects, the scenario is strikingly similar to that seen in *Full Spectrum Warrior*: a dire political and military situation, the failure of the United Nations, a coalition of allied countries agrees to intervene—through the military coalition of NATO—purely for humanitarian purposes or to "preserve peace," and so on. One of the most interesting aspects of these games is that both frame the United Nations as an ineffective organization that is prone to failure. A more extensive document outlining the story and 'history' of *Close Combat: First to Fight* was made available from the game's official Web site and was circulated to industry Web sites and publications. The story again weaves elements from prowar discourse with the fictionalized story of the game. For example, after describing the situation that will bring the Marines to Beirut, the story ends by saying: "Trained in asymmetric warfare and free of U.N. mandated ROEs [rules of engagement] that guaranteed earlier failure, these leathernecks [Marines] are ready for battle" (Destineer, 2006, para. 14). In similar fashion to the George W. Bush administration's continued attempt to marginalize both the UN and any nonmilitary solution during the months preceding its invasion of Iraq, similar arguments are reproduced and repeated for the benefit of an audience who usually pay little attention to mainstream news sources or other traditional arenas for the discussion of politics and current events.

THE REPRESENTATION AND POLITICS OF SOLDIERS

Since these games imply that the only viable solution to international conflict is direct and quick military action free of bureaucratic and even humanitarian concerns, this points to what is perhaps the defining element of military-themed shooters and, specifically, those associated with the U.S. military: their tendency to offer a very narrowly defined point of view. This can be seen most blatantly in multiplayer modes of play. In shooter games that lie outside the military-themed genre (science fiction or Westerns for example), it is common to allow players to play on opposing sides. In contrast, it is more common within the genre of the military-themed shooter for the game to offer the player a single-sided experience and this is especially pronounced in those games that involve the military. In an interview with a prominent gaming Web site, Marcus Beer, project manager for *Delta Force: Black Hawk Down*, explains:

> One of the things in the single player game is that you don't shoot US soldiers and during multiplayer, you don't get to play as the Somalis. You're always playing as the US soldiers. There's no way that we would let people take on the mission from the view of the Somalis. That's not right for us. (Butts, para. 14)

Of course, the involvement of the military made such design decisions a necessity and it is seen in other products, especially the multiplayer options in *America's Army* and *Close Combat: First to Fight*. A curious possibility in interactive entertainment is to allow players, even when they are playing on opposing sides, to always "be the good guy." For example, in *America's Army* and *Close Combat: First to Fight*, it does not matter which side a player is on as he or she will play as an American soldier and will always see his or her teammates as members of the U.S. military while opposing players will always appear as OPFOR. When such a structural design element is combined with other textual elements—such as story that precludes anything but a military solution, the representation of the enemy as overwhelmingly evil (and their killing as morally unambiguous) and "our" soldiers as naturally on the side of "good"—the combination is what perhaps qualifies these games as military propaganda.

The tendency to offer a restricted and narrowly defined point of view is achieved in other ways as well. It is becoming increasingly common for military-themed shooters to adopt a form of characterization that is similar to that commonly seen in the combat genre of film, the ethnically and socially diverse group of soldiers (Basinger). Again, the two games that are significant here are *Full Spectrum Warrior* and *Close Combat: First to Fight*, both of which make the characters of U.S. soldiers a much more prominent aspect of the game. In *Full Spectrum Warrior*, eight

U.S. soldiers (as well but to a lesser extent, the platoon leader) are treated more fully as characters. PFC David Daniel Shimenski is described in the game's opening sequence as a "gun nut" and a "special forces wanna-be" and for whom "Iraq was the most fun he ever had…ever." In the manual, he is described as the younger of two brothers who, as "a typical boy," was "obsessed with war movies, action figures, and realistic computer war games" and, like his father, is "a member of the NRA [National Rifle Association] and an avid game hunter." Cpl. Michael Francis Picoli, 22, or "Nova—short for 'Cassanova'—was rarely without one or two girlfriends (simultaneously) in school, a habit that he has carried into adulthood" (THQ, 6). The brief biographies are quite varied in terms of ethnic and socioeconomic background, as well as describing the difficult family situations of some of the characters. As game director William Henry Stahl of Pandemic Studios explained, the development team wanted the player to care about the characters in the game and consideration was given to this in the game's design, especially the opening movie sequence.[10]

Close Combat: First to Fight takes the characterizations in a different direction. The game itself was developed with the input of 40 active-duty Marines who, according to the various promotional materials used for the game, were "fresh from the frontlines of combat in the Middle East." Before each mission, the player is assigned three soldiers to fill out the player's four-man fire team. Rather than using all fictional characters, the developers used actual, active-duty Marines for 15 of the 20 possible characters available for each mission, most of whom had recently returned from their second combat tour in Iraq (Perry) (table 1). The soldiers involved with the development of the game acted as Subject Matter Experts (SMEs) and their involvement is, as with other games that utilize military SMEs,

TABLE 1: Excerpts from soldier biographies showing the kinds of information provided to the player, source: *Close Combat: First to Fight* Official Website.

NAME: Michael Vaz **RANK:** Sergeant **AGE:** 27 **NICKNAME:** Big Mike **WHY HE BECAME A MARINE:** "I wanted to challenge myself mentally and physically, and I wanted to see the world." **FAVORITE QUOTE:** *"Most people go through life wondering if they've made a difference. Marines don't have that problem." (Ronald Reagan)*	**NAME:** Eddie Garcia II **RANK:** Corporal **UNIT:** 3rd Battalion, 1st Marines. Bloody "G"eorge Company. **HOME TOWN:** Bronx, NY **WHY HE'S PROUD TO BE A MARINE:** "1. The Marine Corps discipline. 2. The importance of being part of the history and tradition of the Marine Corps. 3. Marines are at the tip of the spear." **HOBBIES:** Reading, video games, working on my home, movies.

meant to add authenticity; a fact that is highlighted in promotional materials. The use of actual soldiers for in-game characters also provides an additional point of identification for the player, since the other fire team members under his or her control are not just fictional characters but actual, and actively serving, U.S. soldiers.

The representation of soldiers and the experience of combat is a central characteristic of these games but is enacted in a variety of ways. The stated motivation for releasing *America's Army: Operations* in 2002 was the perceived usefulness of the interactive video game as a training simulation and, especially, as a recruitment tool. As mentioned, the game was the brain-child of Colonel Casey Wardynski, Director of the U.S. Army's Office of Economic and Manpower Analysis (OEMA). In terms of recruitment, Wardynski describes the game as an important tool in helping the general public "make connections between life-course decisions and life-course outcomes" (7).

Wardynski puts this in a historical context that is revealing in many different respects. He says that in the early 1970s, about 30 percent of the American labor force had served in the military. Today, only about one in ten working Americans has seen military service. Wardynski attributes this to the substitution of an all-volunteer force for the draft in the early 1970s and cuts to military numbers and base closures enacted at the end of the Cold War. In an interesting statement, Wardynski says this has "markedly reduced the presence of military forces throughout the United States…[and] has further reduced opportunities for vicarious insights into military service" (6). Wardynski summarizes the situation in the following manner:

> Hence, whereas in the past a young American could gain insights into military service by listening to the recollections or the advice of an older brother, an uncle, a father, or perhaps a neighbor, today opportunities for such insights are relatively scarce. To the extent that information about military service shapes the career plans of young Americans today, these decisions were heretofore influenced by movies, television, magazines, books and advertising. Put simply, these decisions have their foundation in the popular culture. Consequently, it is not surprising that young Americans with little to no contact with Soldiers are less likely to include Soldiering as a potential career. (6)

Wardynski argues that individuals make rational decisions based on "perfect" information, but that perfect information is not evenly distributed and that people tend to make their decisions based upon information that is immediately available in their environment. *America's Army*, therefore, was developed to introduce this perfect information into the immediate environment where it was perceived to be lacking. I think it is prudent, however, to approach Wardynski's claims here with a certain amount of skepticism or at least put them into a larger context. It should be remembered that the soldiers are, in many different ways, a contested and controversial site of meaning and their presentation is carefully guarded by the military. While

Wardynski claims there is a lack of information about the "soldiering experience," it could be convincingly argued that the opposite is increasingly true. What is commonly referred to as the "alternative" press—which, as Douglas Kellner argues (3–5), started to become more significant during the first Gulf War—regularly raises issues and perspectives commonly ignored by more mainstream sources of news, especially the significant range of views among soldiers themselves.[11] Of course, this is not just restricted to the printed word but includes independent filmmaking and documentary productions as well as the "activist" activities of various veterans' organizations.

One of the most interesting forums for communication, however, is one that the military itself helped create: the blogs of soldiers. These blogs are an outgrowth of the military's incorporation of computer-facilitated communications on the frontlines, especially in terms of enabling actively serving soldiers to communicate with family members back home (Knickerbocker). However, the blogs can be accessed by anyone with access to the Web, including members of the general public and members of the press (especially, alternative or activist publications where they are often featured). Consequently, the military has struggled to come to terms with this new development and eventually required soldiers to register their blogs or have shut down some that they said revealed "classified" information. As the journalist John Hockenberry, says,

> Whether posting from inside Iraq on active duty, from noncombat bases around the world, or even from their neighborhoods back home after being discharged—where they can still follow events closely and deliver their often blunt opinions—milbloggers offer an unprecedented real-time real-life window on war and the people who wage it. Their collective voice competes with and occasionally undermines the DOD's [Department of Defense] elaborate message machine and the much-loathed mainstream media….(para. 6)

Undermining the military's dominant message—where soldiers are always honorable, do not question orders, or do not question the reasons for going to war—is certainly not the perfect information that Wardynski had in mind. In the context of the games, especially the characterizations seen in *Full Spectrum Combat* or *Close Combat: First to Fight*, it is much easier to carefully construct the representations of soldiers and to have them "speak" in ways that conform to the dominant message track, especially at a time when soldiers are increasingly speaking their minds. One returning U.S. soldier, referred to simply as Zechariah, said:

> I keep hearing that the troops' morale is high over there. When you have a high-ranking officer standing next to you prepping your answers, it's hard to speak your mind. We weren't allowed to talk to media unless a Major or above was with us to prep our answers and screen certain questions… .

President Bush, like Cheney, obviously has no idea as to what is going on over there and doesn't care. This whole thing about taking the fight to the terrorists has got me mad. He already proved to us and himself that Iraq wasn't a threat and that they had no WMDs and he is still trying to say they were terrorists and we need to stop them. They weren't terrorists until we killed off parts of their family. Now they are terrorists because they have lost something that the US took from them, parts of their families. (De Leon, para. 54–56)

CONCLUSION

In the end, it is astonishing to see how the dominant discourse within these games often reproduces the equally dominant discourses that marginalized antiwar voices and nonmilitary solutions before and during both the War on Terror and the Iraq War. More importantly perhaps, it is tempting to wonder how the strength of these discourses is combined and what effect they may have on the audiences of these games and their views of international conflict. Working from the perspective of peace studies, David Leonard argues:

> The blur between real and the fantastically imagined, given the hyper-presence of war on television and within video games, constructs a war without bloodshed, carnage, or destruction.…The erasure of carnage and bloodshed through smart bombs, CNN, video games, and other forms of virtual warfare is making peace increasingly more difficult.…(para. 6–7)

Within the virtual world created by these games, there is simply no space for a soldier such as Zechariah and there is precious little room for solutions other than military ones. In this sense, by focusing exclusively on a carefully crafted version of the combat experience—and *only* upon the combat experience—these games promote a very narrowly defined point of identification for audiences and one that, as David Leonard argues, might make peace increasingly more difficult to attain both today and into the future. Given the larger context, it is an unsettling development that the U.S. military is involving itself to the degree that it does in the production of entertainment while at the same time actively seeking to limit what the public sees. For what does it mean when the military, and by extension the government, produces video games where civilians are largely absent, where death is inconsequential, where combat is sanitized and made "fun," where soldiers are perfect and never question higher authority, and where the virtual world is exclusively populated by enemies?

NOTES

1. For example, see the opening discussion by Lieutenant Colonel Tammy L. Miracle about why the embedding process in Iraq is so beneficial for the public image of the military and how it

differs from the lack of useful imagery of the Persian Gulf War.

2. *Profiles from the Frontline* (2003), from producer Jerry Bruckheimer and shown on ABC, was probably the best known. CBS, however, produced AFP: *American Fighter Pilot* (2002) and VH1 had its own series called *Military Diaries* (2002). See de Moraes (C07).

3. A political-economic approach that would outline the extensive relationship between the U.S. military and the video game industry is simply beyond the scope of this chapter even though it is helpful in understanding the ongoing relationship the military has with modern entertainment industries. I treat the relationship between the military and the video game industry more completely in my PhD Dissertation (McGill). Tim Lenoir provides an important account of the U.S. Military's evolving role with fields like computer graphics and computer processing, virtual reality, distributed networks, and computer simulation. Lawrence Suid and David L. Robb provide important accounts of the military's role in cinema and especially Hollywood.

4. See the interview with one of the game's designers: Christian Allen (interviewed by Hilary Goldstein), "Ghost Recon 2: Lone Wolf," *IGN.com* (October 6, 2004).

5. More commonly referred to as "Natick," the general Web site for the U.S. Army Soldier Systems Center is available at http://www.natick.army.mil/.

6. As the FAQ for the game indicates—under a question titled "Q: How are you making sure that you are putting out a responsible game?"—"Parents are able to alter and control certain aspects of gameplay in *America's Army*. Parents can disable all the blood in the game, enable a language filter, disallow the ability to play as an Advanced Marksman, and limit gameplay to only those missions which feature the MILES laser-tag type play." When the laser-tag option is enabled, soldiers merely sit down when they are shot. The FAQ is available at http://www.americasarmy.com/support/faqs.php?t=9.

7. The game's scenario was written by Lt. Colonel Raymond Liddy, USMC (Reserve) and developers at Destineer. See: Destineer (n.d.) "Close Combat: First to Fight Story," *Close Combat: First to Fight* Official Website (n.d.), available at http://www.firsttofight.com/html/pr2.html.

8. The game was developed by the UK-based Pivotal games. See GamesIndustry.biz, "Weekly Update—21/04/2004" (Electronic Newsletter), April 21, 2004. *GameIndustry.biz* is a British industry publication.

9. A search of the Library of Congress catalogue, including variations on the author's name and the title, resulted in no matches; note, however, the similarity of 'Harper Jones Press' to the well-known and *real* publisher, HarperCollins.

10. It is also interesting in that the characterizations probably provide a fairly accurate "portrait," if not of the composition of the Army at present, of the way the Army conceives of its recruiting demographics.

11. A single example cannot effectively encapsulate such a phenomenon but one example is especially telling. In 2004, Karen Kwiatkowski published an essay outlining her belief that "hawks" in the U.S. Department of Defense suppressed key information and manipulated intelligence so as to justify the invasion of Iraq. Kwiatkowski had served in the U.S. military for 20 years and retired in 2003 as a communications officer in the Pentagon with the rank of Lieutenant Colonel (U.S. Air Force). See Karen Kwiatkowski, "The New Pentagon Papers," *Salon.com* (March 10, 2004).

WORKS CITED

2K Games (2005). *Close Combat: First to Fight—Instruction Manual, Xbox.* 2K Games/Destineer.

Anderson, R. (2003). "That's Militainment: The Pentagon's Media-Friendly 'Reality' War," *Extra!* (Fairness and Accuracy in Reporting); http://www.fair.org/extra/0305/militainment.html.

Basinger, J. (2003). *The World War II Combat Film: Anatomy of a Genre.* Middletown, CT: Wesleyan University Press.

Baudrillard, J. (1995). *The Gulf War Did Not Take Place.* Paul Patton (trans.). Bloomington and Indianapolis: Indiana University Press. (Originally published in French by Editions Galilée as *La Guerre du Golfe n'a pas eu lieu,* 1991).

Bayer, M. (2003). "Playing War in Computer Games: Images, Myths, and Reality," in R. W. Westphal, Jr. (ed.), *War and Virtual War: The Challenge to Communities.* Oxford: Inter-Disciplinary Press, 71–86.

Bedway, B. (2005). "Why Few Graphic Images from Iraq Make It to US Papers." *Editor & Publisher,"* July 18.

Boujnida, C. (2005). "Army Displays Latest Warfighting Innovations," *Army News Service,* U.S. Army Public Affairs, June 17.

Butts, S. (2002). "Black Hawk Down: We Talk with Two Rangers Advising the Team," *IGN.com,* July 25.

Chambers, J. W., & Culbert, D. (1996). *World War II, Film, and History.* New York: Oxford University Press.

Chandler, H. M. (2005, March). *Production Challenges for Ghost Recon 2 for Xbox.* Paper presented at the Game Developers Conference, San Francisco, CA.

Clearwater, D. A. (2006). *Full Spectrum Propaganda: The US Military, Video Games, and the Genre of the Military-Themed Shooter.* Unpublished doctoral dissertation, McGill University.

Cumings, B. (1992). *War and Television.* London: Verso.

De Leon, C. R. (2005). "A Soldier Speaks: Zechariah," *AlterNet,* August 4.

de Moraes, L. (2002). "'Reality' TV Is Marching to the Military's Tune," *Washington Post,*, March 19, C07.

DeGay, J. L. (2004). "Future Force Warrior Explained (Interview)," *IGN.com,* October 6; http://xbox.ign.com/articles/554/554668p1.html.

Destineer (2006). "Close Combat: First to Fight Story," *Close Combat: First to Fight.*

Eckhart, W. (2000). "Delta Force: Land Warrior Interview," *IGN.com,* October 27; http://pc.ign.com/articles/087/087022p1.html.

Franklin, B. (1994). "From Realism to Virtual Reality: Images of America's Wars," in S. Jeffords & L. Rabinovitz (eds.), *Seeing through the Media: The Persian Gulf War.* New Brunswick: Rutgers University Press, 25–43.

The Game Concept (n.d.). America's Army Official Website; http://www.americasarmy.com

Hockenberry, J. (2005). "The Blogs of War," *Wired,* 13(8) (August).

IGN (2000). "Delta Force 2 Recruited to Serve the Army," *IGN.com,* March 21.

Jenkins, H. (2000). "'Complete Freedom of Movement': Video Games as Gendered Play Spaces," in J. Cassell & H. Jenkins (eds.), *From Barbie to Mortal Kombat: Gender and Computer Games.* Cambridge, MA: MIT Press, 262–297.

Kellner, D. (1992). *The Persian Gulf TV War.* Boulder: Westview Press.

Khouri, R. G. (1992). "Joysticks, Manhood, and George Bush's Horse," in H. Mowlana, G. Gerbner, & H. I. Schiller (eds.), *Triumph of the Image: The Media's War in the Persian Gulf—A Global*

Perspective. Boulder: Westview Press, 234–235. (Originally published in the *Jordan Times*, February 23, 1991).

Kingsepp, E. (2003). "Apocalypse the Spielberg Way: Representations of Death and Ethics in *Saving Private Ryan*, *Band of Brothers* and the Videogame *Medal of Honor: Frontline*," in M. Copier & J. Raessens (eds.), *Level Up* (Digital Games Research Conference Proceedings) CD-ROM. Utrecht: Utrecht University.

Kirk, J. (2004). "N. Korea Angered by New Tom Clancy Game," *Stars and Stripes*. (Pacific edition), June 22; http://www.stripes.com/news/n-korea-angered-by-new-tom-clancy-game-1.21217.

Knickerbocker, B. (2005). "An Officer and a Blogger," *AlterNet*, April 19.

Lenoir, T. (2000). "All But War Is Simulation: The Military-Entertainment Complex," *Configurations*, 8(3), 289–335.

Leonard, D. (2004). "Unsettling the Military Entertainment Complex: Video Games and a Pedagogy of Peace," *Studies in Media and Information Literacy Education*, 4(4).

Lucia, C., & Porton, R. (2002). "Editorial," *Cineaste*, 27(3), 1.

Macedonia, M. (2004). "Spot On: The US Army's There-based Simulation," *GameSpot.com*, April 21; http://www.gamespot.com/news/2004/04/21/news_6093860.html.

"medmark" (2003). "Best Game Ever (America's Army Reader Review)," *IGN.com*.

Miracle, T. L. (2003). "The Army and Embedded Media," *Military Review*, 83(5), 41–45.

Perry, D. C. (2004). "First to Fight Bios: Who's the Toughest Fighting Squad on the Planet?" *IGN.com*, August 31; http://xbox.ign.com/articles/543/543576p1.html.

Robb, D. L. (2004). *Operation Hollywood: How the Pentagon Shapes and Censors the Movies*. New York: Prometheus Books.

Rosenstiel, T., Mitchell, A. (2003). "Embedded Reporters: What Are Americans Getting?" *Project for Excellence in Journalism*, April 3; http://www.journalism.org/node/211.

Seixas, P. (1994). "Confronting the Moral Frames of Popular Film: Young People Respond to Historical Revisionism. *American Journal of Education*," 102(3), 261–285.

Suid, L. (2002). *Guts & Glory: The Making of the American Military Image in Film* (revised ed.). Lexington: University Press of Kentucky.

Swalwell, M. (2003). "'This Isn't a Computer Game You Know!': Revisiting the Computer Games/Televised War Analogy," in M. Copier & J. Raessens (eds.), *Level Up* (Digital Games Research Conference Proceedings) CD-ROM. Utrecht: Utrecht University.

THQ (2004). *Full Spectrum Warrior: Instruction Manual*. THQ/Pandemic Studios.

Wardynski, C. (2004). "Informing Popular Culture: The America's Army Game Concept," in M. Davis (ed.), *America's Army PC Game: Vision and Realization*. United States Army and MOVES Institute, 6–8.

Weissenberger, D. (2004). *Full Spectrum Warrior* (Review). *GameCritics*, September 1.

"You Just Want Stories"

Iraqi Subjects,
American Documentaries

CYNTHIA FUCHS

> The official imaging of war travels through multiple altitudes. Its power is derived from its agility to move between and occupy different spaces, in the air and on the ground and all places in between. However, official documentaries nearly always deny the ground and the bodies (or fictionalize them) because they are too anchored in the aerial, disembodied fantasy of nationalism. Therefore, an insurgent documentary practice must retake the ground, reposition bodies, deploy multiple technological formats, and engage in reconnaissance in order to devise new offensive positions.
> —PATRICIA R. ZIMMERMANN, *STATES OF EMERGENCY: DOCUMENTARIES, WARS, DEMOCRACIES* (87)

> If the people of my country could hear the stories of life under occupation and put themselves into Iraqis' stories, they would understand. I hold that hope because the stories of Iraq are our stories now.
> —DAHR JAMAIL, *BEYOND THE GREEN ZONE: DISPATCHES FROM AN UNEMBEDDED JOURNALIST IN OCCUPIED IRAQ* (291)

Mohammed Haithem wants to be a pilot. "I want to fly the plane," he says. "I imagine if I'm high in the sky, I can see the doves and the sky. I can see the birds. I am in the plane and seeing countries. I'll go to that country, the beautiful one." Just 11 years old, Mohammed lives in Baghdad and looks forward to a future very different from his traumatic past and present—including a father killed under Saddam Hussein's regime and an employer who beats him. Telling his story for James

Longley's *Iraq in Fragments* (2006), the boy is at once self-aware and sympathetic, vulnerable and resilient.

"The world is so scary now," Mohammed observes, as the camera follows him through streets filled with herky-jerky traffic, blown-up building debris, and U.S. armored vehicles. "I started working and stopped dreaming," he sighs, seeming at this point an ideal war documentary subject, on compelling "ground" as a representative "body." Appealing as a child and describing traumas unfamiliar to many viewers, Mohammed embodies a tension between known and unknown. In this way, he is typical of *Iraq in Fragments'* strategy, inviting identification and simultaneously insisting on difference. As the movie reveals bits of individual plots—lives disrupted, hopes dashed, resentments voiced—its structure, at once provocative and poetic, is its point. Organized into three parts—"Mohammed of Baghdad," "Sadr's South," and "Kurdish Spring"—Longley's movie sketches a range of Iraqi perspectives, indicating that the outsiders' impulse to characterize the nation as such is reductive and simplistic.

Shot between 2002 and 2005, *Iraq in Fragments* helps to set up perspective as a representational problem further complicated by several recent documentaries. In particular, Laura Poitras' *My Country, My Country* (2006), Usama Alshaibi's *Nice Bombs* (2007), Nina Davenport's *Operation Filmmaker* (2007), and Petra Epperlein and Mike Tucker's *The Prisoner or: How I Planned to Kill Tony Blair* (2006) take up the relations between film subjects and filmmakers. Even as these participants work together, with the aim of ensuring that Iraqis' stories are told, the films are as much about the telling as about the stories, experiences, and memories. Contemplating their own constructedness, these documentaries look also at how evidence and history are produced in multiple contexts, how subjectivity and objectivity shape one another.

> You folks are gonna be on television all over the world.
> —ELECTION WORKER, BAGHDAD 2005

In *My Country, My Country*, Dr. Riyadh al-Adhadh first appears in his kitchen. As he sets about making tea early in the morning on Election Day, 2005, the orange glow of the stove burns bright in a home without electricity. The sequence of shots at the start of *My Country, My Country* implies a connection between a recent explosion—which might have been echoing anywhere in Baghdad—and the doctor's early rising. Moving from the kitchen to a sofa, he speaks into his phone: "They consider this the fruit of democracy, the outcome of democracy," he says ruefully. Here it appears that Dr. Riyadh is trying, much as you are, to interpret events: the Iraqi Minister of the Interior has almost been assassinated, he reports, and "there's bombing and shooting." Such violence, he sighs, seems to be the result thus far of the American occupation.

Shot during the six months prior to Iraq's 2005 parliamentary elections, Poitras' astute, compelling documentary follows Dr. Riyadh's efforts to treat his patients (and look after his wife and six children) while also running for a seat on the Governorate Council of Baghdad as a representative of the Iraqi Islamic Party. As the movie draws parallels between his "healing" activities, it also approximates the doctor's perspective, his love of "my country" as well as his hopes and disappointments. Dr. Riyadh spends long hours at the Adhamiya Free Medical Clinic, where patients seek help for physical and emotional ailments and even financial needs. The candidate is framed in sympathetic close-ups, handing out cash from his desk drawer to clients in need.

At this point the film cuts to another scene where military personnel and private contractors prepare for the election. Though Dr. Riyadh is nowhere in sight, his sensibility informs what your understanding of this image, in part a function of the workers' own self-awareness, as film subjects. One security contractor explains they've been hired in part to reduce the number of visible U.S. military uniforms at polling stations. In a briefing session, a U.S. Army representative advises his men to keep in mind a figure he calls "Joe Iraqi." ("I don't want to be disparaging here," he says, knowing what he sounds like.) As the officer presents his scheme, aided by a poster on which he's drawn a flow chart of tasks, he explains the U.S. concern: "I'm Joe Reasonable Iraqi," he says, "Am I gonna buy [the opposition's] argument [that the elections are not legitimate]?" He describes their objective, to work against "the disenfranchisement of a willing voting sect," namely, the Sunnis. What's important, he says, is the perception of fairness and openness; voters must believe the election is legitimate, that they have "a voice."

The notion that the United States is putting on a show—and that this show is increasingly unconvincing—is made clear in a cut from the planning session to Dr. Riyadh, a Sunni who fears his constituents do indeed feel disenfranchised. Once he makes his way home through treacherous streets, he and his family debate the merits of a secular democracy versus one shaped by religious affiliations ("There's more justice in Islam than in any other system," the candidate asserts). A background TV report describes the difference between "President Bush the Father" and "Bush the Son," the latter described as having "completed" the job of "throwing Iraq into a state of chaos and an uncertain future"—this as the television screen displays the familiar image of the Saddam statue toppling.

If any doubt remains that the doctor and his fellow Iraqis are fooled by U.S. media campaigns, the next sequence shows Richard Armitage positioned against a stark white backdrop outside the U.S. Embassy "in the Green Zone." His speech is circular: "I've got a very simple mission here in Baghdad. It was to come and put the stamp on this mission, which shows that the U.S. Department of State has planted a flag, and we're gonna run this show better than anybody ever thought was pos-

sible." The camera cuts to his audience, a small gathering of U.S. military troops and diplomatic employees on plastic lawn chairs. "And if we're successful," he continues, "And we fully intend to be, it's an endeavor that will change the face of the Middle East."

This change, the film indicates, has little to do with Iraqi desires, and everything to do with the American self-image. The following sequence is set at Abu Ghraib prison, where Dr. Riyadh tries to take complaints from and notice of the many prisoners residing in the "soft site," their faces obscured by shadow and the barbed wire fencing that surrounds them. "Let them come forward," insists the doctor, as the men push at the fence and hold out their hands to plead for his attention. He jots down their complaints on a clipboard pad: they've been held for weeks and months without charges or formal process, they've been mistreated, they need treatment for chronic and developing diseases. "Pray that God will help us," says Dr. Riyadh. "We are an occupied country with a puppet government, what do you expect?" The scene cuts to a view of city streets from over a U.S. soldier's shoulder. From here, the future looks bleak.

While Dr. Riyadh resists this view, he runs up against it repeatedly—at the prison and at an Iraqi Islamic Party meeting, where his advocacy of Sunni participation in the elections is voted down, though too late to take Sunni candidates' names off the ballots. Though Dr. Riyadh is heartened, briefly, by support from his patients and neighbors ("We would never vote for an outsider"), he is also disheartened by repeated U.S. incursions. Three months before the elections, the U.S.-led Fallujah offensive threatens even the illusion of "security" and stability that elections workers seek to create. Again, background televisions ensure that this context is ever present in scenes presenting the Riyadh family. Listening to descriptions of the chaos and frustrations concerning problems ranging from evacuations and refugees to injuries ("They need doctors and surgeons like you"), his dismay is tempered by his dedication to "my country." At an Adhamiya District Council meeting, he meets with U.S. military personnel to "discuss some things." He faces the soldiers, the camera pushing in on their shadowed faces. "What is the misunderstanding point that leads to this aggression of a city?" the doctor asks. "Many innocent people are killed. It is a process of mass killing." An officer nods in sympathy: "I've heard everything you've just said," he assures his audience, that is, Dr. Riyadh and the camera crew who's following him. "Some of what you've said has touched me in my heart."

The film cuts to a car exploded outside, sirens wailing in the background. A TV news report announces that four people were "killed today at the Abu Hanifa mosque" in Dr. Riyadh's neighborhood. Witnesses describe the scene: "It was the Americans who did the killing," says one woman. Distrustful of these forces purportedly in place to keep order, Iraqis—especially in this Sunni area—are also fearful of Shiia militias. No one feels safe, despite Dr. Riyadh's efforts to assuage his

friends and constituents, as well as educate them concerning the fictions present-ed to them on all sides. Though the elections were over in January 2005, the tensions exposed in *My Country, My Country* remain raw and shifting. Revealing the many sorts of work that go into "running this show," it offers Dr. Riyadh as a counterpoint, a critical viewer and participant, exploiting and exposing the spectacle.

> I ask myself why I needed to go back.
>
> —USAMA ALSHAIBI

When Usama Alshaibi watches the Saddam statue fall in Baghdad, unlike the Riyadhs, he's safely removed. Specifically, he's in a hotel in Amsterdam, honeymoon-ing with his new American wife Kristie. Also unlike the Riyadhs, he pauses to comment on the image: "After 24 years," he says at the start of *Nice Bombs*, "the dictator Saddam Hussein was falling and something different was happening. I was curious to see what might unfold." Describing himself as "born in Iraq and recently sworn in as a citizen of the nation that was now attacking it," Alshaibi observes, "I had a feeling that the news I read and saw could not give me the full story."

His "feeling" inspires him to pursue that story by traveling with Kristie, a fellow filmmaker, to Baghdad to visit his family, camera in hand. *Nice Bombs* tracks his experience "going home," along with his efforts to sort out allegiances and expectations as well as his hyphenated national identity, while also immersing himself—at least briefly—in the hardships of living in Iraq during wartime. Incisively political and certainly international in scope, the film takes up another project as well, namely rethinking the structure and functions of the "home movie." Including images and techniques typical of the genre—intimate exchanges and wide-angle close-ups, hectic single camerawork and awkward framing, point-of-view shots from moving vehicles and heartfelt confessions under duress—the film focuses on the changed and charged environment that Alshaibi's "home" has become. In this way, it recontextualizes the home movie, traditionally understood, according to Patricia Zimmermann, as "amateur," and as such, is more "authentic, less warped, more truthful, and less-manufactured" than the professional production (*Reel Families,* 144). Alshaibi's professional expertise works with and against his low budget: *Nice Bombs* is alternately carefully composed and raw, an excavation of his past and a look into Iraq's future.

At the same time, while *Nice Bombs* submits itself as a "truthful" representation of Alshaibi's individual experiences, it is constructed as an argument, primarily against the U.S. mismanagement of the war. It demonstrates the dreadful costs of war from particularly vexed and shifting perspectives, revealing tensions between home and identity, authenticity and performance in wartime, as these are expressed in combined resentment and rage, guilt and grief.

Alshaibi here appears an "outsider" in multiple contexts. *Nice Bombs* sets up the journey to Iraq as his own quest, amid multiple unfolding stories, intertwined, individual, and collective. Marsha and Devin Orgeron argue that home movies and videos in documentaries function as "narrational and illustrative tools, as conduits to history and memory" (60). As he plans his trip, in the film's formulation of a timeline, he recalls his childhood, over photos and videos made by his camera-bug father. His family moved from Basra to Iowa during the war with Iran; his parents divorced when he was 15. With his father in the Middle East and his mother in the United States, Alshaibi says, "I felt as if I stood somewhere in between."

His return begins with footage from a car heading into the Sunni Triangle from Amman with his father Hameed, who has lived in Jordan since refusing to join the Baath Party 24 years ago. After a harrowing drive through dark smoke and highway signs noting "Baghdad" and "Abu Ghraib," their first night in Iraq is punctuated by gunshots. Looking into his own camera, Alshaibi looks forward to the next day. "I've been warned to be careful of my accent when we go out certain places. That is fucking scary," he says, as choppers sound overhead. Alshaibi's interviews articulate a range of concerns, from resentment voiced by his cousin Tareef ("I think there is a big American empire," he says, "They have control of the country, but the terrorism is out of their control"), and by the famous Iraqi blogger Salam Pax. Such commentary aligns *Nice Bombs* with other recent war documentaries that critique U.S. policy and practice specifically because they see a vacuum in Western news media. *Nice Bombs* grounds its judgment in American ignorance, before and now during the occupation, blaming journalists for seeking the "ordinary Iraqi position." Salam Pax's "position" is complicated: he worries about the turn from Saddam to religious leaders, and he is especially troubled by the Western expectation that Iraqis should be "grateful" for their "liberation." Salam sits outside, amid pieces of buildings and broken windows. "I get this in so many e-mails," he says. "You come here, you change how a whole country is, you turn everything upside down, and then you go, 'Whoops, there is no plan. Sorry.'"

As Tareef and Usama drive through Baghdad, they observe effects of the war: a burned-out bus, uniformed U.S. troops, walls riven with bullet holes. "There is a tension in Baghdad, in the air," says Usama. "It's everywhere. The possibility of violence is always near. Sometimes I felt like my camera kept me separate from the real dangers right in front of me." They approach a U.S. armored vehicle by the side of the road. "Can I shoot that?" he asks Tareef as they drive. Tareef explains the suspicious glance a soldier casts their way: "He look at you because he don't know what is in your hand." The troops and the citizens share a tenuous, mutable relationship. Crossing back into Jordan at the end of his visit, Usama chats with a U.S. checkpoint guard, Sgt. Graulau. Asked how Iraqis respond to him, the sergeant says, "Some of them are not too happy with us, I don't know why. We've just given their

country freedom." No one in Alshaibi's party has to say anything: the soldier's helmet, body armor, and dark glasses make him the stereotype that speaks for itself.

Alshaibi visits a child who extols how "strong" and unafraid he feels in the face of daily bombing (asked what Bush should do, the boy smiles: "Quit!"), and approaches a man who was roused from sleep by a missile landing next to his couch. A cat, mewing loudly and strangely, becomes the recurring metaphor for the decaying situation. By the end of the film, a neighbor appears as if out of nowhere to carry its fly-covered, dying body from Uncle Kama's yard, literally tossing it down the sidewalk, out of sight. The shot of his receding back and Kristie's gasp are not subtle, but effective. Alshaibi's own complex feelings about his homeland are never clearer than when he turns his camera on Kristie. At visit's end, Kristie is sick in bed and he's looking forward to their departure ("I think if I stayed here another week, I'd go a little insane"). Back in Chicago, he describes his frustration: "Neither West nor East has a clear picture of the other," he says, And so, "standing in between," he sees a common "humanity" that has yet to overcome the divisions. When he calls Tareef in 2005, both are disappointed and angry. "I am worried about how will I get out of this misery," says Tareef. "Where's the path to the future? I don't see it." A tracking shot of two boys running along the sidewalk freezes on one, caught between a seeming now and a future that remains unknowable.

Nice Bombs' analysis of U.S. policy is based only partly in what Alshaibi sees and reports in Baghdad. As he shares his insights and access to local culture and appreciation of traditions, he articulates a split and intricate perspective, simultaneously close to and distanced from his homeland. Much as his movie tilts between personal and public stories, between homes and between hope and outrage and hope again, he recreates the concept of authenticity—as art, politics, and a means of argument.

> For better or worse, I found myself filming a power struggle—between me, an American woman holding the reigns as director of the film, and my subject, an Iraqi man—in what felt at times like a microcosm of the endless conflict in Iraq.
>
> —Nina Davenport

The argument made by *Operation Filmmaker*, by contrast, takes seriously the possibilities of inauthenticity, as a mode of representation and truth-telling. The film follows the adventures of Muthana Mohmed, erstwhile subject of MTV's 2003 documentary, *True Life: I'm Living in Iraq*. His self-performance grants him the great good fortune to be spotted by Liev Schreiber, earnest and enterprising first-time director of *Everything Is Illuminated*. Believing he might help the self-declared movie lover enter the industry—and also save his life—Schreiber brings him on set in Prague as a PA. At the same time, he asks Nina Davenport to document Muthana's experience on set and among Americans. Thus, the 25-year-old Iraqi is swept up in a swirl of dreams, expectations, and ambitions, only some of which are his.

A smart, self-deconstructing look at how movies intersect with reality, the documentary presents Muthana's encounters with The West. Challenging and sometimes discomforting, the film reveals increasing tensions between Muthana and his would-be benefactors, including Davenport herself. Indeed, as she's drawn into conversations and debates with her subject concerning his expectations and disappointments, the film includes explanatory and sometimes accusatory intertitles ("I give Muthana money again, but I'm starting to feel there are no limits to his demands") as well as multiple shots following Muthana along sidewalks, sometimes enhancing and sometimes seeming to indict his own sense of growing frustration.

As its subject shifts tone, the film changes subject, becoming less about Muthana per se, and more about how documentaries work, and the blurred lines between maker and interviewee, observation, and intervention. From the start, Muthana inspires contorted confessions from his well-intentioned supporters, interviews that tell as much about the speaker as he or she seems to be saying about Muthana. Even as he describes his aims for the "project," Schreiber begins to sound like a man with talking points: "I felt a little guilty," the director says (in reference to the war and disquieting images he saw in the *True Life*), "and I was also really, really intrigued by him and I wanted to know who he was." *Everything Is Illuminated* star Elijah Wood proclaims, "The movie we're making is crossing a cultural divide," you know, like bringing Muthana out of Iraq. Producer Peter Saraf punctuates: "If we could somehow get to know Muthana, he could only enrich the experience of making the movie."

It sounds like Muthana embodies a potential for the Americans' moral and emotional salvation. Their disillusionment when he doesn't prove abjectly grateful and dedicated to their goals is striking, perhaps especially as they find the fault in him. None of them anticipates that he is his own complex person, with a background both troubled and privileged. "I belong for a middle class family," he explains, with a fine house in Baghdad, a mother who does his laundry and cooks his meals, and, before the war, a driver. After the U.S. invasion, his life is thrown into disarray: he and his friends could no longer party or pursue their studies.

In Prague, the American filmmakers lament that Muthana resents being tasked with the mundane work of a PA. "The most important scene was rolling," he reports, "while I was mixing the [trail mix] snacks [for producers Saraf and Marc Turtletaub]. It's not my fucking job. I saw worse days than this, but at least the worse days were more interesting." Davenport's voice is audible from off-screen: "Whose job is it if it's not yours?" "It's not mine," he repeats, intently.

Unsure exactly what he wants, Muthana finds ways to annoy even the most sanguine seeming of his patrons. When unit publicist Emma Cooper instructs him to "learn how to edit," by putting together a blooper reel for the wrap party ("You're looking for people who make mistakes," she says helpfully, "that's why it's called a

blooper or a gag reel"), Muthana resists what he sees as silly make-work. After spending a few hours on the assignment, he abandons it for a night out with friends. Davenport's camera comes along to the club, low-angled to show dancers in red pulsing light. The next morning, he fudges what's happened. After the meeting with Cooper, Davenport asks him, "Why'd you tell them you went through all the scenes if you didn't?" Muthana sighs, "It's a temporary solution because I'm thinking of something to say."

Such assessment might be applied to much of what goes on in the film. When Davenport asks what it was like in Iraq, Muthana looks into her lens and says, "I'm not able to do that. I can't translate the image by words, it's so hard and so painful…You just want stories, that's it. You just want an interesting story to watch on the television and spend a beautiful moment, even that, over somebody's feelings, that's what you want to do." But if he understands the Americans' exploitation—of him, of Iraq, of the war—Muthana isn't always able to defend against it effectively. He's got his work cut out for him. Turtletaub is troubled that Muthana expresses support for George Bush ("He changed my life"). "Here I am, a left-wing American in terms of my politics," says the producer. "I had to come to terms with [the fact that] you weren't opposed to the war."

Operation Filmmaker exposes such emotional, ideological rifts repeatedly. And it uses them, quite brilliantly, to ground a kind of self-interrogation, revealing its own part in the manipulations and assumptions, however inadvertent, however benevolent, and however self-serving. When Muthana gets a next gig (and crucial visa extension) working on *Doom*, which is also shooting in Prague, *Operation Filmmaker* finds another set of convenient and resonant visual metaphors. The Rock takes a liking to the charismatic Muthana, noting, "The irony of Muthana is that he's gone through hell and back and then some, but yet he's still warm and he still finds time to smile. The Iraqi people should be really, really proud of him for what he's gone through, for what he's done." Conveniently for *Operation Filmmaker*, the *Doom* set also provides all manner of gore, destruction, and mayhem, with zombies to boot.

Cutting between bloody fake corpses and TV footage of ravaged Baghdad, Davenport's movie also indulges images shot by Muthana's friends (to whom she has sent cameras, "to find out what Muthana's life would have been like in Baghdad"). The connections between U.S. entertainment versions of violence and the war's actual effects ("Don't come back no matter what," his brother tells Muthana on tape, "Even if you have to start from zero") come to a head when Muthana begins seeking asylum. He explains that he cannot go back to Iraq, precisely because of the nature of his employment with the Americans: "I go there, I'm gonna expect any moment somebody gonna put a bullet in my head, back because I'm working with the Americans, somebody think I'm working with a Jewish director. An American, a Jewish movie, defending the Jewish theory."

There's no going back for Davenport either. She sticks with her subject even when he leaves the American sets and heads to film school in London, still seeking sponsorship. Their mutual tensions escalate; at one point he pushes her with the camera across his apartment, her voice off-screen documenting, "You're hurting me." He tells her to stop filming, then refuses to see her. Davenport asks for advice from Kouross Esmaeli, the MTV producer who "discovered" Muthana and who has long since left *Operation Filmmaker*. He turns his camera on her as he interprets what's happened:

> As an MTV project, it's an opportunity for some people to make a cool nifty project while they take their cameras and make these sort of semi-factitious stories about other people. In this case "the people" is a desperate Iraqi who will do anything. I've stopped blaming him for that. Being dependent on other people with ulterior motives must be really hard emotionally. He can never trust that person. He can never trust you he can never trust me. And you're his world right now, someone with an ulterior motive, someone with another agenda.

Operation Filmmaker cannot reconcile the hurt feelings, the betrayals, or the disenchantments that it reveals. In offering so many different angles on the vexed relations between filmmaker and subject, it shows, imperfectly and persuasively, how motives, intentions, and beliefs produce "semi-factitious stories."

> After these extreme events, a lot of things don't make the sense they made before.
> —SPECIALIST BENJAMIN THOMPSON

A journalist by trade, Yunis Khatayer Abbas does this sort of work. As suggested in the first shots of *The Prisoner or: How I Planned to Kill Tony Blair*, he takes pictures and tells stories for a living. He is also an effective performer, witty and allusive. Yunis appears first in a seeming snapshot, tacked to a wall. He has a camera in front of his face, and as he becomes "live," from the photo, he cavorts on a beach, surrounded by lumpy American-looking bodies and an assortment of living room lamps. The surreal scene suggests various meanings, at once dreamlike and cinematic, intercut with freezey frames that turn into cartoonish drawings, as if lifted from a comic book. "Marco, Polo," Yunis jokes, as if playing a game where he's seeking out another player. Or maybe a context.

At once playful and discerning, disturbing and outraged, *The Prisoner* is all about lack—of context and history, memory and evidence. As Yunis begins to tell his story, it is immediately intertwined with that of the filmmakers: Epperlein and Tucker first spotted Yunis when they made their previous film, *Gunner Palace* (2004). As the new documentary recalls, Tucker first saw Yunis when he was "an American cameraman follow[ing] American troops in Iraq." In the Abbas' backyard, the troops believe they've discovered a group of bomb-makers: they have Yunis and his brothers Abbas and Khalid kneeling on the grass in the dark night, alternately asking them

questions and commanding them to "shut up." Yunis informs his captors that he is a journalist. A soldier, barely looking at him, says, "I don't care. We've got a journalist with us filming right now." Yunis gazes directly into Tucker's lens: "Yes, you see that in the camera," he says. "I am journalist....You mistake this." Told to be quiet, he keeps talking, "Yes, just shut your mouth in Iraq, I know that: 'Shut up.'"

Without precisely explaining the source of this footage, the film goes on to offer Yunis' perspective on the events once displayed as if from the Americans' point of view. As the soldiers lead him away ("The reporter guy likes to talk, he goes outside the wall"), Yunis looks back again at the camera as his voiceover explains, "My dream always, I've told myself, 'Yunis, you must be famous man. You must be journalist, you must be like the people in the TV. You must be a famous man, you must be a famous man.'"

At this point he is hardly famous, but he is, or soon will be, "on TV." As Tucker remembers in an essay for *Vanity Fair* (2007),

> I had watched that same footage so many times I could repeat the exchanges in my sleep. But I had never understood it from the subjects' perspective. Sitting in an empty lobby with Yunis and [an intermediary named] Hiba, I could see that to them the arrest, indeed the war itself, had been about families torn apart and neighborhoods thrown into chaos. To Yunis, men had come and taken him away from his parents' house—in front of his family and in his own country.

Tucker's shift in perspective is a function of his own self-reflection, the discovery that what he thought he saw in his lens or in the editing bay in 2004 was not what Yunis experienced—and certainly not what he saw. (It is also instigated when Tucker is contacted by former prison guard Benjamin Thompson, who recognized Yunis in *Gunner Palace* and asked Tucker about his whereabouts.) If *The Prisoner* seems in part an attempt to rectify his previous mistake, helping Yunis to make his perspective known, it embarks on a broader project as well. Deconstructing the processes by which images can be misread and stories miscomprehended, it interrogates how documentaries, as a genre, convey and construct truths, however effective or fictional.

On one level, Yunis' story provokes this sort of questioning by being so full of "evidentiary" holes—a lack of images or written documents to support his narrative. Yunis' story is radically reshaped when he's picked up on that night in 2003. Prior to his detainment, he was indeed a journalist and photographer, the film demonstrates with a montage of the photos he's taken of Baghdad burning, during and immediately after the shock-and-awe assault in March 2003. Accompanied by a melodramatic choral soundtrack ("Wie liegt die Stadt so wüst," of Rudolph Mauersberger's *Dresden Requiem*), these images underscore the photographer's skills as well as the theatrical effect as such.

The Prisoner achieves other such effects in its standard-seeming talking head interviews with Yunis. As he describes his past—fond memories of his "best donkey," his early work as a reporter using a typewriter, his incarceration as one of the "special prisoners, writers, journalists, and athletes" targeted by Uday Hussein—the film amplifies the viewer's experience by including sound effects. Some of these are comic (the donkey's braying), some illustrative (typewriter keys clacking or chopper blades whirring), and some jarring, as when Yunis describes his torture. When he recalls how the electrodes fit onto his genitals and other parts of his body, the film shows his finger extended and supplies a zappy sound. As he counts down ("one, two, three, four, ahhh!"), a close-up of his mouth focuses attention on both his storytelling and his reenacted pain.

The shape and presentation of this pain change once Yunis is picked up by the Americans. Tucker's footage from *Gunner Palace* serves as a point of departure for this next chapter, both the scene where Yunis and his brothers are picked up, and an interview with LTC Bill Rabena, describing the process by which the Americans target and invade Iraqi homes. In the course of "Operation Grab-Ass," Rabena says, the unit learned of a plan to assassinate Tony Blair, as well as a stockpile of bomb-making materials. When the troops were unable to find this material at the Abbas home, they took CDs and videotapes as "evidence" of odious intentions. (*The Prisoner* emphasizes the Americans' patently pathetic misinterpretation of information by noting upfront the process by which the operation was named: "We don't just have boring names," Rabena smiles, "We try to do a play on words." For "Grab-ass," the two brothers "actually...used that name," he continues, as the screen offers a typed word: "Abbas," the brothers' family name.) When an interrogator accuses Yunis of having a camera, he sighs. "In America," he observes, "Everybody has a camera video. I saw that on TV. Why Iraqi, he has a camera, he is very dangerous, he is terrorist?" The film cuts here to a shot from its own start, Yunis working on the camera on the beach, which has been used to implicate him.

After being held for months without charge, Yunis is moved to Camp Ganci (the "soft site" at Abu Ghraib), and labeled Prisoner #151186. Here he is interrogated again, and acts as witness to abuses of other prisoners, his recollections of methods rendered in still more cartoonish images as well as the U.S. military's own handbook on "Approved approaches for all detainees," with a list of terms such as "Futility," "We know all," and "Repetition." Yunis recounts being asked his favorite songs and movie stars ("Richard Gere?" "Harrison Ford?"). Apparently, these methods are illustrated with stick figures sporting smileys, as the film uses arrows and underlines to mark that these are "actual" instructions. In contrast to this absurd accounting, Yunis becomes methodical in his reporting. Locked in a cell without access to paper, he begins to write down on his underwear the fellow prisoners' numbers, names, and fates. Whenever inmates die from abuse, neglect, and violence

inside the prison walls, Yunis records them: in a present-day scene, he holds up the white boxers and reads off names and dates. This painstaking documentation is jux-taposed with official forms listing vague descriptions of injuries that may have led to deaths. At the end of the film, following Yunis' release after nine months (with only a dismissive "sorry" from the U.S. government), a title card reveals, "The army claims to have no record of prisoner #151186." As hard as Yunis worked to keep track of events and individuals, the film points out, the U.S. military either worked just as hard to deceive and repress information, or was so inept that it had little con-trol over its employees' day-to-day activities.

In all possible cases, *The Prisoner* argues, reliance on visual evidence—that mainstay of documentary filmmaking—is not only outdated but also politically motivated. The film's alternative storytelling, with illustration, sound effects, and spe-cial effect, challenges conventional documentation and declaration, interrogation and interview. It is a different sort of challenge than those posed by *My Country, My Country, Nice Bombs,* or *Operation Filmmaker.* All reconsider the possibilities of doc-umentaries, as processes of meaning and belief.

WORKS CITED

Jamail, D. (2007). *Beyond the Green Zone: Dispatches from an Unembedded Journalist in Occupied Iraq.* Chicago: Haymarket Books.

Orgeron, M. D. (Fall 2007). "Familial Pursuits, Editorial Acts: Documentaries after the Age of Home Video." *Velvet Light Trap,* 60.

Rabinowitz, P. (1995). *They Must Be Represented: The Politics of Documentary.* London: Verso.

Tucker, M. (February 2007). "My Prisoner, My Brother." *Vanity Fair.*

Zimmermann, P. (1995). *Reel Families: A Social History of the Amateur Film.* Indianapolis: Indiana University Press.

Zimmermann, P. R. (2000). *States of Emergency: Documentaries, Wars, Democracies.* Minneapolis: University of Minnesota Press.

SECTION IV

Word Wars

"George, They Were Only Movies"

The Vietnam Syndrome in Iraq War Culture

ZOE TRODD & NATHANIEL NADAFF-HAFREY

The theocratic cowboy forgetting Viet Nam rides
into town on a red horse. He's praying to himself
not God, though the two are confused
in the heat of vengeance. The music
is the thump of derricks, the computerized
lynch mob geek dissonance. Clint Eastwood
whispers from an alley, "George, they
were only movies." Shock and Awe.

—JIM HARRISON, "POEM OF WAR"

"Vietnam, Vietnam, Vietnam, we've all been there" (260). So ends *Dispatches* (1977), Michael Herr's account of the months he spent as a journalist in Vietnam between 1967 and 1969. And Americans *have* all been there. Though they may not experience jungle warfare, they are vulnerable to the sights, sounds, and scars of the Vietnam experience—found in soldiers' snapshots, field diaries and letters home, on the screens of televisions, PC consoles, and movie theaters. Consumed by the flickering afterglow of a burned-out war, America's is a national imagination afflicted. Yet Vietnam is even more than a scar during this current war. Today, its reference points connect a narrative feedback-loop that encompasses pop cultural representation, political rhetoric, video games, soldiers' blogs, and antiwar imagery.[1]

Vietnam is now revisited through the lens of Iraq. For example, Sam Mendes' film *Jarhead* (2005), which is adapted from Anthony Swofford's memoir *Jarhead*

(2003) and focuses on the Persian Gulf War and by implication the current war in Iraq, is riddled with movie references that suggest the continuing presence of America's Vietnam experience for soldiers in Iraq. "Every war is different, every war is the same," explains the protagonist Swofford in his personal formulation of the feedback-loop that connects 1968 and 2008, and his statement rings true when a party scene from *Platoon* (1986) is replayed in *Jarhead's* Christmas Eve scene or when Mendes pays homage to *Full Metal Jacket* (1987) with his boot camp scenes and the ritualistic "this is my rifle" scene. The specter of Vietnam appears again in a scene where Fowler unveils a dead Iraqi, replaying a scene from *Full Metal Jacket* that saw a member of the Lusthog squad pull back the cover on a dead Vietnamese soldier.

Further, Swofford lays out the smaller but equally closed loop of his own history. His opening monologue explains: "A man…goes to war. And afterwards, he turns the rifle in at the armory…but no matter what else he might do with his hands…his hands remember the rifle." A closing monologue reconfirms this loop in the film's last scene: "Afterwards, he comes home. And he sees that…he will always remain a jarhead… .We are still in the desert." Still "in the desert" even after he leaves Iraq, Swofford is also still in the South Asian jungles. He is a second-generation American soldier ("my uncle and my father served in Vietnam, so I'm proud to serve my country here," he explains) and his father's South Asian jungle has become the desert sweep of Iraq.

In a *Boston Globe* article in August 2004, Robert Lifton paused on a similar image of generational looping, noting that there is "a primal connection between veterans of Vietnam and Iraq. They are literally fathers and sons or daughters… .[S]oldiers fighting in Iraq are…saying things reminiscent of their Vietnam veteran fathers.…[T]he Vietnam experience hovers over everything" (A9). In fact, to uncover this "primal connection"—Swofford's loop—more broadly is to wonder if American culture continues to rely upon the same myths that fuelled Vietnam. Perhaps, so long as Americans remain mired in the oppositional discourse of Cowboys and Indians, Us and Them, Good and Evil, they are condemned to repeat the same experiences. Perhaps, so long as Americans continue to repeat the words of Tim Page in *Dispatches* ("Ohhhh, war is *good* for you" [248]), and continue to read and write and film and fight in the manner of their fathers, they will always be at war.

VIETNAM ON CRACK COCAINE: POLITICAL RHETORIC AND THE FEEDBACK-LOOP

> Operation Iraqi Freedom is Vietnam on crack cocaine. In less then two weeks a 30 year-old vocabulary is back.
>
> —MARILYN YOUNG

In 1991, President George Bush declared that America had kicked the "Vietnam syndrome once and for all." Discussing the Gulf War victory, he told a gathering of state legislators: "The specter of Vietnam has been buried forever in the desert sands of the Arabian peninsula" (qtd. in Dionne, A21). But a decade later, the ghosts of Saigon seemed to rise up from the sands of Baghdad: America's latest war was seemingly yet another attempt to kick "the Vietnam syndrome." In 2005 Vietnam veteran Bill Shunas observed that "the Vietnam Syndrome" was supposed to mean that the United States would never again "sanction a major war of dubious relevance to our safety" yet now "we are going to have the Iraq Syndrome, which is the Vietnam Syndrome all over again" (3). Continuing to explore the "Vietnam Syndrome," Tom Engelhardt observed the following year that "administration after administration has tried…to wipe [Vietnam] from memory or turn it, at least, into a curable medical condition ('the Vietnam syndrome')" yet Vietnam has "sunk deep into American consciousness and tenaciously refused to be expunged" (para. 1). The Bush administration's planning for the Iraq War was therefore "a kind of opposites game based on banishing Vietnam memories" (para. 2) and so it came as no surprise that with "the invasion of Iraq, the Vietnam analogy instantly burst back… .Something deep and essential and American remains familiarly unsettling across the two eras" (pars. 3, 7).

From the outset of the Iraq War, this "bursting back" included the language of Vietnam. Notwithstanding its desire to "banish" memories of that war, the Bush administration immediately recycled Vietnam-era phrases like "support the troops" and "stay the course," echoed the Nixon administration's "Vietnamization" with "Iraqicization," and translated "credibility gap" into "information warfare." Noting this tendency as early as April 2003, the historian Marilyn Young called Operation Iraqi Freedom "Vietnam on crack cocaine." She explained: "In less than two weeks a 30 year old vocabulary is back… .Seek and destroy, hard to tell friend from foe, civilian interference in military affairs, the dominance of domestic politics" (para. 6). A year later, in April 2004, Paul Krugman made a similar observation, noting in the *New York Times:* "'Hearts and minds,' meet 'welcome us as liberators.' 'Light at the end of the tunnel,' meet 'turned the corner'" (A19). And in 2005, traces of Vietnam rhetoric were still mutating through Iraq War culture: "They tell us that…the troops will be home for Christmas, that the mission is accomplished," wrote Lewis Simons. "The enemy body-count fiasco at Saigon's daily '5 o'clock follies'…has been replaced by meaningless claims of dead insurgents. Lyndon Johnson's vision of 'light at the end of the tunnel' has evolved into Dick Cheney's embarrassing 'last throes'" (B1). From 2003 onward, though there were clear differences between the wars in Iraq and Vietnam, the soundtrack was the same.

Politicians' recycling of Old West imagery further revealed the existence of a feedback-loop. Though cowboy dreams were supposedly lost in Vietnam—when

they became "the lowest John Wayne wetdream" (Herr, 20) and doctors dubbed a post-Vietnam stress disorder the "John Wayne Syndrome"—the frontier reared its dusty head again in the twenty-first century. Six days after the 9/11 terrorist attacks, Bush was asked at a press conference whether he wanted Osama bin Laden dead. He responded: "I remember that they used to put out there in the old West, a want-ed poster. It said: 'Wanted, Dead or Alive.'...All I want and [what] America wants [is for] him [to be] brought to justice" (para. 35). And while announcing that his administration was "adjusting" its thinking "to the new type of enemy," Bush revealed no adjustment—proclaiming, frontier-style, "we're going to smoke them out" (para. 25). On other occasions, he expressed a determination to "ride herd" over resistant Middle Eastern governments and branded Iraq "an outlaw regime" (qtd. in Baard, 27).

This feedback-loop provided what Richard Slotkin calls "interpretive grids." Discussing the Vietnam War, Slotkin explains in *Gunfighter Nation* (1992) that "the historical past was itself encoded in the terms of myth.... [T]he scenarios and game-models developed by the policy-makers were not very different from the imagina-tive projections that were developed by fiction writers and filmmakers.... Tropes and symbols derived from Western movies had become one of the more important inter-pretive grids through which Americans tried to understand and control their unprecedented and dismaying experiences in Vietnam" (446, 546). Now, from the perspective of the Bush administration, the interpretive grids of Iraq War culture derived from both Westerns *and* Vietnam.[2]

Some observers also heard this recycled soundtrack as a clue pointing to the existence of recycled *actions*. In September 2003, General Anthony Zinni explained the presence of a historical loop to a group of Marine Corps officers: "We heard the garbage and the lies [during Vietnam] and we saw the sacrifice. I ask you, is it hap-pening again?" (qtd. in Ricks, A16). The following year Senator Edward Kennedy termed Iraq "George Bush's Vietnam" (para. 9), and on August 21, 2005, Republican Senator Chuck Hagel borrowed the analogy and told ABC that "we are locked into a bogged-down problem, not dissimilar to where we were in Vietnam" (qtd. in Hanley, A32). History was repeating itself and the loop seemed never-ending. W. D. Ehrhart observed in a 2005 article for the *Veteran* that Americans should "have learned enough from the Vietnam War to be more skeptical of the present course of events than many of them seem to be." He continued: "They've replaced gook, slope and dink with raghead, towelhead and sand nigger, but I doubt that the swagger, the contempt for what is different, the fear masquerading as bravado have changed at all" (18). America seemed caught in a dangerous feedback-loop, bound by thematic undercurrents that cemented the applicability of past actions.

Sure enough, in August 2007, President Bush confirmed that his administra-tion's rhetoric *and* action were extensively shaped by memories of Vietnam. In a

speech in Kansas City, Bush argued that withdrawing from Vietnam had been a mistake—and one that he would not repeat in Iraq: "Then as now, people argued the real problem was America's presence and that if we would just withdraw, the killing would end," he explained (para. 41). And there was an even deeper connection between Vietnam and Iraq, he said. Withdrawal from Iraq would not only repeat the bloodshed of withdrawal from Vietnam, but withdrawal in 1973—and in particular the image of a withdrawal forced by antiwar protest—had actually *caused* the Iraq War, by causing the attacks of September 11, 2001. "There was another price to our withdrawal from Vietnam," claimed Bush, and "we can hear it in the words of the enemy we face in today's struggle… .Osama bin Laden declared that 'the American people had risen against their government's war in Vietnam. And they must do the same today.' His number two man, Zawahiri, has also invoked Vietnam…declaring that the Americans 'know better than others that there is no hope in victory. The Vietnam specter is closing every outlet'" (pars. 47–49). Bush then turned to recast Vietnam as a victory, in spite of the too-hasty withdrawal of American troops: "[H]istory does remind us that there are lessons applicable to our time… .In Asia, we saw freedom triumph over violent ideologies after the sacrifice of tens of thousands of American lives—and that freedom has yielded peace for generations (para. 55). As far as Bush could see, there was a direct line from antiwar protestors during Vietnam to terrorists during the first decade of the twenty-first century. Bin Laden was thriving on the Vietnam Syndrome that antiwar protestors had transmitted to the country some 40 years earlier. And this meant refighting—and winning—the Vietnam War in Iraq.

PLAYING SOLDIER: THE AMERICAN MILITARY AND THE FEEDBACK-LOOP

> They fill us full of lies / Everyone buys / About what it means to be a soldier.
> —TOM WAITS, "DAY AFTER TOMORROW"

Beyond politicians' rhetoric and decisions, the feedback-loop seems to provide a surreal plane through which would-be warriors learn about combat. As the film *Jarhead* insists, the loop lends soldiers a vernacular and a series of images, thus legitimizing their own experiences as consistent with previous representations of war. The Marines prepare for war in the film's early sequences by watching *Apocalypse Now* (1978), singing along to the "Ride of the Valkyries" sequence. In his book's introduction, Swofford explains that Marines "rewind and review famous scenes… .We watch Willem Dafoe get shot by a friendly and left on the battlefield in *Platoon*; and we listen closely as Matthew Modine talks trash to a streetwalker in *Full Metal*

Jacket" (6). Now, he adds, it is "my time to step into the newest combat zone. And as a young man raised on the films of the Vietnam War, I want ammunition and alcohol and dope, I want to screw some whores and kill some Iraqi motherfuckers" (7).

Recycled imagery fuels a stagnant feedback-loop. Decades earlier, "movies fed a generation a consistent diet of war images from which Americans might learn to interpret the nature of armed conflict" (22), as Lloyd B. Lewis notes of the Vietnam era. Popular culture had created what Loren Baritz describes as an army of "nineteen-year-old Americans, brought up on World War II movies and westerns" (52). Equally, Swofford's soldiers, the post-Vietnam generation, are fed by a celluloid diet of "ammunition and alcohol and dope." And—as Swofford promised—this cyclical undercurrent has been visible beneath present-day soldiers' experiences and behavior. The cinematic feedback-loop has seemingly offered explicit and implicit prowar narratives. "When I asked a 19-year-old marine in Iraq last year why he'd joined up, he said: 'I've always been into explosions and, you know, just, just, uh, action movies,'" recounted one journalist in December 2005 (Meek, 6). The loop might even foster a kind of war-love: in March 2006, Brian Pierrou, a Marine with a MySpace blog, quoted a line from the 2002 Vietnam War film *We Were Soldiers* ("one more thing, dear Lord. About our enemies…ignore their heathen prayers and help us blow those little bastards straight to hell"), and went on to note that he personally wants to die "gloriously in a hail of gunfire" (n.p.).

Chris Hedges, a *New York Times* war correspondent, speculated as to the origins of this kind of war-love. He described to PBS the yearning "to be tested," adding: "That's part of the way the myth is sold to us, that we're not finally complete human beings…until we've been through the experience of war" (paras. 31–32). Then, tracing the process by which war had became entertainment, Hedges continued: "After the Vietnam War, we asked questions about ourselves and our nation. It made us a better people. [But]…love of power and that glorification, that myth of war, rose during the Reagan years, culminating in the Persian Gulf War, where war became not only respectable, but enjoyable—war as entertainment….That's what frightens me so much now" (paras. 29–30). As far as Hedges could see, war had become for Americans a fusion of myth and entertainment—both a rite of passage and a way to pass the time.

Hedges' observation that war is entertainment, and Swofford's observation that entertainment has become preparation for war, are further confirmed by America's gaming industry. Here, the feedback-loop between representation and reality includes the mechanical entertainment component of action figure toys and the "simulation" industry. By 2006, the Elite Force Aviator series of action figures produced by Blue Box Toys had released a popular George W. Bush figure, a 12-inch representation of Bush clad in naval aviator garb, while "simulator" technolo-

gies such as *LaserTag* (and its lower-tech counterpart, *Nerf*) were sustaining high sales. The feedback-loop incorporates the physical component of teen boot camps as well. Programs like "Boot Camps For Struggling Teens" condition their subjects for involvement in the military: "a true teen boot camp will include uniforms, marching in formation, as well as a 'yes sir' and 'no sir' mentality," explained promotional material, adding that "barracks" are "similar to those in the U.S. Military's 'basic training program' and will be authentic" ("Boot Camps," para. 5).

Even more pervasive is the feedback-loop's digital component. As immersive gaming technology has evolved, companies ranging from the venerable Electronic Arts to the controversial Rockstar Games have produced software that simulates the full spectrum of combat opportunities, many of them captured from a first-person-shooter (FPS) perspective. These programs offer immersion in a virtualized war zone, replicating, glorifying, and enabling war-lust with increasing scope and sophistication. Many borrow stories or characters from preexisting cultural artifacts. *Grand Theft Auto-Vice City* draws heavily from the film *Scarface* (1983); *Starsky and Hutch* revises the 1970s television series of the same name; *Tom Clancy's Rainbow Six* was developed as Clancy wrote his bestselling 1998 book, *Rainbow Six* (the game's development team coordinated their efforts with Clancy); and *Full Spectrum Warrior*, originally developed as a training aid for the army and released to the public in 2004, replays numerous scenes from the film *Black Hawk Down* (2001). In a further variation, a joint venture between Activision and Lionhead Studios called *The Movies* (2005) allows gamers to create movies that might inspire games. The feedback-loop turns around on itself, breeding familiar iterations.

In August 2004, Clive Thompson examined *Full Spectrum Warrior* in an article for the *New York Times*, and explained that "after Sept. 11 there were instances of game designers reaching out to the military to offer their services," saying, "I want to do something for the country." He cited Major Cummings, a consultant for the game, who claimed that "this is what you'll really see when you're out there," and expressed his own fears that selling this game to the public might allow "real-life terrorists...to learn about the urban-warfare tactics of American soldiers" (33). But far from offering unadulterated access to what is "out there," the game's reliance on filmic iterations of war was even more pronounced by 2006, when a new version of the game, *Full Spectrum Warrior: Ten Hammers,* came complete with a cast of Hollywood-esque characters.

Even more significant for the *historical* feedback-loop, gamers can not only star in their very own movies but also play at warfare in Vietnam. *Battlefield Vietnam* includes period music; *Wings Over Vietnam* offers missions in a flight simulator; and *Modern Air Power: War Over Vietnam* promises historically accurate scenarios ranging from 1964 to 1972. Some games even set out to revise the war's history and make it a more palatable component of America's military legacy. *Squad Battles: Vietnam,*

released by HPS Simulations in August 2001 and containing more than 70 scenarios revolving around 30 major conflicts of the Vietnam War, comes with a document called "Comments on Jungle Warfare & Traditional Warfare" that transforms Vietnam into a military success. "One of the persistent half-truths so often repeated about the war Vietnam is that the American armed forces were ill equipped for jungle warfare," proclaims HPS Simulations. "There are very few examples…in which the Americans failed to deal a severe blow to the Communists on the battlefield… .[I]t is clear that the fighting men of the American armed forces were every bit equal, if not superior, to their foes on the battlefields of Vietnam" (paras. 2–3). Promotional material quotes Nixon, Field Marshal Montgomery, and General Curtis LeMay's infamous comment: "We're going to bomb them back into the Stone Age."

By 2002, HPS Simulations had further revised history, updating *Squad Battles: Vietnam* for the post-9/11 era. In March it released *Tour of Duty*, a follow-up game that now included "Caves and Tunnels" (echoing numerous media descriptions of Osama Bin Laden's concealment in eastern Afghanistan's Tora Bora caves). Another attempt at connecting these Vietnam games to the current conflict came in March 2005, when *Elite Warriors: Vietnam* was released by Bold Games. Developed with the assistance of Major Plaster, a Vietnam veteran, it supposedly included "patrolling techniques…still being used today in Iraq and Afghanistan" (Charbonneau, para. 4).

Other games recycle the present conflict as well. *War on Terror* and *Full Spectrum Warrior* offer digitalized versions of the contemporary conflict and one soldier observed of a game called *The Hunt for al-Zarqawi*—which includes clips of video news footage, satellite pictures of Iraq, and military reports—that it made him "flash back and think about the war and the aftermath… .But that's not necessarily bad" (Kuma\War, para. 14). The control maps of the Vietnam and Iraq FPS products are very similar, implicitly reinforcing the feedback-loop. Different wars are reduced to a series of similar keystrokes, and the games make it easier to participate in violent conflict, easier to glory in bygone wars, and harder to abandon past mythologies.[3]

Most notable for its blurring of the boundaries between war and entertainment, however, is a free, downloadable game called *America's Army*: a cross-platform program developed in 1999 by Colonel Wardynski, sponsored and approved by the army, subtitled "the official game of the U.S. Army," and funded by U.S. tax dollars. Built around a traditional FPS key map, *America's Army* is a piece of software that enables individual users to participate in both military training and combat missions. Fledgling gamers pass through several training missions that feature obstacle courses and weapons familiarization, and then the online combat missions begin and players can cooperate online in raids on guerrilla camps. The game has captured a huge

audience, tallying some six million registered accounts by 2006. According to its creators, it is one of the five most popular PC action games played online.

Observing this popularity in 2004, Jim Downing cited critics' warnings that "the new round of America's Army tournaments is just one more way for recruiters to get into the heads of impressionable high schoolers." Downing quoted Todd Boyle, a Vietnam-era Navy veteran who believes that *America's Army* is deplorable for just this reason: "The Army games are particularly objectionable because they also include an indoctrination component, deepening the ideology of war" (B1). Sure enough, the company even features on its Web page a "Parental/FAQ" section that leverages the game as a "way for young adults to explore the Army and its adventures and opportunities." The section adds that the game includes "web links through which players can connect to the Army of One homepage" ("America's Army") and army recruiters organize, facilitate, and attend the company's gaming tournaments.

As yet another twist in the feedback-loop, not all gamers are *would-be* soldiers and potential recruits; military personnel modify gaming equipment for practical purposes. In April 2004, the journalist Ben Jenkins reported that parts of Sony's *Playstation 2* video game console were being tested as military equipment for operations in Iraq and Afghanistan. He explained: "The U.S. military has been purchasing hundreds of Playstation analog controllers and retrofitting them to Abrams tanks, Bradley fighting vehicles, and missile defense computers at the U.S. command's headquarters in Baghdad" (para. 2). He then cited a former military official, who observed: "The soldiers today are so used to handling the Playstation controller…it makes perfect sense that they'd use it to control army tanks and shoot missiles" (para. 9). And as well as adapting commercial games for military use, the military passes its training tools onto the commercial market. In April 2005 *First to Fight* was released to the public. The company claimed this tactical FPS was created with the help of more than 40 active-duty U.S. Marines who had been deployed to the Middle East, and would be used by the U.S. Marine Corps for training. The company emphasized that *First to Fight* features a Marine Corps doctrine known as "Ready-Team-Fire-Assist" that was being used in Iraq and Afghanistan.

Embracing this blurring of the boundaries between war violence and entertainment violence, soldiers in Iraq blog about their personal video game habits. One, whose Web-handle is American Soldier, writes: "I'm a total computer geek when I am not playing Soldier. I play online MMORPG's, *America's Army*, and *Counter Strike*. I love to hunt" (para. 13). American Soldier's use of the phrase "playing Soldier," to refer to his time in Iraq, connects real warfare to the digital action games that he references in the next line. He adds, by way of background, that he has "a few degrees from the University of John Wayne" (para. 7). Further connecting

movie-culture, gaming culture, and modern warfare, one journalist quotes another soldier's response to the latest military simulator: "Cool…it's like *The Matrix*" (Thompson, 33).

In fact, gaming technology has become part of the Iraq experience. In a post of December 2005, American Soldier writes: "If anyone happens to come across an XBOX 360 and wants to part ways with it or finds one at a local Walmart/Target and would like to sell it…I will be the official Desert Tester for Sony" (paras. 1–2). Other soldiers seem equally determined to bring video games to the desert, and one, with a Web-handle of Dadmanly, joked in February 2005 that "you'd think we were all kids, with all the…Xboxes, and Playstations" (para. 8). Another blogger shared an email from a "friend in the 278th" that includes "a picture of the soldiers enjoying their new Xbox" (Prosise, para. 1), while a *Washington Post* article of March 2006 described soldiers "stringing Xbox cables from bunk to bunk" (Von Drehle, A1).[4]

In May 2006, the Vietnam veteran Tony Swindell connected this pervasive presence of gaming technology in Iraq to the "monstrous crimes and tragedies from my generation about to be repeated" (para. 2). He observed that "our descent into hell, our 'Apocalypse Now' moment, has begun" (para. 1). Once again, he said, "we've been marched into another lunatic asylum in the Twilight Zone" (para. 12). Expressing despair of this ever-exiting twilight zone, he pointed to the problem of the Iraq War as a "media production": "Raised on the Internet and X-Boxes, maybe Iraq is just another Hollywood-style media production." A turning point in the feedback-loop would only come, he believed, when "Selective Service notices begin arriving in mailboxes." Only then would people "rudely discover that involuntary combat means no video games or boom boxes" (para. 15). In the meantime, Swindell concluded, Americans should assist the arrival of this turning point by "switching off" their media devices and studying "a little American history, like the parts repeatedly warning us about foreign entanglements" (para. 16). Perhaps "history" could tell a different story.

WHERE AMERICA FINALLY TURNED: RECLAIMING THE VIETNAM SYNDROME

Thirty years from now…we will be able to say "Vietnam" and not mean…a filthy obscene memory, but mean instead where America finally turned.

—JOHN KERRY, "TESTIMONY"

Antiwar voices have sought to tell that different story. Explaining in an April 2004 article for the *New York Times* that "Nixonian politics is back," Paul Krugman remembered "Nixon's efforts to suppress dissent." President Bush did a "meta-

Nixon," Krugman added, when he declared that "anyone who draws analogies between Iraq and Vietnam undermines the soldiers and encourages the enemy" (A19). But dissenting voices—like that of Tony Swindell—have nonetheless persisted, often drawing those very analogies. Dissenters use the master's tools to dismantle the master's house: they connect Vietnam and Iraq as part of their protest strategy against the feedback-loop that rehabilitates Vietnam-era rhetoric, images, and military strategies.

For example, in April 2006, highlighting the loop in his own life, Senator John Kerry made reference to his famous 1971 testimony before the Senate Foreign Relations Committee. Looking ahead 30 years he had warned in 1971: "This thing has to end…so when thirty years from now…we will be able to say 'Vietnam' and not mean a desert, not a filthy obscene memory, but mean instead where America finally turned and where soldiers like us helped it in the turning" (paras. 15, 17). Now, exactly 35 years later, Kerry saw no sign of America "turning": "[W]e are in the same place now.…As in Vietnam, we engaged militarily in Iraq based on official deception.…And as in Vietnam, we have stayed and fought and died even though it is time for us to go" (paras. 45, 47, 49). Yet while acknowledging this feedback-loop, Kerry also sought a way out: "As in 1971, this is another moment when American patriotism demands more dissent" (para. 57). The loop could be instructive. The "lesson" of Vietnam, Kerry said, is that "true patriots must defend the right of dissent, and hear the voices of dissenters, especially now" (para. 10).

Senator Kennedy is another who tried to fashion a turning point for the feedback-loop. "We thought in those early days in Vietnam that we were winning," he said in January 2005. "We did not understand that our very presence was creating new enemies." Drawing on Vietnam as an antiwar lesson, Kennedy proposed that at least 12,000 American troops should leave Iraq immediately (qtd. in Purdum, A12). Two and half years later, after Bush's speech in Kansas using Vietnam as a lesson of "no withdrawal," Senator Kennedy observed that the "president is drawing the wrong lesson from history.…America lost the war in Vietnam because our troops were trapped in a distant country we did not understand, supporting a government that lacked sufficient legitimacy with its people" (qtd. in Rutenberg & Stout, A13).

Even more controversially, William Odom, a retired general and former director of the National Security Agency, attempted to use the analogy as a lesson in March 2006. "The Vietnam War experience can't tell us anything about the war in Iraq.…If you believe that, trying looking through this lens, and you may change your mind" (para. 1). He went on to outline the three phases of the Vietnam War and their counterparts in Iraq. It "all sounds so familiar," he observed, and yet "Vietnam can be instructive" (paras. 30, 32): "Once the U.S. position in Vietnam collapsed, Washington was free to reverse the negative trends it faced in NATO and the U.S.-Soviet military balance.…Only by getting out of Iraq can the United States pos-

sibly gain sufficient international support to design a new strategy" (para. 32).

Protestors have also sought a turnaround point in the feedback-loop of war—trying to summon a loop of dissent, instead. In September 2005, Cindy Sheehan told the crowd at a Washington Memorial Rally to "[look] back at how Vietnam was ended." Far from fuelling a closed loop of war, the memory of Vietnam might instruct Iraq War dissenters that "we the people are the only ones who have been able to transform history." Sheehan added: "To those people who question if we are making a difference: I tell them to…read their history books!!" (para. 6). Equally, Marcus Raskin offered opening remarks on the legacy of the Vietnam teach-in movement at the National Teach-In on Iraq at George Washington University in March 2005, and Iraq Veterans Against the War (IVAW) announced their coorganized June 2006 event, "Peace Has No Borders," with the words: "Today we are building on that history [of protest during the Vietnam War] to ensure a living legacy that can serve the struggle for peace today" ("Peace"). Repeatedly, protestors have met prowar voices and the entertainment industry on their own ground by using the memory of Vietnam—but used it to summon a history of dissent.

Veterans have been part of that reawakening too. Some Vietnam veterans are traumatized by the feedback-loop. Between 2000 and 2006, PTSD disability-compensation nearly doubled, with the largest jump in numbers coming after 2003. In June 2006, Donna St. George reported in the *Washington Post* that thousands of Vietnam veterans were seeking help for posttraumatic stress disorder (PTSD), apparently due to images of combat in Iraq. St. George explained that "many veterans of past wars reexperience their own trauma as they watch televised images of U.S. troops in combat" (A1). But other veterans embrace the loop as one that might help end the war in Iraq. For example, Vietnam Veterans Against the War (VVAW), launched in 1967, opposes the Iraq War and collaborates on public statements with IVAW. They explained in an advertisement in a 2002 issue of the *Nation*, titled "No War with Iraq!": "We remember the lessons of [the Vietnam War] and we live to keep the Vietnam Syndrome alive" (16). That syndrome existed, as VVAW noted in an obituary for one veteran, but "may we all stay infected" ("Obituary," 22). Not a memory to be buried under the rubble of more "successful" wars, nor a tool to be brandished by hawks and video game companies, Vietnam becomes an antiwar disease—a countervirus that might help to wipe out America's war-love affliction.

VVAW was prepared for this to be a long process, insisted members Barry Romo, Dave Curry, and Joe Miller in 2003, for veterans "know what it is like to take the long view and maintain our activism" (1). Romo added in 2004: "We want the bombs to stop falling.…Tall order, yes—but we helped end the war in Vietnam.…VVAW is going to be around for a while" (1). By 2004, VVAW had grown in strength, gaining 400 new members since the beginning of the Iraq War,

and this intergenerational connection goes still further. In 2008, one newspaper article pointed to not just the relationship between VVAW and IVAW, but also the community of intergenerational "deserters" in Canada, where "the remnants of a lost counterculture are rising up again as hundreds of aging draft dodgers [who left the U.S. during the Vietnam War] help an estimated 200 Iraq war deserters who fled north with no promise of asylum" (Jones, C1). Here, veteran solidarity provides a very real counterpoint to that "primal connection" (so phrased by Lifton in his article about Vietnam veterans' sons and daughters fighting in Iraq) between second-generation soldiers and their fathers' battles in Vietnam.

In this search for a turnaround point in the feedback-loop, antiwar politicians and dissenting veterans have been joined by protest writers. For these artists, summoning Vietnam means summoning the memory of 1960s protest literature, rather than the John Wayne-esque representations that appear in soldiers' blogs and video games. For example, drawing on the history of antiwar protest literature in 2006, IVAW offered a free DVD of the documentary *Sir! No Sir!*, about the GI movement against the war in Vietnam, to anyone who had served since 9/11. Then, in a 2006 issue of the *Veteran*, Brian Gryzlak found another way into the usable past. Reviewing David Cortright's *Soldiers in Revolt* (2005), he observed, "Three decades later, it is clear that *Soldiers in Revolt* can be read not only as a fascinating and detailed history of mobilized discontent among GIs during the Vietnam War, but also as a resource for the current antiwar movement" (24).

The singer and Vietnam veteran Joe McDonald has a similar faith in the enduring value of Vietnam-era protest. McDonald, who sometimes claims that his band Country Joe and the Fish stopped the Vietnam War, has rewritten his famous song "I-Feel-Like-I'm-Fixin'-To-Die-Rag" (1965) for the Iraq War. He explained in a recent interview that one "legacy of Vietnam protest is contemporary antiwar protest." A feedback-loop exists with regard to the Iraq War, McDonald suggested, because the "war on terror" is hard to protest. It's a "new challenge for those who write about war," he explained. McDonald believes therefore that, far from exposing a lack of imagination, the reliance of contemporary antiwar protestors upon the memory of Vietnam is an attempt to fashion effective protest: only by remembering that this is just "another war like Vietnam," as he puts it, might artists find a way to produce a literature of dissent (Trodd, 482).

Another artist who uses memories of Vietnam to fashion a turnaround point is the San Francisco-based Clinton Fein. Using technology as his protest weapon, he digitally alters images and subversively collages fragments, publishing them continually on his Web site—Annoy.com—as a one-man parallel of the amnesiac 24-hour news cycle. His art is calculated to shock, critiquing a culture of fear and the Bush administration's "Shock and Awe" military policy. Most infamously, his 2004 image "Who Would Jesus Torture?" which was censored by a California

printing company, pictures Bush on a cross with a missile as his phallus (Trodd, 508). It recalls the general straddling a missile at the end of *Dr. Strangelove* (1964), while the crucifixion imagery echoes Nick Ut's famous photograph, "Napalm" (1972). Fein echoed that image, he explained in an interview, because he was struck by the lack of outraged public response to the Abu Ghraib images: "A combination of communications allowing instant gratification, collective attention deficit disorder, information glut and an unwillingness to confront who we are in those grainy photos, all combined to defuse their impact" (Trodd, 509). So he tried to make his image into one that might match the protest art of the Vietnam War.

Poets, too, have seized the master's tools and dismantled the master's house. Numerous poems submitted to the group Poets Against the War, founded in January 2003 after the announcement of "Shock and Awe," connected the wars in Iraq and Vietnam—41 explicitly, and dozens more through allusion. That month, dozens of poets also attended "A Counter-Intelligence Symposium" in New York. The organizer, Anne Waldman, explained: "I am reminded these days of the American/Vietnam wars....This is a *war for the* imagination....We may all resound as magnificent groaning Cassandras here, prophets of doom, but we might also reclaim our world" (335–336, 357).

January 2003 also saw the publication of the "Not in Our Name Statement of Conscience." Signed by more than 66,000 people, including numerous poets, it observed: "We...draw on the many examples of resistance and conscience from the past of the United States...those who defied the Vietnam war by refusing orders, resisting the draft, and standing in solidarity with resisters" (para. 15). In January 2005, the "New Not in Our Name Statement of Conscience" appeared in newspapers. Again, it called upon the example of Vietnam protestors and declared: "The movement against the war in Vietnam never won a presidential election. But it blocked troop trains, closed induction centers, marched, spoke to people door to door—and it helped to stop a war" (para. 9). Not "prophets of doom," nor lonely keepers of the future's secrets, groaning Cassandras become empowered activists and united custodians of the past's inspirations.

Echoing much Vietnam literature, several of these antiwar poems allude to movie-Westerns. Jim Harrison's "Poem of War" (2003), submitted to Poets Against the War, reads: "The theocratic cowboy forgetting Viet Nam rides / into town on a red horse...Clint Eastwood / whispers from an alley, 'George, they/were only movies'" (Trodd, 506). Harrison's February 2003 challenge was to the frontier mythology reinfusing political discourse and was eerily prophetic of observations like that of Pvt. Lawrence in December 2003: "It was like out of a movie," said Lawrence of a battle in Iraq (qtd. in Daniszewski, A1). Harrison and other artists challenge these cowboy dreams and try to turn the feedback-loop back upon those embracing it—just as the language used to justify the Iraq War echoed the frontier

language of the Vietnam era, so antiwar protest literature draws on the frontier sights and sounds of the Vietnam War, seeking to offer a new cowboy code. For, as the journalist Erik Baard observed in 2004, Bush had in fact broken the true "cowboy code" by adopting the "doctrine of preemptive war." The code, written by screen cowboy Gene Autry in 1939, demanded that the "Cowboy must never shoot first, hit a smaller man, or take unfair advantage" (27).

This recasting of the cowboy code by artists and writers has been one of the most extended protest strategies of Iraq War culture. Beyond explicit antiwar literature, it has undergirded mainstream representations as well. For example, in 2005, Ang Lee proclaimed his film *Brokeback Mountain* "post-western," explaining that it marked a break with the "codes of westerns" (qtd. in Huston, para. 4)—now expanded to include gay cowboys. Like Harrison's poem, *Brokeback* reclaimed the frontier myth in response to a self-styled cowboy president who utilizes a Vietnam-era "smoke 'em out" rhetoric. Vietnam looms large in the film; at the end of their summer together, Jack comments to Ennis, "Might be back if the army don't get me." The year is 1963—the year when Kennedy's assassination would place Johnson in the Oval Office. Later, at their reunion, Ennis asks Jack, "Army didn't git ya?" "No," Jack replies; "Too busted up, rodeo ain't what it was in my daddy's day." Jack escaped having to give his body to the John Wayne myth in Vietnam because he's "too busted up" already by that cowboy myth at home. Lee further deconstructs this myth in a scene where Jack's father-in-law insists upon his grandson watching television, commenting: "Want your boy to grow up to be a man, don't ya? Boys should watch football." The scene is one of the few not included in Annie Proulx's original short story: a self-conscious moment of cinematic reflection, it connects performative masculinity to the visual spectacle of a two-dimensional screen and protests the pop cultural feedback-loop of American cowboy manhood.

If Vietnam lurks between the lines of *Brokeback* in this way, so too does America's latest cowboy president. The original "Brokeback Mountain" story was written by Proulx in 1997, before Bush was on the horizon, but Hollywood's decision to take up the story under his presidency remains significant. It even ends with a scene, not part of Proulx's story, where Ennis agrees to attend his daughter's wedding, observing "I reckon they can find themselves a new cowboy." His son-in-law is an oil refinery man and perhaps stands in for the new cowboy of Lee's twenty-first-century world: George W. Bush, cowboy president and former Texas oil man. This connection was not lost on artists. Making the connection in February 2006, the *New Yorker* published its cover image, "Watch Your Back Mountain," by Mark Ulriksen. Depicting Bush and Cheney as Lee's gay cowboys, Ulriksen flipped the feedback-loop on its head one more time.

CONCLUSION

Dismantling the master's house with the master's tools is always a risk. Rather than reimagining their country, perhaps protest writers and artists are deepening the cultural rut that has long since trapped America's westward—or these days its eastward—wagons. Perhaps we would not keep feeding this loop if we did not love the fare. And perhaps by connecting Vietnam and Iraq, contemporary antiwar writers and artists run the risk of never shifting past cowboy dreams. After all, *Jarhead* also features a scene where the platoon trudges through the sand and an aircraft passes overhead, blasting The Doors' song "Break on Through" (1967). One Marine complains: "That's Vietnam music. Can't we get our own fucking music?" Perhaps, so long as they reengage the Vietnam Syndrome, protest artists—ironically—will never "break on through to the other side."

Yet even *Jarhead* signals the loop's shift toward becoming an open curve in a new direction. "This is not Rambo time," confirms Kaczynski at one point, and it is not combat but rather the *lack* of it that pushes the Marines to near-insanity—the film shows no violence whatsoever. And if still a loop, history is moving at a different pace in *Jarhead*'s war: "This war's gonna move too fast for us," says Troy. "All right, we can shoot 1000 yards. To go that far in Vietnam that would take a week…here it's gonna take about ten fucking seconds." The Marines' homecoming parade is then an anticlimax, tempered when a Vietnam veteran climbs onto their bus. Significantly, this moment also echoes the opening scenes of Oliver Stone's film, *Born on the Fourth of July* (1989), adapted from veteran Ron Kovic's 1978 memoir, when the young Kovic, watching a parade, exchanges a glance with World War II veteran played by the real Kovic. Here *Jarhead* recalls the empowered and politicized veterans, like Kovic and VVAW members, who protested the Vietnam War and now protest the war in Iraq. For a brief moment, by remembering antiwar protest and signaling the anticlimactic end of Vietnam-era thrills, Mendes' film aligns itself with Slotkin's assessment, that America is evolving, its myths changing. "By our way of remembering, retelling, and reimagining 'America,' we too engage myths with history and thus initiate the processes by which our culture is steadily revised and transformed," observes Slotkin (660).

Jarhead—along with all the art and literature that remember Vietnam during the Iraq War—is also located within a much broader protest tradition. The replacement of one feedback-loop with activist memory is at the heart of a long-standing tradition of American dissent. Across time, protest writers and artists have appropriated the master's tools and simultaneously borrowing tools from their own heritage of dissent. Choosing and reshaping their ancestry, American protest writers and artists have fashioned an intellectual *bricolage*: images, ideas, and language

stored across time, then transformed by new contexts into a living protest legacy. And as part of that tradition, protest writers now reclaim the protest moment of Vietnam and find a palpable past for their antiwar literature—"The past is not dead. In fact, it's not even past," insisted Horace Coleman of Vietnam-era protest voices, quoting William Faulkner in a 2004 VVAW article about Iraq (27). Activist history has become the contemporary activist's muse. Creating spins and turns from Saigon to Baghdad and back, contemporary dissenters open a space of protest memory where we might deconstruct Iraq War culture.

NOTES

1. The concept of a "feedback-loop" originates with the systems dynamics model. See Jay Forrester, *Industrial Dynamics*. The concept of a "feedback loop" was later popularized by Peter Senge in *The Fifth Discipline*.
2. See also Lloyd B. Lewis's argument that war films provide "a cinematic frame of reference for structuring experience," and "also a cluster of significant symbols for interpreting it" (23, 25); Donald Ringnalda's claim that in "America's trillion-dollar Vietnam movie, we all were actors, not audience" (83); and John Hellmann's argument that the "more developed veterans' literary accounts connect the authors' actual experiences to the American myth they had previously assimilated from popular culture" (102).
3. Gamers also fight in the Old West (*Gun*), World War II (*Brothers in Arms*), the urban jungle (*Grand Theft Auto, Liberty City/Vice City/San Andreas*), the Persian Gulf War (*Will of Steel* and *Battlefield 2: Modern Combat*), and the conflict in Afghanistan (*Will of Steel*).
4. American Soldier is a wounded infantry man who returned from Iraq after his second Purple Heart; MMORPGs are "Massively Multiplayer Online Role-Playing Games" such as *Everquest*, often known as "Evercrack" due to its highly addictive nature.

WORKS CITED

America's Army. "FAQs: Parents Info"; http://americasarmy.com/support.
American Soldier. "About: Who Is American Soldier?" http://soldierlife.com/?page_id=423.
American Soldier. (2005). "XBOX 360," December 29; http://soldierlife.com/2005/12/29/xbox-360.
Baard, E. (2004). "George W. Bush Ain't No Cowboy," *Village Voice*, September 29, 26–30.
Baritz, L. (1985). *Backfire: A History of How American Culture Led Us into Vietnam and Made Us Fight the Way We Did*. New York: Morrow.
Boot Camps for Struggling Teens. "Welcome To Boot Camps"; http://boot-camp-boot-camps.com.
Born on the Fourth of July (1989). Dir. Oliver Stone. Universal.
Bush, G. W. (2001). "Guard and Reserves 'Define Spirit of America,'" September 17, 2001.
Bush, G. W. (2007). "President Bush Attends Veterans of Foreign Wars National Convention, Discusses War on Terror," August 22.
Charbonneau, S. *"Elite Warriors: Vietnam* Ships," http://boldgames.com/pr/ewpress.html.
Coleman, H. (2004). "The Past," *Veteran*, Spring, 34(1), 27.
Dadmanly. (2005). "Xbox Soldiers in Iraq," February 18; http://dadmanly.blogspot.com/2005/02/xbox-soldiers-in-iraq.html.

Daniszewski, J. (2003). "Troops Tell of Street Fight with Dogged Foe," *Los Angeles Times*, December 2, A1.

Dionne, E. J. (1991). "Kicking the 'Vietnam Syndrome,'" *Washington Post*, March 4, A1.

Downing, J. (2004). "Army to Potential Recruits: Wanna Play?" *Seattle Times*, December 7, B1

Ehrhart, W. D. (2005). "Iraq Is Not Vietnam, But ..." *Veteran*, Fall, 35(2), 18.

Engelhardt, T. (2006). "Vietnam Veterans on Civilian Casualties in Iraq," *TomDispatch*, January 22; http://tomdispatch.com/index.mhtml?pid=51741.

Forrester, J. (1961). *Industrial Dynamics*. Waltham: Pegasus Communications.

Full Metal Jacket (1987). Dir. Stanley Kubrick. Warner Bros.

Gryzlak, B. (2006). "The Machine Breaks Down," *Veteran*, Spring, 36(1), 24.

Hanley, C. J. (2006). "Vietnam Casts Shadow Over Iraq Conflict," *Los Angeles Times*, May 28, A32.

Hedges, C. (2003). "Interview with Bob Abernethy for Religion and Ethics," *PBS*. January 31; http://pbs.org/wnet/religionandethics/week622/hedges.html.

Hellmann, J. (1986). *American Myth and the Legacy of Vietnam*. New York: Columbia University Press.

Herr, M. (1997). *Dispatches*. New York: Knopf.

HPS Simulations. "The Campaign Notes: Comments on Jungle Warfare & Traditional Warfare";http://www.hpssims.com/Pages/products/SB/SBVietnam/SBVietnam.html.

Huston, Johnny Ray. "Love, Lee: Behind *Brokeback Mountain* You'll Find a River of Tears," *San Francisco Bay Guardian*, 7–13 December 2005.

Jenkins, B. (2004). "Sony Playstations Used in Military Combat," *Liquid Generation*, April 9.

Jones, T. (2008). "Beyond the Border of War," *Washington Post*, March 17, C1.

Kennedy, E. (2004). "Speech at the Brookings Institution," April 5; http://brookings.edu/comm/events/20040405kennedy.pdf.

Kerry, J. (1971). "Testimony," April 23; http://hnn.us/articles/3631.html.

Kerry, J. (2006). "The Right to Dissent," April 22; http://truth-out.org/article/senator-john-kerry-the-right-dissent.

Krugman, P. (2004). "The Vietnam Analogy," *New York Times*, April 16, A19.

Kuma\War. "Quotes from Players in the Trenches, SGT from HHC 1/64 Armor"; http://kumawar.com.

Lewis, L. B. (1985). *The Tainted War: Culture and Identity in Vietnam War Narratives*. Westport, CT: Greenwood Press.

Lifton, R. (2004). "Made in Iraq," *Boston Globe*, August 25, A9.

Meek, J. (2005). "Visions of Hell," *Guardian Weekly Film and Music*, December 16, 6.

"New Not in Our Name Statement of Conscience," January 2005; http://www.rwor.org/a/007/statement-of-conscience.htm

"Obituary for Dan Priester" (1998). *Veteran*, Spring, 28(1), 22.

Odom, W. E. (2006). "Iraq through the Prism of Vietnam," *Commentary*, March 9; http://commondreams.org/views06/0309–20.htm.

"Original Not in Our Name Statement of Conscience," June 2002; http://technohippie.com/archives/nion_2002.html.

"Peace Has No Borders." June 2006; http://dragonflihost.net/phnb-flyer.pdf.

Pierrou, B. (2006). "You Might Be a Redneck Marine" and "The Survey," March 2, April 24; http://blog.myspace.com/42127521.

Poets Against the War. "Archive"; http://poetsagainstthewar.org.

Prosise, J. (2005). "XBox in Iraq," *Jeff Prosise's Blog*, April 13. http://wintellect.com/CS/blogs/jprosise/archive/2005/04/13/xbox-in-iraq.aspx

Purdum, T. S. (2005). "Flashback to the 60's." *New York Times*, January 29, A12.

Ricks, T. (2003). "Ex-Envoy Criticizes Bush's Postwar Policy," *Washington Post*, September 5, A16.

Ringnalda, D. (1994). *Fighting and Writing the Vietnam War*. Jackson: University Press of Mississippi.

Romo, B. (2004). "The Struggle Continues,"*Veteran*, Fall, 34(2), 1.

Romo, B., Curry, D., & Miller, J. (2003). "On the Oil-Slicked Road to Empire," *Veteran*, Spring, 33(1), 1.

Rutenberg, J., & Stout, D. (2007). "Citing Vietnam, Bush Warns of Carnage if U.S. Leaves Iraq." *New York Times*, August 22, A13.

Senge, P. (1990). *The Fifth Discipline: The Art and Practice of The Learning Organization*. New York: Doubleday.

Sheehan, C. (2005). "Speech at Washington Memorial Rally," September 24; http://huffingtonpost .com/cindy-sheehan/my-speech-at-the-antiwar_b_7823.html.

Shunas, B. (2005). "Fraggin," *Veteran*, Fall, 35(2), 3.

Simons, L. (2005). "A Tale of Two Wars," *Washington Post*, August 28, B1.

Slotkin, R. (1992). *Gunfighter Nation: The Myth of the Frontier in Twentieth-Century America*. New York: Atheneum.

St. George, D. (2006). "Iraq War May Add Stress for Past Vets," *Washington Post*, June 20, A1.

Swindell, T. (2006). "Message from a Vet of My Lai Time," *Counterpunch*, May 4; http:// counterpunch.org/swindell05042006.html.

Swofford, A. (2003). *Jarhead*. New York: Scribner.

Thompson, C. (2004). "The Making of an X Box Warrior," *New York Times*, August 22, 33.

Trodd, Z. (ed.). (2006). *American Protest Literature*. Cambridge, MA: Harvard University Press.

Vietnam Veterans Against the War (2002). "No War with Iraq!" *Nation*, November 11, 275, 16.

Von Drehle, D. (2006). "Voices of 100 Veterans," *Washington Post*, March 19, A1.

Waldman, A., & Birman, A. (eds.). (2004). *Civil Disobediences: Poetics and Politics in Action*. Minneapolis: Coffee House Press.

Young, M. (2003). "Historians Reflect on the War in Iraq," April 5; http://oah.org/meetings/2003/ roundtable/young.html.

The Torturer's Tale

Tony Lagouranis in Mosul and the Media

STEPHANIE ATHEY

Lagouranis:	Well, it's funny, because at that time that that [Abu Ghraib] scandal broke and the picture came out, I was using the harshest tactics that I used all year in Mosul. I was using dogs, I was using stress positions. And I look at those pictures and I was horrified. And I thought that this—you know, these were bad apples. Because …
Matthews:	But you were doing the same thing.
Lagouranis:	Well not exactly.
Matthews:	Were you doing that, putting dogs within a couple feet of a guy's face?
Lagouranis:	Yes, we were doing that.
Matthews:	Well what were they doing differently than you?
Lagouranis:	Well that particular picture could have been a picture of me. I mean that was.
…	
Matthews:	Did it work for you?
Lagouranis:	It never worked for me.

—*HARDBALL WITH CHRIS MATTHEWS*. MSNBC. JANUARY 16, 2006

Perhaps, I've thought for a long time, I also deserve to be prosecuted.

—TONY LAGOURANIS, "TORTURED LOGIC," *NEW YORK TIMES*, FEBRUARY 28, 2006

I think they probably felt they were getting it pretty easy…We were getting prisoners from the navy SEALs who were using a lot of the same techniques we were using, except they were a little more harsh. They would actually have the detainee stripped nude, laying on the floor, pouring ice water over his body. They were taking his temperature with a rectal thermometer. We had one guy who had been burned by the navy SEALs. He looked like he had a lighter held up to his legs. One guy's feet were like huge and black and blue, his toes were obviously all broken, he couldn't walk. And so they got to us and we were playing James Taylor for them—I think they probably weren't that upset about what we were doing. Not that I'm excusing what I'm doing, but their reaction was not very severe to it.
—TONY LAGOURANIS INTERVIEWED BY JOHN CONROY, *CHICAGO READER*, MARCH 2, 2007

Specialist Tony Lagouranis does not shy away from complexity. A Chicagoan, Great Books enthusiast, student of ancient Greek, Hebrew, and Arabic, and military interrogator, Lagouranis was 31 at the time he entered Iraq where he served from 2004 to 2005. There he read literary classics—Hemingway, Tom Wolfe, Twain, Orwell, and Tolstoy's *War and Peace,* twice. Like other soldiers he watched and rewatched Reagan-era war-and-glory standbys—*Top Gun, Red Dawn, Rambo*—and antiwar classics like *Full Metal Jacket, Platoon, Apocalypse Now, Three Kings.*

Lagouranis also watched CNN's coverage of Senate hearings on the torture of Iraqis at Abu Ghraib prison where he was stationed, and he listened in anger and confusion to the bafflement expressed by top military and civilian commanders, including Secretary of Defense Donald Rumsfeld. When General Antonio Taguba's investigation leaked to the media in April 2004, he read the report, which detailed numerous specific assaults not visible in the widely circulated photographs, including rape, sodomy, and 12 corpses (Lagouranis with Mikaelian, 137).

And Tony Lagouranis tortured prisoners in Iraq.

He planned and perpetrated torture in Mosul and al-Asad airfield; he was witness to severe injuries and heard testimony from those who suffered brutality at Forward Operating Base Kalsu in North Babel and at Abu Ghraib where he was stationed, recording evidence of severe beating at the latter well after the prison had been "sanitized" in the wake of the scandal. Lagouranis himself conducted torture by hypothermia, isolation, sleep deprivation, extended stress positions (kneeling, standing, and 90-degree wall-squats), hooding, high decibel sound, hunger, strobe lights, and staged attacks with dogs. At one point he grappled with a deep desire to cut off a subject's fingers.

When Lagouranis stepped forward, voluntarily offering interviews on torture after an honorable discharge in July 2005, media outlets were ready to run his story, and human rights monitoring organizations turned to him for evidence and a form of expertise. His interviews sparked angry exchanges with "ex-military and right-wing" bloggers on sites like Blackfive.net or HaloScan.com, who vehemently reject-

ed Lagouranis' testimony and called him a hypocrite, "buddy fucker," and worse. In part owing to this response, Lagouranis published his own book-length testimonial with the assistance of Allen Mikaelian in 2007.

In *Fear Up Harsh: An Army Interrogator's Dark Journey through Iraq*, Lagouranis claims responsibility and tells his story: how within five months of his arrival in Iraq he had not only become a torturer, but he had begun to recognize himself as such and how he spent the rest of his deployment trying to reckon with that knowledge emotionally, morally, and procedurally. As a firsthand account, Lagouranis' story is important for the way it documents patterns of torture well beyond Abu Ghraib prison. Cast as a developmental narrative, the book attempts to trace several strands of causation and shows them converge at Mosul where, by Lagouranis account, he undertook the worst tortures and faced the worst in himself.

Yet, just as Lagouranis' press interviews seem to mix acknowledgment, denial, and responsibility for torture, the book-length narrative is no straightforward "journey" from moral blindness and failure onward to recognition, responsibility, and remorse. Even as his behavior escalates, his responses are *simultaneously* remorseful, sadistic, and perfunctory. Many times, Lagouranis allows himself to recognize and explore some of these inconsistencies; often they go unremarked. This is to say that the contradictions and crafting of the narrative should draw the reader's attention as much as the content. This chapter examines three aspects and implications of that construction.

First, even though the book emphasizes the institutional, bureaucratic, and social context for torture and the psychodynamics of Lagouranis' involvement, his experience also reveals and then unravels the fantasy of the professional interrogator whose "dark arts"—that is, secret, illicit knowledge and skill—unlock the mysteries in men. The book implicates the military and the civilian world and media in generating and sustaining a fantasy that supports torture.

Second, in place of this fantasy, it makes a strong case that extreme measures amounting to torture were systematically encouraged and protected by the command structure through a combination of intent and incompetence. Ineffective and counterproductive from an intelligence-gathering point of view, such practices fed on a culture of mutual influence and competition and on individuals' own psychological needs.

Third, while the book offers a powerful indictment of the system that produced him, it would be a mistake to take only this from his story. Indeed, Lagouranis' case offers a valuable caution regarding perpetrator confessions and challenges the role of the interviewer and the audience when eliciting or confronting them. In this sense, it is important to consider what this confession is and what it is not.

Lagouranis expresses remorse and owns up to terrible acts capable of producing severe pain and lasting physical, emotional, and psychological damage in the sur-

vivors for life (Physicians for Human Rights & Human Rights First). His account demonstrates torture was systematic and pervasive in many regions inside Iraq. By speaking out, Lagouranis counters official denials and identifies the ideology and infrastructure supporting criminal acts.

Even so, the book is careful not to give up names. Nor does it land him in jail. In exposing torture, his story does not assign responsibility to actual persons or decision makers, nor does it identify those subjected to his tortures. So, one might ask, what is the point of the confession? It does not advance criminal proceedings, call out perpetrators, identify victims, or locate survivors. What is—what should be—the role of perpetrators in advancing the discussion on torture and promoting the cause of justice?

The following discussion takes up that question of justice more pointedly but first places Lagouranis' account in the context of other perpetrator confessions. It then looks at the construction of his story more closely: its presentation of the media, the military, and the man. In the end, what we confront are the dangerous political implications of a persona, a persona embraced by media and carefully crafted to claim responsibility and diffuse it at the same time.

PERPETRATOR CONFESSIONS

> I'd been skeptical of all the things we were doing—the whole torture lite package—and I'd been following orders, and I tried to make sure we didn't go too far.
> —LAGOURANIS WITH MIKAELIAN, *FEAR UP HARSH*, 130

Whether in the context of truth commissions or tabloid TV, from within the post-dictatorial transitions in countries like Argentina or Chile or within long-standing democracies such as France, torturers have been telling their stories for a long time. What have we learned?

Recent documentary films such as *Ghosts of Abu Ghraib* (2007) and *Standard Operating Procedure* (2008) showcase testimony from the military police and interrogators (MPs, MIs) of Abu Ghraib, several of whom have now completed their sentences on charges ranging from assault to dereliction of duty. They show little remorse for torture, violence, or humiliation, although at times a speaker will agree the acts captured in photos were "bizarre." Instead, the speakers blame the system (and each other), and in this sense, support the narrative thrust of the films, which direct attention upward through the chain of command.

The Abu Ghraib photos triggered other testimonial and confessional acts. Several MPs, linguists and interrogators in Afghanistan or Guantánamo, as well as Abu Ghraib have published book-length accounts seeking to separate themselves from the behavior depicted there. In these accounts, participant-observers at U.S.

detention centers—such as Chris Mackey, Erik Saar, James Yee, Janis Karpinski—earnestly excuse themselves as they bear witness to a range of other abuses, place them in a larger context, indict the system, or all of the above. Their denials notwithstanding, these narratives point either wittingly or unwittingly to torture as systematic and system-wide. As the first sustained narrative to attempt to take personal responsibility for acts of torture, Tony Lagouranis' book is exceptional among this group.

Yet, this U.S. phenomenon exists within a larger field. Political scientist Leigh Payne has studied torturer confessions in the wake of deadly regimes in Brazil, South Africa, Argentina, and Chile. Her detailed study foregrounds confession as public performance, each disclosure having a specific set of incentives and circumstances that bring it into being, hence a particular timing, staging, script, audience, and gestural and tonal language. Indeed, Payne has identified several recurring modes of confessional performance: including (rarely) remorse, and (frequently) heroism, denial, betrayal, sadism, silence, amnesia.

Payne cautions that perpetrator confessions are not truths but "explanations and justifications for deviant behavior or personal versions of the past" (2). Most perpetrators never apologize, do not recognize their actions as wrongdoing, and all rationalize their actions in moral terms. Nor are their confessions static: content alters with changing political contexts and opportunities.

MEDIA SCENES OF INSTRUCTION

> Only the sexual humiliation seemed distasteful to me…Aside from that, I was ready to try this stuff myself.
>
> —LAGOURANIS WITH MIKAELIAN, *FEAR UP HARSH*, 51

Tony Lagouranis was developing his 2007 account within the context of multiple media interviews and exchanges. Across 2005–2007, *National Public Radio*, *Frontline, Hardball, Democracy Now!, The Washington Post, The Chicago Reader* and others got interviews. Lagouranis turned down many more requests than he accepted. He was driven not by a desire for celebrity, he says, but by a compulsion: "I went to the media fully admitting that I'd done terrible things…I hoped that if I made a few appearances, it could reframe the public debate, spur a more serious investigation, and let people know about some of the things that were being done in their names" (Lagouranis with Mikaelian, 239).

Human rights monitoring organizations also responded to Lagouranis' testimony. John Sifton of Human Rights Watch found corroboration for Lagouranis' account. Human Rights First involved Lagouranis in an antitorture training video for West Point cadets. Lagouranis was invited onto the set of Fox Television's *24* in

2006, and Human Rights First invited him to judge television depictions of torture for their complexity and accuracy in their first "Prime Time Torture" award competition in 2007.

Though Lagouranis turned down discussions with reporters and producers who "had that same creepy tone I got from people who asked if I'd killed anyone," he found even the well-informed interviews "generally wanted to hear about the worst abuses."

> The problem was that the worst abuses I knew about always came to me secondhand. I saw the injuries, and I heard the stories, but I was not witness to those actual events…leaving behind the facts of what I actually did myself. (239)

Almost exclusively, media attention in the States was interested in the extent to which Lagouranis exposed inefficiency in the larger military effort and pointed toward command responsibility for torture and abusive detention practice. The interviews did not pose questions concerning his legal culpability for torture. Nor did these reports investigate from the perspective of those Lagouranis harmed. U.S. interviewers were more likely to ask him for personal reflection on his role as whistle-blower, his posttraumatic suffering, or the meaning of "moral courage," a question that, to his credit, he said he was the wrong man to answer.

It took a Danish filmmaker to ask him directly why he should not be tried for war crimes. Lagouranis admits being caught off guard, resorting to classic forms of torture denial: shifting blame and pointing to worse cases (Lagouranis with Mikaelian, 241).

Lagouranis discusses some of these media encounters at the end of the book, but mass-mediated culture plays a role worth observing throughout. Certainly, *Fear Up Harsh* is steeped in the current media debate on torture and reflects its contours, and from the beginning, he tethers moments of his own experience to insights from ancient and contemporary texts on war, ranging from the *Iliad* to *A Few Good Men*. The book itself draws its section head notes from such sources as *Hebrews*, Dostoevsky, and military historians of Algeria or Vietnam. His cultural references include literature, comics, film, sociology, and history and reflect the multimedia-saturated, pop culture-laden milieu in and through which soldiers work, play, and understand their lives in Iraq. In this way his book is much like other "grunt lit" from Iraq and Afghanistan to date (Brown & Lutz). Yet Lagouranis also uses these references to craft a persona and bridge contradictions. Connection to Hemingway or Orwell might counter stereotypes that attach to dissent—for example, unmanly weakness, unpatriotic "buddyfucker"—or those that attach to torture: unthinking monstrosity. Instead, he is the dissenting *warrior* or the *humane* perpetrator.

More importantly, they alert the reader to ways of literary culture, cinematic images, and the ongoing media debate on torture preceded his involvement and actually propelled him toward the "dark corners" of the experience he describes. For instance, awaiting deployment with other newly trained interrogators at Fort Gordon, Georgia, he tells us they eagerly read and discussed Mark Bowden's 2003 feature in the *Atlantic Monthly*, titled "The dark art of interrogation: The most effective way to gather intelligence and thwart terrorism can also be a direct route into morally repugnant terrain" (Bowden 2003). Bowden, like many who adopt the formulaic Heart of Darkness conceit when writing on torture, exudes a studied moral ambivalence as he seeks out the torturer and examines his tools, but the feature's fascination with torture and of course its title, all signal a foregone conclusion. According to Lagouranis, Bowden's piece was read as a type of underground guidebook, one that offered the term "torture lite" and justification for stealth torture techniques that leave no marks.

Those techniques—sleep deprivation, hooding, stress positions, noise, hunger, and temperature—had been ruled out by his Ft. Huachuca training.[1] Contemplating this array, Lagouranis says: "Only the sexual humiliation seemed distasteful to me…Aside from that, I was ready to try this stuff myself" (51). This is significant because although Lagouranis will follow with a narrative explaining the military climate and group dynamics that authorized and rewarded torture, he is clear that even before he left for Iraq, he held "a coiled mass of contradictory beliefs and urges inside…[T]orturing helpless prisoners was morally reprehensible…[yet] the 'enhancements' I just learned about were fair and legal. I saw lines and boundaries, however vague…and I desperately wanted to push against them as hard as I could" (51).

Importantly, as Lagouranis carefully examines the roots of his own "moral failing," he blames the military, and he blames himself. But he does not let the civilian world off the hook. For instance, on leave in the second half of 2004, Lagouranis "heard more debate over *American Idol* than over the presidential election and the war combined" and, he adds, nothing on the "still-fresh" Abu Ghraib scandal. Worse:

> The casual and even enthusiastic way people expressed their morbid curiosity was a horrible, unbearable contrast to my despair over the tragic violence and suffering I'd witnessed, and in some measure caused. (155)

An explosive fight with his cousin is representative. He asked if Lagouranis had tortured anyone "because he wanted those terrorists either in severe pain or dead. Our family separated us once he learned my views on the subject and called me a traitor" (230).

If the mixture of ignorance and fascination is maddening for Lagouranis, it is also familiar. The media features on torture he had read so avidly before deployment played on this combination of desire and dread. And in retrospect, he writes, he had shared these same feelings and perceptions well into his first year in Iraq.

PHANTOM PROFESSIONAL

> I did my best to put on a show. Lots of yelling, lots of intimidation. The rest of my team ate it up.
>
> —LAGOURANIS WITH MIKAELIAN, *FEAR UP HARSH*, 54

As his subtitle implies, Lagouranis frames his story as a quest, "an interrogator's dark journey." That quest is for extreme experience and the true knowledge of interrogation. As does Mark Bowden in his journalistic fantasy-quest, from early on Lagouranis seeks a professional who had mastered the "dark arts" of interrogation and therefore had license to use them.

Fort Huachuca teaches no good information comes of torture: "We heard that, but never really believed it" (39). He holds instead to moments when his instructors made joking asides about torture: clipping generators to genitals, hanging people by their hands, throwing them out of helicopters. These moments students discussed "with relish," debating what "the British and Israelis do" (39). Awaiting deployment, he also received "highly informal trainings and briefings from interrogators who'd just returned from Afghanistan and Iraq," offering stories of sleep "adjustment," music, lights, diet manipulation, sexual humiliation, and more (50).

Racism is also part of the training. Lagouranis describes "hate-filled rants and bombast" targeting the Koran and Arabs from his instructors at the Defense Language Institute. Absurd claims concerning Arab sexuality and phobias (based on Raphael Patai's *The Arab Mind*) constitute his first PowerPoint briefing on arrival at Abu Ghraib in early 2004.

There, Lagouranis learns by watching others. He finds his immediate supervisors know less about interrogation than he does, and he begins to notice they believe "that there was some magic to interrogation, that we interrogators 'have ways to make you talk'" (74). Yet, because he himself buys into the "aura of mystery around it," his lack of results leaves him frustrated.

Even so, others presume him to be an expert. Satisfying their expectations requires showmanship more than magic or expertise. He is rushed out of bed to interrogate men at the Abu Ghraib prison gate in front of expectant infantry. Freeing one man, jailing two others with signs of appreciation and admiration from his audience, he is pleased with his intimidating and hostile "fear up harsh"

performance. Yet, once the adrenaline fades he realizes he's made poor judgments based on illogical inferences. As new techniques for fear and pain are added to his repertoire, there is a constant tension between the thrill of performance, immediate feedback from his team, and the lack of results.

> These techniques were propagated throughout the Cold War, picked up again after 9/11, used by CIA, filtered down to army interrogators at Guantánamo, filtered again through Abu Ghraib, and used apparently around the country by special forces. Probably someone in this chain was a real professional, and if torture works—which is debatable—maybe they had the training to make sure it worked. But at our end we had no idea what we were doing...we were just trying shit out to see if it worked, venting our frustration and acting like badasses when, in the dark art of torture, we were really just a bunch of rank amateurs. (119)

As Lagouranis learns, the "real professional" is a phantom. Belatedly, the national Intelligence Science Board concedes the same: no professionals get good intelligence by relying on "dark arts," torture, or coercion.[2] Lagouranis' experience confirms this. At most, one in ten captives he "processed" had any information to offer at all. That information only confirmed things they already knew.

Exhibiting anxiety over his own professionalism, Lagouranis carefully highlights social and organizational factors that laid the groundwork for torture. Based at Abu Ghraib prison in early 2004, he was quickly mustered into a mobile intelligence unit that would serve elsewhere, including Al-Asad airfield, Mosul, and North Babel. As at Abu Ghraib, a detainee had been murdered prior to his arrival at Al-Asad (Human Rights First). Likewise Mosul had seen a recent homicide in custody, and another man was to die while Lagouranis was on site (Human Rights Watch).

Among the organizational elements supporting torture, even homicide, Lagouranis points to the different dimensions of incompetence at work: the absence of basic cultural knowledge, a pervasive presumption of guilt when dealing with Iraqis that reflected and reinforced racist assumptions, and gross procedural inefficiency and malaise.

Alongside incompetence, Lagouranis points to command intention as a key feature of the institutional climate for torture. Carefully designed protocols—authorizing prolonged use of stress positions, sleep deprivation, and dogs, among other things—were signed by Secretary of Defense Donald Rumsfeld in late 2002 (and later rescinded), and reauthorized by Commander of Coalition Forces in Iraq, Lt. General Ricardo S. Sanchez on September 14, 2003. Though dogs had been strictly forbidden at Abu Ghraib by early 2004 (as quiet investigations into photographs began), in Mosul, the Chief Warrant Officer and Officer in Charge pointed to documentation authorizing dogs. These commanders initiated 24-hour interrogation operations that liberally interpreted guidelines on sleep for detainees, among other things. As in this instance, Lagouranis indicates that pressure from commanders was

coupled with a culture of creative interpretation necessitated by the shifting patch-work of Interrogation Rules of Engagement.

Two cousins were the first subjects of the new 24-hour routine at Mosul. Their ordeal lasted four weeks. The Chief routinely called for more intensity without suggesting specifics. The interrogators complied with creative variations on sleep deprivation, positional torture, exercise exhaustion, and hypothermia (e.g., kneeling in 40-degree temperatures and rain for hours). In the third week, the subjects' severe weight loss, physical deterioration, and mental debilitation were clear. Strikingly, a team meeting at this point revealed that the interrogations had not only tapered off but stopped altogether, yet the torture continued. As Lagouranis says, "By now, it was torment done for its own sake, and so I could put down on my report that I did this all night" (129). Command also initiated the use of attack dogs. Despite the complete lack of "results," the techniques quickly extended throughout Mosul.[3]

Even as authorizations and inducements transferred vertically down the chain of command, Lagouranis' book illustrates a horizontal culture of mutual influence. He documents the migration of personnel and tactics from Guantánamo and Afghanistan to Iraq. Guards and interrogators swapped tactics in an atmosphere that mixed bragging, gossip, and professional advice; prisoners themselves passed along descriptions of techniques they suffered under Navy SEALs. Devoid of results or even rumors of results, torture thrived in this command environment and informal circuits of observation, envy, and encouragement.

PLEASURE AND DANGER

> I did these things, basically, for my own amusement. Just to see how far I would go, just to seek out an extreme experience. Here I was in a god-awful war zone…and I was acting like a tourist.
>
> —LAGOURANIS WITH MIKAELIAN, *FEAR UP HARSH*, 131

Just as Lagouranis is carefully evaluating his professional environment, he is also identifying the psychological needs and desires that draw him forward. He describes himself as a boundary crosser, someone who had always been attracted to the kind of extreme experience that pushed past limits. Beyond limits, he imagines realms where he could give up control and experience chaos. Ironically, he says, interrogation demands strict control because one holds absolute power over other human beings.

He quickly finds that power to be deeply addicting. Detainees who understand they can defy him must be punished for that defiance (98). Those who do not

acknowledge his power drive him to a point where he hates himself and the subject (126, 90). When he's lost the ability to increase psychological or physical suffering, he feels "naked and unarmed standing before these prisoners" (95). This disturbing turn of phrase offers a graphic (and outrageous) role reversal common in the rhetoric of the torturer. It justifies violence and obscures it. Here, it also reflects reciprocal relations of dependence and need forged between captor and captive.

This is clear when dogs become part of the routine in the "little discotheque"— the shipping container where sleep-deprived captives face painful positional torture, strobe lights, and excruciating audio bombardment. He depicts the "power" this setting has over *him*: "The music and lights were making me increasingly more aggressive. The prisoner, still not cooperating, was making me increasingly angry" (116). When he escalates with an attack dog, "a darker, less rational part of me liked seeing the man who had defied us for so long try to cover his balls in fear" (110). One prisoner, given the alias "Jafar," urinates in fear. A second man, "Khalid," endures even the dog with resignation, and Lagouranis' anger triggers a serious desire to "chop his fucking fingers off" (127). It is significant that in both cases, Lagouranis describes being suddenly interrupted by roaming soldiers who "heard the music…and decided to join the party," hitting sides of the container, jumping on top, with "wrath and chaos in their screams" (117). In "Khalid's" case, four sergeants arrive, entering with guns, yelling and encircling the prisoner (128). By establishing his own control in these dicey situations and preventing group attacks on his prisoner, Lagouranis contrasts his own forms of assault with the seemingly more sadistic pleasure of group violence as recreation. Lagouranis later sees his own "cruelty reflected in the cruelty of the four men I had just restrained from beating Khalid." He nonetheless maintains he rescued him (when in fact he created the setting that made "Khalid" more vulnerable to this kind of group energy and assault) (130).

Many times in this way, Lagouranis contrasts his behavior with the violence of others so as to forge an identity more professional, rational, and controlled—even humane or compassionate—by comparison. Yet his "compassion" and his "violence" might be less distinct and more complementary or mutually reinforcing than he suspects.

For example, Lagouranis begins apologizing to prisoners at their cages, seeking out "prisoners I'd just tormented, trying to connect on a more human level" (83). Prisoners find this behavior strange or outrageous; some glare with resentment even while seeming to submit politely. Yet, as he says, he's still "behaving badly back in the booth," not backing down on harsh tactics, quite the opposite: "Still psyched" on interrogation, "I wanted to take it as far as I could" (83). This is to say, these seeming demonstrations of remorse are a very mixed bag, indicating the extent to which

both his emotional equilibrium and professional identity are now dependent on getting something, a great variety of things, from the detainees.

The fully sadistic dimensions of this behavior remain unclear to him. He uses his power to force others to fill a range of emotional needs: not only pleasure, but also absolution, comfort, entertainment. Consider his discussion of a prisoner assigned to "another interrogator." The man is made to kneel in the cold for hours while his (unprofessional) interrogator "slept or watched a stupid movie." Lagouranis pulls the man into the heated interrogation booth: "He wanted to go to bed and so I made a deal. Sing me a song, and you can sleep…Night after night, he'd sing, and then I'd take him back to his cage to sleep" (114). Lagouranis portrays this as an act of conscience and compassion. Yet when one imagines a prisoner at the farthest brink of pain and exhaustion asked to sing as a condition of sleep, it seems perversely sadistic, not merciful. How would the prisoner describe this scenario? However earnest or self-congratulatory, these displays of compassion—as with the displays of remorse—demonstrate Lagouranis' power to manipulate the captives emotionally in ways that humanize the perpetrator and confirm his view of himself.

Lagouranis marks the urge to "chop off fingers" as a frightening turning point. After this, he refuses to work "the disco." A second point comes when photos from internal military investigations at Abu Ghraib are leaked to the news. While at first he did not in any way connect the MPs' behavior to what he himself was involved in at Mosul, the Senate hearings forces him outside his "military cocoon": "The only difference they would have noticed between our prison and Abu Ghraib was that our prisoners had their clothes on" (136). When Lagouranis finally tells his superiors he won't work the disco anymore, the entire program ends abruptly.

Halfway into his year in Iraq and back at Abu Ghraib, the Criminal Investigation Division calls him in. Lagouranis sends word to a friend and a lawyer back home. When he realizes CID was not, in fact, investigating him, he still goes ahead and makes a full report on his actions at Mosul. He decided not to participate again in "enhanced" interrogations, but he cannot escape scenes of torture. At North Babel, he finds axe handles used to break feet, exhaust pipes to burn legs, waterboarding, and mock executions (180, 215).

Tony Lagouranis was honorably discharged a few months after his return from Iraq in 2005. He suffered from insomnia, panic, hallucinations, and other severe psychological disturbances. He struggled with medication and therapy, objecting to a therapist who framed his experience within the context of Stanley Milgram's 1961 obedience experiments. He deems this "the worst kind of moral relativism" (231–232). Milgram's findings, by the way, are evoked at the beginning and end of Rory Kennedy's documentary, *Ghosts of Abu Ghraib*, a film that features perpetrator testimony prominently. Lagouranis' rejection of such a frame is in keeping with

the level of critical thought and individual responsibility he brings to his involvement in torture. It is utterly new in writing from the current war on terror. Dramatic and voluntary, his confession is nonetheless strategic.

MORAL AWARENESS AND NARRATIVE POSITIONING

> I could have stopped this at anytime. I could see now that the strides we took into extreme techniques were hesitant and fragile. If I had stood up at any point in this process and said, "This is wrong," it would have lurched to a halt. Why didn't I do this?
> —LAGOURANIS WITH MIKAELIAN, *FEAR UP HARSH*, 134

Lagouranis' book, of course, is an attempt to answer this question. Certainly, elements of his organizational environment present a textbook case in the formation of a "violence worker" (Huggins, Haritos-Fatouros, & Zimbardo; Conroy; Rejali). Without question, attention to this environment is critical. However, while the notion of command pressure, ever-thickening moral blinders, and a spiraling descent into darkness makes a good tale, as does his narrative of increasing addiction to power, many single moments disrupt these narrative threads and hint at stories left untold. Consider: although Lagouranis identifies command pressures, it is clear that others around him simply refuse to participate. They bow out, without repercussion (110). So does he, eventually. Moreover, his self-portrayal as independent professional or compassionate exception is often at odds with those larger storylines and contradictory in its own right. This makes narrative persona, positioning, and timing critical to consider as well.

Fear Up Harsh is an effort to address multiple contending audiences. In 2007, the public was divided on the war in Iraq and perhaps more so on the question of torture: low-ranking military police were serving sentences relating to Abu Ghraib, while high-level executives, attorneys, and legislators were defending the use of waterboarding.

Lagouranis presents himself as a torturer but designs a persona meant to counter accusations of monstrosity. Central to the dignity and humanity of that speaking subject is an alternate "masculinity performance," or dominance persona, a persona intriguing for its contradictions, distinctions, and silences.[4] For instance, the book crafts a warrior identity yet refuses a heroic narrative and bemoans the folly of empire. He rejects torture as inexcusable but also depicts his worst violence as a response to personal dishonor, disrespect, or failure to acknowledge his dominance. He distances himself from violence used for pleasure, stress, recreation, competition, or bonding. His depictions also steer clear of racist, misogynist, or sexualized verbal (or physical) abuse. In fact he tells us little of what he yelled at detainees during hours of "enhanced interrogation." Though a set of Navy SEAL techniques that

spread quickly throughout Mosul also included nudity, he offers little discussion. Sexual abuse, he repeats, was an absolute limit; nude searches were not gratuitous or used to terrorize. He disassociates himself entirely from the problematics of sexual pleasure, intimidation, or anxiety that surface in so many reports from detention centers in Iraq.

This complex persona works in tandem with a shifting strategy of narrative positioning that allows the speaker to reflect upon, deflect, or own responsibility at different moments. At times his anecdotes and commentary reinforce the storyline of organizational, social, and psychological forces against which he struggles and yields. At others he undercuts that narrative, claiming full personal responsibility for torture. Each claim to responsibility elevates the speaker, identifying him in the same instant as perpetrator, victim of larger forces, and man of "moral courage," as one interviewer implied (Goodman). But this is calculated courage. He "comes clean" without naming names, inviting retribution from the system, or triggering prosecution for his crimes.

JUSTICE

In the end, I did what I did because I wanted to. That has been very hard to accept.
—LAGOURANIS WITH MIKAELIAN, *FEAR UP HARSH*, 135

Fear Up Harsh is a multifaceted performance, but as a confession to torture, this book is much more: it is a record of assaults against human beings in custody.

We learn late in the book that Lagouranis was named in a criminal complaint by at least one man, an individual he calls "Jafar Ali Abdul Naser." He is the man described as urinating when Lagouranis orders the attack dog to lunge. "Jafar's" complaint to the Criminal Investigative Division concerned the Mosul "disco" under Lagouranis and naked ice water treatment in the SEAL compound. (One man subjected to hooding, beating, water, and hypothermia died there during Lagouranis' term.)[5] Lagouranis mentions the investigation at two points and says he disputed some details. Then ostensibly he hears no more about it, and the question of criminal liability together with the survivor's claims—"Jafar's" or *any* of the survivors' claims—simply disappear from the book (121, 164).

Where these same men are now—and the long-term economic, physical, and psychological consequences of their suffering—we are not to know. How, one wonders, might they react—or their parents, children, spouses—to learn Lagouranis is now back in the United States and situated as something of an expert, not only an outspoken opponent of torture but a spokesman at human rights conferences and a judge for television depictions and awards? There is an outrageous, gaping silence

concerning survivors here and in other perpetrator accounts that mutes all practical exploration of "responsibility" and leaves the deeper problem of justice unsounded. More outrageous, interviewers and filmmakers who elicit and package torturers' tales scarcely seem to note this silence, let alone protest (which may mean, at the least, to present a significant challenge to that absence or to perpetrator elisions and euphemisms via explicit verbal or formal interventions).

As Lagouranis' case and recent films and commentary on Abu Ghraib demonstrate, perpetrator confessions can evoke fascination and sympathy, just as they can retraumatize survivors or trigger renewed denials from regime supporters. Payne maintains that they can also advance fact-gathering and justice but, she adds, they never do so on their own. In the United States, the urgent quest to expose and prosecute high-level facilitators should not displace the critical need to confront perpetrators at all levels: to challenge their claims, pursue them legally, and put them to political use. In fact, the latter can assist the former.

John Conroy has proposed that torture is "the perfect crime." Perpetrators, facilitators, and beneficiaries are rarely charged. When charged, they are rarely found guilty. When found guilty, the sentence never rises to the level of the crime. Culpability is masked and mitigated by the structure of the violence system itself: perpetrators were all following (illegal) orders, commanders were trusting subordinates to stay within legal bounds.

The crime becomes more "perfect" still when regimes that torture, be they democratic or authoritarian, routinely institute layers of legal amnesty to shield the perpetrators and their many facilitators—executive decision makers, lawyers, doctors, psychologists, contractors, and others. The U.S. Congress, in fact, had already instituted sweeping torture immunity in the Military Commissions Act of 2006.[6] What is more, by 2009 the heated debate over legal prosecution for Bush-era executives, legislators, and lawyers promised, at the least, to extend across the Obama administration's first years, despite the new administration's flat denunciation of their predecessor's "enhanced interrogation" protocols, specifically waterboarding, as torture. This was as regrettable as it was predictable. Amnesty law and other protections for perpetrators can last a long time. In 2005, after more than 20 years of activist struggle, Argentina overturned amnesty laws instituted in the mid-1980s. Laws from the 1960s in France continue to protect General Paul Aussaresses despite his gloating 2002 testimonial describing his use of torture in the Algerian war of independence.

In the United States we face the strong possibility that perpetrators will draw all the air time, attention, and credibility to themselves, eclipsing survivors and their claims. Unlike Brazil, South Africa, Argentina, and Chile (Huggins et al.; Payne), the vast majority of those suffering torture in U.S. war-on-terror detention centers

and secret prisons were not and are not part of the U.S. body politic. Detainees have been deported and silenced by the terms of their release. Calls for legislation to ensure these survivors may never enter the United States to become a political force began in 2008 and continue (Lichtblau). So too, what class of detainees has standing against which class of perpetrators will be tested for some time.[7] U.S. courts have thrown out cases brought by those assaulted by military contractors or by survivors of rendition, deferring to government "state secrets" arguments, and the Obama Justice Department has continued to put forth "state secrets" claims despite emerging skepticism on the bench. Courts have also accepted the argument that high-profile defendants, for example, former Secretary of Defense Donald Rumsfeld, were "acting within the scope of their employment."

No justice emerges without vigorous citizen action. Nor will it be justice without political participation of survivors and full attention to their testimony and demands. The transitional justice movement provides a necessary context for the question of justice. As truth commissions have evolved experimentally across widely varied political contexts since the 1980s with disparate and contentious results, a complex paradigm for accountability and transformation has emerged. That model suggests "truth-telling" must be accompanied by criminal prosecution, for one, but also that justice must be much broader than punishment. It must include reparation to survivors and communities; public acknowledgment and memorialization of past deeds and losses; "guarantees of nonrepetition" that include structural reforms of perpetrator institutions such as the police, military, judiciary, and so on, as well as initiatives to abate any ongoing intercommunal violence.[8] The presence, pressure, and perspectives of survivors—in political movements as well as in investigative, historical, and documentary accounts—will be critical in the U.S. context, not only because perpetrators and facilitators, from Tony Lagouranis to George W. Bush, must be held legally accountable for their crimes, but also because survivors must have a large role in shaping collective memory, directing attention to civilian and media complicity, and determining all that justice demands.

Notes

1. The European Commission on Human Rights, after 17 months of deliberation and 119 witnesses, declared these techniques torture in 1976. The European Court on Human Rights demoted them to "inhuman and degrading" on appeal in 1978. See Conroy (2000) for the politics surrounding these cases. For decades, the U.S. State Department had listed these techniques as torture and human rights abuses.
2. The Intelligence Science Board was chartered in 2002 as a scientific advisory group to the U.S. intelligence agencies and was tasked by the Director of National Intelligence. Based on examination of all existing social and behavioral studies on effective interrogation, the report said flat-

ly: "Virtually no research indicates accurate information can be produced from unwilling sources through torture or coercive techniques." It found that technical research and development in this field has gone in the wrong direction: "Ninety-nine percent of US research has been about how to achieve compliance not cooperation" from unwilling sources. More astonishingly given that the U.S. torture mythology has been fueled exclusively on anecdotes, the ISB report found that even "most personal and anecdotal accounts indicate that torture is not effective."

3. Lagouranis' 2007 account of cousins differs slightly from that recorded by Human Rights Watch (2006) as his story of two brothers. Lagouranis' HRW testimony differs in that he spoke of entering Mosul to find an interrogation setting already using these techniques.

4. Huggins et al. (2002) identify three distinctly different "masculine performances" in Brazilian police torturers and death squad workers. Lagouranis' persona approximates "blended masculinity." Their insight that perpetrator masculinities are multiple is welcome though they seem aware their terminology (and their discussion) might falsely fuse masculinity with violence. Perhaps "masculinity performance" is better analyzed as a multifaceted "dominance persona" that also incorporates differently racialized and sexualized gender positions, imperial and nationalist projections, and more. Gay, straight, male, or female, soldiers all enact dominance and group bonding through violence, misogyny, and homophobia, and they combine multiple modes of "masculinity" and "femininity" to choreograph confessional performances. So too, male subjects of torture are masculinized, feminized, sexualized, and racialized in multiple ways, as are female subjects. We require more deliberate understanding of ways gender, race, and sexual differentiation are made and remade in the scene of violence for perpetrators and subjects of violence; these are remade yet again in our media accounts and theoretical work on the subject. See also Rejali (2008) and Puar (2005).

5. Twenty-seven-year-old civilian Fashad Mohammad died about 72 hours after capture, around April 5, 2004. The autopsy left cause of death "undetermined" but notes "multiple minor injuries, abrasions and contusions" and "blunt force trauma and positional asphyxia." Human Rights Watch (2006) found three Navy SEALs were recommended for court-martial in association with his death but still had not been charged.

6. The Military Commissions Act stripped detainees of the ability to sue over conditions of their detention and extended blanket amnesty to lawyers and agents of government for acts reaching back to 1997.

7. Such survivors include the variety of immigrants to the United States caught in post-9/11 sweeps and held in Brooklyn or other U.S. metropolitan sites or military brigs as well as the foreigners captured and transported in renditions to overseas black sites under CIA control or to Guantánamo and other facilities under U.S. military control. The courts that will continue to test these cases are not static entities. Lawyers who crafted legalistic torture evasions or amnesty statutes, such as Jay Bybee, have been promoted to the federal bench or to prestigious teaching posts where they continue to train a new generation of lawyers and judges. Evidence has also been contested. In May 2009 the Obama administration reversed its position on release of visual evidence of torture and abuse sought by the ACLU, putting aside the legal and moral claims of those who suffered and maintaining instead that the images "would not add any additional benefit to our understanding of what was carried out in the past by a small number of individuals" (Zeleny and Shanker, 2009).

8. This last is particularly interesting in the case of the United States: First, U.S. torture in the current period has been cited as justification by torture regimes world over, and U.S. military assaults in Iraq and Afghanistan have set the context for the atrocity work of "intercommunal"

or "sectarian" death squads and torture teams. Second, Rejali (2007) points to a 20-year shadow period in which torture tactics abroad return to "a neighborhood near you" as perpetrators return to police, security, and correction work at home. See also Mamdani (2001); Posel and Simpson (2003); Grandin and Klubock (2007).

WORKS CITED

Bowden, M. (2003, October). "The Dark Art of Interrogation," *Atlantic Monthly*, 51–70.

Brown, K., & Lutz, C. (2007). "Grunt Lit," *American Ethnologist*, 34(2), 322–328.

Conroy, J. (2000). *Unspeakable Acts, Ordinary People: The Dynamics of Torture*. Los Angeles: University of California Press.

Goodman, A. (2005, November 15). "Former U.S. Army Interrogator Describes the Harsh Techniques he Used in Iraq," *Democracy Now!* http://www.democracynow.org/2005/11/15/

Grandin, G., & Klubock, T. M. (2007). "Editors' Introduction—Truth Commissions: State Terror, History, and Memory," *Radical History Review*, 97, 1–10.

Huggins, M. K., Haritos-Fatouros, M., & Zimbardo, P. G. (2002). *Violence Workers: Police Torturers and Murderers Reconstruct Brazilian Atrocities*. Berkeley: University of California Press.

Human Rights First. (2006). *Command's Responsibility: Detainee Deaths in U.S. Custody in Iraq and Afghanistan*. http://www.humanrightsfirst.info/pdf/06221-etn-hrf-dic-rep-web.pdf

Human Rights Watch. (2006). *No Blood, No Foul: Soldiers' Accounts of Detainee Abuse in Iraq*. http://hrw.org/reports/2006/us0706.

Intelligence Science Board. (2006). *Educing Information: Interrogation, Science and Art*. Washington, DC: National Defense Intelligence College. http://www.fas.org/irp/dni/educing.pdf

Lagouranis, T., & Mikaelian, A. (2007). *Fear Up Harsh: An Army Interrogator's Dark Journey through Iraq*. New York: New American Library.

Lichtblau, E. (2008, July 22). "Administration Calls for Action on Detainees," *New York Times*. http://www.nytimes.com/2008/07/22/washington/22justice.html?ref=opinion

Mamdani, M. (2001). "Reconciliation without Justice," in Hent de Vries (ed.), *Religion and Media* (376–387). Palo Alto, CA: Stanford University Press.

Payne, L. A. (2008). *Unsettling Accounts: Neither Truth Nor Reconciliation in Confessions of State Violence*. Durham, NC: Duke University Press.

Physicians for Human Rights & Human Rights First. (2007). *Leave No Marks*. www.physiciansforhumanrights.org.

Posel, D., & Simpson, G. (Eds.). (2003). *Commissioning the Past: Understanding South Africa's Truth and Reconciliation Commission*. Johannesburg: Witwatersrand University Press.

Puar, J. K. (2005). "On Torture: Abu Ghraib," *Radical History Review*, 93, 13–38.

Rejali, D. (2007). *Torture and Democracy*. Princeton, NJ: Princeton University Press.

Rejali, D. (2008). "Torture Makes the Man," in T. Hilde (ed.), *On Torture*. Baltimore: Johns Hopkins University Press.

Zeleny, J., & T. Shanker. (2009, May 14). "Obama Moves to Bar Release of Detainee Abuse Photos," *New York Times*. http://www.nytimes.com/2009/05/14/us/politics/14photos.html

SECTION V

Teach the Children

From Auschwitz to Abu Ghraib[*]

Rethinking Adorno's Politics of Education

HENRY GIROUX

Visual representations of the war have played a prominent role in shaping public perceptions of the United States's invasion and occupation of Iraq. The initial, much celebrated, image widely used to represent the war in Iraq captured the toppling of the statue of Saddam Hussein in Baghdad soon after the invasion. The second image, also one of high drama and spectacle, portrayed President Bush in full flight gear after landing on the deck of the *USS Abraham Lincoln*. The scripted photo-op included a banner behind the President proclaiming "Mission Accomplished."

The mainstream media gladly seized upon the first image since it reinforced the presupposition that the invasion was a justified response to the hyped-up threat of Saddam's regime and that his fall was the outcome of an extension of American democracy and an affirmation of America's role as a beneficent empire animated by "the use of military power to shape the world according to American interests and values" (Steel). The second image fed into the scripted representations of Bush as a "tough," even virile, leader who had taken on the garb of a Hollywood warrior determined to protect the United States from terrorists and to bring the war in Iraq to a quick and successful conclusion.[1] The narrow ideological field that framed these images in the American media proved impervious to dissenting views, exhibiting a disregard for accurate or critical reporting, as well as indifference to fulfilling the media's traditional role as a fourth estate, as guardians of democracy and defenders of the public interest. Slavishly reporting the war as if they

were on the Pentagon payroll, the dominant media rarely called into question the Bush administration's reasons for going to war or the impact the war was to have on the Iraqi people, let alone its profound implications for domestic and foreign policy.

In the spring of 2004, a new set of images challenged the mythic representations of the Iraqi invasion with the release of hundreds of gruesome photographs and videos documenting the torture, sexual humiliation, and abuse of Iraqi prisoners by American soldiers at Abu Ghraib. They were first broadcast on the television series, *60 Minutes II,* and later leaked to the press, becoming something of a nightly feature in the weeks and months that ensued. Abu Ghraib prison was one of the most notorious sites used by the deposed Hussein regime to inflict unspeakable horrors on those Iraqis considered disposable for various political reasons, ironically reinforcing the growing perception in the Arab world that one tyrant simply replaced another. In sharp contrast to the all-too-familiar and officially sanctioned images of good-hearted and stalwart American soldiers patrolling dangerous Iraqi neighborhoods, caring for wounded soldiers, or passing out candy to young Iraqi children, the newly discovered photos depicted Iraqi detainees being humiliated and assaulted. The success of the American invasion was soon recast by a number of sadistic images, including now infamous photos depicting the insipid, grinning faces of Specialist Charles A. Graner and Pfc. Lynndie R. England flashing a thumbs up behind a pyramid of seven naked detainees, a kneeling inmate posing as if he is performing oral sex on another hooded male detainee, a terrified male Iraqi inmate trying to ward off an attack dog being handled by American soldiers, and a U.S. soldier grinning next to the body of a dead inmate packed in ice. The sheer horror of these images has led some commentators to invoke comparisons with the photographs of lynched black men and women in the American South and the treatment of Jews in Nazi death camps.[2] One of the most haunting images depicted a hooded man standing on a box, with his arms outstretched in Christ-like fashion, electric wires attached to his hands and penis, and another revealed a smiling England holding a leash attached to a naked Iraqi man lying on the floor of the prison.[3] In 2006, previously unpublished pictures of prisoner abuse were broadcast by an Australian television station. Circulated throughout the world, these new images include an Iraqi prisoner having his "head slammed into a wall....a naked detainee with multiple injuries to his buttocks [and] a naked male prisoner forced to masturbate in front of the camera" (Oliver). Three additional pictures released by CNN on February 15, 2006 show a hooded detainee holding a large cinder block, two naked men, hands behind their backs handcuffed to each other, and a naked male hanging by his ankles from a second-tier bed bunk. All three of these pictures cannot be viewed as anything other than abuse. These pictures followed video images released only a week earlier that show British soldiers beating Iraqi youth

who had been dragged from a street demonstration into a fenced area and, as reported in the press, were "pulled to the ground and beaten by at least five alleged British soldiers with batons and fists" (Editorial). Like Oscar Wilde's infamous picture of Dorian Gray, the portrait of American patriotism was irrevocably transformed into the opposite of the ideal image it sought to present to the world. The fight for Iraqi hearts and minds has been irreparably damaged as the war on terror appeared to produce only more terror, mimicking the very crimes it claimed to have eliminated.

Susan Sontag has argued that photographs lay down the "tracks for how important conflicts are judged and remembered" ("Regarding the Torture of Others"). But at the same time, she insists that photographs are never transparent, autonomously existing outside of the "taint of artistry or ideology." Lacking any guaranteed meaning, the photographs of Abu Ghraib prison abuse exist within a complex of shifting mediations that are material, historical, social, ideological, and psychological in nature.[4] This is not to suggest that photographs do not record reality as much as to insist that how we render that reality meaningful can only be understood as part of a broader engagement with questions of ethics, ideology, and politics and its intersection with various dynamics of power. Photographic images do not reside in the unique vision of their producer or the reality they attempt to capture. Representations privilege those who have some control over self-representation, and they are largely framed within dominant modes of intelligibility. Reading the photographs and rendering them intelligible is then both a form of cultural production and a form of public pedagogy.[5]

The now endless pictures of torture at Abu Ghraib prison circulate as a form of public pedagogy not only because they register the traces of racial and cultural mythologies such as American triumphalism over evil, terrorists, and the West over East—which must be critically mediated and engaged—but also because they function to align power and meaning in particular ways that inform how one's response to these images should be organized and represented. As these photographs circulate through various sites including talk radio, television, newspapers, the Internet, and alternative media, they initiate different forms of address, mobilize different cultural meanings, and offer different sites of learning. The meanings that frame the images from Abu Ghraib prison are "contingent upon the pedagogical sites in which they are considered" (DiLeo, 9). and limit or rule out certain questions, historical inquiries, and explanations. Often framed within dominant forms of circulation and meaning such images frequently work to legitimate particular types of recognition and meaning (i.e., soldiers following orders or fraternity pranksters), marked by disturbing attempts at evading racist and misogynist commitments. For example, news programs on the Fox Television Network systematically occlude any criticism of the images of abuse at Abu Ghraib that would call

into question the American presence in Iraq. Notorious cases of torture such as those that took place at Bagram prison in Afghanistan are brought to public attention years after the abuses were committed (Golden). Even when recent accounts of the existence of CIA secret prisons used to hold and torture terror suspects were revealed in the popular press, they were either covered with little analytical depth or if engaged critically such accounts were often dismissed on the hugely popular right-wing talk shows as being unpatriotic (Pries, A01). A similar evasion is evident in those politicians who believe that the photographs from Abu Ghraib, Afghanistan, and other detention sites are the real problem, not the conditions that produced them. Or in the endless commentators who bemoan the presence of a few "bad apples" in the military in spite of the evidence supplied by recent investigations.[6]

What is often ignored in the debates about Abu Ghraib—its causes and forms of necessary response—are questions that foreground the kinds of education (not ignorance) that enable one to participate in acts of torture, killing, and sexual humiliation as against the kinds of education that prevent such inhumanity or enable one to bear moral witness when degrading acts of abuse occur. Such questions would clearly focus, at the very least, on what pedagogical conditions must be in place to enable people to view the images of abuse at Abu Ghraib *not as* part of a voyeuristic, even pornographic reception, but through a variety of discourses that enable them to ask critical and probing questions that get at the heart of how people learn *to participate* in sadistic acts of abuse, sexual abasement, and torture, *to internalize* racist assumptions that make it easier to dehumanize people different from themselves, *to accept commands* that violate basic human rights, *to become indifferent* to the suffering and hardships of others, and *to view dissent* as basically unpatriotic. What pedagogical practices might enable the public to decipher the codes and structures that give photographs their meaning while also connecting the productive operations of photography as evidence, for example, with broader discourses of justice? In other words, how might the images from Abu Ghraib prison be understood as part of a wider debate about dominant information networks that condone torture, and play a powerful role in organizing society around shared fears rather than shared responsibilities? How do we understand the Abu Ghraib images and the pedagogical conditions that produced them without engaging the discourses of privatization, particularly the contracting of military labor, the intersection of militarism and the crisis of masculinity, and the war on terrorism and the racism that makes it so despicable? And finally, how might one explain the ongoing evaporation of political dissent and opposing viewpoints in the United States that proceeded the events at Abu Ghraib without engaging the pedagogical campaign of fear-mongering adorned with the appropriate patriotic rhetoric waged by the Bush administration? How does the growing political authoritarianism and religious extremism in

the United States help to explain "the Bush administration's enthusiasm for torture as the most striking aspect of its war against terrorism?" (Pfaff). Photographs demand more than a response to the specificity of an image, they also raise crucial questions about the sites of pedagogy and technologies that produce, distribute, and frame them in particular ways. At stake here is the role that pedagogy plays as part of a broader discourse of articulation in the context of contemporary representations and politics. What do these pedagogical operations mean in terms of how they resonate with established relations of power, ensure that some meanings have a force that other meanings don't, and put into play identities and modes of agency that enable established relations of power to be reproduced rather than resisted and challenged. Put differently, how do photographic images translate into ideological practices that define the nature of contemporary politics?

I have suggested that there is a link between how we understand images and the kind of pedagogical practice that informs our capacity to translate them because I am concerned with what the events of Abu Ghraib prison might suggest about education as both the subject and object of a democratic society, and how we might engage it differently. What kind of education connects pedagogy in its widest articulations to the formation of a critical citizenry capable of challenging the ongoing quasi-militarization of everyday life, the growing assault on secular democracy, the collapse of politics into a permanent war against terrorism, and a growing culture of fear increasingly used by political extremists to sanction the unaccountable exercise of presidential power? What kinds of educational practices can provide the conditions for a culture of questioning and engaged civic action? What might it mean to rethink the educational foundation of politics so as to reclaim not only the crucial traditions of dialogue and dissent but also critical modes of agency and those public spaces that enable collectively engaged struggle? How might education be understood both as a task of translation and as a foundation for enabling civic engagement? How might education be used to question the official arguments legitimating the war on terror or to rouse citizens to challenge the social, political, and cultural conditions that led to the horrible events of Abu Ghraib? Just as crucially, we must ponder the limits of education. Is there a point where extreme conditions short-circuit our moral instincts and ability to think and act rationally? If this is the case, what responsibility do we have to challenge the irresponsible violence-as-first resort ethos of the Bush administration?

Such questions extend beyond the events of Abu Ghraib; but, at the same time, Abu Ghraib provides an opportunity to connect the sadistic treatment of Iraqi prisoners to the task of analyzing pedagogy as a political and ethical practice, and of reconsidering the sites in which it takes place. I want to emphasize that there is more at stake here than the political responsibilities of criticism; there is also the question, as my friend John Comaroff points out, of what it means to theorize the pol-

itics of the twenty-first century as one of the most challenging issues now facing the academy.[7]

In order to confront the pedagogical and political challenges arising from the reality of Abu Ghraib, I want to revisit a classic essay by Theodor Adorno, titled "Education After Auschwitz," in which he tries to grapple with the relationship between education and morality in light of the horrors of Auschwitz. While I am certainly not equating the genocidal acts that took place at Auschwitz to the abuses at Abu Ghraib, a completely untenable analogy, I do believe that Adorno's essay offers some important theoretical insights about how to imagine the larger meaning and purpose of education as a form of public pedagogy in light of the Abu Ghraib prison scandal. Adorno's essay raises fundamental questions about how acts of inhumanity are inextricably connected to the pedagogical practices that shape the conditions that bring them into being. Adorno insists that crimes against humanity cannot be reduced to the behavior of a few individuals, but often speak in profound ways to the role of the state in propagating such abuses, to the mechanisms employed in the realm of culture that attempt to silence the public in the face of horrible acts, and to the pedagogical challenge that would name such acts as a moral crime against humankind and translate that moral authority into effective pedagogical and political practices throughout society so that such events never happen again. Adorno's plea for education as a moral and political force against human injustice is just as relevant today as it was following the revelations about Auschwitz after World War II. As Roger Smith points out, while genocidal acts claimed the lives of over 60 million people in the twentieth century, 16 million of them took place since 1945 (Smith). The political and economic forces fueling such crimes against humanity—whether they are unlawful wars, systemic torture, practiced indifference to chronic starvation and disease or genocidal acts—are always mediated by educational forces, just as the resistance to such acts cannot take place without a degree of knowledge and self-reflection about how to name these acts and to transform moral outrage into concrete attempts to prevent such human violations from unfolding in the first place.

Adorno's essay, first published in 1967, asserted that the demands and questions raised by Auschwitz had so barely penetrated the consciousness of people's minds that the conditions that made it possible continued, as he put it, "largely unchanged."[8] Mindful that the societal pressures that produced the Holocaust had far from receded in postwar Germany and that under such circumstances this act of barbarism could easily be repeated in the future, Adorno argued that "the mechanisms that render people capable of such deeds" (192) must be made visible. For Adorno, the need to come to grips with the challenges arising from the reality of Auschwitz was both a political question and a crucial educational consideration. Realizing that education before and after Auschwitz in Germany was separated by

an unbridgeable chasm, Adorno wanted to invoke the promise of education through the moral and political imperative of never allowing the genocide witnessed at Auschwitz to be repeated. For such a goal to become meaningful and realizable, Adorno contended that education had to be addressed as both an emancipatory promise and a democratic project in order to reveal the conditions that laid the psychological and ideological groundwork for Auschwitz, and also to defeat the "potential for its recurrence" (191). As he put it, "All political instruction finally should be centered upon the idea that Auschwitz should never happen again. This would be possible only when it devotes itself openly, without fear of offending any authorities, to this most important of problems. To do this education must transform itself into sociology, that is, it must teach about the societal play of forces that operates beneath the surface of political forms" (203).

Implicit in Adorno's argument is the recognition that education as a critical practice could provide the means for *disconnecting commonsense learning: from* the narrow framing mechanisms and codes produced and circulated through the mass media; *from* the regressive tendencies associated with hypermasculinity; *from* the rituals of everyday violence; *from* the inability to identify with others; and *from* the pervasive ideologies of state repression and its illusions of empire. Adorno's response to retrograde ideologies and practices was to emphasize the role of autonomous individuals and the force of self-determination, which he saw as the outcome of a moral and political project that rescued education from the narrow language of skills, unproblematized authority, and the seduction of common sense. Self-reflection, the ability to call things into question, and the willingness to resist the material and symbolic forces of domination were central to an education that refused to repeat the horrors of the past and engaged the possibilities of the future. Adorno urged educators to teach students how to be critical, to learn how to resist those ideologies, needs, social relations, and discourses that lead back to a politics where authority is simply obeyed and the totally administered society reproduces itself through a mixture of state force and orchestrated consensus. Freedom in this instance meant being able to think critically and act courageously, even when confronted with the limits of one's knowledge. Without such thinking, critical debate and dialogue degenerates into slogans, and politics—disassociated from the search for justice—becomes a power grab or simply banal.

Adorno realized that education played a crucial role in promoting consensus and in creating the psychological, intellectual, and social conditions that made the Holocaust possible, yet he refused to dismiss education as an institution and set of social practices exclusively associated with domination. He argued that those theorists who viewed education simply as a tool for social reproduction had succumbed to the premier supposition of any oppressive hegemonic ideology: nothing can change. Against this disastrous determinism and a complicitous cynicism,

Adorno argued that the political and critical force of pedagogy could intervene and challenge what he called "reified consciousness." As he put it, "Above all this is a consciousness blinded to all historical past, all insight into one's own conditionedness, and posits as absolute what exists contingently. If this coercive mechanism were once ruptured, then, I think, something would indeed be gained" (200).

Recognizing how crucial education was in shaping everyday life and the conditions that made critique both possible and necessary, Adorno insisted that the desire for freedom and liberation was a function of pedagogy and could not be assumed a priori. At its best, education would take on a liberating and empowering function, refusing to substitute critical learning for mind-deadening training (Adorno, "Philosophy and Teachers," 19–36). Such an education would create the pedagogical conditions in which individuals would function as autonomous subjects capable of refusing to participate in unspeakable injustices while actively working to eliminate the conditions that make such injustices possible. Human autonomy through self-reflection and social critique became, for Adorno, the basis for developing forms of critical agency as a means of resisting and overcoming both fascist ideology and identification with what he calls the "fascist collective." According to Adorno, fascism as a form of barbarism defies all educational attempts at self-formation, engaged critique, and transformative engagement. He writes: "The only true force against the principle of Auschwitz would be human autonomy…that is, the force of reflection and of self-determination, the will to refuse participation" (Hohendahl, 58). While there is a deep-seated tension between Adorno's belief in the increasing power of the totally administered society, on one hand, and his call for modes of education that produce critical, engaging, and autonomous subjects, on the other, he still believed that without critical education it was impossible to think about politics and agency, especially in light of the new technologies and material processes of social integration. Similarly, Adorno did not believe that education as an act of self-reflection alone could defeat the institutional forces and relations of power that existed beyond institutionalized education and other powerful sites of pedagogy in the larger culture, though he rightly acknowledged that changing such a powerful complex of economic and social forces begins with the educational task of recognizing that such changes are necessary and could actually be carried out through individual and collective forms of resistance. What Adorno brilliantly understood—though in a somewhat limited way given his tendency, in the end, toward pessimism—was the necessity to link politics to matters of individual and social agency.[9] Engaging this relationship, in part, meant theorizing what it meant to make the political more pedagogical; that is, trying to understand how the very processes of learning provide the educational foundation for constituting the realm of the social and the political mechanisms through which identities—individual and

collective—are shaped, desires are mobilized, and experiences take on form and meaning.

Adorno was acutely aware that education took place both in schools and in larger public spheres, especially in the realm of media. Democratic debate and the conditions for autonomy grounded in a critical notion of individual and social agency could take place only if the schools addressed their *essential* role in a democracy. Hence, Adorno argued that the critical education of teachers was essential in preventing dominant power from eliminating reflective thought and engaged social action. Such an insight appears particularly important at a time when public education is being privatized, commercialized, and test-driven, or, if it serves underprivileged students of color, turned into disciplinary apparatuses that resemble prisons.[10]

Drawing upon Freudian psychology, Adorno was also concerned with addressing those dominant sedimented needs and desires that allow teachers to blindly identify with repressive collectives and unreflectingly mimic their values while venting acts of hate and aggression (Adorno, "Education After Auschwitz," 192). If *unlearning* as a pedagogical practice means resisting those social deformations that shaped everyday needs and desires, critical learning means making visible those social practices and ideological and material mechanisms that represent the opposite of self-formation and autonomous thinking with the aim of resisting such forces and preventing them from exercising power and influence.

Adorno also realized that the media as a force for learning constituted a mode of public pedagogy that had to be criticized for discouraging critical reflection and reclaimed as a crucial force in providing the "intellectual, cultural, and social climate in which a recurrence [such as Auschwitz] would no longer be possible, a climate, therefore in which the motives that led to the horror would become relatively conscious" (Adorno, "Education After Auschwitz," 194). Adorno rightly understood and critically engaged the media as a mode of public pedagogy, arguing that they contributed greatly to particular forms of barbarism, and that educators and others must "consider the impact of modern mass media on a state of consciousness" (196). If we are to take Adorno seriously, the role of the media in inspiring fear and hatred of Muslims and Arabs, and suppressing dissent regarding the U.S. invasion and occupation of Iraq, and the media's determining influence in legitimating a number of myths and lies by the Bush administration, must be addressed as part of the larger set of concerns leading to the horror of Abu Ghraib. Until recently, the media have consistently refused, for example, to comment critically on the ways in which the United States, in its flaunting of the Geneva Accords regarding torture, was breaking international law, favoring instead the discourse of national security provided by the Bush administration. The dominant media have certainly been more

critical of the Bush administration's role in prison torture and abuse at Abu Ghraib and other U.S.- run detention facilities as well as the overall military and judicial whitewash that has led to the indictment of low-level soldiers, but the larger implications of Abu Ghraib regarding what kind of country America has become has been largely ignored. Largely devoted to a discourse of jingoism, patriotic correctness, narrow-minded chauvinism, and hypermilitarization that render dissent as treason, the dominant media have viewed the tortures at Abu Ghraib largely outside of the discourses of ethics, compassion, human rights, and social justice.

Adorno also insisted that the global evolution of the media and new technologies that shrank distances as face-to-face contact eroded (and hence enhanced the ability to disregard the consequences of one's actions) and had created a climate in which rituals of violence had become so entrenched in the culture that "aggression, brutality, and sadism" had become a normalized part of everyday life. The result was a twisted and pathological relationship with the body that not only tends toward violence, but also promotes what Adorno called the ideology of hardness.

This ideology of hardness with its hyped-up masculinity and indifference toward pain as such aligns itself, as Adorno puts it, all too easily with sadism can be found in the currently fashionable rituals of popular culture, especially reality television programs like *Survivor*, *The Apprentice*, and *Fear Factor*, and the new vogue of extreme sports. All of these programs condense pain, humiliation, and abuse into digestible spectacles of violence,[11] just as they serve an endless celebration of retrograde competitiveness, the compulsion to "go it alone," the ideology of hardness, and power over others as the central feature of masculinity. Masculinity in this context treats lies, manipulation, and violence as a sport that lets men connect with each other at some primal level in which the pleasure of the body, pain, and competitive advantage are maximized while violence comes dangerously is close to acquiring a glamorous and fascist edge.

The celebration of both violence and hardness (witness the fanfare over Donald Trump's tag-line, "You're fired!") can also be seen in those ongoing representations and images that accompany the simultaneous erosion of security (health care, work, education) and the militarization of everyday life. The United States has more police, prisons, spies, weapons, and soldiers now than at any time in its history—this coupled with a growing "army" of unemployed and incarcerated. Yet, the military is enormously popular, as its underlying values, social relations, and patriotic, hypermasculine aesthetic spread out into other aspects of American culture. Public schools have not only more military recruiters but also more military personnel teaching in the classrooms. JROTC (Junior Reserve Officers Training Corps) programs are increasingly becoming a conventional part of the school day. Humvee ads offer the fantasy of military glamor and masculinity, marketed to suggest that ownership of these military vehicles guarantees virility for its owners and promotes a

mixture of fear and admiration from everyone else.[12] The military industrial complex now joins hands with the entertainment industry in producing everything from children's toys to video games that both construct a particular form of masculinity and also serve as an enticement for recruitment. In fact, over 10 million people have downloaded *America's Army,* a video game the Army uses as recruitment tool (Thompson).[13] Such representations of masculinity and violence mimic fascism's militarization of the public sphere where violence is the ultimate language, referent, and currency through which to understand how, as Susan Sontag has suggested in another context, *politics "dissolves... into pathology"* (emphasis added, cited in Becker, 28).

The ideology of hardness in its present form, however, also speaks to a discontinuity with the era in which the crimes of Auschwitz were committed. As Zygmunt Bauman has pointed out to me in a private correspondence, Auschwitz was a closely guarded secret of which even the Nazis were ashamed. Such a secret could not be defended in light of bourgeois morality (even as it made Auschwitz possible), but in the current morality of downsizing, punishment, violence, and kicking the excluded, the infliction of humiliation, pain, and abuse on those considered weak or less clever, is not only celebrated but also taken for granted as a daily ritual of cultural life. Such practices, especially through the proliferation of "Reality TV," have become so familiar that the challenge for any kind of critical education is to recognize that the conduct of those involved in the abuse at Abu Ghraib was neither shocking nor unique.[14]

The ideologies of hardness, toughness, and hypermasculinity are constantly being disseminated through a militarized culture that functions as a mode of public pedagogy, instilling the values and the aesthetic of militarization through a wide variety of pedagogical sites and cultural venues. Such militarized pedagogies play a powerful role in producing identities and modes of agency completely at odds with those elements of autonomy, critical reflection, and social justice that Adorno privileged in his essay. Adorno's ideology of hardness, when combined with neoliberal values that aggressively promote a Hobbesian world based on fear, the narrow pursuit of individual interests, as well as an embrace of commodified relations, profoundly influences individuals who seem increasingly numb to those values and principles that hail us as moral witnesses and call for us to do something about human suffering. Adorno suggests that this indifference toward the pain of others was one of the basic arguments of Auschwitz.

Adorno's prescient analysis of the role of education after Auschwitz is particularly important in examining those values, ideologies, and pedagogical forces at work in American culture that suggest that Abu Ghraib is not an aberration so much as an outgrowth of those dehumanizing and demonizing ideologies and social relations characteristic of militarism, expanding market fundamentalism, and nation-

alism. While these are not the only forces that contributed to the violations that took place at Abu Ghraib, they do point to how particular manifestations of hypermasculinity, violence, and jingoistic patriotism are elaborated through forms of public pedagogy that produce identities, social relations, and values conducive to both the ambitions of empire and the cruel, inhuman, and degrading treatment of those who are its victims. What ultimately drives the ideological vision behind these practices and what provides a stimulus for abuse and sanctioned brutality is the presupposition that a particular society is above the law, either indebted only to God, as former Attorney General John Ashcroft insisted, or rightfully scornful of those individuals, and their cultures, who do not deserve to be accorded human rights because they are labeled part of an evil empire or dismissed as terrorists.[15] The educational force of these ideological practices allows state power to be held unaccountable while legitimizing an "indifference to the concerns and the suffering of people in places remote from our [...] sites of self-interest" (Bilgrami, x).

Adorno believed that the authoritarian tendencies in capitalism created individuals who made a cult out of efficiency, suffered from emotional callousness, and had a tendency to treat other human beings as things, ultimate expressions of reification under capitalism. Adorno's insights regarding the educational force of late capitalism to construct individuals who were incapable of empathizing with the plight of others are particularly prescient in forecasting the connection among the subjective mechanisms that produce political indifference and racialized intolerance, the all-compassing market fundamentalism of neoliberal ideology, escalating authoritarianism, and a virulent nationalism that feeds on the pieties of theocratic pretentiousness. Under the current reign of free-market fundamentalism in the United States, capital and wealth have largely been distributed upward while civic virtue has been undermined by a celebration of the free market as the model for organizing all facets of everyday life (Harvey). Financial investments, market identities, and commercial values take precedence over human needs, public responsibilities, and democratic relations. With its debased belief that profit-making is the essence of democracy, and its definition of citizenship defined by an energized plunge into consumerism, market fundamentalism eliminates government regulation of big business, celebrates a ruthless competitive individualism, and places the commanding institutions of society in the hands of powerful corporate interests, the privileged, and unrepentant religious bigots. Under such circumstances, individuals are viewed as privatized consumers rather than public citizens. As the Bush administration systemically attacks the New Deal, rolls American society back to the Victorian capitalism of the robber barons, social welfare is viewed as a drain on corporate profits that should be eliminated, while at the same time the development of the economy is left to the wisdom of the market. Market fundamentalism destroys politics

by commercializing public spheres and rendering politics corrupt and cynical.[16]

The impoverishment of public life is increasingly matched by the impoverishment of thought itself, particularly as the media substitute patriotic cheerleading for real journalism.[17] The cloak of patriotism is now cast over retrograde social policies and a coercive unilateralism in which military force has replaced democratic idealism, and war has become the organizing principle of society, a source of pride rather than a source of alarm. In the face of massive corruption, the erosion of civil liberties, and a spreading culture of fear, the defining feature of a politics that celebrates conformity and collective impotence seems to be its insignificance (Bauman). For many, the collapse of democratic life and politics is paid for in the hard currency of isolation, poverty, inadequate health care, impoverished schools, and the loss of decent employment (Phillips). Within this regime of symbolic and material capital, the other—figured as a social drain on the accumulation of wealth—is feared, exploited, reified, or considered disposable; and rarely is the relationship between the self and the other mediated by compassion and empathy.[18]

The pedagogical implications of Adorno's analysis of the relationship between authoritarianism and capitalism suggest that any viable educational project would have to recognize how market fundamentalism has not only damaged democratic institutions but has also compromised the ability of people to identify with democratic social formations and invest in crucial public goods, let alone reinvigorate the concept of compassion as an antidote to the commodity-driven view of human relationships. Adorno understood that critical knowledge alone could not adequately address the deformations of mind and character put into place by the subjective mechanisms of capitalism. Instead, he argued that critical knowledge had to be produced and democratic social experiences put into place through shared values, and practices that create inclusive and compassionate communities, which safeguarded the autonomous subject through the creation of emancipatory needs. Knowledge, in other words, becomes a force for autonomy and self-determination within the space of public engagement, and its significance is based *less* on a self-proclaimed activism than on its ability to make critical and thoughtful connections "beyond theory, within the space of politics itself" (Couldry). Students have to learn the skills and knowledge to narrate their own futures, resist the fragmentation and seductions of market ideologies, and create shared pedagogical sites that extend the range of democratic politics. Ideas gain relevance in terms of whether and how they enable students to participate in the worldly sphere of self-criticism and the publicness of everyday life. If Adorno is correct, and I think he is, his call to refashion education in order to prevent inhuman acts has to take as one of its founding tasks today the necessity to understand how free market ideology, privatization, outsourcing, and the relentless drive for commodified public space radically diminishes those polit-

ical and pedagogical sites crucial for sustaining democratic identities, values, and practices, while also defending the public spheres vital to a democracy.

Adorno's critique of nationalism appears as useful today as it did when it appeared in the late 1960s. He believed that those forces pushing an aggressive nationalism harbored a distinct rage against divergent groups who stood at odds with such imperial ambitions. Intolerance and militarism, according to Adorno, fuelled a nationalism that became "pernicious because in the age of international communication and supranational blocks it cannot completely believe in itself anymore and has to exaggerate boundlessly in order to convince itself and others that it is still substantial....[Moreover] movements of national renewal in an age when nationalism is outdated seem to be especially susceptible to sadistic practices" (Adorno, "Education after Auschwitz," 203). Surely, such a diagnosis would fit the imperial ambitions of Richard Cheney, Richard Perle, Donald Rumsfeld, Paul Wolfowitz, and other neoconservatives whose dreams of empire were entirely at odds with both a desire to preserve human dignity and a respect for international law. Convinced that the United States should not only maintain political and military dominance in the post–Cold War world, but prevent any nation or alliance from challenging its superiority, nationalists across the ideological spectrum advocate a discourse of exceptionalism that calls for a dangerous unity at home and reckless imperial ambitions abroad. Belief in empire has come to mean that the United States would now shape rather than react to world events and act decisively in using "its overwhelming military and economic might to create conditions conducive to American values and interests" (Devan). American unilateralism buttressed by the dangerous doctrine of preemption has replaced multilateral diplomacy; religious fundamentalism has found its counterpart in the ideological messianism of neoconservative designs on the rest of the globe; and a reactionary moralism that divides the world into good and evil has replaced the possibility of dialogue and debate. Within such a climate, authority demands blind submission at the same time as it rewards authoritarian behavior reproduced "in its own image" so as to make power and domination appear beyond the pale of criticism or change, providing the political and educational conditions for eliminating self-reflection and compassion even in the face of the most sadistic practices and imperial ambitions.

American support for the invasions of Iraq and the Apartheid Wall in Israel as well as targeted assassinations and the outsourcing of torture are now defended at least in principle in the name of righteous causes even by liberals such as Niall Ferguson and Michael Ignatieff, who like their neoconservative counterparts, revel in the illusion that American power can be used as a force for progress (Ferguson & Ignatieff). The discourse of empire must be deconstructed and replaced in our schools and other sites of pedagogy with new global models of democracy, models grounded in an ethics and morality in which the relationship between the self and

others extends beyond the chauvinism of national boundaries and embraces a new and critical understanding of the interdependency of the world and its implications for citizenship in global democracy. Memory must serve as a bulwark against the discourse of empire, which is often built on the erasure of historical struggles and conflicts. Memory in this instance is more than counterknowledge; it is a form of resistance, a resource through which to wage pedagogical and political struggles to recover those narratives, traditions, and values that remind students and others of the graphic nature of suffering that unfolded in the aftermath of America's claims for a permanent war on terrorism. Teach-ins, reading groups, public debates, and film screenings should take place in a variety of sites and spaces for dialogue and learning, and they should focus not simply on the imperial ambitions of the United States but also on the dehumanizing practices informed by a political culture in which human life that does not align itself with official power and corporate ideology is deemed disposable.

Adorno believed that education as a democratic force could play a central role in constructing political and moral agents and in altering the rising tide of authoritarianism on a national and global level. His call to rethink the importance of critical education as a central element of any viable notion of politics offers an opportunity, especially for educators and other cultural workers, to learn from the horrors of Abu Ghraib, and to rethink the value of public pedagogy—produced in a range of sites and public spheres—as constituting cultural practices, the future of public institutions, and global democracy itself. In addition, Adorno brilliantly understood that it was not enough to turn the tools of social critique simply upon the government or other apparatuses of domination. Critique also had to come to grips with the affective investments that tied individuals, including critics, to ideologies and practices of domination. Analyses of the deep structures of domination might help to provide a more powerful critique and healthy suspicion of various appeals to community, the public, and even to the democratic principles of freedom and justice; for, while it is imperative to reclaim the discourse of community, the commons, and public good as part of a broader discourse of democracy, such terms need to be embraced critically in light of the ways in which they have often served the instruments of dominant power. For Adorno, ongoing critical reflection provided the basis for individuals to become autonomous by revealing the human origins of institutions and as such the recognition that society could be open to critique and change. As a condition of politics and collective struggle, agency requires being able to engage democratic values, principles, and practices as a force for resistance and hope in order to challenge unquestioned modes of authority while also enabling individuals to connect such principles and values to "the world in which they [live] as citizens" (Said, 6). The capacity for self-knowledge, self-critique, and autonomy becomes more powerful when it is nourished within pedagogical spaces and sites

that refuse to be parochial, that embrace difference over bigotry, global democracy over chauvinism, peace over militarism, and secularism over religious fundamentalism. Education after Abu Ghraib must imagine a future in which learning is inextricably connected to social change, the obligations of civic justice, and a notion of democracy in which peace, equality, compassion, and freedom are not limited to the nation-state but are extended to the entire international community. Hopefully, upcoming generations will fight for those forms of critical education in which it will become possible to imagine a future that never repeats the horrors of Abu Ghraib, a future in which justice, equality, freedom, respect, and compassion become the guiding principles of a global democracy, and peace its fundamental precondition.

NOTES

* A longer version of this chapter appeared as "What Might Education Mean After Abu Ghraib: Revisiting Adorno's Politics of Education" in *Comparative Studies of South Asia, Africa, and the Middle East*, 24.1 (2004), 3–22.

1. For an interesting comment on how the Bush media team attempted to enhance presidential persona through the iconography of conservative, hyped-up, macho phallic masculinity, see Goldstein.

2. There is a long history of such abuses and racist violence being photographed by the perpetrators of Western colonialism. See, for example, Razack, 6.

3. Since the release of the initial photos, new rounds of fresh photographs and film footage of torture from Abu Ghraib and other prisons in Iraq "include details of the rape and…abuse of some of the Iraqi women and the hundred or so children—some as young as 10 years old." One account provided by U.S. Army Sargent Samuel Provance, who was stationed in the Abu Ghraib prison, recalls "how interrogators soaked a 16-year-old, covered him in mud, and then used his suffering to break the youth's father, also a prisoner, during interrogation." See McGovern. Another account that appeared in the Washington Post quoted an Army investigation citing the use in Abu Ghraib prison of unmuzzled military police dogs as part of a sadistic game used to "make juveniles—as young as 15 years old—urinate on themselves as part of a competition." A new round of images were released in 2006. See Oliver.

4. For an excellent discussion of this issue, see Lucaites and McDaniel.

5. This issue is taken up brilliantly in Solomon-Godeau.

6. For instance, Pentagon documents released in January 25, 2005 revealed that the systematic abuse of prisoners has taken place not only in Iraq but "at U.S. military detention facilities across the globe. Human rights organizations along with the ACLU have released thousands of documents revealing widespread torture 'reaching well beyond the walls of Abu Ghraib'" (Hendron). The systemic nature of abuse committed by the U.S. government was also revealed and condemned by a 2005 Amnesty International Report in which Secretary-General Irene Khan called the detention center at Guantanamo Bay, Cuba "the gulag of our times" (Khan).

7. Personal e-mail correspondence with John Comaroff dated Saturday, April 19, 2003.

8. This was first presented as a radio lecture on April 18, 1966, under the title "Padagogik nack Auschwitz." The first published version appeared in 1967. The English translation appears in

Adorno, "Education After Auschwitz."

9. Some might argue that I am putting forward a view of Adorno that is a bit too optimistic. But I think that Adorno's political pessimism, given his own experience of fascism, which under the circumstances seems entirely justified to me, should not be confused with his pedagogical optimism that provides some insight into why he could write the Auschwitz essay in the first place. Even Adorno's ambivalence about what education could actually accomplish does not amount to an unadulterated pessimism as much as a caution about recognizing the limits of education as an emancipatory politics. Adorno wanted to make sure that individuals recognized those larger structures of power outside of traditional appeals to education while clinging to critical thought as the precondition but not absolute condition of individual and social agency. I want to thank Larry Grossberg for this distinction. I also want to thank Roger Simon and Imre Szeman for their insightful comments on Adorno's politics and pessimism.

10. On the relationship between prisons and schools, see Giroux, *Terror of Neoliberalism*.

11. George Smith refers to one program in which a woman was tied up in a clear box while some eager males "dumped a few hundred tarantulas onto her....you can hear the screaming and crying from her and witnesses. Some guy is vomiting. This is critical, because emptying the contents of the stomach is great TV. Everyone else is laughing and smirking, just like our good old boys and girls at Abu Ghraib" (Smith).

12. See Nicholas Mirzoeff's interesting discussion of the symbolic capital of SUV in *Watching Babylon: The War in Iraq and Global Visual Culture*.

13. One Web site claims that "more than 30,000 people log onto the game's servers every day; thousands more play in unofficial leagues"; "*America's Army* and the Last Starfighter."

14. This paragraphs draws almost directly from a correspondence with Zygmunt Bauman, dated August 31, 2004.

15. This issue is taken up with great insight and compassion in Lifton and Giroux, *Against the New Authoritarianism and Beyond the Spectacle of Terrorism*.

16. I take up this issue in great detail in Giroux, *Public Spaces, Private Lives: Democracy Beyond 9/11*.

17. One of the best books examining this issue is McChesney's *Rich Media, Poor Democracy*.

18. Constructions of the impoverished other have a long history in American society, including more recent manifestations that extend from the internment of Japanese Americans during World War II to the increasing incarceration of young black and brown men in 2004. Of course, they cannot be explained entirely within the discourse of capitalist relations. The fatal combination of chauvinism, militarism, and racism has produced an extensive history of photographic images in which depraved representations such as blacks hanging from trees or skulls of "Japanese soldiers jammed onto a tank exhaust pipe as a trophy" depict a xenophobia far removed from the dictates of objectified consumerism. See Lucaites and McDaniel, and Bauman, *Wasted Lives*.

WORKS CITED

Adorno, T. W. (1998). "Education after Auschwitz," *Critical Models: Interventions and Catchwords*. New York: Columbia University Press.

Adorno, T. W. (1998). "Philosophy and Teachers," *Critical Models: Interventions and Catchwords*. New York: Columbia University Press, 19–36.

"America's Army and the Last Startfighter," *Technovelgy.com*, February 17, 2005; http://www.technovelgy.com/ct/Science-Fiction-News.asp?NewsNum=334

Bauman, Z. (1999). *In Search of Politics*. Stanford: Stanford University Press.

Bauman, Z. (2004). *Wasted Lives*. Cambridge: Polity Press.

Becker, C. (1997). "The Art of Testimony," *Sculpture*, March, 28.

Bilgrami, A. (2004). "Forward" by Edward Said. *Humanism and Democratic Criticism*. New York: Columbia, 2004.

Couldry, N. (2004). "In the Place of a Common Culture, What?" *Review of Education, Pedagogy, and Cultural Studies*, 26(1) (January–March), 15.

Devan, J. (2004). "The Rise of the Neo Conservatives," *Straits Times*, March 30.

DiLeo, J. R., Jacobs, W., & Lee, A. (2002). "The Sites of Pedagogy," *Symploke* 10, 1–2, 9.

Editorial. (2006). "Outrage over Torture Video," *Gulf Daily News*, February 13.

Ferguson, N. (2004). *Colossus: The Price of America's Empire*. New York: Penguin Press.

Giroux, H. A. (2003). *Public Spaces, Private Lives: Democracy Beyond 9/11*. Lanham, MD: Rowman and Littlefield.

Giroux, H. A. (2004). *The Terror of Neoliberalism: The New Authoritarianism and the Eclipse of Democracy*. Denver, CO: Paradigm Press.

Giroux, H. A. (2005). *Against the New Authoritarianism*. Winnipeg: Arbeiter Ring.

Giroux, H. A. (2006). *Beyond the Spectacle of Terrorism*. Boulder, CO: Paradigm.

Golden, T. (2006). "Years After 2 Afghans Died, Abuse Case Falters," *New York Times*, February 13, A1, A11.

Goldstein, R. (2003). "Bush's Basket," *Village Voice*, May 21–27; http://www.villagevoice.com/2003-05-20/news/bush-s-basket/1/

Harvey, D. (2005). *A Brief History of Neoliberalism*. New York: Oxford University Press.

Hendron, J. (2005). "Pentagon Reveals More Torture in Iraq," *Los Angeles Times*, January 25.

Hohendahl, P. U. (1995). *Prismatic Thought: Theodor Adorno*. Lincoln: University of Nebraska Press, 1995.

Ignatieff, M. (2004). *The Lesser Evil: Political Ethics in An age of Terror*. Princeton: Princeton University Press.

Khan, I. (2005). "Amnesty International Report 2005 Speech at Foreign Press Association," *Amnesty International External Document*, May 25.

Lifton, R. J. (2003). *Super Power Syndrome: America's Apocalyptic Confrontation with the World*. New York: Thunder Mouth Press.

Lucaites J. L., & McDaniel, J. P. (2004). "Telescopic Mourning/Warring in the Global Village: Decomposing (Japanese) Authority Figures," *Communication and Critical/Cultural Studies*, 1(1) (March), 1–28.

McChesney, R. W. (1999). *Rich Media, Poor Democracy*. New York: New Press.

McGovern, R. (2004). "Not Scared yet? Try Connecting These Dots," *Common Dreams*, August 11.

Mirzoeff, N. (2005). *Watching Babylon: The War in Iraq and Global Visual Culture*. New York: Routledge, 36–42.

Oliver, M. (2006). "New 'Abu Ghraib Abuse' Line Images Screened," *Guardian*, February 15.

Pfaff, W. (2004). "Torture Reconsidered: Shock, Awe and the Human Body," *International Herald Tribune*, December 22; http://r7fel.blogspot.com/2004/12/torture-reconsidered-shock-awe-and.html

Phillips, K. (2003). *Wealth and Democracy*. New York: Broadway Books.

Priest, P. (2005). "CIA Holds Terror Suspects in Secret Prisons," *Washington Post*, November 2, A01.

Razack, S. H. (2004). *Dark Threats and White Knights*. Toronto: University of Toronto Press. Said, E. (2004). *Humanism and Democratic Criticism*. New York: Columbia University Press.

Smith, G. (2004). "That's Entrail-Tainment!" *Village Voice*, August 3; http://www.villagevoice.com/2004-

07-27/news/that-s-entrail-tainment/

Smith, R. W. (2004). "American Self-Interest and the Response to Genocide," *Chronicle Review,* July 30; https://chronicle.com/article/American-Self-Interestthe/25904/

Solomon-Godeau, A. (1994). *Photography at the Dock.* Minnesota: University of Minnesota Press.

Sontag, S. (2003). *Regarding the Pain of Others.* New York: Farrar, Straus and Giroux, 26.

Sontag, S. (2004). "Regarding the Torture of Others: Notes on What Has Been Done—and Why— to Prisoners, by Americans," *New York Times Sunday Magazine,* May 23, 25.

Steel, R. (2004). "Fight Fire with Fire," *New York Times Book Review,* July 25, 12–13.

Thompson, C. (2004). "The Making of an Xbox Warrior," *New York Times Magazine,* August 22, 34–37.

White, J., & Ricks, T. E. (2004). "Iraqi Teens Abused at Abu Ghraib, Report Finds," *Washington Post,* August 24, A01.

Contributors

Stephanie Athey is associate professor of English in the Department of Humanities at Lasell College. She works in race, gender, and literary studies and has published on torture, race, and reproductive technology, eugenic feminisms, and colonial discourse in the Americas. She is editor of *Sharpened Edge: Women of Color, Resistance and Writing* (2003), a collection of scholarship concerning armed resistance, human rights organizing, cultural resistance, and development strategies of women in Africa, India, and the Americas. Her book-in-progress *Torture's Echo* examines the public discourse of torture in American media, military and detainee memoirs, and fiction since 2001.

Patrick Brantlinger is James Rudy Professor (Emeritus) at Indiana University, where he served as editor of *Victorian Studies* (1980–1990) and chair of the Department of English (1990–1994). Among his books are *Rule of Darkness: British Literature and Imperialism 1830–1914* (1990), *Dark Vanishings: Discourse on the Extinction of Primitive Races* (2003), and *Victorian Literature and Postcolonial Studies* (2009). With William Thesing, he coedited the Blackwell *Companion to the Victorian Novel* (2005).

David Clearwater received his PhD (Art History and Communication Studies, McGill University) in 2006 and teaches in the Department of New Media/Faculty of Fine Arts at University of Lethbridge. His research interests revolve around the

aesthetics and politics of media, including advertising, gaming, documentary, and propaganda. Following an earlier degree in the visual arts, he maintains an ongoing creative practice in graphic design, photography, and digital illustration.

Anna Froula is assistant professor of Film Studies at East Carolina University. She has published on media representations of Pfc. Jessica Lynch and Pvt. Lynndie England and on Arundhati Roy's *The God of Small Things*. She is currently completing a coedited collection, *Reframing 9/11: Film, Popular Culture and the "War on Terror"* (Continuum, forthcoming) and a manuscript that explores depictions of U.S. servicewomen in popular culture from World War II to the present.

Cynthia Fuchs is director of Film & Media Studies, as well as associate professor of English, African and African American Studies, and Film & Video Studies, at George Mason University. She has published numerous articles on popular culture and images of war. She edited *Spike Lee: Interviews* (2002), and coedited *Between the Sheets, in the Streets: Queer, Lesbian, and Gay Documentary* (1997). Her current book project focuses on post-9/11 documentaries.

Henry Giroux currently holds the Global TV Network Chair Professorship at McMaster University in the English and Cultural Studies Department. His most recent books include *The University in Chains: Confronting the Military-Industrial-Academic Complex* (2007), *Against the Terror of Neoliberalism* (2008), and *Youth in a Suspect Society: Democracy or Disposability?* (2009).

Joe Lockard is associate professor of English at Arizona State University. He teaches early American and African American literatures, and directs the Antislavery Literature Project (antislavery.eserver.org). His recent books include *Watching Slavery: Witness Texts and Travel Reports* (2008) and, with Mark Pegrum, *Brave New Classrooms: Democratic Education and the Internet* (2007). He has published extensively on American literatures and cultural studies, and develops projects in Internet-based public scholarship.

Leanne McRae is the Senior Researcher and Creative Industrial Matrix Convenor for the Popular Culture Collective (www.popularculturecollective.com). She teaches mobility and media studies, cultural studies, screen studies, and creative industries to international students in Perth, Western Australia. Her current research interests involve investigating the politics of intimacy, exploring intellectual property rights and fashion, and a continuing investment in the currency of "cult" as a mobile meaning system. Ongoing research concerns revolve around men's studies, postwork cultures, and the place of popular cultural studies within the academy.

Nathaniel Nadaff-Hafrey is a writer and musician. He currently works for a media company that focuses on digital video. He researches modern Middle Eastern

culture and film, ethnomusicology of Mexico and the American South, graphic novels and comic book culture. Most recently, he has begun to study trends in digital media and Internet video consumption. He has published articles on Hip Hop and Vietnam War films.

Tony Perucci teaches courses in performance, cultural, and media studies at the University of North Carolina at Chapel Hill, where he is assistant professor of Communication Studies. His writing has appeared in *Text and Performance Quarterly* and *The Drama Review* (forthcoming) as well as in the edited volumes *Violence Performed* (2009) and *Performing Adaptations* (2009). He is currently completing a book manuscript, *Tonal Treason: Paul Robeson and the Politics of Cold War Performance*.

Murray Pomerance is Chair and Professor in the Department of Sociology at Ryerson University and the author of *The Horse Who Drank the Sky: Film Experience beyond Narrative and Theory* (2008), *Savage Time* (2005), *Johnny Depp Starts Here* (2005), *An Eye for Hitchcock* (2004), and *Magia d'Amore* (2000). He has also edited or coedited numerous anthologies including *Cinema and Modernity* (2006), *American Cinema of the 1950s: Themes and Variations* (2005), *Where the Boys Are: Cinemas of Masculinity and Youth* (2005), *BAD: Infamy, Darkness, Evil, and Slime on Screen* (2004), and *Enfant Terrible! Jerry Lewis in American Film* (2002). He is coeditor, with Lester D. Friedman of the "Screen Decades" series at Rutgers University Press and with Adrienne L. McLean of the "Star Decades" Series there; and editor of the "Horizons of Cinema" series at SUNY Press.

Zoe Trodd is a postdoctoral fellow at the University of North Carolina, Chapel Hill, in the Center for the Study of the American South. She researches American protest literature, especially the literature of abolitionism, antilynching, and desegregation. Her books include *American Protest Literature* (2006), *To Plead Our Own Cause: Personal Stories by Today's Slaves* (with Kevin Bales, 2008), *Modern Slavery: The Secret World of 27 Million People* (2009, with Kevin Bales and Alex Kent Williamson), and *The Long Civil Rights Movement* (2009, with Brian L. Johnson).

Iraq War Cultures